ALASDAIR GRAY

RODGE GLASS is now a novelist (*No Fireworks* and *Hope for Newborns*), but wasn't when he first encountered Alasdair Gray in a Glasgow pub in 1998. Since then, while pursuing his own writing ambitions, he has filled many roles in the life of the writer/artist. He has taken dictation whenever and wherever asked: whether Gray was in bed, in hospital or drinking soup cold from the can, he was there with a pad or a laptop, awaiting instructions. He has been a barman, tutee, secretary, signature-forger, driver, researcher, advisor, chief technology negotiator, tea-maker and paper boy, with varying degrees of success. In this book Glass attempts one more role: biographer. Born in Manchester, he lives in Glasgow.

ALASDAIR GRAY

A Secretary's Biography

12/9/09

RODGE GLASS

Dear Don & Ruth,

Hope you enjoy your visit to the UK & have fun with the family

Lots of love,

Rodge

BLOOMSBURY

LONDON · BERLIN · NEW YORK

First published in Great Britain 2008

This paperback edition published 2009

Copyright © 2008 by Rodge Glass

All photographs in the illustration section have been provided courtesy of
Alasdair Gray with the exception of the following: 'King of Gibraltar, 1957'
(courtesy of Margaret Bhutani); 'With friends Liz Lochhead and Edwin
Morgan in Berlin' (image courtesy of the *Herald & Evening Times* picture
archive); 'Preparing for his public, with biographer and glass of wine at the
Aye Write! book festival, Glasgow' (Tommy Ga-Ken Wan
www.tommygakenwan.com)

The author is grateful to Alasdair Gray and the following publishers for
permission to reproduce copyright material in this book. Jonathan Cape for
extracts from: *Lean Tales*; *1982, Janine*; and *Something Leather*. Canongate for
extracts from: *Lanark*; *Unlikely Stories, Mostly*; *The Fall of Kelvin Walker*; *How
We Should Rule Ourselves*; *The Ends of Our Tethers*; and *A Life in Pictures*.
Bloomsbury Publishing for extracts from: *Ten Tall Tales and True*; *Poor Things*;
Mavis Belfrage; *The Book of Prefaces*; and *Old Men in Love*

Bloomsbury Publishing Plc
36 Soho Square
London W1D 3QY

www.bloomsbury.com

Bloomsbury Publishing, London, New York and Berlin

A CIP catalogue record for this book is available from the British Library

ISBN 9780747596233

10 9 8 7 6 5 4 3 2 1

Typeset by Hewer Text UK Ltd, Edinburgh
Printed in Great Britain by Clays Ltd, St Ives plcn

This book is blamed on Ross McConnell,
who introduced me to the work of Alasdair Gray in 1998,
and persuaded me to stick with it.

———

In memory of the people in this story who died while
it was being written: Angus Calder, Archie Hind,
Malcolm Hood, Philip Hobsbaum, Ian McIlhenny,
Alasdair Taylor and Jeff Torrington.

———

A BIOGRAPHY IS A JOINT EFFORT

A SECRETARY DOES HIS DUTY

A Short Poem About Junk E-Mail,
and the Problems of Introducing Ageing Artists
to the Subtleties of the Form

Alasdair!
Don't look!
What? he says. *What is it? Show Me!*
I click, to messages from
Viagratastic; Nikkicam;
WecanmakeyouthreeinchesbiggerbyChristmas.
The great man stands, paces, pouts, points skyward
(He replies to all his mail)
says, *Take dictation!*

'Dear Sir or Madam,
You will do no such thing.
Yours Truly.'

RG 2003

CONTENTS

PREFACES

HOW THIS BOOK HAPPENED

The first conversation between biographer and artist about this project took place during a short coffee break in February 2005 – a much-needed one for me. The previous night I had gone to bed, not sober, with an idea in my head I was now finding it difficult to get rid of, and I was struggling to concentrate on my secretarial duties.

The day before, I had met a friend for a quiet afternoon drink in the university bar. Professor Willy Maley[1] arrived, shook my hand and introduced himself, saying: 'Hi, Rodge, not seen you in ages. When are you starting your Ph.D.?' I had no plans to begin one. But after some stuttering of lame excuses on my part and some strong convincing on Willy's, I found myself being dragged away from the bar towards an introductory talk he was giving to prospective Creative Writing Ph.D. students. Ten minutes later I was sitting in a university classroom, grim-faced, trapped, with no choice but to listen to the Maley sales pitch, which focused largely, it seemed, on the healing power of footnotes.[2] Creative Writing Ph.D.s were a growth area, apparently. Rachel Seiffert[3] was doing one, a novel mixed with an extended essay. They were all the rage. Well, my Grandma Betty would finally be able to claim a doctor of sorts in the family (very important for a nice Jewish boy), and perhaps there were financial benefits if I could get funding, but I was far from convinced by the idea.

After the session we returned to the bar, and I told Willy very definitely that I simply wanted to write novels. If I ever mastered it (unlikely) and wanted to be an academic (possible) then I'd give him a call, but for now I had other work to do. Besides, the book I was working on was about two young, sexy people locking themselves in a bedroom for five days – hardly the stuff of serious academic theory. The only proper cultural contribution I could make, I said, speaking without thinking, would be to write a biography of Alasdair Gray – and not a dry, academic project that anyone with a stack of books and a love of bibliographies could do either, but something more ambitious –

something funny, entertaining, personal, a proper record for future
generations – and everyone knew that, typically, Alasdair wanted to do
the project himself. But we made an appointment for the following
week anyway and I stumbled home. I wasn't sure I meant it, but there it
was. Alive.

The idea was not an entirely new one. Several weeks earlier (again,
I'm afraid, after a night out) Alan Bissett[4] had encouraged me to
document my relationship with Alasdair. 'You're a part of living
history, Rodge . . . you should write his biography . . .' he'd said,
drink in one hand, drink in the other. 'If you don't, in a hundred
yearsshh, Shhcotland will be very annoyed with you!' This, I told him,
was a ridiculous proposition, and that it was time for us all to go home
to bed. But now here I was, so soon after, in the Gray kitchen, getting
ready to announce it as if it was my own plan. Pouring out the third
coffee of the morning and struggling with a hangover, I brought up the
idea of the biography with the man himself. Perhaps I just wanted to be
rejected so that I could get on with the day's work. But, more likely, I
wanted to be told it was a great idea and to go off and start right away.

That day Alasdair had been furiously working on the historical
sections of *How We Should Rule Ourselves*, a pamphlet he was co-
writing with Glasgow University law professor Adam Tomkins; they
planned to do the whole thing in three weeks, because, as Alasdair put
it, 'political books should be spat out'. He was dictating his parts to me,
occasionally asking my opinion on a small thing here or there, sending
me off to find out a date or fact, but less so than usual. It had been – for a
man ten years late with his *Book of Prefaces* – a tight schedule, and we
were having a difficult afternoon. With only a few days until deadline
(and working a thirteenth day out of the last fourteen) he was hurriedly
racing through the entirety of British chronological history, trying to
get up to the French Revolution by six o'clock but getting distracted by
small, infuriating details like the Hundred Years War. Pacing the room,
stuttering, pointing at the screen, dictating, re-dictating, starting again,
forgetting what he'd already done, losing the latest printout and picking
up one a week out of date, Alasdair was at his most infuriating. Like
many of his assistants before me I was going steadily insane trying to
hurry him up, politely explaining that if he wanted to get the book out
in time for *this* General Election he really did have to get on with it,
while his wife Morag McAlpine sat up in bed reading the *Herald* and
chuckling: 'Tom Leonard described working with Alasdair as like being

a sandcastle fighting the sea,' she announced triumphantly from behind her paper. 'Can you see why?' Morag had been the last person to give up the secretarial job I was now engaged in, and she seemed to be really rather enjoying watching me suffer, but even at the most frustrating points, I wanted to do this work. And I was starting to think about the book I could write about it.

In the past few years I had spent more time with Alasdair than I had spent with many members of my family, received help with my debut novel while he was my tutor at Glasgow University, and had seen him work at close quarters on several books: *The Ends of Our Tethers*; *A Life in Pictures*, *Old Men in Love* and now *How We Should Rule Ourselves*. He had taught me about writing and taken an interest in many aspects of my life. I had been summoned to the hospital the day after his heart attack (to take notes, which I refused to do – until the following day), seen him first thing in the morning, last thing at night, sober, drunk, excited, depressed, asleep, naked (passing me in the hallway on the way to the bathroom), clothed, and had come to him for advice many times. At that time, apart from Morag herself and his assistants at the Oran Mor, the arts centre (see pages 270–3), I probably saw as much of Alasdair Gray as anyone else. But perhaps I was too indebted to him – I started out as a fan, and even now was partly dependent for financial support – maybe I was the worst person in the world to write his biography. So when I tentatively raised the subject over coffee that morning, I half expected him to see the suggestion as a betrayal, but Alasdair was perfectly cheerful about the idea. He admitted it appealed to his vanity, said he thought I'd probably do a fair job, and after a brief chat we got back down to the afternoon's work as normal, which went much more smoothly than hoped. Between paragraphs on the French and American revolutions he introduced me to Boswell's famous biography of Samuel Johnson, suggested I use that format as a partial template for my book, granted free copyright on everything he'd ever done, promised not to try to influence the content any further, and even said he wouldn't read or criticise the work until it was published. From then on we'd not discuss the idea but he'd always know I might be taking notes. 'Be my Boswell!' he shouted, dancing a jig around the room and raising a finger to the heavens. 'Tell the world of my genius!' He then went on to narrate a ten-minute story about Boswell recording Johnson's preoccupation with orange peel. I told Alan Bissett my plan, and

explained to Willy at our meeting the following week that I wished
to be Dr Glass and what could he do to help me.

CROW-BARRING MY WAY
INTO THE LIFE OF A. GRAY

Written Spring 2005, Before Embarking

The main street through Glasgow's West End is called Byres Road. But
when this road was still countryside, a pub called Curlers already existed
in what would become the centre of a busy street many years later. So
the story goes, King Charles II stopped in to Curlers on his way to the
centre of Glasgow one cold winter's night in the seventeenth century.
At the arrival of the King, the sleepy landlord was called out of bed and
summoned to the pumps. When His Royal Highness (who was famous
for enjoying a good time) finally got back on his horse at sunrise,
significantly less able to ride, legend has it that 'the Merry Monarch
bestowed upon the inn the right, by Royal Charter, to be open day and
night, Sundays included, in perpetuity.'[5] The offer was not taken up,
but rumour has it that this Charter still exists in Register House in
Edinburgh – a reminder that twenty-four-hour drinking is not a
modern idea, and proof that even kings say things they haven't properly
thought through after a pint or two. There is little evidence of this
grand history in the two-storey cottage's current incarnation, now
sitting between a Starbucks and a newsagent – part of the It's a Scream
chain of student pubs, decorated in black and bright yellow, with a
reproduction of Edward Munch's 'The Scream' hanging out front.
This current state is considered sacrilege for many of those who knew
the old Curlers and many older people don't go there any more – but it
was in this unlikely place that, in 1999, this biographer (then a twenty-
one-year-old barman) first met the subject of this book.

It may seem strange that Alasdair Gray should choose this place for a
quiet drink of a weekday afternoon,[6] but Curlers did have a long
history as a literary hang-out before the It's a Scream re-invention;
Gray drank there in those days and was still an occasional visitor. The
landlord was an evangelical fan of Alasdair's books, so it was well
known that he came in sometimes – there was a bit of a Gray alert
system in operation on both floors. I had not been on shift when he'd

been in before, but I'd made it plain to the rest of the staff that, should he ever appear, I wanted to serve. I wasn't quite sure what I wanted to get out of attending to the mysterious Mr Gray, apart from being able to tell friends that I'd done it; he didn't do anything in particular, according to accounts – just stood at the bar, had one or two drinks and left. But that made little difference. *Lanark* was one of the first novels I had read on moving to Glasgow the year before,[7] and during my time working at Curlers I had read Alasdair's entire back catalogue, discovering the work of other Scottish writers like James Kelman and Agnes Owens along the way. So though my English family had no idea who I was talking about when I explained that I worked in a pub visited by the great Alasdair Gray, for me this was exciting. I was desperate to meet him. Like many distant fans, I had built up an inaccurate picture of how Alasdair would be.

I still wince at the thought of this. Where Boswell orchestrated a formal introduction with Samuel Johnson (allowing plenty of time to plan a good opening sentence) my first meeting with Alasdair was significantly less grand. He walked into the pub when it was quiet and no one else was around – no customers, no other staff – and I was completely unprepared. I thought I recognised him, but perhaps I'd made a mistake. Having never met one before, I imagined authors and artists to be bold, suave people who understood that the world enjoyed them entering a room and acted like it. This scratchy little man with wild grey hair looked very lost standing there in a soaking wet anorak trying desperately to find his money. When it appeared, his voice – high, stuttering and unsure – was not what I expected either. But he was polite in the extreme, and friendly. I took his order, nervously made up the drink, put it down on the counter and blurted out:

'So do you think *Lanark* is a postmodern work, or merely one that has been called postmodern by critics?'

Alasdair looked at me blankly. I tried to rescue the situation: 'If you tell me, I'll buy you that gin and tonic.'

In those days I was unused to abrupt, direct answers, so was taken aback by the tone of his reply: 'Well . . .' he muttered, not pleased. 'I don't know. But I can pay for my own alcohol.' He sank the thing quickly and left.

Alasdair had forgotten who I was when he next came in, and on each occasion I served him after that I made a slightly better job of it, starting again each time as if we'd never met. Fewer questions about post-

modernism, I thought, more good service: that was the way to go about it. Around this time Morag had begun coming in to the pub some mornings for a quick half-pint and a read of the *Herald* – I tried to buy her a drink too, but this attempt also failed. She sometimes spoke briefly of the threats from Religious Leaders that Alasdair's contribution to Canongate's *Revelations*[8] book were bringing, but otherwise she was silent. And they never came in together.

One quiet daytime Alasdair seemed in a chattier mood than usual. Unprompted, he told me there used to be a large painting on a now-destroyed Curlers wall portraying past Scottish writers and journalists who had lived in or around the city. He said it had gone missing and described some of the people in the painting, the way it was laid out, why he liked it. He even talked about his work a little, and asked what I wanted to do with my life – which at the time, I thought, was run a pub. Or sing in a band. Or a number of other half-baked ideas. Then he explained he would not be coming back any more because Curlers had changed too much and he didn't like it, but I was not offended. I had met Alasdair Gray. He might even recognise me next time we saw each other. (Though I am now almost certain he had completely forgotten these early exchanges by the time we met again in 2001.) Anyway, somebody said that Peter Mullan[9] had been spotted at a corner table recently having a peaceful pint and reading the *Evening Times*, and I was on the lookout for other famous folk.

My first consistent contact with Alasdair also came about by chance. Inspired by his books and other Scottish writers I was reading, I had abandoned my plans of being the next in that long line of Curlers' landlords, finished a degree at Strathclyde University, and, encouraged by writer-in-residence Alan Jamieson,[10] applied for the Masters in Creative Writing being run jointly by Strathclyde and Glasgow universities. By the time I read in a newspaper in the summer of 2001 that Gray, James Kelman[11] and the poet Tom Leonard[12] were all to become professors on the course, I had already been accepted on to it. On the Open Day for the M.Phil. there were readings by all three, and also Anne Donovan,[13] Louise Welsh[14] and Zoë Strachan.[15] I wanted to do two things from then on – write a novel which I could one day read out to future students, and seize Alasdair Gray as my personal tutor. On the Tutor Request Form, there were seven to choose from. I listed three preferences in very large, clear lettering – 1 ALASDAIR GRAY, PLEASE. 2 ALASDAIR GRAY, PLEASE. 3 ALASDAIR GRAY,

PLEASE. In my second year they attempted to give me another tutor but I was not interested. I complained until they returned Alasdair to me.

He was not a great tutor to all – some students only had a couple of meetings all academic year, and a few stopped seeing him out of sheer frustration – but to me he seemed a very good one. He rarely directly answered the questions I asked, often rewrote entire passages of my fiction in his own style (something I learned to reprimand him for), and we usually spent longer talking about him than me, but he was, in his own way, dedicated. He saw me twice as regularly as his job description demanded,[16] gave attention to my early, often poor short stories, and allowed meetings to go on for more than a couple of hours. Each time, I stayed until he kicked me out.

Alasdair conducted most of our sessions at his wife's home, surrounded by his many paintings and imposing library, which stretched across every wall of his compact West End flat, top to bottom, with stray volumes spilling out over the sides, piled on desks, chairs and some parts of the floor. We sat across from each other, often getting agitated – me at him for not sticking to the point, him at me for not improving. (He often felt newer versions of my work were worse than the ones I had produced before receiving his advice. This upset him, and resulted in letters of irritation between meetings telling me it really was time I started doing as he said.) But though I knew little about writing and was often too excited to concentrate, these sessions were crucial for me. Also, without really noticing, I was forgetting my initial fan's adoration and getting to know my tutor, less afraid of losing his approval. I had lost that in the first week by not being a genius, and losing it wasn't as bad as I'd feared. I was no longer angling for ways to ask questions about his books either; I was learning how to work.

I had now met many writers, and even some of the most talented didn't match up in person to the image in my mind. But Alasdair spoke, gestured, thought, dealt with people socially and in business as if he was from another, far more interesting time that made interaction almost magical. In those early meetings I often felt he would have made an excellent Victorian-era officer or private detective. His library overflowed with ancient, dusty editions of the works of Shakespeare, Shaw, Burns, which sat alongside a big collection of contemporary Scottish writing and a section of books around his artist's desk on the work of Picasso, Velásquez and Blake. Gray paintings, finished and unfinished,

hung in all rooms. A fake fire blazed where most people's televisions stood. He wrote with a fountain pen in large, slow, elaborate loops. He referred to the *Manchester Guardian* and the *Glasgow Herald* as if they were still local dailies. If it wasn't for Morag's computer, their home might have been one from Glasgow at the end of the nineteenth rather than the twentieth century. Mixing good manners and repeated apology, failure to recall the simplest facts with the ability to quote obscure poets verbatim, often acting out parts of plays and operas in his front room then collapsing into fits of giggles, apologising, farting and returning to work, Alasdair Gray was a rare personality. Maddening, peculiar, but never dull. And yet I was not intimidated, because he was not stuffy or judgemental. A man unafraid to admit sexual mistakes to virtual strangers is no traditionalist.

As I progressed on the M.Phil. course we continued working on my writing, and sometimes he talked about his. He was part way through writing *The Ends of Our Tethers*,[17] which I and some other students saw early versions of in class. We had one long talk about the ideas behind two pieces in this collection, but these official exchanges about writing were the limit of our involvement. Until I heard that he had asked another of his students, Griselda Gordon, to do some typing for him. She felt it would be impolite to refuse on this one occasion, but did not have the time to become Alasdair Gray's part-time secretary. I was keen to be. I put myself forward, Alasdair agreed, and so began our third phase of dealings.

Our meetings became excuses to work on Alasdair's own fiction, with *The Ends of Our Tethers* growing and evolving all the time. I can't be sure whether he felt he had passed on to me all he could – 'You know my rules, now apply them!' he exclaimed angrily one day after a particularly difficult couple of hours – whether it was more convenient for him to use me as a way of getting out of university work or whether he simply needed help after Morag refused to work with him any longer. But I didn't mind which it was. He had already done more than any tutor could be expected to, and I now needed time to craft something of my own that was consistent, not fortnightly meetings where we would both get exasperated that I hadn't got better yet. As well as the meetings at his flat I now started to visit Alasdair's university office on some weekdays, trying to drag out each session as much as possible. (He was paying me twice what I was getting in the bookshop I was now working in, and, besides, it was fun waiting for the next

entertaining Grayism to relate to my friends.) One day, while dictating a letter, he rose from his seat, walked behind me, went to the sink in the corner of the room and began to urinate in it – without warning, and without pausing for breath. Facing the other way, legs crossed, pen and pad in hand, I continued without comment. I felt certain that anyone able to dictate under these circumstances should be able to rely on my services without question. But I didn't wash my hands in that sink ever again. Or accept a cup of coffee made with water drawn from it.

Around this time, I finally supplied a single short story that he thought didn't need correction. I also wrote a brief piece the American Jewish short-story writer Grace Paley liked when she visited Scotland; something Alasdair considered praise enough for anyone's ego. From this point on, in late 2002, he seemed to consider his work done, and though I pressed on with the course and was now handing him occasional early versions of my novel, it was not the most important thing any more. Alasdair and James Kelman were having disagreements with other members of staff about the direction of the course and were in the process of deciding to give up the job altogether at the end of that academic year. By the time I handed in my portfolio for judgement in September 2003 neither was involved in marking my work, but I was seeing Alasdair more regularly than ever. We discussed my mark only once. 'Don't think about it,' he said. 'It doesn't matter.' This is a period of Alasdair's life he now regrets. Two years after it finished he told me that his 'new artistic assistant' Richard Todd[18] and I were the only useful things he had got out of his time as professor, and that he should have just looked us up in the phone book.* I should have been pleased at this, but was not. I wanted him to think of those two years with the same affection as I did.

In early 2003 I was in the process of getting an agent, progressing with my novel, doing occasional (terrible) readings – one particularly horrible memory is performing an early effort concerning a romance between a goldfish and a horse in the Scotia Bar while watching James Kelman grimacing in the front row – but in time I began to learn. Kelman's understandable grimace probably forced me to raise my

* This omitted several others, most notably Chiew-Siah Tei, a student of AG's and novelist/playwright who he has rated highly since 2003. She was then working on her novel *Little Hut of Leaping Fishes*, published by Picador in 2008, and which AG hailed in a review for the *Times Literary Supplement*.

standards. Meanwhile, being Alasdair Gray's secretary made me believe I was somehow more of a writer, though in reality I spent most of my time with him tidying his flat, addressing letters, taking dictation and looking for misplaced things. (There are always lots of misplaced things in the Gray–McAlpine household.)

During 2003 Alasdair took to sitting directly beside me at the computer and dictating fiction off the top of his head. He began doing everything from that spot, in that way. Then I set up and began to run his e-mail account. He let me deal with less important work myself; I liked this because I finally felt like a proper secretary. I enjoyed contributing in these small ways – occasional corrections, word repetitions, research, advice, official letters – but immaturity made me want to make him do things my way. One early letter concerning the proposed writing of a new novel left me infuriated.

'I would like £300 a month on which to live during the writing of this book,' he dictated, in a letter to his agent – 'No, no, no, no – £400. No, £500! I'm worth it!'

At this point he went quiet, before asking politely: 'Actually Rodger . . . *what do you think I am worth?*'

I had absolutely no idea. 'A thousand?' I suggested. 'More?'

'Damn it, a ttthhousssand then! Let them DARE TO SAY NO!' he cried, laughing as if he couldn't care less about the actual result.

I struggled to keep my mouth shut but the bluff worked out well – Gray got his cheques. After that it was understood between us that I should learn all I could – as long as I did what he required, I was free to take notes while he worked on whatever I pleased, so when it came to dealing with similar issues myself I would be aware of *how things worked*. This continued until I moved south to Warrington, in Cheshire, in late 2003, where I stayed for a year.

My move made our work no less regular. Alasdair sent me jobs by post, and in early 2004 I spent several weeks typing up his old plays[19] ready to go on his website, using old bound copies from the sixties and seventies, often with different titles, or different character names to the ones that finally appeared in later, adapted novels. When there was new fiction he sent me handwritten notes by post, and I earned more Gray money while living in England than I had living five minutes from my boss's house. During this time I made monthly visits to Glasgow, arriving on Friday night, working with Alasdair on Saturday and Sunday, seeing friends in between and going home on Sunday night.

So when I returned to Glasgow in October 2004, now a full-time novelist, it seemed natural to continue as before. We agreed on one day a week for me to work on all things Gray-related, but six months later I realised that arrangement had been naïve. Between the political pamphlets, hospital visits, day trips across Scotland, computer-related errands and last-minute newspaper articles, most weeks I spent more time working for Alasdair than I did working for myself.

I now think of Alasdair Gray as a normal human being, with some remarkable attributes but also some flaws. I mostly treat him like a grandfather and he mostly treats me like an equal who happens to have the necessary typing skills. There is occasional physical contact between us, in the form of the odd manly touch on the arm, or a pat on the back, but never more than that. It is, I suppose, an odd arrangement, but I like it. Though it is hard to explain, there are few things more satisfying for me, even now, than being woken at 7 a.m. to be asked to send an e-mail. And now every meeting has another purpose. Our relationship is about to change once more.

A Note to Anyone Hoping for a Tidy Book

Like Gray's work, life and much of his speech, the pages that follow are neither tidy nor a chronological series of events that lead to easy conclusions. Those expecting a traditional biography, starting with the day he was born, steadily working up to the present, may be disappointed. However, I hope you will enjoy this unorthodox, affectionate book, and not wish it was a simpler one. That may yet come. Many of those types of biography create fictional characters of their own by trying to simplify their subjects and hide the biographer from view. This book prefers to let you see and make your own mind up.

Alasdair Gray was not always the rapidly ageing, fat Glasgow pedestrian he enjoys describing on the inside leaf of his books. There was once a time when he was young. A time when he was really rather thin. Many years when he was poor, unpublished and unrecognised. This book aims to document, as faithfully as possible, that journey from son of a boxmaker encouraged to paint and write to septuagenarian 'little grey deity'.[20] Alasdair claims to be satisfied, living in the West End of Glasgow with his wife, splitting his time between writing and painting. Aside from work, Gray's pleasures include daytime whisky, giving money away, reading books by people he doesn't have to meet and 'getting what I want'. This

book will look at the people, events, books, paintings, plays, poems and circumstances that conspired to make the man he is today.

You could say I am, as Edmund Wilson[21] described Boswell, 'a vain and pushing diarist'. Or, as Donald Greene[22] once accused Boswell, of being a minor writer trying to make a name for myself through memorialising a great one. You could say I am taking advantage of a frail old man. You could say I have got him to sign away his life story to further my own writing and academic career, and to please my grandma. And there would be something in that. (I am not the first to pursue letters after my name to please the folks and prove old school-teachers wrong.) But Alasdair is acutely aware of his legacy and is in the process of tying up loose ends in all aspects of his work; he is as sharp – if not sharper – than ever, and would spot if I was trying to trick him; also, he knows I will want to do this properly, which means recording the unpleasant. For example, he has said, 'I would rather you didn't talk about my women', but has since discussed them openly in interviews while I took notes. The project is a calculated risk on his part.

On the other side, there will be those concerned that this will be a fawning, sickeningly sweet version of Alasdair Gray's existence. They are right to be suspicious. Gray was. But I have no intention of treating the subject this way – anyone who has had a conversation with him or read one of his books will know he is one of his own harshest critics. I would have to try hard to outcriticise him. This is a man who insists on quoting negative reviews on the backs of his books, and has invented a fictional critic to tear apart his own work. There are plenty of positive things to say about my subject – and I more than most have the motivation to make him look good – but there would be no point in producing *A Sycophant's Bible of Alasdair Gray*. In the spirit of Alasdair's long-established insistence on declaring influences, plagiarisms and downright steals, this biographer will hide nothing. I am not good at concealment, and would be bad at it if I tried. I begin with the following:

Embarrassing Facts Worth Getting Out of the Way

1 I know Alasdair is more important to me than I am to him.
2 I know I have used him as a role model for my own life and writing, and sometimes copy his techniques.
3 I have taken inspiration from seeing someone else with asthma and eczema become a successful artist despite the condition, and

this may have made me more sympathetic to his condition and its consequences than necessary.

4 I have sought to please Alasdair in the past in order to gain more work in the future.

This book will be a history of Gray's life and work (focusing mainly on his literary output), but also a more personal document of the biographer's journey; it will include stories of encounters with Alasdair, talking to him about his life, working with him on current projects. I will use evidence from Gray's creations to back up arguments about the man himself. This is sometimes considered a risky strategy – the artist is not the art! say some critics – but I'll argue that with Alasdair Gray it would be remiss of me not to tackle such things. He openly uses and abuses autobiography in his work. This biographical style is at his request, and is in homage to the biography of Johnson by Boswell, who was also invited to include himself in the process, making the book more personal. In that case, Boswell was a young Scot looking to climb the literary ladder, with Johnson the distinguished elder Englishman with nothing to prove. In this case it is the Scot who is the elder, with the young Englishman taking notes, putting up with bad habits and making friends in high places. Many of the best projects in this field of literature have been attempted by people close to their subjects, and so have many of the worst. James Hogg wrote *The Domestic Manners and Private Life of Sir Walter Scott*. Goethe enjoyed Eckerman taking down his every thought – 'Be my Boswell!' Goethe told him, and so Alasdair has me – though he now denies it. I here start a very personal book on what I have discovered: a secretary's observation. If Gray is spared, he may do one of his own.

It is necessary to ask: why does Alasdair Gray deserve a biography written about him? There are many reasons. Anthony Burgess famously called him 'the first great Scottish novelist since Walter Scott'. Gavin Wallace has called him 'one of the most successfully multi-faceted imaginations Scotland has ever produced'[23] and many agree. But he is a lot more than that. As well as being a master storyteller, he also looks in on each of his works, like his readers, inviting multiple interpretations. Graham Caveney has said that Gray forces readers to 'reconsider their relationship to storytelling, the lies that we tell ourselves to make our experience real'[24]. All 'great' artists – and this book argues that Alasdair Gray is one of those – must surely make those who come across their

work re-examine something of themselves and their world. Even at its most compromised, Gray's work does this. For all his maddening, frustrating diversions and minor projects and political preoccupations and social awkwardnesses, it is this biographer's belief that Alasdair Gray is the greatest artist his home country has seen in the last hundred years, and also one of Europe's most important in the same period. And he is certainly one of the most fascinating personalities on the current artistic landscape. He has been everything from shy teenager to extrovert 'dirty old man of Scottish letters'[25] and much in between, an obsessive worker (sometimes to the detriment of his non-work relationships) and has seen no decent reason to resist invading and playing with every form he can think of: novel, poem, radio, television or stage play, polemic, portrait, mural, short story, essay and song. Gray is nothing if not unique.

As well as inspiring readers in many countries, good writers have cited him as a direct influence or inspiration, too. Many of the best, in his home country and elsewhere, who have come through since Gray came to prominence, have directly credited him: the likes of Jonathan Coe, Irvine Welsh, Ali Smith, Will Self, Janice Galloway. A younger generation of writers, particularly in Scotland, has known nothing but the literary landscape he helped form. His best work will last for generations to come. This book exists because those generations may want to know what Alasdair Gray was like: it is half a traditional biography, half a portrait of the artist as a remarkable old man.

1 1934–45: EARLY YEARS, WAR YEARS, WETHERBY

NOTES ON EARLIER LIVES

As Alasdair says when directing interviewers to his CV or his *Saltire Society Self-Portrait* (a pamphlet about himself that Gray was asked to write in 1987), 'Certain facts cannot be disputed.' So who is Alasdair Gray and where does he come from?

In 1865 a baby called Jeanie was born to Agnes Stevenson (née Nielson) and her husband Archibald, a coalminer in the county of Lanark. Jeanie grew up to marry Alexander Gray, Alasdair's grand-father, who was in turn the son of William Gray and his wife Anne (née Binning). Alexander Gray was a gaunt, stern-looking industrial black-smith and devout Christian, kirk elder and Sunday School teacher, whose political heroes were William Ewart Gladstone (an artistically inclined four-time Prime Minister of Britain known as the 'Grand Old Man' by the working classes and a 'half-mad firebrand' by Queen Victoria) and Keir Hardie (who founded the Independent Labour Party in 1888, set up the Scottish Parliamentary Party in 1892, and who Alexander Gray knew personally). These are the kinds of role models that his grandson Alasdair would choose for himself in years to come.

Alexander Gray married Jeanie Stevenson, a power-loom weaver, and in 1897 they had a son, Alexander Junior. Alasdair's dad grew up in Glasgow, where he would go on to live for most of his life. He explained some aspects of this upbringing in a document titled *Notes on Early Life in Glasgow*, written in 1970–1 at Alasdair's request. Alexander described the late nineteenth-century city he grew up in, also providing an affectionate portrait of his parents. It was a strict, deeply religious upbringing. Grace was said before every meal, and each night before bed Alexander's father would read the daily lesson from the Bible to him and his younger sister Agnes. Then their mother Jeanie would say a prayer, or the children would be required to lead it. As a boy Alexander always took part in this family ritual and as an adult he always respected it. There was much in his home life he thought admirable. It was characterised by a toughness he felt

proud of – a toughness which was absolutely necessary for working-class families like the Grays in the early part of the twentieth century. Alexander remembered:

[T]he first years of this century had no social security or health insurance and doctors' bills had to be avoided. I remember father coming home with his face and hands bandaged after he had been splattered with molten lead at work. He came from hospital where he had the pieces of lead picked from his skin, had his dinner and went back to work.[1]

Alexander's father had little other option but to return to work – there was no prospect of compensation in those days, and few laws that protected men in dangerous workplaces – but the quiet, accepting way his father dealt with these kind of trials was typical of the family, as Alexander saw it. He called both of his parents 'mild of temper',[2] and one example, of a burglary in the home, illustrated how they responded to crises with a positive attitude: '[D]rawers and dressers and cupboards had been ransacked and clothing etc taken. His [Alexander Senior's] first thought was for his working clothes and all he said was "Well, they have left me the best suit, the one I need for my work."' This level of emotional control certainly impressed his son. Despite considerable religious differences, Alexander Gray considered his parents to be the model of honourable, good behaviour, a sound example for parenthood. This was an opinion he also formed from his observing his mother, who always knitted, baked, made jam and saved enough from the little money she earned to pay for a week's holiday every year during Glasgow Fair.[3] Alexander described both his parents as: 'examples of Christian living for they not only observed the daily observances but in their treatment of people of all religions or none, were helpful and kind and tolerant'.[4] Though he didn't follow in their religious ways when his own son was born, he otherwise continued with the moral traditions he learned as a boy.

Alasdair's maternal grandparents, Emma Needham and Harry Fleming, were from a similar kind of working-class family to the Grays, but they married many miles south of Glasgow, in Lutton, Lincolnshire, in 1898. Harry was a foreman in a shoe factory there, but later the two would be forced to move to Scotland after Harry was blacklisted in

England for trade union activities. Before the establishment of the British Labour Party in the early twentieth century, merely being a member of a trade union was a dangerous business. (The very fact of blacklisting became a source of pride for a certain Scottish Socialist born several decades later.) Harry and Emma had three children – Alasdair's aunt Annie, Alasdair's mother, Amy, born on 11 January 1902, and his uncle, Edward Fleming. Edward only lived for seven years before dying of an unknown disease; just one photograph of him survives. Alasdair wouldn't find out about the existence of his uncle until years after his mum died.

There are few surviving details on the early life of Amy Gray, but Alasdair still keeps a record of his mother's schooling at Onslow Drive Public School. Her certificate of merit, gained on 16 February 1916 when she was fourteen, showed as much about the period as her personal ability, but it did declare her 'very good at English, Arithmetic, Handwriting, Laws of Health, Civics, Empire Study, Trill and Singing, Cooking, Laundry, Housewifery, and Dressmaking'.[5] Amy Gray had academic ability, therefore. And a knowledge of the Empire! Un-fortunately, because of the era and personal circumstances, she was never able to continue her studies.

So, one of Alasdair's parents had a long line of Scottish ancestors, and the other had been brought north from England by a father looking for work. But there were some years yet before the two would meet. First, Alexander was sent to fight for the British Army against the Germans in the First World War, returning after service in the trenches of Europe for the famous Black Watch regiment with a minor injury – towards the end of the war he took a 'shrapnel wound in the belly . . . for which he would receive a small pension for the rest of his life'.[6] As Andrew, Alasdair's son, recalled many years later, his grandfather fought in the Highland Light Infantry on the Somme and at Passchendaele, but though this wartime involvement was a source of pride to Alexander, he rarely discussed it. Andrew remembers: 'I was always trying – and failing – to get information about Passchendaele out of him. That was not his way . . . but it certainly affected him. Sometimes I would jump out from behind a door to give him a friendly shock, but he never responded. After the war, he said he could not be shocked in that way.'[7] When Alexander joined the army in 1914, he was only just old enough to do so. An old family photograph of him, in full uniform, surrounded by both parents and sister Agnes, shows what appears to be

much more a boy than man. As Alasdair has written, his father 'bought his first pipe and tobacco with his first pay'.[8]

After recovering from his injury Alexander Gray had to find manual work that would not be affected by it. He stayed in the same paid job from 1918 to 1939, in a box-making factory in Bridgeton, and took part in voluntary work in his spare time. He did unpaid secretarial work[9] for 'a short-lived entertainment company called the Co-Optimists, The Ramblers' Federation, Camping Club of Great Britain, Scottish Youth Hostel Association and Holiday Fellowship',[10] with whom he went hillwalking regularly. Alexander Gray's war injuries didn't stop him from being an active member of the local community, from taking part in physical exercise or from pursuing political goals. Just as Alexander had taken the moral lead from his parents, from this his own son, Alasdair, would learn that wounds were no decent excuse to stop working.

In 1929, eleven years after the end of the First World War, Alexander Gray met shop assistant Amy Fleming through the Holiday Fellowship while walking at a local outing. Alexander and Amy got together fairly late by the standards of the early twentieth century – by the time they were married on 13 April 1931, Alexander was thirty-four, his bride twenty-nine. After marrying, they moved into a new housing scheme in the north-east Glasgow district of Riddrie that would shape much of the experience and politics of the boy born to them three years later. On 28 December 1934 at 11.15 p.m. he was brought into the world at the family home in Findhorn Street.

There was some difficulty over the delivery. When her waters broke, Amy Gray went to her mother's house, which was only a few streets away but, as Alasdair later recounted, 'despite having borne three children herself . . . my granny panicked and told her to go away'.[11] She returned home. Eventually the baby Gray was delivered by Mrs Liddle, a neighbour in the flat below who had been a nurse, while his dad cycled around the streets trying to find a doctor. It is hard to imagine a father doing this now, but the vision of Alexander Gray cycling in circles, hoping to come across someone on the streets of Riddrie prepared to deliver his firstborn, is appealing. Two years and two months later, a daughter was born to Alexander and Amy – they were more prepared for that – and Mora Jean Gray, Alasdair's sister, was born in hospital in Riddrie on 4 March 1937.

THIRTIES RIDDRIE

Alasdair has gone to great trouble to describe Riddrie during his youth. He has portrayed his childhood home as 'one of the earliest and best planned housing schemes built under the Wheatley Act, the only egalitarian measure passed by the first Labour government elected in 1924'. He says: 'Our neighbours were a nurse, postman, printer and tobacconist, so I was a bit of a snob.'[12] This alludes to the fact that he grew up, from a very early age, assuming that there was nothing he couldn't do. Alasdair continues: 'I took it for granted that Britain was mainly owned and ruled by Riddrie people – people like my dad who knew Riddrie's deputy town clerk (he also lived in Riddrie) and others who seemed important men but not more important than my dad.'[13] This kind of language is typical of Alasdair's memories of where he was born. He manages to make an entirely ordinary place sound like a paradise where he learned everything he would ever need to know. But don't all young children learn to walk and talk while assuming their parents are the most important people in the world? Which child does not assume he or she is the centre of the universe – at least until they are shown otherwise? Mora describes the Gray family home in cooler language:

> We had bright but brown floors – the floors were covered in brown linoleum, and we had a brown suite with wooden arms. The only source of heat was the fireplace in the living room, which had a table by the window, a piano, a sideboard, a bookcase and Mum's desk – we had an end of terrace window seat. Also, there were communal back greens in the tenements, and a big air raid shelter out the back.[14]

She admits the Gray family were fortunate, but her sober assessment of her home is very different from her brother's. He sees everything in terms of the political background, places like the local library that made his childhood seem magical – but where Alasdair idealises Riddrie, Mora describes a simple, ordinary working-class home, right down to the roles within the family. The contrast is crucial, as Alasdair has written so many times about the Riddrie of his youth that it has almost become a Gray Creation: which it remains until someone else comments upon it. For example, Riddrie is also home to Barlinnie Prison, infamous in Scotland

for its poor conditions, for being overcrowded and for retaining 'slopping out' until 2001. That is not to say that all Riddrie was this grim, a prison is a community all of its own, but it is important to remember that Alasdair's version of the place is not the only one.

Alasdair's parents gave him the tools to begin creative play at a very early age: 'My mummy and daddy gave me a pencil and crayons to scribble with long before I went to school,'[15] he has said, in a rare use of the more affectionately childish term for his parents. Once provided with the basics he spent most of his time using them, also developing his imagination through watching Walt Disney films, pantomimes, fables like Aladdin and Cinderella, and reading A. A. Milne's Winnie-the-Pooh books, whose cast of characters Alasdair particularly related to. He has written: 'Kind lazy poetic Pooh, bouncy Tigger, melancholy Eeyore were recognisable people, and aspects of myself.'[16] Alasdair also began to exercise his imagination out loud: 'I suppose my first audience was my sister . . . I invented stories I told her as we walked to school, versions of stories I'd read, or films or plays I'd seen. I twisted the most exciting bits together around a central character who was basically me.'[17]

Like so many other aspects of his childhood, these recollections were to find their way into early sections of Alasdair's debut novel Lanark, as was his sister Mora, presented as Ruth in the book. This period of infancy was a jumble of realisations, brought about by childish curiosity, but also by the fact that nobody told him to stop using his imagination, something Alasdair considers to have been very important in his primary school days, despite its simplicity. Through his father's book shelves, a regular series of Readers' Book Club novels received at home[18] and through visiting Riddrie library, he learned about literature and art. The main difference between him and most of his peers was that though they sometimes enjoyed the same stories (Alasdair also loved comics like Dandy and Beano), Alasdair wanted the power of being able to create his own, with him as the star. By this time he was basing many of his little stories on ones he had recently read, or seen performed locally. Alasdair has revealed how he responded as a boy to fantasies he enjoyed:

I only liked fairy tale stuff: Hans Andersen, Lewis Carroll etcetera . . . I especially remember one of the features of pantomimes, which they may still have. The grand finale in which, on a staircase

at the back, there would descend all the cast in escalating order of importance to music and big applause from the audience. [In voice of evil villain] Of course the clown usually got the most applause. I remember being fascinated by this and wanting a set-up in which it would be me descending the staircase to the vastest applause of all![19]

Alasdair now regularly says in interviews that he has always been more interested in fame than money, and that is borne out by this childhood fantasy.

STARTING PRISON

Alasdair's short-story collection *Ten Tales Tall and True* (which does not contain ten stories, and most of which are lies) is completed with a single, partly true story – 'Mr Meikle – An Epilogue'. The story begins with Alasdair explaining the concept and detail of primary school as if none of his readers would understand what this alien place was:

At the age of five I was confined to a room made and furnished by people I had never met and had never heard of me. Here, in a crowd of nearly forty strangers, I remained six hours a day and five days a week for many years, being ordered about by a much bigger, older stranger who found me no more interesting than the rest. Luckily, the prison was well stocked with pencils . . .[20]

Gray hoped he would not be ordinary for long.

One day, children of this primary school prison were asked to come up with five items they thought poetic. They chose five inoffensive ones – a fairy, a mushroom, some grass, pine needles, a tiny stone – and were then asked to write a poem about one or more of these things. Alasdair used all, presenting the following piece, which he claimed was written with 'ease, speed and hardly any intelligent thought':

A fairy on a mushroom,
sewing with some grass,
and a pine-tree needle,
for the time to pass.

> Soon the grass it withered,
> The needle broke away,
> She sat down on a tiny stone,
> And wept for half the day.[21]

The story then describes the teacher reading the poem out to the class. Alasdair relates how this sudden attention made him feel, slipping quickly into its consequences. He doesn't claim the poem itself was amazingly good, but explains in a straightforward, unashamed manner that he learned creativity could be a way to get attention and praise:

> While writing the verses I had been excited by my mastery of the materials. I now felt extraordinarily interesting. Most people became writers by degrees. From me, in an instant, all effort to become anything else dropped like a discarded overcoat . . . I aimed to write a novel in which all these would be met and dominated by me, a boy from Glasgow. I wanted to get it written and published when I was twelve, but failed. Each time I wrote some sentences I saw they were the work of a child. The only works I managed to finish were short compositions on subjects set by the teacher. She was not the international audience I wanted but better than nobody.[22]

Alasdair spent the next couple of decades trying to close the gap between what he wanted to achieve and what he was capable of.

ARTISTIC BEGINNINGS

There was also a first artistic realisation, from around the same time. This is fictionalised in *Lanark*, with the description of a young Duncan Thaw, Alasdair's alter ego, sitting at home drawing 'a blue line along the top of a sheet of paper and a brown line along the bottom' (one to represent the sky and the other the ground). This is a factual description of how a young Alasdair first began to draw. In a piece he wrote for the 2006 exhibition 'Divided Selves: The Scottish Self-Portrait from the 17th Century to the Present', Alasdair told these events from his childhood as fact, dictating to me with a copy of *Lanark* in front of him to help him remember his own past, so maybe (if there was ever

any difference) truth and fiction were now merging. Since the only other person present at the blue-line drawing was Alexander Gray, and he is no longer alive to argue, we will have to take Alasdair's word for it. At least, this was how Alasdair remembered it.

Sitting at home entertaining himself with colours he has been given, Thaw (or Alasdair) is unable to draw what he wants. What he wants is to portray a beautiful princess, but unable to make her 'lovely enough' he hides her in a giant's sack instead, then tells his father the picture is of 'A miller running to the mill with a bag of corn'.[23] The father then questions the single lines representing sky and ground, going on to try to explain to the boy what gravity is and why there's nothing on the other end of the sky. His son does not understand this, and dreams that night of repeatedly falling through a thin cardboard sky to an unknown other side. But he has drawn a picture, and has learned that he can get away with hiding emotions in art. Even when it is there, plain on the page, his father still could not see what he saw – a princess trapped by a giant. This event, as described in the Thaw section of Lanark, was certainly a moment of artistic realisation – but it was also a description of Alasdair's first experiences of lying, shame and confusion.

After that, the idea of attention via creativity was reinforced regularly. Alasdair was happiest when left to his imagination, allowed to leave food he didn't like and when performing in the family home. The home equivalent of his 'fairy on a mushroom' piece came when Alasdair and Mora's parents encouraged them to have a party piece, something to show off on social occasions. So Alasdair came up with more silly poems, usually imitations of A. A. Milne's style. Gray was consciously trying to achieve something great enough to get him fairy-and-mushroom attention on a much bigger scale, but perhaps it is also possible to see Alasdair's early life not as one or two key moments of absolute realisation, but more of a drip effect, where the boy steadily began to realise people noticed some potential in him. Alasdair has said:

From an early age I had an incredibly high conceit of myself as a maker of imagined objects. Quite early on I found degrees of recognition, some public, some purely local. Hardly a year passed without some encounter, some publication, some encouragement. I frequently had signs from people . . . even when I was a small boy.[24]

Alasdair believes his journey towards recognition started as early as five or six years old.

During Alasdair's first years Alexander Gray worked as a folding-box maker and Amy worked at home raising the two children, a situation that would continue until a change was forced with the beginning of another world conflict. In September 1939 Britain declared war on Germany; little Alasdair was sitting on his mother's knee listening to the wireless when Neville Chamberlain announced it. In 1940 the Battle of Britain began, and many children were moved out of large British cities, even ones as far north as Glasgow.

WAR YEARS AND WETHERBY

Like many who had fought in the First World War, Alexander became one of an important group of older men (he was forty-one in 1939) whose position in society became more elevated at home during the Second World War. He had been a manual labourer in peacetime, but in wartime he suddenly found himself an organiser of others. The Holiday Fellowship, with which he had been involved for some years, needed a manager for a residential hostel in northern England. Considered a steady, responsible type, Alexander gained this job through the offices of J. S. Edbrocke, Secretary of the Holiday Fellowship and the man whose company had become managing agents for the Ministry of Supply.

In 1940 Amy Gray and her two children were evacuated to a farmhouse close to the small Scottish village of Auchterarder, Perthshire, where Alasdair had his first asthma attack beside a threshing machine. Mora remembers the cramped conditions: 'We lived in what seemed like a converted coach or railway carriage,'[25] she has said. During that period Alasdair had particular problems with his health, perhaps because of the sudden change of atmosphere – according to Mora he had whooping cough, measles and chickenpox all within a short space of time. Later the family moved on to Stonehouse, a mining town in Lanarkshire, while Alexander moved south to Reading to work as assistant manager in a munitions workers' hostel. In 1942 he was put in charge of a Royal Ordinance Factory residential hostel at Wetherby, Yorkshire. He was responsible for administration during the opening hours of the hostel, and was in charge of nearly two hundred staff.

Alexander arranged for his family to follow him to Wetherby, so although Alasdair and Mora did have to cope with evacuation, it was in relatively comfortable circumstances compared to those of many who had similar wartime experiences. They even lived in a bungalow especially reserved for the manager's family. Where some were separated from both parents and siblings, sometimes moving to communities which did not necessarily understand or want them, the young Gray children were part of an upwardly mobile move that saw their father in a new-found position of responsibility, with the added bonus of accommodation. They were part of a community that protected them from any sense of alienation. Their new home seemed far more exciting than any previous ones. Pictures of the canteen, library and communal gardens of the munitions factory show it was comfortable, with many things shared equally, though the manager's family bungalow tended to give them an elevated status. Mora remembers the period well:

It was an idyllic time for the Grays . . . for the first time, we had money! Before going to Yorkshire we were totally unaware of class because everyone we knew was like us. But in Wetherby, the class system seemed to be accentuated. Everybody seemed to be aware of it . . . We went to the council school, not the private one, and some people were horrified. I wonder if my father enjoyed suddenly being important, wearing a suit and tie. I remember: we even had a cleaner. She was called Ruth Wilson. My parents thought they were on the same level as Ruth.[26]

So Wetherby was a kind of alternative universe where working-class Glaswegians were briefly considered gentry. But everyone knew it wasn't going to last, and perhaps that is what reinforced rather than reduced the family's socialist politics during that time. They took part in community events like everyone else – Mora took dancing lessons and Alasdair even joined the church choir. Writing about it years later, he explained this without mentioning God: 'I joined the Church of England choir because it paid me two shillings a week for attending it and rehearsals. I also enjoyed the singing.'[27]

Though their home in Wetherby was quite protected, Alasdair was certainly affected by the evidence that crept in from time to time that something unpleasant was going on outside their little world. Mora

recalls: 'We would stand and count the planes going out – to bomb Germany – but some crashed before they left shore. I remember it because Perspex was new then, so people went and took the Perspex off the crashed planes. But Alasdair was a lot more aware of that kind of thing than I was. He had terrible nightmares.'[28]

There were a number of other experiences in this period that affected Alasdair: an important one was his first sight of public art. A surviving photograph of the Wetherby canteen shows the first murals Alasdair saw, which made him feel that art could be something that belonged to people. A very socialist kind of art, then: free, on walls, instead of in galleries with a price tag attached. As an adult Alasdair would use this philosophy to help decide which jobs to prioritise and which to put off.

MOTHER AND FATHER

In Alasdair's accounts of wartime, the references to his father and mother are curiously uneven. Though his father appears regularly, there is little mention of his mother in his diaries, autobiographical writings, or indeed his Personal CV,[29] apart from a few lines reproduced almost word for word in journalistic pieces and interviews. All we learn about Amy Gray is a short list of facts: she was brought to Scotland by her father, was reduced to tears when he read *Tess of the D'Urbervilles* aloud, and she 'liked to sing, could accompany herself on the piano, attended opera and joined the Glasgow Orpheus Choir'. It also includes how she met her future husband, but aside from this her most significant mentions in the young Gray life story are disguised references in *Lanark*. In the few surviving photographs she seems sad, even when smiling, but despite a slightly awkward posture inherited by her son she was pretty when young. One early photograph shows her enjoying herself with trouser legs rolled up to the knees, eating an ice cream while paddling in the sea. A later one shows she grew into a sensible-looking older woman who sat cross-legged, facing away from the camera, as if trying to divert attention from herself. That may go some way to explaining why there is otherwise a lack of information on what she was like. Perhaps she had been taught to keep much of that to herself.

Seen in isolation, this lack of reference might not seem so strange

– not all children are highly influenced by their parents, or even find their parents interesting enough to want to discuss them at length – but considered alongside Gray's other descriptions of events in his life, this almost complete omission of Amy Gray from the narrative seems more curious. The praise heaped on her husband is consistent and almost completely uncritical – in *Lanark* he emerges as an almost saintly figure, and in descriptions of Alasdair's early life he makes regular, influential appearances. His work life is described in great detail, as is his first World War contribution. He is largely credited with bringing his son up with an understanding tolerance of religion (though he was not a believer himself), and for giving him access to the literature that made him a lifelong socialist. More tellingly, perhaps, in Gray's *Saltire Self-Portrait* seven of the leaflet's twenty pages are given over to Alexander's account of the family history as he saw it. There is no mention of Amy at all. It is likely that this is because she had few ways of expressing herself. No one doubts that Amy Gray's daily life was as restricted as that of many women of this period. Alasdair has admitted: 'My mother was a good housewife who never grumbled, but I now know wanted more from life than it gave – my father had several ways of enjoying himself. She had very few. They were, from that point of view, a typical married couple.'[30] Alasdair only realised in later life that he and the rest of his family had taken Amy Gray for granted.

BUTLER: GRAY'S FAVOURITE TORY

Before the end of the war, a piece of legislation was passed by Parliament that changed Alasdair's life. To understand why the 1944 Butler Education Act was quite so important to him it is worth saying a little about the Act. It claimed to account for 'The Whole Child' and, though Britain was still at war in 1944, it reflected a country looking towards peacetime, anticipating the new life to come. Many children had experienced evacuation and it was felt by some politicians that this widening of experience offered an opportunity to break down traditional class barriers. Free transport to school was brought in along with free milk at break time, free medical care and guaranteed full-time education for all until the age of fifteen.

 Left-leaning commentators sometimes romanticise this period of
educational history. It also saw the birth of the three-tier grammar,
technical and secondary modern schools which many feel accentuated
the class system, but these aren't details Alasdair has dwelt on in his
assessments. The key thing was the feeling that the government cared
what happened to *him*. The principles and effects of the Butler Act,
along with his parents' views, still shape him today – he uses Riddrie
and Butler as a crutch to explain the person he has become, repeating
the social and political history of the area almost every time he writes an
essay, introduction or postscript to something, whether it be related to
his own life and work or that of – well – anyone.

 This has been the case for decades now, and reappeared as recently as
2006, in a piece Alasdair wrote entitled 'Infancy to Art School, 1934–
1957',[31] intended for his artwork retrospective volume *A Life In
Pictures*. It's easy to see how these measures influenced Alasdair as
an adolescent but why keep coming back to them years later? Every-
thing in some way leads back to Riddrie – or at least to his romantic
view of how it was when he returned to it at the end of the Second
World War. Twenty-first-century children might not consider it an
idyll, but according to Alasdair it had everything you could ever need.
A library! Two cinemas! What else could anyone desire?

 A good illustration of his perception of the area, and what he thought
made it an example to others, can be found in a version of Alasdair's CV,
printed in *Alasdair Gray: Critical Appreciations and a Bibliography*, pub-
lished by the British Library. He added family and social history in
several entries which explain, as he sees it, how his part of Glasgow came
to be. After three long historical entries the author interjects with a
statement of intent that could not be clearer. Even when telling the
basics of his childhood home, it's with a political objective. He says: 'I
have annotated these three entries [1897, 1902 and 1931] more than
most others because they show why I know that Socialism can improve
social life, that the work we like best is not done for money, and that
books and art are liberating.'[32] These few lines indicate the points that,
above all others, Alasdair wanted to make – Socialism is possible, people
work best when happy, there is freedom in creativity. Rab Butler's Act
of Parliament and its aftermath were an irreversible truth to him that
people from all sides of the political spectrum could do good things if
they wanted to. It was this wartime government of Labour, Liberals and
Tories that gave rise to the healthiest generation of children Britain has

ever seen. Large parts of the young Gray's politics were formed by these few key measures of government, not always suggested by Socialists, that taught him (along with what he saw in Riddrie) that Socialism was a good way to improve the world. Alasdair has written:

> Churchill, a Conservative who had begun his career as a Liberal, ruled Britain through a coalition government which rapidly passed every Socialist measure that had formerly been resisted as wicked or impractical. Every industry was brought under government control, deals were struck with the Unions, profits were frozen, wages fixed, rationing imposed, and Labour leaders joined the cabinet.[33]

The word 'Socialism' goes in and out of fashion (at the time of writing it is rarely used, especially by prominent members of the ruling British Labour Party), and there is no universal agreement about the meaning of it, but Gray has a set idea of what it means to him, based on mid-twentieth-century Labour Party usage in Britain – and over time he has not changed his opinion of its worth. Many of these 'Socialist' measures were brought in during wartime, generally remembered as a time of hardship, fear, uncertainty and severe rationing. But as we have seen, not so for Alasdair Gray. He had no close relatives injured or killed in the Second World War: it was a time which proved things could and should be done to better society as a whole.

THE END OF THE WAR

The war ended, and Hitler killed himself and his new wife in a bunker. Meanwhile, Alasdair had seen relatively little nastiness in the last few years. He was too young, and had been protected from much of it during evacuation. Instead, what made its way through to his consciousness was the importance (and, later, the result) of government measures that he felt gave people like him an opportunity they would not previously have had. He remembers the aftermath of the end of the war:

> I was eleven in 1945 when the Labour government's sweeping electoral victory ensured (I thought) that the British Welfare State would remain and be an example to the world forever. Despite the

fact my Dad now had to return to a manual labouring job, the
benefits of this New World were obvious to me. I was a sickly child
and my parents now paid for my healthcare through their taxes,
instead of sitting with me in long charity queues or paying fees to
specialists who did little or nothing. The schooling that finally made
me an author and artist was got through the Butler Acts . . .[34]

Here Alasdair emphasises the connection between 1945's political
climate and the turns his life took in coming decades. As far as he
was concerned, without one the other could not have happened. And
that explains his political stance ever since.

 An examination of these early years shows the things Alasdair feels
made him. Many of these happened with no one else (that is, still alive)
apart from Mora around to disagree. Lucky for Gray! He has already
shown a capacity for elaborating on the truth when it suits him. But the
tight control the subject of this book has on the evidence of his early life
does not continue for long.

DIARIES: Old Family, Old Friends, Old Papers

11 December 2004: Season's Greetings
At Alasdair's today, doing the annual Christmas card list. Jotted the
following down after it occurred, while Alasdair was on the toilet:

> *Scene from a domestic drama. Conversation between Alasdair and Morag
> while each addresses Christmas cards in the Gray–McAlpine front room.
> Secretary Glass orders envelopes silently in background:*
> AG: Are you all right, my dear? You seem unhappy.
> M: [*licking stamp grumpily*] You know too many people. Can you not
> get rid of some of them?
> AG: No fear! They're dying at a rate of knots, even *without* my
> intervention!
> M: Not quick enough.
> AG: Very well then – [*Turns*] Glass! Send a letter to everyone I know,
> thus: Dear Ex-Friend/Acquaintance/Family Member – My wife
> and I wish to end our days alone, and we will, by thunder! Yours
> Sincerely, Grumpy Drawers McGraw. [*Quietly, sincerely*] Do you
> think they'll know who it's from?

GLASS: I have no doubt, sir.

AG: [*In a state of wild abandon*] Good. Haha! We're free! Now, I must celebrate by taking a shit. [*Exit Gray, triumphantly, to toilet. Exit McAlpine, to bedroom*]

11 September 2005: Amy

Today Alasdair and I met for an interview exclusively on the subject of Amy Gray, who died from cancer when Alasdair was eighteen: in the past, whenever I had tried to subtly introduce her to the conversation, or ask questions relating to her as part of an interview on something else, she always seemed to get squeezed out – even when he'd start talking about her he would veer towards something else mid-sentence and before I knew it we would be talking about his father instead or *Lanark*, or Karl Marx, or Scotland. So we sat down opposite each other in his front room, by the fire, with my brand new Dictaphone at his side, a machine Gray requested I purchase, and we talked for an hour or two. The first thing he said was this:

'If you are lucky enough not to be separated from your mother, it is difficult to describe her character, because she is the climate in which you live . . . but . . . and Mora and I have discussed this . . . she was, physically, slightly cold.'

He says it like he needed Mora to back him up on his memories, to make sure he had got them right.

'She didn't cuddle us much,' he continued, 'but I remember always having a goodnight kiss, even after we had argued – usually about food she had prepared that I wouldn't eat. Our arguments were always over food that repelled me. She found that very hard to take.'

Throughout the conversation, Alasdair didn't look at me at all. Often he gazes at the floor in interviews when he's thinking hard, but usually with some occasional brief eye contact. Today he studiously concentrated on something by his foot, which was almost level with his hand – he now owns a chair with a reclining feature, making it seem, as I sat taking notes, like Alasdair was lying back on a psychiatrist's couch. I tried to work out how his mind leaps from one topic to another seemingly unconnected, and wondered at some moments whether he was deliberately wandering. But if that was happening, I think it was unconscious. Because after ten minutes on the history of Scandinavia he suddenly stopped mid-sentence and said: 'I did not cry over my mother's death . . . for

many years after it occurred . . . but when I did, it was like releasing an unmelted iceberg of tears. I was very relieved to discover that iceberg had been there all along.'

If you've recently been reading his books, listening to Alasdair talk can sometimes be like getting a very strong sense of déjà vu – most of the things he thinks or believes have been put down on paper already. At least the things on the surface have. 'If you have written a good sentence already,' he says, very often, 'why change it?' Which explains the similarities between, say, sections of his political books. But beneath the statements about how he is grateful to his parents for giving him paper and crayons to play with, and the usual recollections of Riddrie library, I thought there was something more. His attitude to his mother's life is an understanding one, because, as he puts it, 'it was considered disgraceful of a woman to work' in those days, so she was confined to duties in the home. But it means that this is mostly how he saw her: the person who fed and clothed him and sent him off to school.

Alasdair described their years during the Second World War as the 'happiest family time of my life'. While soldiers fought on battlefields in Europe and beyond, a young Alasdair was blissfully happy in his countryside idyll. He even recalled having several friends to play with; this was not something he experienced so much in Glasgow, where he spent more time indoors, scribbling and writing and scratching away. As he wandered off into fond wartime memories, describing the feeling of walking around the munitions centre knowing his father was in charge, I tried to bring him back to the subject of his mother once more.

'She didn't have much fun,' he said. 'Latterly, my mother felt lonely. During the war, her only social life was being involved in the Church of England Women's Institute.'

'How did she cope with the asthma and eczema you had as a child?'

'She was always worrying about my health. She took me to a naturopath, a homeopath, I received massage and gave up fried food and wheat.'

'Did it help?'

'Oh, yes. For a while. But only for a while. The illnesses always came back.'

Alasdair didn't elaborate, knowing that through my own asthma and

eczema (which we have often discussed, comparing wounds and medicines) sometimes 'remedies' work for a while and then the disease learns how to cope with, then defeat, the medication. Then something else has to be tried.

'What about your relationship. Did you talk to each other much?'

'Before my fantasies became sexual and I realised I could not share these with my mother, I told her stories in the evenings that I just made up off the top of my head . . . I held her hand and sat at her bedside, just talking, you know. To pass the time.'

This memory seems to be a positive one. Alasdair clearly feels this was a good thing he did, and hopes it gave some comfort.

'She asked me once, when she was dying, whether I believed anything happened after death . . .'

Most children would, out of fear of upsetting an ill parent on the verge of dying of cancer, have said they believed in heaven, and that their mother or father was definitely going there; that they'd see each other soon, in that place. But Alasdair said something else:

'I told her I thought there was nothing; that it was probably just like being asleep – but that many wise people disagreed with me.'

This was his great concession, and he was prepared to make no more.

In *Lanark*, the character of Ruth (strongly based on Alasdair's sister Mora) refuses to believe her mother will die, and today Alasdair said he and his sister had arguments about it. Perhaps she thought it was cruel of him to insist she was going to die; he just thought it was inevitable, and believed what his father had told him. Also, he didn't feel as directly involved with events in the home as his sister did:

'I think it was something to do with my temperament,' he said, thoughtfully. 'I exist at a certain . . . *distance* . . . from my own feelings . . . in that . . . there are many feelings that I have that . . . don't reach my consciousness. [*Long pause*] Which can be handy.'

This detachment allowed him to postpone feelings about his mother's dying, and eventual death, whereas Mora had to become a housewife when Amy Gray took to her bed. It was a job she would have to continue once her mother was dead. 'Ach . . . it's all in *Lanark*,' said Alasdair, finding himself getting too deep into his past. 'It's all in *Lanark*, anyway.' Simply by being male, Alasdair, inclined to escapism anyway, was more able to tune out – to accept as fact that his mother

was dead, but not really feel sad. Mora found that harder. She had to be the woman of the house. The absence of her mum was obvious in every extra responsibility she had to take on. Alasdair instructed me to go back to *Lanark* for evidence, and in both book and real life the practical tensions brought about by suddenly having no mother are clear. This chaotic, fraught situation was compounded by Alasdair's asthma and eczema, which was not well understood in 1950s Scotland – certainly not in the very obvious way his mother's cancer was. This from *Lanark*:

> [The] reorganization was never effectively managed. Thaw and Ruth quarrelled too much about who should do what; moreover, Thaw was sometimes prevented from working at all and Ruth thought this a trick to make her work harder and called him a lazy hypocrite. Eventually nearly all the housework was done by Mr. Thaw, who washed and ironed the clothes at the weekend, made breakfast in the morning and kept things vaguely tidy. Meanwhile, the surfaces of linoleum, furniture and windows became dirtier and dirtier.[1]

Later in our interview, Alasdair talked about that first crying again, and went back to the 'unmelted iceberg of tears' that so relieved him when he realised they were there after all.

'Did you feel guilty because of that?' I asked him.

'No. I was just numb.'

He thought some more, then said: 'It's shocking to recall now but not only did my father beat me, but he also beat my sister – with a leather belt. I didn't think too much of it at the time, but that strikes me as horrible and sinister. He told me once that he regretted beating us. But it was the done thing in those days. Mother was in charge of the house, Father was in charge of disciplining us. That meant the belt.'

The Dictaphone tape stopped there, and Alasdair used the click of it stopping as an opportunity for him to do the same. We had been talking long enough. But what was most unusual about this thought-out-loud was not just the revelation of the beatings – as we got up out of the fireside chairs I realised I had never heard Alasdair criticise his father. Irritation, yes, confusion, yes, but never outright condemnation over anything.

I felt strange when I left the flat today, like a heartless lover escaping

in the middle of night without even leaving a note. I had drained Alasdair of his past, and was gone.*

7 November 2005: The Magic Red Box

Today Alasdair told me that he had in 1986 made a record on small index cards of everything he had written and painted in his life so far. Since 1986, with the exception of a few notes stretching to 1991, the box of cards had remained mainly untouched on a shelf somewhere. Recently he has been in hospital: on my last visit he raised the subject of this little stack of handwritten cards and asked if I wanted to make use of it. For now this attitude suits both of us, and I promised to take the information from the cards and put them on a single computer file which could be used in future, for *A Life in Pictures*. 'You know I won't assume it's all fact,' I said to the patient, who gave an expression of mock horror, then opened his mouth to speak, then decided against it. I hurried to the house to pick up the Magic Red Box and see what was inside.

The Box contains more about Gray than I could have hoped. In his usual meticulous style he had documented not only what he had created but his entire family history too. Also, there were entries about personal crusades, court cases, complications with publishers and agents, and plenty of juice otherwise. The entries range from the factual to the furious. After some historical cards about various family members, entries date the beginnings and ends of books, specific paintings and projects. Around the time Alasdair starts art school the entries become more anecdotal – apart from the notable and utterly factual exception of his mother's death.

Like diaries in miniature, these cards show Alasdair's development from dreaming schoolboy to the first ten chapters of *Poor Things*. They also take us through the development of his family life, the many times he wrote 'gave up teaching forever!' only to find he couldn't make a living by art alone, all the key moments of a life, as well as the kind of minute detail that only hardcore Gray devotees could possibly care about. For example: who could fail to be interested in facts such as '18th June 1974: I was paid £106 for helping the Bellmyre Arts Festival, Dumbarton'? Gold indeed. Pure gold. The more I see of Alasdair's work, the more I think his real love is history. I am pleased to have his Magic Red Box, and will keep it for as long as possible.

* After this meeting, I did not see Alasdair for several weeks. It was the first time I felt dirty about writing this book.

28 November 2005: A Sundial in Reverse

I spent the weekend copying out all 291 cards from Alasdair's Magic Red Box. Today, while searching around the kitchen for a clean implement to stir his Lemsip, we discussed the Box and I asked why he took great care to give the exact dates and details of who rejected *Lanark* and when – but didn't think it important to record when it was accepted, or include the publication date. I located a fork and stirred:*

'My diaries were mainly written when I was not busy,' he reflected. 'And . . . like a sundial in reverse, my notes tend to show . . . *the shadier sides of life.*' Alasdair now has over fifty notebooks which are kept in the National Library of Scotland, mostly diaries from when he was a teenager. They too almost exclusively focus on life's shadier sides.

7th April 2007: Mora

This month, Alasdair's sister Mora is seventy. As a present, her brother paid for her to spend a few nights in a West End hotel, so the two of them could spend some time together over the Easter weekend. Recent days have seen several light walks (with breaks for Alasdair's breathing) and plenty of fresh air. This morning Mora left for Edinburgh to see her daughter, and I gave her a lift to the station, but before I dropped her off we stopped for a quick coffee and a chat. As we sat down in the bright morning sunshine I asked her if she had enjoyed the time she and Alasdair had spent together. She smiled widely and said, 'Oh yes. But I always forget that . . . hmm. He has such . . . *verbal diarrhoea!*' She sipped her water. 'Everything we passed on the way, he had to describe it, give the whole history of everything. It's exhausting.' She smiled again, making sure I understood that this was said in a friendly way, and we began.

The first thing that struck me about Mora was the physical contrast between brother and sister. Mora has retained a remarkably youthful look, and could easily be mistaken for someone many years younger. This is clearly because she enjoys exercise (she is wearing trainers and carrying a rucksack). But there is also a personable brightness about her that shows the weight of the world does not press so heavily on her shoulders as it does on her brother's. And it has always been so. Mora

* Historians will be fascinated to know there are rarely clean teaspoons in the Gray–McAlpine household. This strongly reinforces the theory of Oedipal-Freudian-Socratic-Nietzschean influence which is plainly obvious in Gray's fiction.

modestly described their early relationship: 'I was always very aware of how clever he was. When I was reading Enid Blyton he was reading George Orwell. But that made him very serious. Very. And I felt bad for him sometimes.' This led us into talking about the old Gray family home, and Mora's early memories.

One of the important things about today's interview was to get a clearer idea of the family home and explore whether Alasdair's version was real or not, the people in it too. Mora's version of her parents brings them to life in a new way – these are the fond observations of a daughter, but they show a more personal, alive, believable home life than Alasdair's version, which concentrates largely on books and how he got to them. Many of Mora's descriptions are useful in building a picture of those early years – and she is the only one left able to give a first-hand account – here are a few of her memories of her mother to show the contrast:

Amy as single girl:
'Of the two of my parents, she was the flighty one. She used to tell me how she met my father at the Holiday Fellowship. Well, she was in her late twenties by then, and she said she went to HF because girls used to joke it stood for "Husbands Found". So she wasn't shy. She went to Switzerland, I think, with a friend before she got married – which was very unusual for a single girl in those days.'

Amy as manager:
'She was an exceedingly good manager. It was only due to her good management during the war that she saved enough for us to live off after it, when we returned to Glasgow. She was a very efficient person. Knitting, sewing, cooking – she was always working hard. And she controlled the finances too. Dad came home with his pay packet every week, handed it over – and then she would give him his "pocket money" for the week! Dad, like Alasdair, was very bad with money . . .'

Amy as confidante:
'Mum was very kind, but not demonstrative. She was like a sponge . . . people could tell her anything and know it wouldn't be gossiped about.'

This gives a very dissimilar picture to Alasdair's 'climate in which you live'. That 'climate' seems blander, and the divergence between brother and

sister's interpretations suggests Alasdair was not your typical child. He was introverted, aggravated, nervous. He was bookish, and had grand dreams. Mora was a happy-go-lucky girl who enjoyed life and remembers Aunt Annie and Uncle Ned coming round to play bridge, and Thursday's high teas, and insists she was never told her mother was dying.

Mora has more seventieth-birthday presents to come. She is off to see her daughter in Edinburgh now before returning to husband Bert Rolley in Northumbria – which she says is very beautiful – then jetting off to Venice to celebrate again. When I dropped her off at the station, Mora ran across the road towards her train.

26 April 2007: Twentieth-Century Documenter

Recently, rumours surfaced about a possible future Gray short-story collection with the same friends as *Lean Tales*, a book released in 1985 which was split between Gray, Agnes Owens and James Kelman. These turned out to be untrue but the rumour set me thinking about history, friendships, and methods of support.

Along with more obvious talents, Alasdair developed another interest in early childhood which has stayed with him for the rest of his life: history. If he hadn't gone on to be a writer or a painter – if he hadn't been good enough – perhaps Alasdair Gray would have been a historian specialising in twentieth-century Scotland, perhaps even Scottish literature. Because he *did* grow up to be an artist, his passion for history found its place within his works instead. The primary place for this is hidden amongst his story books, in various forms – either embedded in his fictions, in end notes/postscripts/introductions in later editions of reissued volumes, or in factual pieces to be found in books passed off on their covers as made up.

Good examples of this are to be found in *Lean Tales*, the very existence of which is an example of Gray's inclination for ushering others into the limelight. *Lean Tales* came about because Gray suggested it. In the 1995 edition he put the collection in context in a Postscript and explained the relationship as he saw it between the three authors, no doubt for future critics of 1980s Glasgow to refer to. (Which shows either confidence or arrogance regarding that scene.) Towards the end of this edition were three revealing Gray pieces: '*A Small Thistle*', '*Portrait of a Playwright*' and '*Portrait of a Painter*', three stories used to make historical points as well as personal ones, through the prism of the lives of Alasdair's friends.

'A Small Thistle': for Bill Skinner

This short piece sums up the dry official details of a Glasgow man's life, explaining that Skinner lived with his mother, never married, worked for several bosses in jobs that didn't last, and had no descendants or relatives. That sad picture is then turned on its head as Gray describes an inspiring, lively man with many friends, a home more like a laboratory, a talent for painting and a remarkable sideline in inventing strange alcoholic drinks. Gray salutes his friend (who died in 1973) with the words: 'He *succeeded* in life.'[2]

'Portrait of a Playwright': dedication to Elisabeth Carswell aka Joan Ure

A more detailed piece on the life of this little-known Scottish playwright, the reasons why Alasdair respected her so much and the struggles she had to endure. Includes a summary of (in Alasdair's opinion) her best work, and a grand summary of her contribution to the arts: 'Joan Ure became the name of an imaginative intelligence pointing us to the passionate self-knowledge which can make us too self-governing and tough to be managed and dropped by other people.'[3] She died in 1978. Says Gray: 'Luckily the value of a life is not in the end of it but in what a woman or man gives while able to give.'[4]

'Portrait of a Painter': dedication to Alasdair Taylor

Essay on life and work of Alasdair's old art-school friend, described here as 'native artist, a full-time painter, and something of a hermit'.[5] Includes a dedication to Alasdair Taylor's wife Annalise (for her understanding and support) and a critical analysis of Taylor's output. In Gray's assessment, 'Alasdair Taylor, living in Glasgow, crucified an umbrella on a canvas and wrote swear words underneath it because his artistic gift was lyrical and nothing around him fed it.'[6]

These additions to the original *Lean Tales* collection are interesting, not least because readers may notice that the majority of Gray friends seem to be, in his opinion, greatly overlooked creative types who deserve to be remembered. Also, these are interesting to anyone who wishes to examine the way Alasdair perceives his personal relationships and his duty to those who have/had received less attention than him in their lifetimes. But there is a bigger issue here. In each of these 'portraits', Gray begins by setting the historic scene. In Taylor's story, he begins

with the line: 'The art of painting is in a poor way', then goes on to describe extensively the weaknesses of the Scottish arts establishment in the last one hundred years before even getting round to talking about his friend. In Bill Skinner's case, Gray opens with the American Declaration of Independence, getting to Bill himself via his family line, the absorption of the Scottish priesthood by the English and by referring to Jesus's blessing of St Peter as alive and well in 'contagious form' in 1784 Britain. 'A Small Thistle' is finished with the words: 'Scottish Socialist Republic/Neutrality' in large letters, centred. With Joan Ure's story, much of her history is put into context as Gray sees it, incorporating all his own prejudices – making sure to mention the lack of National Health Service when his friend's family needed it, and complaining of the national stereotype of Scots as 'violent people' in order to explain why the more restrained, formal language of Ure's plays were not popular. Can he not help himself? Are these dedications actually just excuses for Alasdair to talk more about himself?

There are several reasons why these pieces are written in a similar style. Firstly, by placing each friend in the wider political, social and economic scene of their lifetime, they seem grander, therefore more entitled to be remembered. Also, their lives can be used to explain why (in Gray's opinion) they were not recognised, compared to him, compared to anyone. But importantly, Alasdair is a documenter, of lives and of people and of politics and of worlds. On a personal level, he appears to feel that if he does not document the work and achievements of these people he knew well, then no one will – and he could not avoid feeling guilty about that. He feels he needs to be a voice for hermits and unrecognised talents and inventors with no descendants. More than that, he feels that all life has something to contribute, that twentieth-century Glasgow is as relevant as anywhere else, anytime, and that mostly what keeps those who are remembered apart from those who are not are these three things: money, opportunity and a megaphone to be heard through. These short pieces are examples of Alasdair's attitude to friendship and his contribution to it.

2 1946–59: AMY GRAY, SCHOOL & ART SCHOOL

RETURN TO RIDDRIE

Alasdair re-settled well in the old family home in spring 1946, but he was now a child clearly happiest when left alone to daydream. In those first couple of years at his new school Alasdair retreated into his imagination whenever possible, and only came out of it when made to. He remembers: 'I usually spent spare time in my bedroom, at a small version of a senior executive's desk my dad had made when his hobby was carpentry. Here I sat scribbling pictures and illustrating stories of magical worlds where I was rich and powerful.'[1] Although Alasdair did not go out much, and did not have many friends since his family moved back to Glasgow, his parents approved of this artistic outlet and they encouraged it. In 1946, some of his drawings were used to get him into an art class run at the grand Kelvingrove Museum and Art Gallery by a woman called Jean Irwin. The tender tone of the following memory, written by Alasdair sixty years after the event, describing how he found himself in that particular class, shows just how big her influence would become. Children were supposed to have a recommendation from an art teacher for the class, but Alasdair's mum took him without one:

> A half-hour tram ride brought us to Kelvingrove, not yet open to the public, but she [Amy Gray] swiftly got admission from an attendant who explained where to go. We went up broad marble stairs and along to a marble-floored balcony-corridor overlooking the great central hall, and I heard exciting orchestral music. At the top of more steps we saw 20 or 30 children busy working at little tables before very high windows, painting to music from a gramophone, as record players were then called. I drifted around looking at these kids painting while Mum showed my scribbles to Miss Irwin, who let me join her class.[2]

Kelvingrove Museum would certainly have been imposing to a small boy, but Alasdair's clear image of that first Saturday morning

demonstrates his ability to present very ordinary childhood experiences like attending an art class as great gifts. He went to that class most weeks for the next five years, loved it, learned to feel comfortable in grand surroundings and got into some useful working habits. Also, Alasdair found that Kelvingrove Museum held many exciting artefacts from different eras, alongside large stuffed animals and historical information on everything from ancient Egyptian culture to modern Clydeside life.

WHITEHILL SENIOR SECONDARY

1946 was a big year. As well as joining the Kelvingrove art class, Alasdair entered Whitehill Senior Secondary School in Dennistoun, in Glasgow's East End. Around this time he began to realise that attainment in the classroom was not the only way to get attention. By now, the poems and stories he had been writing (initially as party pieces) were bringing some unexpected rewards:

> I found it possible to write verses which were as good, if not BETTER [than A. A. Milne], because they were mine. My father typed them for me, and the puerile little stories I sent to children's magazines and children's radio competitions. When I was eleven I read a four-minute programme of my own compositions on Scottish BBC children's hour.[3]

This conjures up an amusing image of an eleven-year-old Alasdair pacing back and forth in his bedroom, in preparation for his first national broadcast, dictating poetry to his father: he did dictate the poems, and he is still most comfortable with a secretary taking down his words. It must have felt like an intoxicating kind of power. But at Whitehill Secondary Alasdair was not treated like a powerful little person at all. He believed teachers wanted him to stop paying attention to the subjects he enjoyed most – history, English and art – and concentrate on those he despised, like maths, in order to even out his marks and ensure him an unremarkable but steady set of qualifications. Alasdair thought this was the wrong way round. He remembers how some of the subjects made him feel:

> Compound interest, sines, cosines, Latin declensions, tables of elements tasted to my mind like sawdust in my mouth: those

who dished it out expected me to swallow while an almost bodily instinct urged me to vomit. I did neither. My body put on an obedient, hypocritical act while my mind dodged out through imaginary doors.[4]

This is a theatrical way to describe disliking maths, but Alasdair was always a serious child who was keen to learn some things and could not bear to be force-fed others. And it's no coincidence that he used a physical metaphor to explain that. The connection between mental stress and physical illness has always been a close one for him, and during these secondary school years Alasdair's facial eczema and asthma attacks became increasingly oppressive: breathing was often difficult, which frequently brought on panic. Mora remembers:

Our parents were always taken up with this ill son . . . Alasdair would have terrific, powerful nightmares. He couldn't breathe. He would sit up on the side of the bed, holding on to the sides of the bed, trying to breathe . . . they tried everything to make him better. On advice, they did things that these days would be considered child abuse. They held him in cold baths of water to try and get him to calm down.[5]

But none of those things worked. They made him more isolated, more distant, harder to live with. Alasdair was becoming an increasingly confused, angry and frustrated boy. The only things that seemed to ease the condition were practising the very creative things (writing and painting) teachers preferred him to ignore, saying repeatedly that he would pass exams for the subjects he enjoyed without trying. So what was the point in pursuing them? Well, he pursued them anyway. The books he was reading gave him great pleasure, particularly the ones which came through the door because of his dad's membership of the Readers' Book Club, which introduced him to everyone from Ernest Hemingway to Oscar Wilde. One of the key books he read was *The Horse's Mouth*, a novel about a young artist that has reached near-legendary status among Gray followers, and which Alasdair read at the age of thirteen. Some fans assume that whenever Gray refers to this book in interviews he is teasing readers with a simple pun, inventing a novel that doesn't exist. But he didn't get the *Lanark* idea from *the horse's mouth*, he got it (partly) from the very real novel by Joyce Cary, published in 1944.

Though not a popular boy, Alasdair was not friendless. He did make a strong connection with another at Whitehill, George Swan:[6] George was also one of the first characters in Alasdair's life outside his immediately family to make it into *Lanark*: he became the character Coulter, and their friendship is represented in the early Thaw chapters. The two of them sometimes went on walks. George remembers one walking holiday in the Trossachs which for him summed up Alasdair the schoolboy:

> I think it was when we slogged to the top of Ben Venue and made to come down the other side that Alasdair, tired and hot, decided to throw his rucksack down ahead of him. It bounced and crashed several hundred feet. We followed, telling Alasdair it wasn't a smart idea, but, as usual, it all washed over him. When we got to the level we thought the rucksack should be, we discovered we couldn't see it among the high ferns. So, one of us had to climb back up, locate the rucksack and yell down directions to the rest of us. When we finally got the rucksack – what a mess! Eggs he'd been carrying were broken and jam and butter were all over the place. Nobody was amused![7]

Alasdair was not, by his own admission, entirely comfortable with ordinary outdoor pursuits of any kind; when his father tried to encourage a little outdoor activity his son often insisted on bringing books with him on their trips to read in all too frequent breaks. Indeed, Alasdair wasn't very comfortable with anything outside the worlds he discovered at his father's desk or in Riddrie library. He remembers that time, so restricted by asthma, as one only made easier by exercising his imagination:

> I often did not want normality. I wanted exciting heavens, hells and farcical riots. My childhood would have been a dull business without art: the Hollywood art of Walt Disney, Tarzan and slapstick comedy: the BBC art of broadcast, music halls and serial dramas based on fantasies by Conan Doyle and HG Wells; the cartoon art of DC Thomson's *Dandy, Beano* and *Sunday Post*. Had there been television I would have become an addict. In those days my greed for extravagant existences brought me to the local library where I ate up all the existing stories and illustrations I could find.[8]

Many of these words and pictures filled Alasdair's head, and remained with him for life.

MR MEIKLE: FIRST EDITOR AND PUBLISHER

In 1947 Alasdair was twelve years old. Arguably the most important thing that happened in this year was that he got to know his English teacher Mr Meikle, who later gave his name to a Gray story in the collection *Ten Tales Tall and True*. Much like the *Lean Tales* portraits, this story is a tribute, but it focuses more on Gray himself than previous examples. In contrast to the teachers who tried to make him eat those sawdusty cosines, Meikle drew out the best in Alasdair without his student even noticing his influence. Describing running the school magazine's literary and artistic pages, Alasdair has said: 'There must have been times when he gave me advice and directions. I cannot remember them: I was only aware of freedom and opportunity.'[9] The very fact that Meikle saw Alasdair's talent and encouraged him to get involved in the school magazine was a crucial contribution at a time when Alasdair felt he had few other public outlets for his imagination. It gave him something to take pride in that would not be assessed by exams.

The Christmas 1947 issue of *Whitehill School Magazine* includes a rare insight into Alasdair's early style and development. His story 'Way up a 'Ky' appeared in a magazine whose first page focused on opportunities for young people in the Home Civil Service and was printed opposite an advertisement for Ross's Certified Milk:

Way up a 'Ky

 Have you ever seen a comet? You know what I mean – those masses of luminous gas which drift about the universe. I hadn't, and it had always been my ambition to see one, so when the newspapers broke the news last year that the comet Giacabinizziner would pass 'within visible distance from the earth,' I was quite excited. The newspapers further told us that 'a display of aerial fireworks is forecast as part of the comet, reaching the earth's atmosphere, will probably solidify into meteorites. Scientists will view the proceedings and record its effect on radar. The comet may be seen with the naked eye at approximately 10 o'clock to-morrow night.'

Next day, however, proved to be disappointing. It was dull and overcast, and when half-past nine arrived, the sky could not be seen for a blanket of thick cloud. 'Well,' said my Mother, 'there doesn't seem to be much chance of seeing a comet to-night.' 'Ah well, you never know, we might catch a glimpse of it,' I replied. At a quarter to ten I set out with my Sister (who would persist in coming with me) and walked to the flag-pole in the park. I thought it was the best place in which to view a comet.

We waited, or rather loafed there, for about twenty minutes, but nothing happened. Just as I was saying it was past ten-fifteen it happened. Suddenly, from beyond Carntyne, a rosy glow lit up the clouds. 'Jings!' we gasped. 'It's Gicacaca – it's Giacabibizizz – it's the – the comet.' We stared awe-inspired for quite a minute. As quickly as it had come, the light went out.

After waiting for a minute we hurried home and poured out the story of the amazing occurrence to our parents. My Father listened carefully to the recital and when it was finished said, 'You did say the light came from the direction of beyond Carntyne didn't you? Well, hasn't it struck you it might have been caused by a furnace at the Clyde Iron Works?'

And so I am still waiting to see a comet. But there really is no need for despair, because if the astronomers are correct, I will be able to see Halley's Comet if I wait another thirty-eight years.

A. J. G. I.1.

This first-person autobiographical account includes some key indicators of the writer thirteen-year-old Alasdair would grow up to be. His sense of language was already highly developed and there were signs he was learning how to construct a plot with a twist at the end: the mixing of imagination with the utterly realistic is something that would stay with him, too. In addition, the choice of familiar characters shows that his frame of reference was still mostly his immediate family. The use of 'Jings!' is an exclamation learned from the comics he was reading. And the final paragraph, where Alasdair says he is already looking forward to the appearance of Halley's Comet, nearly four decades in the distance, shows he was already thinking long term.

Alasdair felt able to be honest with Mr Meikle, and one day, probably during 1948, the two had a serious conversation about education. Alasdair described his own (excepting art, history and English) as 'a

painful hindrance, a humiliating waste of time for me and my teachers';[10] Mr Meikle gently explained that 'Scottish education was not designed to produce specialists before the age of eighteen'.[11] This was depressing news. Alasdair's parents were keen that he should be the first in the family to go to university (for which he would need to pass Latin): the thought of another five years of subjects he hated in the meantime made him feel resentful. It is a common problem: in this at least, Gray is not unique. But for Alasdair, it wasn't just that he didn't like certain subjects, but also that those who insisted he pay attention in them didn't seem to value the subjects themselves. They were merely hoops to jump glumly through. Gray and Meikle's conversation took another dark turn:

> I [Alasdair] answered that Latin and Maths were not taught like languages through which we could discover and say great things, they were taught as ways to pass examinations – that was how parents and most of the teachers viewed them; whenever I complained about the boring nature of a Latin or mathematical exercise nobody explained there could be pleasure in it, they said, 'You can forget all that when you've got a steady job.'

Mr Meikle sadly replied that most people grew up to do jobs they didn't enjoy, and that school had to prepare those people for a life of *doing what you're told*.

The next part of the 'Mr Meikle' story, subtitled 'Freedom and Serfdom', records a key event in Alasdair's adolescence, because it made him question many of the assumptions he had about the world. 'I expected the world to become a mosaic of Riddries, each with a strong local flavour,' Alasdair has said of his earlier childhood. Now that illusion was shattered:

> This discussion [with Mr Meikle] impressed and disturbed me. Education – schooling – was admired by my parents and praised by the vocal part of Scottish culture as a way to get liberty, independence and a more useful and satisfying life. Since this was my own view also, I had thought the parts of my education that felt like slavery were accidents which better organization would abolish. That the parts which felt like slavery were a deliberate preparation for more serfdom – that our schooling was simultaneously freeing some while preparing the rest to be their tools – had not occurred to me.[12]

At the end, the 'Mr Meikle' story shifts away from truthful memory. It describes how Gray's teacher became a character in *Lanark*, then zooms up to date, then quickly becomes fantasy, ending with Meikle imagined among some of Scotland's best writers who were also teachers: Norman MacCaig, Iain Crichton Smith, Robert Garioch and Sorley MacLean. Which goes to show how much Alasdair valued this man.

AMY'S ILLNESS, AND DIARIES

In the following year, 1949, Amy Gray fell ill. The family doctor said he thought she was going through the menopause, but she disagreed and insisted on seeing a specialist. The doctor reluctantly referred her to a gynaecologist, who saw this had been a mistake and promptly referred her to another doctor, who diagnosed cancer of the liver. Amy Gray was operated on and sent home: at the time it wasn't clear to her offspring that the illness was serious. The symptoms of the cancer were not all immediately felt and home life continued almost as before for Alasdair and Mora. Around this time Alasdair read George Orwell's *1984*, which along with Joyce's *A Portrait of the Artist as a Young Man* became a key building block for *Lanark*. But he doesn't remember reading *1984* with affection, or say it represented the birth of a new inspiration. This was because it showed so many things in a nightmarish alternative world that Alasdair was beginning to realise very much existed. In his diaries Alasdair has written: 'I was fourteen or fifteen when I read that book [*1984*] and it made me miserable for a fortnight – I've been unable to open it since.'[13]

By 1950 Alasdair was regularly keeping a diary, something he would continue throughout the decade to come. These were partly conventional diaries recording thoughts and feelings, and partly notebooks for writing out his fiction and poetry, as well as plans for books he wanted to write. In these extensive, emotional, detailed illustrated notebooks, he wrote about his daydreams and plans for the future:

7/8/1950: I vainly sought joy in reveries, in which I did many gallant and outstanding things before many glorious and complete beings, yet somehow I derived little pleasure from it. My God, help

me. What a poor, silly, idle, apish, assish, clumsy, lumpish, ridi-
culous, laughable, incomplete, pitiable animal I am. What a lot I
have, and how much more I need. What a great deal I have to do,
what a strange road I must follow.[14]

The difference between this florid writing – almost like an eighteenth-
century-style epistle to himself – and that of 'Way up a 'Ky' only a few
years earlier is significant. These diaries are certainly anguished, and
somewhat melodramatic, but for the diaries of a fifteen-year-old they
show an incredible capacity for extravagant language, and already a
clear idea of what Alasdair planned for his future. The 'strange road' was
the road of the artist: in this period he was still very much experiment-
ing with different painting styles, but he made a few pieces he would
value for the rest of his life: 'The Three Wise Men' (1950), 'And the
Lord Prepared a Gourd' (1951) and 'Scylla and Charybdis' (1951).
There is a subtle suggestion in the diary entries of a link between
Alasdair's recent sexual awakening (to which there are many references
in 1950–1 diaries), subsequent frustration at not being able to attract the
objects of his affections, and his creativity. He was certainly drawn more
to inward activities by a lack of sexual opportunity in these mid-teenage
years. But the following year a firmer connection between the two
would emerge.

FIRST FANS

Whenever the subject of Riddrie is raised (usually by the man himself)
Alasdair always returns to the importance of its public library, which
he called the 'centre of my imaginative life from 1945 onwards'.[15]
Alasdair read most of the children's section of the library, including
comics, annuals and magazines, but at the beginning of the 1950s one
publication in particular took his interest – Collins Magazine for Boys
and Girls. This magazine was mainly aimed at middle-class English
children and was edited from London. Alasdair says he was always
very aware of the Englishness of it but it didn't occur to him that he
wasn't middle-class. So when Collins invited story contributions from
readers, he thought he was exactly the kind of boy they were hoping
to hear from. He now had the experience of appearing in the school
magazine, and he'd already appeared on the radio! In 1949–50 he had

a couple of short pieces accepted, and in 1951 he had something new to send.

On holiday on the Isle of Arran that summer, Alasdair had produced the first story he had written which seemed to him to have some value. He had scrapped all earlier stories, thinking them too childish, but 'The Star' was the first piece he wrote that he is still proud of. Also, this was the first thing he thought he created *all on his own*:

> Unluckily everything I wrote before the age of sixteen was obviously the work of a child or pretentious adolescent. I knew this by comparing it with Hans Andersen's tales. These were as fantastic as I wanted my own to be, but contained pains and losses too strong to be doubted. *The Star* was my first story which did not seem silly when compared with (for instance) Andersen's *Drop of Ditchwater*. It was also the first story written in a gust of inspiration.[16]

The importance of the achievement he considered this breakthrough to be is clear. Alasdair explained this moment of inspiration during a meeting in summer 2005[17] when he summoned me to his favourite restaurant for lunch and a talk about the past. He said he thought of 'The Star' while on a family holiday, walking on Arran:

> I climbed on to [a] rock, brooding about some of my stories. I'd written little ones before, stupid versions of *Aesop's Fables* — I was painfully aware they were childish — but here I suddenly got the idea for 'The Star'. I wrote it and sent it into the magazine, convinced it was my first original work. But most inspired writing is subconscious reminiscence. Though Pope's writing seems utterly different from Milton's, much of it was written with Milton in mind. One year later I realised that 'The Star' came from H. G. Wells' 'The Crystal Egg'.[18]

Pope! Milton! H. G. Wells! Grand comparisons indeed. But in spite of its origins in the work of another man, 'The Star' was published by Collins in 1951. From then on Alasdair stopped trying to escape the influence of others in his writing, and, more than merely accepting the notion of subconscious reminiscence, he set about trying to harness all those influences and use them.

Publication of 'The Star' resulted in Alasdair's first fan letters, sent to him care of the magazine. These came from two girls also about sixteen years old, both studying at the same English boarding school near Guildford, Surrey. One of these was Ann Weller, who became his pen pal. Alasdair has said: 'I was frank about many things, including my sexual fantasies – it was rather a passionate correspondence . . . I was sexually excited about my letter communion with a person of my own age, and I believe she probably was too . . . as we were both *completely sexually inexperienced*.'[19] Their correspondence became regular, and this interest resulting from the publication of 'The Star' gave Alasdair some literary confidence, enough for him to try something more ambitious. Around this time he started thinking about his idea of a big fantastical story with a Glasgow hero.

This was the beginnings of *Lanark*. Common critical opinion suggests he began work on what became that book in 1954, but according to Alasdair's notes it was much earlier, when the author was still only seventeen. He wrote the following in his notes: '*Autumn* 1951: Start of a novel with an asthmatic glum hero whose heroism and asthma derive from his being an extra-terrestrial agent sent down by a higher authority to save the world. His name is Boreas Brown.'[20] Boreas was a very different character to Gray's alter ego, Duncan Thaw, in the book(s) that finally became *Lanark*, but this was an early version of Gray's idea of planning 'a book containing all I valued in other works'[21] – featuring an early, admittedly very dissimilar incarnation of what become his most famous hero. Other versions followed: subsequent diary entries show plans and many drafts for a book called *Obbly-Pobbly* (with eponymous hero who was also Alasdair's alter ego), then later sketched chapters for a big book with a hero called Gowan Cumbernauld, a similar character who was another alter ego. In subsequent versions 'Gowan' was replaced by 'Duncan', who later became Duncan Thaw. 'Cumbernauld', a town on the outskirts of Glasgow, was replaced with a Scottish town, 'Lanark'.

AMY DISAPPEARS

Amy Gray had been ill for some time. In autumn 1951 her condition deteriorated and it became clear that she would not recover. The doctors had spotted her cancer too late and treatment was useless. Amy lay in the double bed in their Findhorn Street home, steadily growing

weaker. There is little clear evidence of life in the household during this time, or how Alasdair felt in the spring of 1952 – there is virtually no mention of it in his diaries or Personal CV. We are not even told what Amy Gray died of (cancer), whether she suffered (she did), the date of death (24 May 1952) or how this changed her relationship with her son, if at all, before she died. One thing we do know is that Amy Gray was disappointed, in her last days, to discover Alasdair had failed his Latin exam, which meant he could not be the first in the family to go to university. He passed English, of course, but that was not enough. For more details, we have to go to *Lanark*.

The character of Mrs Thaw in *Lanark* is Amy Gray undisguised, and her illness is documented thoroughly – the after-effects of her operation, her decline, her relationship with her children, on to when she 'had to be nourished on nothing but fluids and was too weak to speak clearly or open her eyes',[22] and finally to the scattering of her ashes. At the end of the chapter 'Mrs Thaw Disappears', the narrator describes Thaw's feelings in the wake of his mother's death: 'Grief pulled at an almost unconscious corner of his mind like a puppy trying to attract his master's attention by tugging the hem of his coat.'[23] This kind of slight, numb, puzzling emotion echoes Alasdair's feelings about the loss – but it is interesting that he only felt able to communicate his grief through literature. He used it as a way to confront events in real life, and so *Lanark* is littered with the evidence of his adolescence. But *Lanark* isn't the only book in which Amy Gray surfaces. Another, *Old Negatives*, is dedicated to her, and makes explicit reference to the effect her death had on her son.

Gray's first book of poetry, *Old Negatives*, is split into four sections, each relating to, and written in, different stages of his life. The first begins in 1952, the year Amy Gray died – the illustration that precedes it depicts a young, serious-looking man with a snake coming out of his forehead as if directly from his brain, with the head of the snake opening its mouth to reveal an egg lying inside. It seems peculiar that something so delicate should be able to survive in such a dangerous place; this was Alasdair's way of saying he was the egg, and felt vulnerable. In the first poem of the sequence, 'Time and Place', he muses on searching for 'that hint of revelation'[24] to bring him out of hopelessness. Perhaps he was too consumed by this to think about anything else. Perhaps this was a selfish state. Or maybe just a teenage one.

During the writing of these early poems Alasdair was like any other eighteen-year-old, so perhaps it's not surprising that his first works

should focus on the themes of longing, a romantic understanding of what love might mean, directionlessness, confusion. Already the poet sees himself as an outsider in the world. In the poem 'Predicting' he asks, 'What is there for me when the cold morning comes?'[25] 'Few thoughts. No purpose, a remote hope' – but a hope of what? This repeated theme of coldness reflects that he thinks his hopes will have to be small ones; the crumbs from somebody else's more satisfying, loving, interesting existence. Later in that same poem he goes on to describe not a romantic or sexual encounter but the hope of a girl stopping to talk to him in a spare moment between leaving her lover and returning to him. In 'Loneliness' the poet explains that 'love and affection seem/part substance and part dream'.[26] He says he has 'a heart crippled by its weight of lust'. What all these expressions have in common is a distinct absence of the feminine.

The poems in the first section of *Old Negatives* were mostly written shortly after Amy Gray died, so she is once more conspicuous by her absence in these laid-bare confessional poems. But she does finally appear several poems from the end of the sequence, once she is gone. 'Statements by an Unceilinged Blood' is a lengthy, dark hell-vision in capital letters starting 'IN THE BEGINNING WAS THE CAVITY' and going on to parody the Book of Genesis, describing the appearance of life on the planet as a 'CANCER OF THE CLAY', and treating all other developments no more positively. But towards the end it becomes more personal, until suddenly Gray creeps out from behind his mask of doom:

MOTHER, LOST MOTHER
 WHERE HAVE YOU TAKEN ALL MY HEAT
LEAVING ME ALONE,
AS COLD AS WATER, AS COLD AS STONE?

I DID NOT WEEP WHEN YOU DIED,
 I WAS WARM THEN.
WE LAY ON ONE BED,
ONE PILLOW UNDER OUR HEAD.

MOTHER, WHEN I WAS DRIVEN
 OUT OF YOUR QUILTED WOMB
DID YOU MEAN ME TO GO WITH SO LITTLE HEAT
INTO THIS IMPLACABLE MACHINE?

Alasdair considered himself thrown out into the world to fend for
himself, the artist misunderstood.

ART SCHOOL AND 1950S GLASGOW

In the summer of 1952 Alasdair took his Higher art exam: there weren't
enough students in the locality taking it so he had to leave Whitehill
and go to nearby Eastbank Academy. Also taking the exam that day was
a boy called Ian McCulloch. The two didn't know each other yet but
McCulloch remembers that even then Alasdair Gray was known to be
an unusual talent: 'He came from Whitehill trailing clouds of glory,' he
says, remembering Gray's arrival for the exam. 'He was obviously an
important personage, even at that early stage . . . the work he did for
the Higher art exam was virtually identical to his work now – he
seemed to come fully formed.'[27] Alasdair entered Glasgow School of
Art in autumn 1952 after a scholarship allowed him to take up a place
his father would otherwise have been unable to afford – a key example,
as Gray sees it, of socialism in action. But when he arrived, art school
life was a shock. Previously, Alasdair was the only artist he knew –
which at least made him different. Now *everyone* was one.

In the early 1950s the student body at Glasgow School of Art was
small, being home to only about 250 students, which helped create a
keen sense of community. Many students had a detailed knowledge of
the work of others at the Art School during this period, especially those
like Alasdair, who quickly developed a reputation as unusually dedi-
cated and unusually talented. The atmosphere was relatively relaxed –
after the first six months (when there was a cull of those lagging behind)
the authorities very much left students to get on with their work.
Compared to the later climate of league tables, specific targets and
regular exams, the system of Alasdair's time was a liberal one. There
were no degrees: everyone took the same diploma, and for the first two
years each student took general classes. Ian McCulloch remembers:
'We did everything, from life drawing two hours a day to layout,
lettering etcetera – and if you look at Alasdair's artwork now, you can
see he has considerable graphic skills. Those first two years gave us an
invaluable, broad artistic education.'

As well as having to settle into the community of students at art
school, Alasdair also had to get used to the centre of Glasgow. Before he

left Whitehill Secondary the Glasgow outside Riddrie was largely
unknown to him, and the kinds of people he came across at art school,
based on a hill two minutes' walk from Sauchiehall Street, were not to
be found in the housing estates of East Glasgow. In 'Unfit', a poem
written in this period, Alasdair wrote: 'Terrible structures have been
erected on the skyline/through which the sun must grin on rising'.[28]
The city was changing fast. Alasdair's good friend since the 1950s,
Archie Hind, explains that then, 'when the River Clyde still had ships
sailing down it, the city was different – very similar to the futuristic city
described as Unthank in *Lanark* – all smog and disappearing light and
trams and industry.' Social life was different, too. Pubs opened for just a
few hours at lunchtime, closed at two, reopened at five and closed at
nine thirty. Most places didn't let under twenty-ones in, so even if art
school students did manage to go at the right time, they couldn't always
get served anyway.

This makes sense of the reason why art school students went to
Brown's Tea House on Sauchiehall Street so much. It's not that they
weren't all big drinkers, just that the times when the students (who
mostly lived with parents, or had to travel home to other parts of
Scotland) wanted to socialise, expensive pubs weren't always an option.
So Alasdair and friends sat in Brown's Tea House before or after classes,
talking politics and art. From the accounts of various members of the
group it seems there was some affection for this place; it was cheap, the
waitresses were friendly and nobody minded them sitting there for
hours, cradling a single cuppa and chatting. Alasdair's friend Katy
Gardiner said of the place, 'Brown's was his [Alasdair's] territory. He sat
there and worked, he sketched people who came in – it was his
home.'[29]

Brown's Tea House became the model for the Elite Café that
features in *Lanark*.[30] In the opening chapter, set in the Elite, Sludden[31]
says, 'Art is the only work open to people who can't get along with
others and still want to be special', but this arty bunch seemed to have a
common bond. Sludden's words remind me that Alasdair didn't always
feel able to communicate, or to be understood in the way he wished.
Eleanor Hind, Archie's wife and Alasdair's friend from this time
onwards, explains the view others had of Gray at that time: 'A lot
of people didn't take Alasdair seriously when he was young. The girls
liked to pet him, but none would consider going out with him – and
few people expected he would make anything of himself.' She says this

with a smile that shows how pleased she is that those people were wrong. Some of the art school characters that used to frequent Brown's eventually found themselves portrayed in *Lanark* nearly thirty years later.

By the end of 1953 Alasdair was settled at art school, and though he didn't find many of the exercises he was expected to carry out satisfying, this didn't stop him from beginning to think of himself as a talent waiting to be discovered. A scrap of Gray postcard from the period, found at the bottom of a drawer of papers, reads: '1953: On the last day of this year, after closing time outside the State Bar, I met Robert Kitts, a Slade Art Student come to Glasgow for Hogmanae [sic]. We convinced each other that we were geniuses, meeting next day to discuss and share poems and books we were writing.'[32] So they weren't at the Tea House all the time.

In spring 1954, three years after his plans for a book about an alter ego, Obbly-Pobbly, and three years after the publication of 'The Star', Alasdair re-embarked on 'a tragic novel about Duncan Thaw . . . knowing the start and end'. He considered his growing experience, if only of art school, grief and sexual frustration, sufficient ammunition to make his work appear that of a mature adult. He hoped to finish the book by the end of the summer holidays and could not have anticipated how big the project would be. But Gray was not, by his own admission, ready to write great parts of *Lanark*. The book he wanted to complete would take in many aspects of life that, though he planned to, the young student had simply not yet seen. He did complete one chapter, 'The War Begins', and the hallucination episode in 'The Way Out' in this period. If the early fifties were a frustrating time in terms of output, they did provide several scenes for *Lanark*, and gave him the idea for the protagonist, his eventual alter ego, Thaw. Like Gray, Thaw is delighted to be at art school, but finds the reality of it far from what he imagined. And as he would later write, he felt as limited by some of the dry painting exercises like 'Washing Day with Three Figures'[33] as those old maths equations and he went from keen to disillusioned, increasingly focusing his energies on out-of-class activities.

In 1954–5 Alasdair turned from painting mostly on canvas to painting mostly on walls. After the first two years students were allowed to specialise, and, not feeling accomplished enough at anything else, Alasdair chose mural painting as his main discipline: the most public kind of art available, the art form most like the pieces on the

walls of the canteen in Wetherby where he had spent the latter part of the war. It was around this time that he began his 'Horrors of War' mural in the Scottish–USSR Friendship Society building in Belmont Crescent, in Glasgow's West End. This was controversial from the outset because of tensions between Britain and Communist Russia at the time, and some art school officials assumed Alasdair was a Communist when in fact his mural, which showed the gruesome aftermath of a nuclear war, replete with ghastly human mutations, simply argued for peace between the two countries. His many distortions were intended as a warning against possible nuclear futures. Alasdair was not happy with all of this mural – he was very new to the form, and was still experimenting with it – but, despite the political reservations of nervous officials, none of them were in doubt as to Alasdair's potential.

This was a key period, not just because of Alasdair's painting work but also because he was developing a real sense of community. For the first time in his life he was popular, and was valued by his peers for the quality of his work. Many of the people he was drawn to (and who were drawn to him) were also working-class people who were the first in their families to go on to further education, and to benefit from student grants, and this is another link between the key events of Alasdair's life and the Acts of Parliament that defined it. As Gray's creation Jock McLeish says in his novel *1982, Janine*: 'I am very sorry God, I would like to ignore politics but POLITICS WILL NOT LET ME ALONE. Everything I know, everything I am has been permitted or buggered up by some kind of political arrangement.'[34]

YOUNG GLASGOW GROUP(S)

At first glance Alasdair's art school network seems simple to explain. From the evidence of writings, interviews and exhibitions Alasdair has put on over the last several decades, he sees himself as part of a group of five Glasgow artists all emerging in late 1950s Glasgow – himself, Alan Fletcher, Alasdair Taylor, Carole Gibbons and John Connelly. Even now, in conversation, he still sometimes talks of the five of them as one coherent entity, as if they were all working towards similar goals. But there is some debate over who Alasdair was close to during his art school years, which group he was part of, or whether he was part of a group at all. Alan Fletcher was several years older than Alasdair (he had

done National Service first), Alasdair Taylor was a couple of years behind, not starting at Glasgow Art School until 1955, and John Connelly didn't go to art school at all. Add to that the larger Glasgow Group that emerged later in the decade, and the issue becomes muddied. However, no one doubts Fletcher is the key.

Alan Fletcher was the most dominant personality in the group. He was very confident, talented and rebellious – Carole Gibbons describes him as 'completely wild – the first bohemian – before people were calling themselves bohemian'.[35] The combination of Alan's boldness and his association with Carole (at that time a slender, attractive woman with an air of studied cool), encouraged others to see him as a natural leader. Alasdair believed Alan was a truly great artist, and thought of him as a great friend too. From the accounts of others, and also from Alasdair's own writings, he didn't consider his friendship with Alan an equal one. It was born partly out of jealousy, like the character of Jack in his later book *The Fall of Kelvin Walker* (who Alasdair says is a greatly toned-down version of Alan), the rebellious artist who is more extreme, more courageous, more dangerous to know than pompous little Kelvin – Alan was confident, impulsive and better-looking than Alasdair. Years later, remembering his friend, Alasdair would say they had only one thing in common: painting.

During some of the art school years Alan and Carole Gibbons were a couple, and according to Carole, who said they were 'like Glasgow Beatniks',[36] the two of them 'went everywhere together, with Douglas Abercrombie',[37] another student of the time. In Alasdair's mind, he and Alan were close, but Carole believes she, Alan and Douglas were a coherent three. She has said:

> Alan's closest friend was definitely Douglas Abercrombie. The two of them were very kind to Alasdair, but Alan's more intimate thoughts about painting and things like that, his closest thoughts, were shared only with Douglas and me. Alasdair and Alan – their work was very different. Alasdair was interested in Blake, and was more well read than the rest of us.[38]

Carole makes it sound like the group of three were sympathetic to Alasdair, but not as personally close as he imagined, also that Alasdair's work was too different from theirs for them to be true allies in art. But she does claim that an art school 'elite' developed between 1953 and

1955, with students drawing closer together as they identified the other most gifted ones around them and developed alliances. Alasdair was certainly one of these: his ongoing Scottish–USSR mural gained him a reputation for recklessness and fierce dedication to his work.

By 1955 other students at Glasgow School of Art were beginning to compete for attention: the likes of Anda Paterson, Jack Knox, Ewen McAslan and Ian McCulloch (who got into Glasgow School of Art at the second attempt, a year behind Alasdair). Though Gray has not emphasised these connections much, these people were certainly friends, and some of them considered Alasdair and also Carole Gibbons to be part of something relevant: later they would call themselves the Young Glasgow Group. Despite the fact that none of these artists went on to make a significant public mark, some of the names above still consider themselves part of an important scene which has been unfairly and consistently ignored by critics. The Young Glasgow Group (which later became simply the Glasgow Group and still exists today) was officially formed in 1957, but all the 'members' were at the art school before then.[39]

Many of these young artists rebelled against the prevailing culture at Glasgow School of Art – at that time Modernism and Post-Impressionism were ignored or discouraged by the teachers, an attitude some students thought positively 'philistine'.[40] In one of his harsher moments, Alasdair, who considers himself 'an old-fashioned Post-Impressionist',[41] described the atmosphere:

> [T]eachers painted in what was then called 'the academic tradition'. They painted as they thought Van Dyke or Corot would have painted had these great men been forced to work in Glasgow. They warned us against Post-Impressionism, though one said Cézanne would have painted perfectly well if his eyesight had been repaired by decent spectacles. Students who wanted to make new, exciting art had to learn from each other. Luckily, Alan Fletcher was among us.[42]

Or, as Carole Gibbons puts it, 'Only a few of us at art school knew what art really was.'[43] But despite the fact that Fletcher, Gibbons and their contemporaries shared opinions on the Establishment, there was nothing that unified these rebels in terms of artistic style; they had no manifesto, no common way of working – as Carole says, the Young Glasgow Group 'was put together in desperation, only loosely put together; there was no common philosophy, it wasn't a true move-

ment'[44] – which makes it hard to have reason to call them a group at all, except perhaps because of what they stood against. Many at Glasgow School of Art at this time believed they were operating in tough conditions: they felt alienated by the art school establishment, by Edinburgh College of Art, which had a richer history and more developed scholarship and funding system, but also by the wider British art establishment based in London.

Alasdair continued to work outside the art school as well as in it, and he was already drawing together two of his passions, art and politics. In 1956 he wrote a play called *Jonah*, based on his favourite Bible story, for the art school puppetry department, and soon after he finally completed his 'Horrors of War' mural, which had dragged on for much longer than anyone expected. (No representatives from the art school staff attended the opening, as they feared being labelled Communists. As one friend put it, 'McCarthyism was alive and well in 1950s Glasgow.') Despite practical difficulties, these two projects taught Alasdair that as long as he was prepared to put in the extra hours, and work without assuming he would be paid, then he could create public art and make political statements at the same time. The political element seemed like a particularly important one then, as in the mid-1950s several things caused Alasdair to become disenchanted. Against the backdrop of an escalating Cold War, 1956 saw two major world events: Soviet troops crushed the Hungarian Uprising in the spring, and shortly afterwards, the Suez Crisis. Alasdair thought Britain shouldn't have been involved in the conflict, and letters to Bob Kitts from this time show that Suez changed his view of the armed services, and of British governments, for good.

Alasdair ought to have graduated in 1956, but didn't because he had taken several periods off due to struggles with asthma and eczema, being in hospital for part of three consecutive summers, with one particularly bad stint when he spent several weeks in Stobhill Hospital. So he had to stay on for another year and finish his diploma. During this time, he wrote two stories for *Ygorra*, the art school student magazine: 'The Spread of Ian Nicol', about a man who literally splits down the middle and starts fighting himself, is still one of Alasdair's favourites. A second, 'The Cause of Some Recent Changes', is set within the art school itself. This is a fantasy which sees a student suggesting the idea of digging a tunnel under the grounds, and ends with that student wishing he'd kept his mouth shut.

These stories were very real indicators of what was to come from the wilder side of Alasdair's fiction, but at the time it seemed as if he was simply going through another year of the same – though at least Alan Fletcher was still around. His work was getting some exposure already, he was assisting the sculptor Benno Schotz, and was planning a series of exhibitions. Between classes the friends still spent a lot of time in Brown's: Alasdair in particular could often be found there of an afternoon, with his portfolio. He made new friends here, like Katy Gardiner (then Donaldson), who recognised his work as that of the 'genius' she had heard so much about from students and teachers at Glasgow School of Art. 'Are you Alasdair Gray?' she asked him. 'I know all about you.' They have been friends ever since.

Once he received his diploma in 1957, twenty-three-year-old Alasdair was recommended for the Bellahouston Travelling Scholarship by his principal, Percy Bliss. This resulted in an extended trip to Gibraltar, where he was financed to paint for a year: the only condition of this was that he write about his experiences when he returned. The events of this year are documented in Alasdair's story 'A Report to the Trustees of the Bellahouston Scholarship'.

THE BELLAHOUSTON SCHOLARSHIP

As with many of Alasdair Gray's letters, applications and appeals, his 'Report to the Trustees' begins with an apology: it was delivered a year late. But though this irritated the trustees at the time, the gap between the living and writing enabled Alasdair to take a cooler, more objective look at his Gibraltar experience. As he said in his opening paragraph, 'I have had to examine the events deductively, like an archaeologist investigating a prehistoric midden. It has taken a year to understand what happened to me and the money between October 1957 and March 1958.'[45] The report still constitutes one of Gray's very finest pieces, whether fiction, fact or a mix of the two. It is mature, considered, confident and strong. Readers who search out 'A Report to the Trustees' (published in *Lean Tales*, Alasdair's joint book with James Kelman and Agnes Owens) will find a fascinating, exciting document. But it is not the only record of what happened. There was one other Glasgow art student who also took the trip, and his memory of it is different.

Ian McCulloch also gained a scholarship to paint on the move; McCulloch usually presents his Young Glasgow Group as a coherent whole, and says eight members planned to go to Spain to paint together (he refers to a photograph with them preparing for it). According to him, the others dropped out one by one and only he and Alasdair were left. But Alasdair says in 'Report to the Trustees' that he didn't intend to go abroad at all. He claims his desire was to travel to, discover and paint parts of Scotland he didn't yet know, only a condition of the money was that he go further afield. In the report, he describes McCulloch as only an acquaintance prior to the trip, not a close friend, and says he made his strategy alone.

Alasdair made a vague plan to go via London towards the south of Spain, seeing some of the works of his favourite painters like Velásquez and Goya on the way back, at the end of the trip. But even before leaving Glasgow's Central Station he was already doubting 'the value of a tourist's shallow experience of anywhere'.[46] This indicates Alasdair's often depressive personality in his early twenties. His tone does not suggest a young man excited to be paid to travel Europe as he pleased, released from rainy Glasgow into the big wide world! – it showed that at heart Gray was already the man he became in later life – most comfortable when close to home. Doctors had recently suggested a spell in the sun might improve Alasdair's health, but this diagnosis ignored the anxiousness he experienced: anxiousness over possible oncoming attacks, over not having enough medication to hand to be able to ease breathing, over not being close enough to a hospital when one is needed. All of which makes an attack more likely.

The record of Alasdair's miserable asthmatic tourist fortnight in London is written as if being told to someone who has never heard of the city before, while also describing the artist's sense of confusion, irritation and homesickness. He likens London to a desert, admits being unfair to it, then goes on to criticise most of what he sees. Westminster Abbey is a 'government Church', the Tower of London is 'less pretentious but nastier', King Edward is referred to as 'Edward the Fat'. No cheerful holiday postcard, this. But on to Gibraltar: Alasdair met Ian McCulloch one morning, and off they went.

They departed on the ship *Kenya Castle*. Alasdair wrote a detailed description of the response of these inexperienced Glasgow boys to the unfamiliar splendour: 'long before it unmoored we found it a floating version of the sort of hotel we had never been in before'.[47] Ian and

Alasdair did not know how to order food or what to eat, what to spend their money on or how to act when spending it. The two working-class students were not used to the grandeur of the *Kenya Castle*, the company of the kind of colonial administrators aboard or the attentions of the Goan attendants who insisted on serving them, even running their baths for them, and bringing in more water part way through bathing to freshen it up. This cultural shock created considerable nervous tension even before Alasdair got seriously ill. He had been sent from Scotland with a supply of asthma inhalers and also a self-injection kit for 'emergencies', but had frequently found himself short of breath during the past fortnight and was already looking for ways to conserve the remaining supply. This also made things worse. As Ian remembers their arrival on the ship, Alasdair was already ill before it left. On the second morning of the trip, hung-over from drinking, seasickness and vomiting on the first night, and agitated by homesickness and boredom, Alasdair had a huge asthma attack. In 'Report to the Trustees' he wrote:

> I lost all memory of normal breathing, and so lost hope of it. However, I could clearly imagine how it would feel to be worse, so fear arrived. Fear lessened the ability to face pain, which therefore increased. At this stage it was hard to stop the fear swelling into panic, because the more pain I felt the more I could imagine.[48]

This situation was not improved by Gray trying to distract himself from his attack with thoughts of women from the advertisements he had recently seen on the London Underground, and this was compounded by the fact that the doctors and nurses onboard were not very familiar with their patient's condition or how to respond to it worsening. Eventually Alasdair realised he had to contact home to explain what was happening:

> Ian came and I dictated a letter [to AG's dad, Alexander Gray] to be posted from Gibraltar. A radio telegram had been sent to him and I wanted to mitigate any worry it might cause. I noticed nothing special in Ian's manner but later he told me he had difficulty restraining his tears. The doctor had diagnosed pneumonia with probable tuberculosis, and said it would be a miracle if I reached Gibraltar alive.[49]

Ian does not remember anyone telling Alasdair directly about this diagnosis, and he only knew about it by pressing the ship's Scottish doctor for information. Not knowing what else to do, Ian thought more clearly than anyone else present and sent a telegram to Percy Bliss alerting him to the impending death of his student. But back in Glasgow, the Gray trip had been forgotten. The reply was short. It said: 'What is Alasdair Gray doing in Gibraltar?'

On arriving in Gibraltar the patient was taken straight to a hospital, where he stayed until he ran out of the twenty-one shillings a day he needed to remain there. In the meantime Ian put off his own trip to paint locally, visit Alasdair in hospital every day and steadily see his friend get better. Alasdair was not entirely well yet, and didn't fully recover for the rest of the trip (which was shortened by lack of money, then burglary, then more lack of money), but he did briefly recover enough to begin a mural on a Gibraltar wall in his hostel before returning home in an ambulance. The fact that Alasdair chose to leave a mark (later removed) on a place rather than return home with evidence of it, especially with the rest of the trip so disturbed, shows that he didn't much care for the approval or otherwise of those who paid for his trip. But by this time mural painting was Gray's favoured artistic form, and his teachers at Glasgow School of Art knew it.

Alasdair's account of the scholarship period, documented so eloquently in 'Report to the Trustees' focused mainly on health and unhappiness, but it was splashed with the odd happier moment, including accounts of the patient writing what became some early sections of Book One of Lanark. As the 'Report to the Trustees' progressed, Alasdair began to slip further into his fictional style, describing hospital characters and paraphrasing conversations. But at the end of the report he did attempt to sum up his time out of Glasgow, deciding it may not have been entirely wasted: he recounted that since returning home the asthma that had ruined so much of his year had abated, perhaps by way of thanks for returning to the place the Gray body felt safest: Glasgow.

That was the adventure itself, but the events either side of it are not described in their entirety in 'Report to the Trustees'. Alasdair did explain some of his experiences at his stop-off point on the way to Gibraltar, but did not mention his night at the home of Ann Weller, the pen pal he had been corresponding with for the past six years: this was the first time they arranged to meet. This event is something Alasdair did not speak of for many decades because he considered it so

dishonourable, but he did explain his version of his meeting with Ann Weller during an interview with me in August 2005.[50] Alasdair thought carefully before explaining what Ann Weller was like:

> She was . . . a nice . . . pleasant . . . sensible English girl with none of the charms that are advertised in cinemas and underwear adverts. Her people were farmers. She was intelligent, nervous. Not unlike myself – but female. At that time I was in a state of being unlikely to find women of a similar age and experience to me attractive unless they were FLAMBOYANTLY ALIEN in some way. I was looking forward to the encounter being a MAJOR SEXUAL EVENT, having looked forward to it for six years and fantasised often about how it would turn out. When I met this decent, intelligent, calm English girl who had recently graduated from Oxford University – or was it Cambridge? – I was horribly disappointed. Having met her on the way to Gibraltar I never wrote to her again.[51]

Alasdair paused to drink some wine, and to think. After a few moments, he continued:

> When I got back home . . . *to Scotland* . . . she wrote me several letters, but recognising her handwriting on the envelopes I threw them away without reading them. She then wrote to my father asking if anything had happened to me while I was abroad . . . she was concerned I may have died in Gibraltar. My father brought me this letter and said I should answer the girl, but I wouldn't. I remember shouting him down, a thing I would normally not do to him. I refused to hear a word from him about Ann Weller. I destroyed her letters. I only hope she destroyed mine. That is the most horrible thing I have ever done to another human being. I wonder now whether my father ever wrote back to her. He never said so, but I suspect he did. He wasn't the kind of bloke to tell lies. He probably wrote saying, 'I'm very sorry. *Alasdair will not discuss you or why he will not reply to your letters. I don't know why.*'

This secret was shameful enough for Alasdair to keep it for many years and it affected the way he behaved with women in future. From now on he would put up with anything they said or did to him, no matter how bad, and would never again sever contact with anyone.

THE LIFE AND DEATH OF ALAN FLETCHER

While Alasdair was in Gibraltar, Alan Fletcher was also abroad: he
received the John Keppie Travelling Scholarship and went off to Milan
with Douglas Abercrombie. But unlike Douglas, and Alasdair, he never
returned from it. Suddenly, on 1 August 1958, Alan Fletcher died.
Describing the event, Benno Schotz wrote: 'In Milan, while on his
scholarship, he met with a fatal and tragic accident. In the courtyard of a
students' hostel he stepped at night over a parapet, not knowing that on
the other side there was a sheer drop.'[52] Fifty years later, Carole
Gibbons says she has always quietly wondered whether Alan may
have been drunk that night at the hostel, which would have explained
his fall. She remembers:

> I don't think I've ever mentioned this to Douglas . . . which is
> incredible really . . . but because Alan didn't drink – he and I hardly
> ever drank alcohol – when he did have some, it affected him more
> than most people. Perhaps he had been out drinking with Douglas on
> that night, and he tried to climb the wall because he was drunk.[53]

When news of Alan's death reached Alasdair it had a shattering effect
on him, and also a wider impact on many of the others Fletcher had
inspired during the art school years. In the wake of his friend's death
Alasdair dedicated a poem to him, called 'Lamenting Alan Fletcher'.
The tone of it is bleak, and bitter, and opens with the line 'He will not
occur to us much again'. But the poem is full of admiration. It argues
that, through his absence, the very things that characterised Alan
Fletcher's personality will fade too:

> Now what we love in him deprives us of him.
> Jokes, height, fox-grin, great irony and nose
> Will not occur to us much again.
> They have been put in a box to rot.[54]

This reads more like a love poem than a funeral song, and shows that
Alan Fletcher was certainly one of the most influential figures in Gray's
early life.

 Alasdair has said that for a long time he wanted to *be* Alan Fletcher –
and in many interviews he has explained how he imagined most of the

heroic acts carried out by his characters as being carried out by Fletcher, no matter who they were. Alan is also one of very few people who appears in Alasdair's fiction under his real name. This might have been because he was dead by the time it was written, and Alasdair didn't have to disguise him. The relationship between Jock McLeish, the protagonist of *1982, Janine*, and the character of Alan is similar to the one Alasdair perceives he and Alan Fletcher shared, with some scenes copied direct from his memories of their friendship. Part of the reason *1982, Janine* is Alasdair's favourite of his books is because Alan Fletcher is in it.

All these years later, Alasdair is still sure of his friend's talent. He has said: '[I]n the four years before his accidental death in 1957, [Alan] made paintings and sculpture that proved him a creative genius.'[55] But Alasdair's praise of Alan went further than the artistic: he also felt his friend understood people better than anyone he knew, as evidenced by his perception of Carole. Before Alan's death, Alasdair said that Carole 'struck most people as fascinatingly beautiful, passive and mysterious in a Mona Lisa way – many males wanted to love her at first sight. Only Alan noticed she had a will of iron and creative mind of her own.'[56] These descriptions show Alasdair's habit of comparing his friends, family and acquaintances with major historical or artistic figures, and how he thought Alan could do no wrong. After Alan died, Alasdair's outlook on life reached its bleakest state yet:

> I do not live by hope, but certainty.
> I hold stones tight: these are the things I know.
> I build a tower of them. I do not grow.
> Distrustful of the air through which I go
> I rise, back foremost, slowly to the light.[57]

This poem, 'Cowardly', shows just how aching, cynical and desperate Alasdair was feeling. Not only that, but also that he felt he was no longer developing, as a person, as an artist or as a writer.

Many of Alasdair's contemporaries did not know he wrote poetry at all, apart from the odd note they saw him jot down in his notebooks. Alasdair was writing the realistic parts of *Lanark* by now, too, writing about his life at Art School, including a character called 'Thaw' in some poems, but few people knew it. In those days, to Alasdair's art school contemporaries the idea of being a writer was ridiculous, even more

unlikely than making a living from art, but Alasdair did know a couple of writers by now, one of whom was the playwright Elisabeth Carswell (who wrote under the name Joan Ure, and to whom Alasdair later wrote a dedication in *Lean Tales*).

Not all was negative in this dark year: Alasdair entered a short-story competition for the *Observer* under the pseudonym Robert Walker and was runner-up. (He briefly considered using this as a professional name, and several notebooks from this time show work attributed to Robert Walker.) The story he sent in to the *Observer* was from his early versions of *Lanark*, 'The War Begins', the first chapter of the realistic sections of the book, which tells his boyhood experience of learning to draw and describes fights with his mother over food he wouldn't eat. So, a little more hope. But not much.

THE REAL WORLD

After returning from Gibraltar, Alasdair had to find work – he had overspent on the trip and owed his father money – but he would have had to find employment quickly anyway. Alasdair has said:

> [F]or four or five years a lot of us were able to feel we were entering the profession of Michelangelo and Rembrandt, though we well knew that after we received our diplomas there would be no great patrons to commission work from us, no dealers to handle it, and hardly any manufacturing firms who wanted our skills as designers.[58]

With jobs scarce in Scotland a few young artists moved south, but most Glasgow School of Art graduates went straight into teaching in local schools.

Alasdair did so without being qualified to do it, but between teaching jobs he did try to make an impact with his art alongside some of the Young Glasgow Group, being part of a number of small-scale exhibitions from its inaugural 1958 show onwards. One of the earliest shows was at Glasgow's McLellan Galleries, which posthumously included work by Fletcher: his 'Man on a Wheel' was pictured in the *Scotsman* in June 1958. This review of Alasdair's work suggests he didn't quite fit the Group:

A. Gray is a nervous liner artist very different from those we have so far considered [at this exhibition] and more isolated than any of the others in this group. His intensity of expression is rather over-powering in 'Crucifixion' and 'The Marriage Feast of Cana'. His art seems to find its most satisfactory expression in black and white illustrations for example those for '19 Border Ballads'.

He was certainly different from the others on show: no one else was doing work even vaguely similar to his 'intense', 'overpowering', intricate paintings: this also contributed to Alasdair feeling slightly distant from the others.

Members of the Young Glasgow Group usually exhibited two or three at a time: 1958 saw Carole Gibbons's first public exhibition, a year after she and Alasdair left art school, and others soon followed. The next year there were more shows, including a Memorial Exhibition for Alan Fletcher which took place at the McLellan Galleries – this was the venue for many of the Young Glasgow Group's local shows, though they were usually brief because it was expensive for its members to hire the space. There were a few reviews of these shows, one of which showcased eleven artists all the way down in Leicester Square, London. This was reviewed by Ian S. Munro, who said Alasdair's work revealed 'powers of compassion spiritually akin to those of the late Stanley Spencer'.[59] But the odd positive comment in the press was little consolation when exhibitions rarely resulted in more than a few sales, and there was little prospect of the kind of momentum the artists hoped for. Alasdair has said: 'During the Leicester Square show there was a hugely popular exhibition of what became known as "Pop Art" going on nearby. I remember feeling really rather . . . *old fashioned*. Even then I was out of touch!'[60]

Meanwhile Alasdair worked, for free, creating a new mural on the ceiling and side wall of Greenhead Church in Bridgeton, Glasgow, believing it would be his first great masterwork and his best chance of being noticed as an artist. This is a period Alasdair documented in detail in Book Two of *Lanark*. Though some of the facts are exaggerated, there is much in the way Thaw describes his working process that exists in Alasdair's own. And the mural itself, based on the Seven Days of Creation and featuring God in human form, is shown in the book as Alasdair created it in Greenhead Church. He worked long hours on this project, and spent many nights there, often sleeping in the pulpit. It was

his largest, most impressive artwork to date, but few saw his emerging Seven Days of Creation. It could not be picked up, moved out and put in a gallery. And it could not be finished quickly.

In 1959 Christopher Murray Grieve (better known as the radical poet Hugh MacDiarmid) opened an exhibition of some members of the Young Glasgow Group at Iona Community House, Glasgow. Never shy of a sweeping statement or two, Grieve made comments that were reported in the *Glasgow Herald* on 19 January, which must have been sobering for the artists he addressed. He labelled Scotland 'the most anti-aesthetic country in Europe', said that Scottish artists had been 'subjected to a tyranny of mediocrity and to an alien culture which did not allocate a fair share of the available funds to Scotland', and advocated redirecting funds that currently went to 'the lame, the halt and the blind' into supporting artists. 'All the arts are integral to the whole development of humanity,' he said, repeating one of his long-favoured themes, 'and there is no reason on earth why young artists who have shown any ability at all should not be subsidised up to the hilt.' MacDiarmid's views were more extreme than most, but he was one of the country's leading poets of the period and his speech gave a flavour of the bleak climate for young artists in 1950s Glasgow. Despite his rousing call to arms, nothing much changed.

Alasdair Gray was not being exhibited that night. As the end of the 1950s approached he associated with the Young Glasgow Group less and less – he concentrated more on his own work and most of his spare time was taken up with his huge Greenhead Church mural, which was already taking longer than he (and the church elders) had hoped. While McCulloch, Knox, Abercrombie, Gibbons and Paterson continued to put shows together with the likes of James Spence and Marjery Clinton (both presented that night at Iona Community House), Alasdair drifted back into creating alone, spending most of his non-teaching time painting. But eventually he had to concede that teaching might have to be a more long-term solution to his financial problems and in the autumn of 1959 he enrolled in Jordanhill Teacher Training College. The 1950s had started with dreams and seemingly endless possibility. They ended with Alasdair once more in education, wondering yet again how he was going to get out of it.

DIARIES: Art

7 June 2005: Tracing Old Paintings

When I entered the flat today I was immediately suspicious; it was the tidiest I'd ever seen it. But there was an explanation. Alasdair had just completed a hardcore version of one of his infamous 'clean-ups for the cleaners', a weekly ritual which involves sweeping up letters, sketches, paintings in progress, completed works, cheques, cash, newspaper articles from the *Times Literary Supplement* he feels 'broaden my knowl-edge of this big old wooooorld, RRRRodger!',[1] old family photo-graphs and funeral service leaflets of friends who have recently died, all into one maddening pile by the front window, an area he knows the cleaners can't decently get to because of all the paint pots and brushes blocking the way. This pile made an hour's work for us both once they'd gone, just to find the letter he had received yesterday and needed for the morning's planned work. Alasdair took the day off from the Oran Mor to . . . to . . . we weren't entirely sure. Something to do with *A Life in Pictures*. But he couldn't remember what it was – so we answered e-mails instead.

Several weeks ago Alasdair dictated an advert to be put in the *Herald*, appealing for help in finding a number of artistic works that have gone astray over the years, many of which he wishes to use in *A Life in Pictures*. One got lost on a train to Edinburgh in 1981; one got left in a janitor's office in a school; others he has forgotten entirely. The advert went in as part of a feature where Gray declared all losses solely his own fault and promised to credit anyone who could help compensate for his stupidity. There have been many replies, and showing them to him today was a delight – an exercise in dipping into how he feels about his past and his art:

'Ooh, I remember this one! There's a flamingo at the bottom of this! I haven't seen this flamingo in thirty years!' he cried, as the downloaded image of 'Garden of Eden' appeared before him on the computer, bit by bit. This set him up for a fit of giggles that lasted, on and off, for about twenty minutes. While waiting for the rest of the picture to appear before him he excitedly went on to explain what was in other parts of it (Adam, Eve, elephant, trees and, of course, a serpent). This is the happiest I had seen him in some months. Until recently I had to persuade him to even look at e-mails when he was working on something else, but he now seems to look forward to seeing if any

more magic has appeared on the little machine in the bedroom, and likes to check what's new before getting down to work.

Some interesting oddities have turned up during this search. One is a set of photographs from Crosshill Synagogue, one of Gray's now-demolished murals. Though fans write to say what a shame, disgrace, national scandal it is that they no longer exist, despite how much work they were to create, the artist himself seems to accept this is a part of normal life: things are born, things die. No big deal. 'I started painting the city around me,' he said today, 'because it was disappearing before my eyes, and an artist's job is to document.' But when his documents die, he doesn't get overly upset. Crosshill Synagogue has surfaced several times now on this search. I forget Alasdair was young some-times, but in a retrieved *Jewish Chronicle* article from 1964 sent as an attachment he is excitedly described by the journalist as 'a young Scottish artist, recently featured in a TV programme!'[2] The article suggests this is good for the profile of the local Jewish community, which in Glasgow is small, even more so now than then. Forty years on, looking at the article and a set of black-and-white photographs found in the Jewish Scotland Archives on the computer, Alasdair suggested quietly: 'I don't mind whose God I work for.' This pro-nouncement tickled him greatly.

Enjoying the memory, Alasdair described how fifteen years after he completed the project the synagogue committee called to say that the synagogue was to be knocked down and replaced by another in nearby Newton Mearns, where many of the community had moved on to. The committee politely asked if he'd like his mural back, in the form of a pile of neatly stacked, decorated wood panels, each with his painted bits of cloud on. The now-not-so-young artist explained brusquely that he did not have room to store clouds and would have no use for them anyway. Returning to the newly discovered photographs, Alas-dair thanked Mr Kaplan of the committee for replying to his recent advert, and for sending these documents of the site in its prime. Then he moved on to the next find. 'Netta With Fur Collar' may have been retrieved, it seemed; also, a portrait of Alasdair's ex-patron, Professor Andrew Sykes.

Friday 16 September 2005: Enjoying Purple
After a month in hospital being treated for an ulcerated leg Alasdair finally came home today, in an ambulance, and I went over to see him.

I walked in to find him sitting at his old artist's desk reciting parts of
Shakespeare's *Hamlet* to himself while painting block purple sections of
a piece I hadn't seen before, dipping his brushes happily into a Baxter's
Country Garden Soup can half-full with muddy water. One leg was
still heavily bandaged, propped up on a nearby chair.

'So you're resting then?' I said.

'Oh yes. No work for me!'

He continued painting, and even whistled. He was pleased to be
home, and happy to show it. I was too pleased to see him in good spirits
to complain.

Alasdair said the portrait was of two people[3] he had met in July in the
Studio One bar on Byres Road, Morag's regular pub, one of whom had
a Mohican hairstyle and many tattoos down his arms. The details of
date, venue and names of subjects were written large and elaborate over
the bottom quarter of the portrait.

'People who take great care over their appearance have always
fascinated me,' he said cheerfully. 'I asked this young man if he would
come to the house to be painted and he said yes, as long as his girlfriend
could come too.' Sometimes when Alasdair paints at home he does so
slowly, with great care. Today, the carefree movement of thick brush on
plain background is more like the style of a decorator working on a vast
wall. Alasdair says his greatest peace is painting in that way – he will miss it.

I don't know what the work situation will be over the next few
weeks and months, but as long as Alasdair is unable to walk without
crutches then at least he can't work on the Oran Mor ceiling. His boss
there, Colin Beattie, is putting no pressure on him to return to work
and his publishers Bloomsbury and Canongate have no immediate
deadlines. The text for *A Life in Pictures* is supposed to be finished by the
end of the year though. Alasdair says he wants to do it, but 'I won't be
killing myself to get it done'. So we can all be pleased about that. The
last postcard I received, sent from hospital, read 'I will probably do
some more years work, with less haste.' Meaning: he can't continue the
same way if he expects to live. The difference between old and new is
minimal though. Today he decides he wants to write an essay for the
Talbot Rice Gallery's self-portrait show. He feels he has to battle more
for attention for his artwork than his writing, and so this opportunity
takes priority. But even this one had to be manufactured.

A couple of months ago the gallery wrote asking Alasdair to write an
essay about a great Scottish self-portrait. Sitting behind me, chuckling,

Alasdair dictated a half-jokey, half-serious e-mail demanding *a thousand guineas* for this essay, given his great offence at being asked to comment on the work of another instead of himself. He would, he said, happily write such an essay on one of his own self-portraits – 'For no charge! No charge, I say!' – but would accept no less than the thousand guineas if his artwork was turned down. 'I fully expect never to hear from you again!' he dictated. The gallery wrote back promptly saying they would consider his work. Soon, they accepted it.

PICTURE INTO WORD INTO PICTURE
An Academic Overview of Gray Art and Where it Comes From – Summer 2006[4]

Origins

The notions of image and word have always been strongly connected in Alasdair Gray's mind. His father's library contained the plays of George Bernard Shaw and the essays of Marx, and these both had a lasting effect on his politics and personality, but the books he discovered with pictures in them were equally as important: particularly those by authors who did their own illustrations. This is highly unusual, but there have always been examples of those who preferred to do it themselves. The likes of Lewis Carroll, whose *Alice in Wonderland* Gray read, and Rudyard Kipling, whose stories provided early inspiration, ushered Alasdair towards a simple but important childhood realisation we all experience when we see something we find interesting or useful in the world around us, whether it be someone using a knife, throwing a ball or illuminating a story with pictures. Namely, *if someone else can do it, then so can I!* Seeing there didn't have to be strict rules over what jobs a writer or artist could take on, Alasdair developed both his creative talents simultaneously. Since then he has conceived all his works not just as texts to be stuck between covers but as an aesthetic whole whose parts are indivisible. Those writers before him had an influence not only in opening up the possibility of mixing forms, but also in the style he developed and the themes he has explored since. Rudyard Kipling is one whose artistic influence can be seen clearly.

Like Gray, Kipling cut up his prose with biblical images, a famous example being a procession of animals that appeared in his

Just So Stories, echoing the Noah's Ark tale. *The Jungle Book* contained an illustration done by Kipling's father, John Lockwood Kipling (also an artist), showing Mowgli hiding in a tree. But far from his Disney reincarnation, this muscle-bound boy seemed to merge into the tree he sat in, holding one hand up for a bird to rest on, leaving the other to dangle down and stroke the head of a wolf below. The image is not dissimilar to Alasdair's 'Garden of Eden' from his Greenhead Church mural or a number of other Gray works which used animals and humans interacting in a natural setting – usually Adam and Eve amongst the animals. But why has an agnostic Scottish Socialist spent so many years concentrating on traditional Judeo-Christian themes? 'Because,' says Gray, 'any form of happiness seems to me to be a form of heaven, any form of unhappiness a form of hell. The Genesis story includes both.' And because young children copy what they see. William Blake was another key influence on a young Alasdair – perhaps the most important. Blake also often painted the Garden of Eden ('The Agony of the Garden') and Adam and Eve ('The Angel of the Divine Presence Clothing Adam and Eve', 'God Judging Adam'). He even dared to depict God, something Gray's alter-ego Thaw does in *Lanark* to tragic effect.

Teenage Years: Joining Together

As he grew older, Alasdair began to not only illustrate his stories but also blend picture into word into picture. While working on the germ of the idea for *Lanark*, Alasdair began to pass his spare time writing stories and poetry in artist's notebooks, framing his favourite verses with illustrations in pencil evoking the dark themes his writing dealt with whilst an adolescent – loneliness, confusion, frustration. In one early drawing a horned angel stands solemnly underneath the words: 'Alone Alone cold cold cold and alone'; in another a hunched, naked man sits central on the page below the words 'anarchy crouched beastwise in the dark'. If there was ever any doubt that these twin loves of art and words had become fully inter-connected in Gray's mind, surely these personal drawings are the evidence of it.

This style developed when Alasdair began to get stories published in magazines, and had actual printed pages to dissect and arrange. The opening paragraph of early short story 'The Spread of

Ian Nicol' would not be as effective without the depiction of the
back of Ian Nicol's head on the first page, suggesting he might be
about to split down the middle: the last page would not work as
well without the inverse pictures of the two Ian Nicols facing each
other, in matching caps, ready for a scrap. The simple, fable-like
aura of the sentences is echoed by the same spirit in the drawings,
and the fable would be less without them.

A Sketchbook in Print

More than thirty years after 'The Spread of Ian Nicol' was written,
Alasdair's first poetry book, *Old Negatives*, was finally published.
This showed how those early ideas developed, as the poems dealt
mostly with early work and the corresponding pictures were done
in his earlier style. *Old Negatives* is almost as much picture as word –
all in black and white, like his old school-notebook drawings. The
book is almost like a Gray sketchbook in print. A Picasso-inspired
depiction on the inside cover shows a mother figure drawn sparely
with abrupt, straight lines, and both a fully-grown man and woman
contained inside her womb, embracing. They are surrounded by
other creatures of the earth, with an owl, swan and octopus sharing
the womb, another echo of the Garden of Eden theme. One of
Alasdair's most frequently reproduced images is to be found
replicated fifteen times on the jacket of *Old Negatives* – a winged
cherub crouched inside a skull, representing life and death in one.
The survival of the delicate in tough circumstances is the main
theme, and the bleak, adolescent introspection of some of these
works contrasts sharply with the confident images and textual play
found in later work.

 Direct statements relating to the themes of a Gray book, like the
cherub and skull, are replicated elsewhere in many of Alasdair's
works, often in words as well as pictures. On the jacket of the
original hardback edition of Alasdair's novel *1982, Janine*, a naked
man with outstretched arms is shown surrounded by many re-
productions of the letter Y, both upright and upside down, with
the same effect appearing in the mental breakdown section of the
novel. The upside-down Ys also represent the 'legs astride astride
astride' motif that runs through the sexual fantasies of protagonist
Jock McLeish. This technique of forewarning continued through-
out Gray's career. On the hardback of the 1994 novel *A History*

Maker, a fantasy about future wars, a gold-coloured imprint of the stump of a tree with one surviving branch is accompanied by the words 'TRY AGAIN'. This statement had a more direct political point to make: Gray was comparing his fictional war tale to real ones, and suggesting that Scotland should aim to recover from past setbacks by reaching once again for independence.

Battling the System

There is a long tradition of authors challenging what is acceptable to put in a book, as seen with the example of Blake. In the main, Gray has been lucky enough to work with people who understand his need for his books to be physical things of beauty. His works must be pleasant on the eye, he insists, and make sense in the context of the books' themes. Every page has to be laid out in a very specific way. He considers every part of the process to be his business, and largely that has been indulged, though it has made the production of Gray books a complicated, protracted and expensive business.

Joe Murray has been Alasdair's intermittent typesetter since the early 1990s. One of the books Joe worked on was the sprawlingly ambitious *Book of Prefaces* project, painstakingly putting every individual page together, lining up art, original text and commentary time and again exactly as Alasdair desired only to have to go back and alter it when he changed his mind. The section on Shakespeare was a particularly difficult one to marry in Gray's mind and on the page, particularly because of his dependence on technological experts to realise his vision. (Before Murray he had worked with Jim Hutcheson of Canongate on designs for a number of his books, implementing everything from choice of font onwards together, so he had never had to work completely independent of technological specialists.)

One particularly fraught afternoon working on the Shakespeare section of *The Book of Prefaces* the usually cool Joe Murray lost his temper when Alasdair made yet another request to alter the make-up of the entire section, and he sent Alasdair home . . . until the following day, at least. After Alasdair's peace offering of a curry, a few pints and a promise to be less anxious to achieve utter perfection all was well between the two again, but the story shows how difficult it can be to arrange books amongst art, especially with

purists who have a vision that may not be practical, easy or
consistent with the technology of the day. The end of the story
bears that out. The following day came, Alasdair changed his mind
once more about how to present the bard and Joe had to rearrange
all the pages yet again. (With this form of typesetting, changes to a
single page can affect the appearance of all the others.) These days,
quite understandably, Joe Murray does not like to think about
Shakespeare. In the wake of this episode, Murray even put pen to
paper himself to write a nightmarish story called 'A Short Tale of
Woe' about how awful it was to work on *The Book of Prefaces*.[5] He
is sure to praise Alasdair's many other talents, but gives a real insight
into how dependent he is on people who understand forms he is
not prepared to learn about, and also how incapable Alasdair is of
changing his ways, no matter what trouble that brings.

There is a good reason why Alasdair relies on friends like Joe
Murray rather than deal with full-time, professional typesetters: he
has learned that he can get away with more by sitting in the same
room as Joe while he works, than he can when dealing with people
based in London publishing houses, that he does not know
personally and cannot persuade to keep making alterations. But
he was not always able to keep control over this side of book
production. He was originally told that his desired versions of
several early short stories were impossible to produce in a book
because they split the typed page diagonally, or flipped the type
upside down, or the type increased or decreased in size.

Some of *Unlikely Stories, Mostly* used these techniques, which
Alasdair had first seen as a small boy. He 'got ideas for them from
the mouse's tale (and tail) in *Alice in Wonderland* and gnat's speech in
Through the Looking Glass'.[6] He had also noticed ambitious layout
and design in the books of avant-garde author BS Johnson in the
1960s and 1970s – so he knew unusual things could still be done
when the will was there. Alasdair's own novel *1982, Janine* used
similar techniques to the above examples but ran into technical
problems concerning its mental breakdown section where the text
divides many ways at the same time. It was difficult to make happen
but Alasdair insisted on finding a way, despite the fact that he had
no technical knowledge of how to do so. This process was a real
struggle, but eventually it was made as Gray wanted it, the mental
breakdown section became one of the most talked about aspects of

1982, Janine and it went on to inspire several others. Irvine Welsh's *Marabou Stork Nightmares* was applauded for using similar stylistic techniques ten years later; by then there was a clear precedent for this kind of work.

Acceptance, Nearly

There have always been mavericks working outside the usual rules, but Alasdair's approach to book-making is so different from most in the last century that he has often run into difficulty trying to turn the books in his head into real objects. Particularly in the early days, before he was known and admired for his approach, it was certainly difficult for Alasdair to exist as designer *and* writer of his own books – and even today these problems have not entirely gone away. As recently as Gray's 2003 short-story collection *The Ends of Our Tethers*, Joe Murray gave up, for the first time ever, on a Gray book, citing difficulties in the process. Alasdair believed the first edition of 2007's *Old Men in Love* was imperfect because of problems with typeface, and last-minute corrections he wanted to make to the panoramas of Glasgow, Florence and ancient Athens which divided up the book. Perhaps there will always be difficulties in implementing his preferred process, and tensions between him and those who are prepared to work with him. But at least now the design is an accepted part of his output – as it has always been for him.

25th April 2006: Saint X

Today Alasdair was deep in *A Life in Pictures* with Helen Lloyd, his new assistant, when I arrived to give him back some papers: I spent yesterday copying out wall calendars from the last fifteen years, and now he wants them back. Immediately. Why, nobody knows. Entries like 'July 7 1990 – clean stairs and landing' next to a picture of skull and crossbones, scrawled ones like 'August 24 1992 – Inge walk meal', mysterious entries labelled 'Saint X' and a series of weight-related entries between '94 and '96. Most entries are only a word or two, referring to readings or meetings with friends. This is to be added to the Magic Red Box which stopped dead in 1987 – the regularity of documenting the minutiae of his life may have diminished since then but the desire to save even the smallest evidence has not. Does Alasdair think these are important? If so, why? Is it out of a sense of self-importance, believing every evidence of his actions – even when he paid the window cleaner

– will be wanted by the National Library, or more like a habit where the process of accumulation is the key thing? Perhaps that goes some way to explaining the increasingly completist, autobiographical nature of *A Life in Pictures*.

Tomorrow Alasdair is giving a talk at Glasgow School of Art. These days, the parts of the building the public can visit exclusively advertise Charles Rennie Mackintosh,[7] the architect now synonymous with Glasgow who brings many tourists to the city. It's a fine building but in recent times, after years of ignoring Mackintosh, the art school has cashed in on one popular designer at the expense of others, and even has a Mackintosh shop which sells Mac key rings: despite three Turner Prize winners in the last ten years no other ex-students are represented in the building. Alasdair certainly hasn't made the gift shop cut, and he's worried nobody will come to hear him speak.* Today he sadly recalled that until a few decades ago there was a policy of retaining work by promising students. 'After the Mackintosh revolution,' he said, 'they disappeared.' Alasdair shrugged. I shrugged. We both scratched. It was time to go.

8 June 2007: Yes Yes, But Is It Any Good?
An Unacademic Rant

I'm agitated. There are many interesting things happening with Alasdair now, for example, he has been responding in print to the new Scottish National Party First Minister quoting him in his first speech after the recent election, in a piece entitled 'Scottish Politics Now' that has been sitting in my bag for several weeks, unread. But instead of concentrating on this I am immersed in Scotland of the mid-1950s, trying to make sense of the mess of what was going on at Glasgow School of Art – and attempting to work out whether it matters fifty years later. One question will not leave me alone: is Alasdair Gray's art any good? It's all very well describing how it was influenced, and documenting who his contemporaries were, but if this bunch were talented enough, would they not have been remembered more? Elspeth King (a great Gray supporter) once wrote that Alasdair has referred to himself in artistic terms as 'one of those interesting second-raters'.[8] This has got me thinking about whether he was just joking, or really believed it. There's almost no surviving criticism of any of the art school characters that keep coming up in the Gray story except that

* They did.

done by the characters themselves, and despite the fact that Alasdair's friends clearly value his work and publishers have mostly been prepared to let him design his own work since *Lanark*, he was not even paid for doing the artwork for that book, and there's little evidence that the art is valued by anyone who's not already sympathetic to the literature.*

I have been doing interviews and research, trying to get somebody to tell me Alasdair's art is important: but, though I'd like to think so, perhaps the reality is, it's just not true. Perhaps, like Blake and Kipling before him – two great Gray influences – his art is at its most satisfying when it's partnered with the words of a book, or accompanied with a political statement, or adorning the wall of a pub. Surely there's nothing wrong with admitting that? What if the most important thing about Gray's art is its social function: the fact that it's a political statement. It's public. It's for everybody, not private investors. It's out in the world, not stuck in a gallery. It's free. That's a rare and special thing. Isn't that compliment enough? And what about his portraits – what if their greatest pleasure is that they give to those they are portraying? He has done many line drawings when visiting the houses of friends like Madeleine and Bernard MacLaverty, or Eleanor and Archie Hind (whose daughter Nellimeg he has drawn a whole sketch-book of), and sometimes when he is signing his books for his friends he will include a quickly done portrait of the friend in question next to where he has signed his name.

This niggling question that will not leave me alone, this thing I keep thinking when talking to or reading about people from Alasdair's old art crowd who believe they have been unfairly overlooked is this: *What if it has been ignored because it's no good?* As a writer, Alasdair has been recognised by readers and critics in his home country, through-out Europe, and has been translated into over a dozen languages. His work is studied on university courses abroad as that of an important writer and he is revered in his home country. Scotland's new First Minister just (mis) quoted Gray in his very first speech after the election. But as an artist, Gray has not been recognised internationally, nationally, or even accepted by some elements of the Scottish art scene. How many of the recent rash of Scottish Turner Prize winners has he inspired? Where is the generation of young artists who cite him

* Helen Lloyd read this sentence in a draft of this book on 29/6/07 and wrote in red: 'O blasphemy! I like the pictures more!' So not everyone agrees.

as an influence? I can only find one young artist, Lucy MacKenzie,* who
has publicly credited Alasdair's influence (though I keep being told there
are others). Only one book, by Edward Gage, the art critic for *The
Scotsman*, acknowledges the 1950s Young Glasgow Group at all, that
group is totally ignored by twentieth-century art books: by even
twentieth-century *Scottish* art books: in which Alasdair Gray is a
footnote. The only consolation for Alasdair is that 'in 1994 Duncan
Macmillan gave my big *Cowcaddens* landscape a good place in his Scottish
Artists in the 20th Century'.[9] Something then, but not much. Is that
because when high-minded critics look at his work, they see the cartoon
influences and dismiss it? Ian McCulloch called the 1950s Glasgow
Group 'a uniquely interesting group of people'. This may be cruel, but I
wonder if every group of young art students who and grow up together
don't at some point think they are part of something hugely important
. . . all of which makes me wish somebody else would write a book
purely about Gray's art and tell me whether I'm right or not – because it
needs an art critic to criticise art! But the only person writing about
Alasdair's art is the man himself: in *A Life in Pictures*. Which, as he admits
in the introduction to that book, says something.

Later the Same Day: Response to Gray's '5 Scottish Artists Retrospective Show: Five Colour Cartridges and an Introduction'

I have just found Alasdair's introduction to his '5 Scottish Artists'
exhibition of 1986 amongst my Gray files. In this piece, he presents a
retrospective of his work alongside that of Carole Gibbons, John
Connelly, Alasdair Taylor and of course Alan Fletcher. He has rarely
sounded more bitter. It's remarkable how many artists who appear to
lament the lack of opportunities for their kind are really lamenting the
lack of opportunity for themselves.

Alasdair wrote this introduction partly as a reaction to a 1985 New
Image Glasgow exhibition of four young Glasgow artists: Steven
Campbell, Peter Howson, Adrian Wiszniewski and Ken Currie.
One review of that show, by Waldemar Januszczak, referred to the
artists as the 'Glasgow Pups', and coined the phrase.[10] Despite relatively
few references to this group (which was never universally acknowl-
edged as a group at all), Alasdair opened the introduction to his own

* Since this book was completed, Lucy MacKenzie has been employed by AG to
work for him at Oran Mor.

show with a response, under the headline 'Organiser Tells Everything –
Astonishing News!': he began it with a sideswipe at this younger lot,
describing the attention New Image Glasgow received as having been
engineered by sinister-sounding 'British publicity machines'. He con-
cluded that 'painting in Glasgow is now news' and then said:

> Some local history is needed to explain why this news induces a
> mixture of anger, envy and hope in other Glasgow Artists: espe-
> cially in us old ones who grew up in The Dark Age between the
> emigration of Rennie Mackintosh in 1914 and the coming of the
> Glasgow Pups seventy years later.

That opening allowed him to begin a historical summary of art in
Scotland as Alasdair sees it, starting with the 'Golden Age' around
1900, going through 'The Dark Age' and up to the present, explaining
why it has been so hard for the five artists in Gray's exhibition. A little
80s Alasdair background partly explains why he was writing in such a
tone – unlike the Pups (who received some support in New York and
London which Gray says enabled them to return to Scotland as
'recognised' artists), Alasdair's exhibition had to be partly paid for
by selling thirty years' worth of his own personal diaries to the
National Library of Scotland, who were now interested enough in
him as a writer to want them. But the presentation of this introduction
could not have helped Alasdair and friends seem anything but out of
touch and resentful in 1986 Glasgow: the piece included subtitles such
as 'The Catastrophe' and 'A Sourer Note'; it gave the usual Gray
Riddrie background about how things were better in the old days; it
complained about the atmosphere at Glasgow Art School in the
1950s; it moaned about the decline of Clydeside and finished by
(partly) telling the story of how Alasdair funded '5 Scottish Artists',
describing the four others as 'a very important, but hardly ever visible,
part of Scottish painting' who not even current Glasgow Art School
students had heard of. But the question is, who apart from the artists
themselves and their friends consider them to be important? It's
difficult to find anyone who says so except for Edward Gage and
the academic Margery McCulloch, Ian McCulloch's wife, in her essay
about the period, 'Making it New in Glasgow'. In his '5 Scottish
Artists' introduction Alasdair described how Chris Carrell, director of
Glasgow's Third Eye Centre,[11] wanted to take his work on a Britain-

wide tour in the mid-80s but the establishment was not interested: '. . . he posted advertisements for this show to other British galleries, asking if they would like to take it [Gray's exhibition]. Hardly any answered, and those who did said, "No".'

In many ways, this introduction was classic Gray writing. He has always felt the need to contextualise whatever he is presenting, whether it be fact, fiction or exhibition. And he's always used that opportunity to put forward his political position. It's not unusual to see him take a swipe at those who hold art's purse strings. But rarely have I read anything by Alasdair with so little control over those swipes. He comes across as sarcastic, and so in turn damages his argument. A good example of this is in the acknowledgements section. Even that isn't a straight 'Thank You'. Here's a complaint about a Glasgow baillie who Alasdair appealed to for help with gallery rents:

> Many decision makers who don't say yes to a request respond with silence instead, since a refusal often offends. But I suspect the fault may have been mine. My information sheet was seven pages of factual detail and most politicians, whether local or national, have not time for a lot of reading.

Alasdair didn't want anyone to think the result of his appeal was actually his fault: he wanted readers to be appalled at the way he had been treated, to acknowledge the 'facts' as Alasdair represented them. And he wanted readers to be appalled at how Alan Fletcher, Carole Gibbons, John Connelly and Alasdair Taylor had been ignored. This is partly down to Gray's guilt over his own success contrasted with his friends', and partly out of duty to Alan, who he will always want to support. That's understandable. But the more I read this kind of writing, the more I believe Alasdair's ongoing crusade is really not about the art at all, but about holding on to the past. If the art was really that good – despite all the setbacks Alasdair describes – would it not have been noticed by now?

3 1960S: MARRIAGE, FATHERHOOD, FAKE DEMISE

IN BETWEEN WHILES

The beginning of the sixties was a strange time. Alasdair was working on several big projects but had little prospect of getting paid for them; he was young but in some ways already felt old and bruised; he was known to be talented, but kept being told it was impossible to succeed as an artist in Scotland. Alexander and Amy Gray had been concerned when their son said he wanted to create luxury items for a living, and Alasdair has since admitted: 'They were right to be worried.'[1] A passage in *Lanark* has Thaw's friend Coulter saying it was unlikely that good art should appear from out of Glasgow because artists were expected to be artistic in their spare time, which is what Alasdair was doing in 1960, painting outside teaching hours. In January of that year he had already been working on Book One of *Lanark* for eight years and had been out of art school for three. It was seven New Year's Eves since he and Bob Kitts had decided they were geniuses. At twenty-six he was paying the bills by teaching art in a new job at Wellshot Secondary School.

With his difficulty communicating, nervous manner and instinct to want everything done his way regardless of time constraints, Alasdair disliked teaching, especially the responsibilities that came with the job — paperwork, organisation, disciplining children. It reminded him of his own frustrations at school, and he kept giving it up, but each time he ran out of money he needed to go back to it. He usually stopped teaching after receiving a commission, but often these were not enough to live off, so he had reluctantly to return to the classroom. And, meanwhile, Greenhead Church remained unfinished. He was still spending nights there. Alasdair remembers: 'I always preferred to sleep on the premises — at Greenhead Church, I was quite comfy. I slept in the foetal position, and had a foot-warmer curling round me.'[2]

Several exhibitions of Alasdair's paintings took place in 1960 — one with art school friend Malcolm Hood in May — but there were few sales and still no momentum to the shows. They were not well received by the critics in Scotland either. Alasdair has kept a record of a particularly

bad review of the exhibition with Malcolm that appeared in the *Herald*. The reviewer, acknowledged as C.O.,[3] said the following. Italics represent what Alasdair underlined in the copy he kept:

> Having made the necessary effort to overlook a most untidy and unattractive presentation, I find the wall filled by the work of Alisdair [sic] Gray unsatisfying. Here and there I think I can faintly glimpse what he might be capable of – the almost oriental restraint of 'Girl at Table' and the *sensitive* drawing of the arms and hands of 'Carole'[4] – but, for the most part, I find him *curiously lacking in what surely must be a necessary, even primary, attribute in a painter of murals – a strong and rhythmic sense of design.* His print 'Tam O'Shanter' illustrates this.

Malcolm Hood got no better reception. There were at least a couple of good reviews elsewhere[5] and one letter of objection to the above criticism, which was printed in the *Herald* on 20 May 1960. Lamenting a 'remarkable lack of insight' on the part of the reviewer, the four signatories call Alasdair 'one of the most original and inventive minds in Scottish painting today'. This letter was sent by Alasdair's friends. But it was not enough good or bad exposure to buy further attention.

In the same year Alasdair went to Milan with Alan Fletcher's mother to help arrange his friend's tombstone. Around this time he was finishing off his story 'The Answer',[6] one of his saddest, showing how Alan's death affected Alasdair's writing even when it didn't refer directly to it – because it affected the way he looked at the world. It was no longer a place where young artist friends could hope for a bright future together; each person was alone. In 'The Answer' a man phones his girlfriend and she goes silent when she realises it is him on the other end of the line. He visits her and she hides. When he finally forces his way into her house, she finishes their relationship. Afterwards the man goes to a friend to explain what's happened and in the course of the conversation talks himself into believing the woman has been kind to him. He muses on the meaning of rejected love and concludes that his feelings will probably fade. The friend, hearing this emotional outpouring, falls asleep. In the context of the book in which it finally appeared, *Lean Tales*, it just seems like one negative piece among varied material. But alone it shows up Alasdair's defeatist state of mind at the time.

This was also partly as a result of Alasdair's lack of romantic success. He had many female friends – the likes of Katy Gardiner, Eleanor Hind,

Carole Gibbons – but mostly these people were already in relationships of their own. Then there were others like Margaret Gray (no relation, later Margaret Bhutani), a friend Alasdair got to know in the mid-1950s. Though the relationship was a close one – Margaret typed some of Alasdair's early work for him – it was never a possibility that it might become romantic. Margaret was a popular, attractive woman who would later be portrayed as Rima, the main female lead in *Lanark*. She remembers:

> Alasdair was unlike the others and I loved his conversation, his knowledge, his mind. We became friends, wrote letters often, shared our diaries. I had no thought of a physical relationship and he did not have confidence there so although the friendship was most intimate there was no physical contact. We met, we read our writing, we examined and analysed my relationships and character. I guess, I was very self-absorbed and of course flattered.[7]

There is clearly affection here, and respect, and admiration, but also a suggestion that Alasdair may have wanted more from the relationship: this is borne out by Rima's prominent role in *Lanark*; she does not feel as strongly for Lanark as he does for her. This has never led to a break in the friendship between Alasdair and Margaret, even when both have been married, but it is clear that in the late 1950s and early 1960s Alasdair was quietly falling for girls who were attracted by his mind, but not his body.

Alasdair was struggling in the world of school teaching, particularly as he was spending much of his out-of-school time working at Greenhead Church, which made it harder for him to stay alert all day. George Swan remembers:

> [Alasdair] was working as an Art teacher in a Glasgow School. Each day the teacher had a free period, presumably to sort out various ideas or whatever. Alasdair, however, had a plan of his own for his free period. He locked the classroom door, switched on his alarm clock and settled down on the floor for a nap. This worked well until one day he failed to hear his alarm or the period bell. The kids couldn't get into the classroom. Consternation! The headmaster was called, emergency keys used to open the door and there was Alasdair still asleep. I don't think I need to tell you what happened after that![8]

George Swan alludes here to the fact that Alasdair did not last in that particular job, but there were others, and he had to get used to the teaching. Later in 1960 he took an art teacher's job at Riverside Secondary on the banks of the Clyde, near Celtic Park, where he met a lifelong friend: Rosemary Singleton (later Hobsbaum) was teaching English in the same school and sometimes they got the bus into work together. It was a long journey so there was plenty of time for talking. Rosemary remembers her early impressions:

> He was an exotic figure – he was working on the mural in the Bridgeton church at that time – in a rough neighbourhood. He was often there all night and sometimes looked quite ill in the mornings. He really did look like how you imagine a nineteenth-century Parisian figure, the stereotype people have of that. He was living such an eccentric lifestyle but he managed to cope amazingly well. Apart from when it came to money. He was pathologically careless with money.[9]

This description of the penniless, eccentric bohemian burning the candle at both ends, put together with George Swan's memories of sleeping on the job and Alasdair's lack of enthusiasm, suggest that he was a bad teacher. But Rosemary says he did focus on it, and certainly did his best for the students:

> Yes, he found the teaching very difficult, but he was interested in getting good work from the children. His mind was on his artwork sometimes, but he didn't neglect them. They liked him – he had a brilliant sense of humour . . . When he told the students to be quiet he said: 'No FARTING above a whisper!' Very loud. He wasn't much of an authority figure . . .[10]

It was tough to balance commitments, but the image of Alasdair stumbling absentmindedly through his teaching life, improvising from class to class, is not absolutely true. He would certainly rather have been at Greenhead during school hours, but at least he was teaching something he cared about.

In the early 1960s Alasdair became increasingly involved with local peace movements and anti-nuclear campaigns. He had been a member of CND since 1958, and in 1961 he joined the 'Count Down'

exhibition in the McLellan Galleries alongside Carole Gibbons and Ian McCulloch. The now-defunct newspaper the *Daily Herald* covered the event, which was sponsored by the Glasgow Council for Nuclear Disarmament. Under the headline 'Artists Wage War on War', the paper proclaimed: 'In a frenzy of oils and garbage they produced a slashing indictment against nuclear weapons. Every painting illustrated the horror of atomic warfare.'[11] The piece was printed next to a large photograph of Alasdair at the top of a ladder in shirt and waistcoat, large rag in his left hand, finishing off the biggest piece on show – his intricate, nightmarish 'Homage to Polaris'. Even his paintings, those small enough to be presented in galleries, were very large – closer to murals. Alasdair's biblical scenes and portraits of friends had little in common with the other, more experimental pieces on show, pieces like 'War', an aluminium foil montage, or 'Epitaph', which was made from a fireguard, flattened kitchen basin, bed springs, barrel hoops and tin cans.

FESTIVAL LATE AND
THE BEGINNING OF INGE

Shortly before the 1961 summer holidays Alasdair made what proved to be a crucial decision – he gave up his teaching job and temporarily moved to Edinburgh, getting involved in a Festival Fringe Cabaret Club organised by his friend Brian Smith. Nowadays the Edinburgh Fringe is a part of one of the world's largest festivals, with hundreds of events on all day and night. The festival was much smaller then and there were only a couple of places open after ten o'clock in the evening. One of those was a popular folk club called The Howff, which hosted singers of the day like Bert Jansch; the other was Festival Late, where many people moved on to after The Howff closed for the night. Carl MacDougall, who met Alasdair at Festival Late through a mutual friend, remembers: 'Everything was going on there. People queued around the block to get in – acts from different shows in the Festival would appear, there were bands. It was always very busy.'[12] This summer's events were fictionalised in *1982, Janine*[13] with a large part telling the story of an unlikely company of idealistic, left-wing theatre folk putting on a show in 1960s Edinburgh. In reality Alasdair was actually one of the singing performers as well as the scene painter –

this depiction has much of the flavour of that heady summer of freedom and excitement. Alasdair remembers:

> Brian Smith, secretary of Scottish CND, leased a soon-to-be-demol-
> ished ancient building in West Bow, Edinburgh, and ran it as a CND
> nightclub called Festival Late, with a staff of helpers paid irregularly
> out of the door takings. I painted murals in black and gold on the
> whitewashed walls of the main dance room, and did a variety of
> cabaret turns (a lecture on how to build your own rhinoceros, and
> singing melodramatic sentimental and patriotic Victorian ballads).[14]

The songs were boomed out with gusto, as was the rhinoceros lecture: that has been recorded on a black-and-white photograph that shows Alasdair all dressed up, acting proud and ridiculous, extending his right hand and holding out a fake sword. These 'daft wee lectures'[15] went well enough for him briefly to consider a career as vaudeville comedian, developing a number of absurdist pieces, including one about dinosaurs that used to live in Glasgow's River Clyde, based on sketches he wrote at school.

During the Festival, Alasdair met an eighteen-year-old Danish nurse called Inge Sorensen while he was going from table to table in Festival Late, sketching people on the spot.* Inge was keen to fit in with the Festival Late crowd. According to Alasdair's friends, Inge thought the 1961-era Gray a rather glamorous species, and though his act flopped badly on some nights he may have looked like a man on the rise. Later she might regret thinking so, but if that was her impression it was an understandable one. Firstly, she was much younger than Alasdair. Secondly, Alasdair was now not only an ambitious painter, but a writer and an alternative comedy performer, too – Eleanor Hind described him as 'very much as striking in appearance as he is now', only 'in a younger body so more likely to stand out in a crowd'. Carl MacDougall remembers his first impressions: 'He was an endearing combination of gregariousness and shyness. He was very outgoing in some ways but he was very reticent to speak

* In a work session with RG on 15/4/08, AG claimed he was sketching in a notebook
(since lost) he donated to Brian Smith after the Festival. AG: 'I was sketching Inge
and I discovered I had an erection! Now, art and erections don't usually go together
well . . . I knew there was, ahem, SOMETHING GOING ON HERE!' Perhaps AG
was attracted to Inge because she was the 'flamboyantly alien' woman he had been
looking for since Ann Weller.

too much about himself – he was much happier talking about literature. He was great conversation on a wide variety of topics, but not on a personal level.'[16] Though keen to divert attention from himself on a one-to-one basis, on stage Alasdair was every bit the performer, changing from the stumbling, stuttering, scratching Gray to the confident man who could bound about the stage, totally in character, as soon as the lights went up. Which must have been impressive to a young Danish girl who'd never seen anything like the Edinburgh Festival before.

Accounts of Inge's approach tell a story of a woman determined to get her man, and of a man succumbing to her advances without a great deal of considered thought. According to friends who saw them at Festival Late, he was besotted with her. This was was understandable. When they met, Alasdair was frequently plagued by asthma and eczema, obsessed with his sexual unattractiveness and – after a series of failed (or entirely imagined) brief romantic fascinations – convinced that he'd made a pact with God that exchanged artistic talent for any possibility of love. He has said: 'He'd let me imagine, write and paint what I wished, as long as I couldn't have anything else I wanted.'[17] So he was pleased to find he was wrong, and God seemed to be giving him a break. There was little physical element to this new relationship, though. Indeed, one of Inge's conditions of intercourse was marriage.

Their courtship was therefore brief. Inge and Alasdair spent one weekend together, and then Inge made it clear on their second weekend that there would not be a third without a proposal. When Alasdair left his teaching post at Riverside Secondary School at the beginning of the summer of 1961 he was a single man with no ties and no romantic prospects. A couple of months later he was engaged to someone he hardly knew. And he already had doubts, especially after their first major argument. The way Alasdair remembers it now, it was so serious that both wondered whether it was a good idea to continue with the wedding at all: but then presents began to arrive, and they didn't want to send them back, so they went ahead. (When AG explained this to me, I asked if he really made such a big life decision because of worries over the etiquette of present-giving. He said, with a baffled expression, 'I must have been mad!'[18]) Much to the irritation of a majority of Alasdair's friends, some of whom thought Inge a devious sort, looking to attach herself to someone promising, Alasdair and Inge married on 3 November 1961:

MARRIAGE CERTIFICATE: Alasdair Gray, 26 years, Mural Painter and son of Alexander Gray, Publicity Officer, and Amy Gray (deceased) weds Inge Sorensen, Nurse, aged 18: she being the daughter of Marius Wilhelm Sorensen, Market Gardener, and Gudrun M.S. Hansen: both resident at 11 Findhorn Street, district of Provan.

Alasdair claims he didn't even know his bride's age when they got married – it was news to him when they signed on the dotted line. But when asked, he does not provide that detail with any regret: he just talks as if it was not important, and it had not occurred to him to ask. They honeymooned jointly in a friend's cottage on the Isle of Arran, the place where he had spent childhood summers, along with other friends Ian and Frances McIlhenny. According to Alasdair the newly-weds did not have sex during the holiday: by the time they returned, it was clear not all was well.

After the honeymoon Inge went on a month-long family visit to Denmark, telling Alasdair that unless he found them a new place to live she would not be returning. (Alasdair still lived at home with his father.) On her return the newlyweds moved into a cheap new home at 158 Hill Street, leaving Alasdair's dad behind. This upset Alasdair, and even before they moved he felt regret for the change to come. Meanwhile, Inge struggled to get on with her new husband, and suspected he was not about to make the glorious expected breakthrough that had recently seemed possible. Alasdair remembers:

> After Festival Late, I thought to myself – *I am now a famous and established man! I must now be able to make some kind of living . . .* I soon realised this was going to be more difficult than expected, and I thought, *Oh fuck!*[19]

A number of factors conspired against the newlyweds in this period, making the early days difficult: for example, a key mural commission fell through and Alasdair had to return to teaching (again) just as he thought he'd be able to give it up (again). As early as March 1962 Alasdair was writing in his personal notebooks about his despair over work, his marriage and his health:

> I crouch here by this fire, the time between one and two at night, in great dryness of the heart, with little confidence in myself as an

artist. I have dealt in no artistic activity since I married. I teach full time. I no longer handle the machinery that brings me the rich experiences. The will has crumbled. Without sufficient access to a surface to impose the form of a painting on I am without interior form. I contain the crumbling parts of an artist. My work, like an iron mould holds me in the shape of a teacher.[20]

As he says in this extract, all artwork, including Greenhead Church, had stopped by now; there was no time for it. It wasn't practical for a married man to be working all hours for no money. The enthusiasm of the Bridgeton congregation for the project had long since been exhausted anyway (they had not expected it to take so long), and Alasdair now believed his great work had come to nothing. But this self-pity is still curious for a newly married man: it led him to turn inwards – his skin condition became his focus, and in the following section from his diaries he described the beginnings of what became dragonhide[21] in *Lanark*, the skin condition which the poet Iain Crichton Smith described as 'the symbol for the absence of love'.[22] Alasdair wrote in his diaries:

Eczema breaks the skin surface of the cheeks, wrists, arms and backs of hands. I brood for half-hours or more, on these half-dead bark-like not human-looking surfaces, brooding, relating them to my 'Journey In' fantasy, filing some surfaces with all four nails at once; fastidiously picking and plucking off, prising up the plaques of dead scab, distilling dust from my flesh with quick fingertips.[23]

Alasdair was tired of the condition; it was all-consuming, exhausting, depressing. Many sections of his diaries refer, directly or indirectly, to a void in his life. His marriage was already struggling and he lamented his lack of artistic opportunity, too, describing self-harm as 'the only wholly self-centred activity open to me'. This diary section finishes with a yet more frantic plea:

I cannot pray to God with a full heart: but half-prayers may sometimes get an answer. Allow a return to the ardour of creation. Make my ardour for my wife depend on this. HELP ME INGE, not as I appeal to God but as I would appeal to a friend.[24]

Even at this early stage Alasdair is complaining of that fact that he has to look up to his young bride, as a man looks up to God – but he doesn't explain whether this is because she insists upon it or because he knows no other way of behaving with women. He may want to appeal to her as he would to a friend, but doesn't know how. Also, it is interesting that in this passage Alasdair prayed for 'a return to the ardour of creation'. Often, even when discussing relationship problems, his first thought was for his art.

From the accounts of Alasdair's friends and acquaintances, Inge comes across very negatively. When I raised her name in interviews with those who care about Alasdair the most, some struggled to control their fury – many had stories to tell of selfish behaviour which, they said, was often designed specifically to anger or humiliate Alasdair. Even in the portraits that Alasdair did of her during the early parts of their marriage her face is always portrayed in a surly, disapproving expression, as if she is struggling to control her contempt for him. But perhaps we should be charitable to a young girl living abroad, who may have married hastily, and then become frustrated with her depressed new husband's lack of ability to communicate or provide for her in the way she needed. It certainly must have been an unstable existence; the life of the struggling artist does not leave much space for pleasure, or offer a hopeful future. Sadly, Inge died in 2000 so it is not now possible to get both sides of what this marriage was like to be in, but certain details are undisputed, and we can at least know how Alasdair felt about it.

The most striking of these details is that it seems to have been public knowledge from early on in the partnership that Inge was unhappy with Alasdair, and was looking outside her marriage for the kind of attention she felt she was not getting from her husband. Indeed, relations between the two were so poor that on several occasions in the early 1960s Inge complained about Alasdair in public. Two old friends describe how at one party, with more than twenty people in the room, she waited until things went quiet, turned to someone next to her and said at the top of her voice, to the horror of a roomful of Alasdair's friends, 'Of course, Alasdair's *awful* in bed!' It makes sense that someone so young (eight years younger than her husband), living abroad, might sometimes demand attention or behave childishly – even desire others, given how young she married – but I could not help but feel that this one-sided view of Inge was too extreme to be believable. Given the protective instinct of many of Alasdair's friends, they may well have

disapproved of whoever came and took him away from them, especially someone from such a different background. Also, they may have been alarmed by the suddenness of developments, though Alasdair and Inge themselves thought there was nothing that unusual or even noteworthy about their short courtship. Either way, would Alasdair, insecure as he was, really marry simply because he could, and then remain in his marriage out of duty, even when it was obvious that it had been a mistake? Or was he really in love? Evidence of their love is hard to find.

Alasdair's records give the impression that the relationship was in freefall from the moment they signed their names on the marriage certificate. The imagery in his poem 'Married' is ominous:

> With gravity that holds all possible love
> a king and queen go gravely side by side.
> His fists are lightly clenched beside his thighs:
> she presses his shoulder and she holds his wrist
> like a strong mother guiding her son's feet,
> like a meek daughter clinging to her guide.[25]

There's a strange solemnity here. The 'possible love' referred to seems to have little chance of survival; the image of Alasdair with 'fists clenched beside his thighs' and Inge pressing his shoulder and holding his fist suggests nervousness, tension, a lack of willingness to go through with the marriage. Inge is portrayed as being desperately dependent on Alasdair, a 'meek daughter clinging to her guide' but is also 'a strong mother guiding her son's feet'. This is a relationship only ever portrayed with either 'king' or 'queen' in a parental role: it has no sexuality in it – it is never an equal relationship between two adults. The poem continues:

> The sculptor only noticed in these two
> the things a couple feel when most alone:
> the solitude of being me and you –
> two feeling hearts in towers of rocking bone.
> Not sad to live they advance without fear
> to an end they cannot see.[26]

The 'two feeling hearts in towers of rocking bone' are shown to be utterly separate from each other in this part of the poem: Alasdair writes about 'the solitude of being me and you' on the one day when he

might be expected not to feel lonely. The couple do 'advance without fear', but that lack of fear soon becomes a very real one. In the next poem of the sequence, 'Mishap', the first verse is:

> The tide ebbed before flowing strongly,
> the moon waned before it seemed a globe,
> the sun began setting an hour before noon
> and the loved woman was loved wrongly.[27]

The use of the words 'ebbed', 'waned' and 'setting' in a poem called 'Mishap' surely have sexual connotations. The couple's sex life was troubled from the start, and these lines suggest either poor performance and/or premature ejaculation on their first night together. Alasdair loved his new wife, but not in the way she wanted to be loved. This is a strong indicator for the rest of the relationship. He can attempt love clumsily; she cannot accept it or give back:

> There is no excuse for this and can be none.
> Soft pricks won't be stiffened by verbal alloy.
> But the man resorts to words out of old habit.
> The woman has only rage for what she did not enjoy.[28]

It is clear from this section, which is even more explicit about the husband's sexual performance, that the marriage was in danger of collapsing right at the beginning. Alasdair responded by ignoring the situation, returning to what he knew and loved best – the 'words' referred to here being his art.

In 1962 Alasdair managed to get some work as a scene painter for Glasgow's Pavilion Theatre. (Sometimes show organisers let him take home bits of costumes nobody wanted after productions had finished – on occasion he was spotted wearing strange clothes on his way home from work.) At this time, Alasdair became friendly with John Connelly, an artist who was working for a company who shared the same back court as the Pavilion. He did a painting of Alasdair which showed him in this period,[29] and it portrays him very differently from the man of today: lean, confident, almost swaggering. He has a full shock of brown hair, wears a jacket and green pullover, and has a thin little pencil moustache. He looks rather dashing. Connelly showed his friend sympathetically, but the picture is an interesting indicator of how his developing group of friends

perceived him – quite differently from his wife. After the Pavilion Alasdair then moved on to do scene-painting work at the Citizens' Theatre for a season. That work became even more important when he discovered in spring 1963 that Inge was pregnant.

REJECTION, AND THE BEGINNING OF ANDREW

Inge's pregnancy may go some way to explaining why Alasdair chose this moment finally to send off Book One of *Lanark*, at that time called *Thaw*, to Curtis Brown literary agency in London, with a view to delivering three other foreseen books later, as part of a series. It was refused and Alasdair has never forgotten it. A search through the Gray archives uncovered the actual letter, dated 6 August 1963, complete with returned manuscript and rebuttal of the author's assertions that there was something particularly worth documenting about Glasgow, which he refers to as a 'provincial town'. Most writers hold one rejection dear. This is Alasdair's:

Dear Mr. Gray,

Dorothy Daly passed to me your novel THAW. She told me that she thought you had a gift of writing and I agree with her. However, I very much agree with the remarks you yourself made in your letter about the book. It is just another of those books about the sensitive author when young, going through to tormented adolescence. Unfortunately I am not sure that I agree with you that the personalities and the period dealt with are unlike those in similar books. Every young man I have read about seems to me exactly the same and I am not convinced that Glasgow in the last 20 years is all that different from Manchester in the last 20 years, or Wolverhampton in the last 20 years, or indeed any other provincial town in the last 20 years. I am sorry that we cannot help you with the book, but I really believe no publisher would take on yet another self-exploration.

I do hope that you may hit on a theme which is creative rather than merely recollective, and should you do so, I'd be very happy to read it.

Yours Sincerely,
Spencer Curtis Brown

My first reaction on reading this was that Alasdair was lucky not to get
the kind of mass-photocopied one-liner that twenty-first-century aspir-
ing writers have to put up with, but this letter does contain some harsh
criticism. The letter hit Alasdair particularly hard because it came in a
year when he was going from supporting and being responsible for only
himself to supporting three people – a new wife who didn't appear to
like him very much, and a child on the way. On 4 September 1963 Inge
gave birth to a son, Andrew Gray. But even the issue of what to put on
the birth certificate was a disputed one, with Alasdair trying to give
Andrew his father's middle name – Alexander. On hearing this, Inge
suggested a change to 'Andrew Alexander Wilhelm Gray', including his
father's name too. But that was considered too ponderous. So (the way
Andrew tells the story), Alasdair went back to the Registry and removed
it: now Andrew has no middle name. One thing Alasdair *was* in control
of was how he described himself on the birth certificate: a 'scenic artist'.

Andrew's birth did not have a positive effect on the state of his
parents' marriage. Around this time several revealing poems were
written, and the one addressed to his son seems the bleakest of all.
'To Andrew, Before One' describes home miserably:

> 'You shall not' makes him know he is not God,
> dividing think from feel and dream from do,
> creating adjectives like good and bad,
> pronouns like you and me and mine and those,
> till home is a place minced into tiny words,
> the spoon is a place no longer his
> and food the bait of an enormous trap
> he hardly will accept as universe.[30]

Gray writes of Andrew drinking from his mother's breast, waving a
spoon, at one with himself and the world, but the description is made
tragic. As Andrew begins to learn about the world around him, and
about the language used to describe it, 'home is a place minced into tiny
words': he learns he 'is not God', so learns he is powerless.

Though he always used his own experience for inspiration, poetry was
the artistic form Alasdair used most explicitly to discuss his personal life,
without the masks of characterisation. In these poems, the central
character is simply the poet; the others portrayed are the poet's family.
This makes them a useful portal into Alasdair's thoughts at this time. In

the early 1960s, he began to have some of his poems published in small magazines.[31] But this was not the beginning of a bigger poetic career. Once again, Alasdair had no work at all. The mural at Greenhead Church was finally finished, but, being so late, and unpaid, it provided little satisfaction. Alasdair could now see how unlikely it was that painting a ceiling in an East Glasgow church – no matter how grand – might bring him much attention. Soon after the church was demolished, to make way for a new road and soon after Andrew's birth the work as a scene painter came to an end. Alasdair found himself drawing social security as an *unemployed* scene painter soon after the above poems were written. But 1964 was better.

UNDER THE HELMET

In the year after Andrew's birth Alasdair went from being an un-employed scene painter to being the subject of a BBC documentary with a few pounds in his pocket to finance exhibitions. *Under the Helmet* was conceived and directed by the same man who had declared Alasdair (and himself) geniuses back at art school – Bob Kitts. It was produced by Huw Weldon and occurred because Kitts was 'in a position to make films about anyone he liked and decided to make them about obscure friends who he felt OUGHT to be famous. So he made one about me. I was living on social security at the time and got a telegram saying "PHONE BBC. REVERSE CHARGES".'[32] The timing and cir-cumstances were fortunate. Not only could Alasdair not afford to travel to London for a meeting, he initially said he couldn't make the meeting because it fell on a Thursday and that was the day he had to sign on. So it was lucky the documentary maker was his friend. Bob Kitts ensured Alasdair was picked up, dropped off and didn't have to pay for anything along the way, allowing him briefly to enjoy 'the huge social derange-ment of being made to feel rich and famous'.[33] It was shortly after this that the idea came to him for *The Fall of the Kelvin Walker*, a story of a poor young naïve Scot going to London to seek his fortune.

It is hard to imagine a programme like *Under the Helmet* being commissioned today, despite the many specialist channels on offer that did not exist in the 1960s. By modern standards it is extremely slow-paced, with some very dry appraisals of Alasdair's work presented alongside stiff interviews and very lengthy sections where a camera

simply pans across Gray's Greenhead Church mural to the accompani-
ment of background music, or the recital of Alasdair's early poetry. In
1964 viewers of BBC programmes like this had little else to choose
from for evening entertainment, but little effort was made to gently
bring viewers into Alasdair's world. On the contrary, *Under the Helmet*
was presented as strangely as any of his wildest fictions, providing an
early showcase for his desire to make people question their preconcep-
tions of the very basics of digesting any art – in this case, through their
televisions. The programme opened with Gray talking directly to the
camera, saying 'What you are about to watch is lies.' Then some of
Alasdair's works were shown in an exhibition space, being analysed by
experts. But that was not all.

The real idea for this project was quietly to suggest to the viewer that
the artist in question was dead. A white lie, yes, but considered a necessary
one if an unknown Scottish artist was to garner any serious attention at all.
Only by seeming to unearth the great works of a lost, tragic figure could a
director of an art-related documentary hope to create a fuss. So the music
was funereal, interviews with friends conducted seriously – as if they were
remembering a lost talent – and when Alasdair's family home was filmed
it was done with a camera gliding slowly from empty room to empty
room – the suggestion being, this is where Alasdair Gray *used to live. When
he was alive.* At the end of the documentary, viewers saw something even
stranger: as the 'dead Alasdair Gray' programme ended, the camera
panned back to show Alasdair standing in an editing suite alongside the
programme makers, watching many screens of his face, discussing
whether what they have just done (i.e. trick people into thinking that
Gray is dead) was unfair. This kind of thing was uncommon in 1964 but
viewing figures were respectable. The likes of Rosemary Singleton, who
gave a short interview for the programme, were stopped in the street for
weeks afterwards by people wanting to discuss her cameo. And the
money that *Under the Helmet* brought in allowed Alasdair to (once again)
become an employed artist and writer.

In the wake of *Under the Helmet*, Alasdair continued to behave like a
living person: being seen in the usual pubs, talking, moving, that kind
of thing – inappropriate behaviour for a dead man – which some friends
commented upon. So he wrote a letter to the *Herald* entitled 'An
Apology for my Recent Death'. It was refused publication on the
grounds that the editor in question, David Hogarth, an old school
friend, was afraid of accusations of libel, and explained that there was no

way it could go in the paper. So Gray had to continue to be dead. Fears that this would inhibit his being alive were premature, though. The documentary might have received some favourable attention, but not enough for anyone really important to question the physical state of the subject. In the wake of the programme Alasdair went on to get *The Fall of Kelvin Walker* commissioned for the BBC and nobody raised an eyebrow. Seven one-man exhibitions of his art appeared at the Edinburgh Traverse and Glasgow Kelly galleries. Also, he did the first of a series of jobs for Glasgow University, lecturing on art appreciation. (No doubt his deadness helped convey a sense of inevitable tragedy to his students.) Alasdair remembers that familiar hopeful feeling: 'After the broadcast of *Under the Helmet* I thought, *I am now a famous person. I will have no difficulty making money now! Haha!* But it made no difference really.'[34]

1964 also saw Alasdair teaching for a term at his old home, Glasgow School of Art. He approached them in the hope of earning money as a part-time life-drawing teacher – as he has admitted, he didn't have the understanding of colour to be a teacher of painting, so it was his only option. They did employ him, but he soon discovered that he was not really there to teach art at all. *Under the Helmet* had lately been on TV, but despite his recently broadcast artwork, they asked him to teach on a new course which included *writing*. He said:

> On my first lesson, I instructed the students to write a piece called 'Who I Am and Why I Came to Glasgow School of Art'. Of course, most of them didnae want to be writing, and said so! But nevertheless, some of the things they wrote were good, even when complaining about the task . . . On the second lesson, I told the students that if anyone thought they had anything better to be doing, I would mark them present and they could leave. Three of the most intelligent got up and went. Perhaps I was not a very good teacher . . .[35]

After a single term the art school suggested they might be better to call on Alasdair if and when they needed him, for individual classes. He agreed. But they only called on him once. Only years later did he discover that after his dismissal Alasdair Taylor had written an angry letter to the art school complaining of their treatment of his friend – and that might have had something to do with why he wasn't asked again.

From here he went into another teaching job. Gray wrote in his diaries: '[Alasdair] now teaches full-time in Sir John Maxwell school, and has bad eczema, and feels miserable because he seems unable to be an artist, now.'[36]

This indicates more about Alasdair's state of mind than the reality: in 1964 he created what has become one of his most well-known paintings, 'Cowcaddens in the Fifties', a large landscape with figures, which depicted the old disappearing Glasgow he wanted so much to record. This would later become a jacket for an edition of *Lanark*. Also during this period Alasdair was commissioned to paint the ceiling of Glasgow's Crosshill Synagogue, a low, almost hut-like building standing next to a much bigger church. After much nervous committee consultation, it was decided he should only paint clouds – the finished product made for an imposing swirl of white and shades of grey, cascading above a large Star of David, creating a powerful, dizzying effect, particularly because of the enclosed nature of the space.

SEPARATION AND WORK

In 1965 one of Inge's affairs led to their first separation, with Andrew being taken with Inge to the home of a not-very-close friend of Alasdair's, a potter by trade. It was no surprise. In recent months, Inge had taken to leaving the house after Andrew had gone to bed and returning from her lovers before he rose in the morning. Alasdair's response to his wife leaving him was not to get angry but to plead with her to return. When she refused, he told her he would keep space in their home free for them to come back to whenever they liked, whether Inge wanted to renew her relationship with Alasdair or not. But friends and family were already urging him to move on: 'When Inge left me, my father persuaded me to let the other rooms in the flat to lodgers to provide me with a steady source of income. He said, "Right, now concentrate on making yourself as good as Picasso!" I did let the rooms, but I was miserable. Katy Gardiner thought I burgeoned in her absence but I desperately wanted her to return.'[37] Tellingly, it was only when Alasdair ran out of money and told Inge he had no option but to rent out the final spare room (to a female university student) that Inge returned to him.

Alasdair immersed himself in writing and painting. He entered a furiously hard-working period in which he made the beginning of works

which would appear decades later: as well as working on *The Fall of Kelvin Walker* he also wrote a play called *Agnes Belfrage* and produced the earliest version of one called *A History Maker* – another example of just how much writing he did in these first years of marriage and fatherhood. Also, some of Alasdair's friendships were breaking down, with many friends having poor relationships with Inge. This certainly affected George Swan and several others. Rosemary Hobsbaum remembers:

> Our friendship tapered out for a while, gradually, during his marriage – Inge put a wedge between Alasdair and quite a few of his friends. She was a difficult, strong personality – her whole agenda, she certainly made it so you felt awkward. In some ways she slightly despised Alasdair, it was like a game with her. Several of Alasdair's friendships petered out during that period.[38]

But not everything was gloomy in the mid-1960s. Until recently Alasdair didn't know anyone who had successfully published anything of note – which made publication seem like a far-off dream. But Alasdair's friendship with Archie and Eleanor Hind had remained strong, and in 1966 Archie's novel *The Dear Green Place*, a book about a working-class Glaswegian struggling to get by and dreaming of becoming a writer, was published. Alasdair saw it was possible to create in Glasgow and be published; *The Dear Green Place* was a fine book which received many plaudits on publication,[39] even impressing the notoriously hard-to-please Hugh MacDiarmid, who called it 'wonderfully authentic and very searching'. This was a significant sign for Alasdair, who had written in *Lanark* that nobody imagined living in Glasgow and nobody wrote about it. Not any more!

In the same year as Archie's breakthrough, Alasdair became a playwright for both radio and television, a form he knew little about. He certainly wanted to write plays but had been working on *Lanark* for fifteen years by this point, did not own a television set (never mind spend time *watching* one) and could not have expected a career as a BBC playwright to overtake both artistic work and novel-writing so rapidly. It was a time of great opportunity for artists developing a reputation in television writing, then an exciting new medium with a great deal of additional television hours waiting to be filled. Many good writers were throwing their hats into the ring. And they were writing to commission, something Alasdair had not thought himself capable of, until it

was his only option. To his surprise, he found he could do it: *The Fall of Kelvin Walker* was the first broadcast piece he wrote. Though it wasn't actually broadcast until 1968 he was writing it in the mid-sixties, and in 1967 it was performed by the art school's drama society. This is arguably one of Alasdair's strongest works, and was later successfully turned into a novel. It is worth taking a closer look at.

THE FALL OF KELVIN WALKER

The Fall of Kelvin Walker has its roots in the Scottish tradition of stories about the 'lad o' pairts' (smart young man of promise) who leaves his home village to seek his fortune elsewhere. Before the turn of the twentieth century these popular, escapist novels came most famously from the pen of writers like J. M. Barrie (writing as 'Gavin Ogilvy' early in his career) and John Watson (writing as 'Ian McLaren'), and were sometimes referred to as the 'Kailyard' school. George Douglas Brown's 1901 masterwork *The House With the Green Shutters*, one of Gray's favourite books, was widely seen as an attack on these Kailyard writers, who were criticised for portraying Scotland in an overly sentimental, romantic way. In contrast, Brown portrayed Scottish villages as inward-looking centres of gossip, fear and superstition. *The Fall of Kelvin Walker* is certainly inspired by *The House With the Green Shutters*, following our hero Kelvin from the small Scottish town of Glaik to London at the opening of the novel. Having left his father's grocer shop the day before – the only place he has ever known – Kelvin arrives in England's capital, dazzled by its grandiosity, with dreams of making a dramatic impact there. The thought of moving to a major Scottish city had occurred to him, but he had dismissed the idea:

> Other British cities, Glasgow for example (he had seen Glasgow) had been built by money and still contained large amounts of it, but money seemed a slower substance in the north – a powerful substance, certainly, but stolid. Those owning it had not been liberated by it. Their faces were severe, their mouths as grimly clenched as those without. But here in London – had it happened a year ago or a century or many centuries? – money had accumulated to a point where it flashed into wealth, and wealth was free, swift, reckless, mercuric.[40]

So Kelvin went further afield than the lad o' pairts, beginning his search for greatness in Trafalgar Square, his head filled with the works of Nietzsche – and already Kelvin rejects the idea of God. But his naïvety is obvious from early on. He attaches himself to the first young woman he sees, Jill (a character based on Jane Mulcahy, a girlfriend of Alan Fletcher's), instructing her to take him to the most expensive restaurant she knows, but before the meal is over Kelvin finds the wealth he thought he possessed has almost gone. All the money, and more, he has come to the capital with is swallowed up by the cost of a single meal. Kelvin is humiliated on his first night and, penniless, goes back with Jill to stay at her studio flat. Jill explains to her boyfriend, Jake the artist, who her new companion is: 'He's a wee Scotch laddie just arrived in London to take us all over. He's got no money, no friends, and nowhere to stay.'[41] The locals patronise Kelvin but he's determined to succeed, despite a suffocating seriousness and no qualifications. The qualities he thinks he needs to succeed are unshakeable self-belief, eloquent polite-ness and cunning, all of which he has plenty of. Soon he leap-frogs his landlords on the social ladder. Kelvin applies for one highly paid job after another until he gets one, attending many interviews each day. Every night he returns to the hippy-style flat Jake and Jill keep, a simple one-room place they cannot afford to pay for. Jake is outgoing and affable with Kelvin, but cruel to Jill; Kelvin has already decided he will steal her away. Via a free-love-spirited one-night stand (which Jake allows), and some good old-fashioned bribery, he does exactly that.

So Kelvin succeeds in grabbing Jill, as he succeeds in grabbing everything else he came to London for – within weeks he is a highly paid, aggressive TV journalist whose conservative ideas are popular with the public. (He gets the job after an on-the-spot test proves he can act as a man of the people who asks direct questions and expects direct answers. This is exactly the kind of man the BBC are after – as long as he doesn't threaten the status quo.) After becoming violent with Jill, Jake is cast out of the flat that now belongs to Kelvin, who explains, in the most complimentary way he knows, his love for Jill. But Jill doesn't see the world the same way:

> [K] 'It's queer that something as physical as love can change our feelings about life. I thought only ideas could do that. Jill, only Colonel Ingersol and Friedrich Nietzsche have done for me what you have done.'

[J] 'I wish you didn't put everything into words, it makes them different from how they are.'[42]

As the story progresses Kelvin starts to revert to the ideas he originally rebelled against, revealing more of himself in interviews with public figures than he does about his subjects. He has always been 'a traditionalist',[43] but because his life has suddenly taken a turn for the better he begins to believe in a God – one who is stern and morally judgemental, just like the father he escaped. Kelvin proposes marriage to Jill, and (now that he's part of the Establishment and will soon be getting an audience with the Queen) insists on a church wedding. Jill doesn't understand. Kelvin explains:

> 'I never said I did not believe in God, I said I was against him. I also said that he was dead. But he came alive on the night I finally obtained you.'
> Jill covered her eyes with a hand. His mildly tuneful, careful voice went on saying things which he clearly thought were reasonable but which made her feel she was in a bad dream.[44]

The end of the play sees this kind of absolute confidence shattered by his father, in the form of a public humiliation, and (in an echo of the old Kailyard novels) Kelvin returns to his home town to preach the kind of Christianity he grew up hating.

When *The Fall of Kelvin Walker* appeared on the BBC on 22 April 1968, with Peter Copley, John Philips and Corin Redgrave in the lead parts, Alasdair held a party to celebrate. As he didn't have a television of his own he invited friends to a local shop with several screens in it owned by someone who let him use the wall space for an exhibition of his artwork – part television audience, part exhibition. During the screening, however, Inge fell ill and asked Alasdair to take her home, so he missed part of the programme. Afterwards he could not face returning alone to the party, so went to Sauchiehall Street instead:

> While drinking, I met a woman called _____, who explained she would like to sleep with me – which I wanted to do. But I told her I would need to check with my wife first. I was astonished to find that, when I spoke to Inge about this, she was furious! I could

not believe it, but I accepted her refusal, and told _____ it was not possible. I thought Inge was a terrible hypocrite. On that night I thought to myself . . . *Right, Gray, your marriage is over, you will obviously never have any love – God will not let you. You must accept that he will let you paint and write, but THAT'S ALL YOU'RE GOING TO GET!*[45]

Gray rarely invoked God, blamed God or used God to explain events, but on the rare occasions when he did so, it was usually with reference to his marriage. This did not signify a new religious belief. Alasdair just began talking to Him Upstairs whenever things got tough and he had no other way of explaining life away.

THE HILL STREET MURDER FLAT

But the marriage was not dead yet. Inge and Andrew had been back in the family home for some time, and Andrew was old enough to notice something of his surroundings. His memories of the late sixties are mostly positive. He was aware of regular, sometimes intense arguments between his parents, but that was not what defined the home for him. Andrew describes his father at this time in relation to the large six-room Hill Street flat they rented, and to Alasdair's work space, which dominated it – though he presents it now as inspiring, not irritating. Andrew was only five in 1968. He remembers:

Alasdair[46] had a very big studio room – but then, every room of Alasdair's was a studio room! . . . I remember the smell of turpentine. Every room was paint-related . . . there was a distinct rule that all paintbrushes had to be facing straight up in jars or their fibres had to be changed. I remember a huge landscape in the main room, too, a hexagonal picture, I think. He did other kinds of work, too. I was fascinated when once I found him carving things out of polystyrene – cut through heated wire . . . there was always something going on.

This flat Andrew refers to was 160 Hill Street – they had moved from number 158 to the downstairs flat next door after the landlady had been murdered by her lodger. Instead of being repelled by these events

(which had left the flat in question partially damaged by fire and in a state of disrepair), Alasdair asked the agents of the property if he could move in, giving him more creative space, and less stairs to climb. The agents agreed. Alasdair remembers the flat as palatial, airy and pleasant but Katy Gardiner, a regular visitor, remembers:

> There was a typically Alasdair mural on the wall of their first flat, but they had to leave it behind when they moved downstairs. It was a basement flat really; I remember the kitchen was in the basement, with a back door that led into the unlit cellars of everyone else on the street! I thought to myself, 'I could not live in this flat!' Most of it was empty, and there was blistered woodwork everywhere.[47]

Unfortunately the family had to move out of the second flat, too: at the end of the sixties it was demolished to make way for new roads. This meant a fight to get somewhere else, which was unlikely to be as spacious. Alasdair thought it crucial that he should have a large studio as well as bedrooms and a kitchen in their new home. (This is another example of Alasdair's perceptions being based on work, not necessarily the wellbeing of his family.) It must have made for entertaining conversation when Alasdair went to the Glasgow Housing Association and put forward his argument for needing 'essential artistic space' – they weren't very understanding – but Alasdair did have one contact he could count on. Bill Gray[48] (no relation) was on the housing board of Glasgow's City Council in the late 1960s and advised Alasdair to ask for one of the Kersland Street flats in the West End, which were about to become available. They were dirty, he said, and needed work, but once he was an occupier he would be able to ask the Council to repair it, which is what happened. The Kersland Street flat was not pretty but it was big, with a number of potential studio rooms to choose from. Alasdair came across some strange characters there. He had not embraced hippy culture during the sixties, and rarely came into contact with anyone who had, but occasionally he got a sniff of it while at Kersland Street. Pete Brown[49] was one such character, a lyricist for the rock band Cream: in 1968 they met at a party and Brown brought Alasdair to London to paint a mural he later described to the artist as 'too much man, too much'. Alasdair returned to Glasgow a few pounds richer.

A BIT OF *AGNES*

As might be expected of a writer who puts so much of his own life into his work, Alasdair's writing at this time reflected his recent experiences. Most characters in his plays from this period are trapped in situations they feel they cannot, or should not, get out of. Virtually all men are crippled with unhappiness. Many of Alasdair's frustrations surfaced as sexual tension in his plays. In *Dialogue* (broadcast on BBC Radio Scotland in 1969) a lonely, recently divorced man persuades a female stranger to go for a drink with him – soon they are talking about the sexual meanings of their dreams, and they end up on a sofa together – until the man calls out the name of his ex-wife, bringing the story to an unhappy end. His portrayals of women were developing into a type, which Alasdair has noticed and defended in interviews:

> I have a line in heroines who are tough-minded without being callous (I think), and I don't pit them against nonentities. In *Agnes Belfrage, Dialogue* . . . the sexual encounter is painful but exhilarating, the parties retreat from each other intact, perhaps having learned something useful. My characters are stoics resigned to loneliness because I think everyone is essentially that. (P.S. Stoical loneliness is only a tragic state if it has turned callous or hopeless. If it has not, then it is the best foundation for co-operation, and even love, between people of different sexes, classes or cultures.)[50]

Alasdair was right to include *Agnes Belfrage* among those tough-minded heroines. Shaun McLaughlin first commissioned the play in 1968, and the original manuscript shows how Alasdair was feeling at this point. Much the same happens as it did in Alasdair's life – a woman arrives to disrupt the relationship between father and son, and demands that the father leave the family home. Alasdair has admitted that the character of Agnes/Mavis is partly a Scottish Inge, so it is interesting to see what personality he gave her male partner, Colin, in the story. On the outside Colin, a quiet, Cambridge-educated academic who plays with models, is nothing like Alasdair. But there are similarities; for most of the novel, Colin is so pleased that Mavis is interested in him that he puts up almost no resistance to her childish, attention-seeking behaviour, even tolerating her affair. Alasdair felt that if he didn't put up with Inge's behaviour, then nobody else would put up with him, and he would end up alone. 'She got exactly

what she wanted. Always,' Alasdair told me during a 2004 session working on the new typed version of a story he eventually called *Mavis Belfrage*. 'Even some of my friends.'

In not becoming the overnight success that briefly, it seemed, might be within his grasp, perhaps Inge never forgave Alasdair. He didn't assert himself, instead allowing himself to be increasingly controlled. On the back page of the hardback version of *Mavis Belfrage*, Alasdair writes in inverted commas a key line from the narrative: 'She wanted to shake him until he came alive!' That might be about the 'living death' of teaching – which for Alasdair represented failure – or a reference to how much he felt he was limited by the marriage itself. It had been clear for some years now that Inge was not interested in Alasdair, and if not for Andrew (or the fact that she could continue her affairs without her husband objecting) she probably would have already left him for good. Meanwhile, he was usually working: as well as all the new plays, there was still time for muralling, too. 'Jonah and the Whale' and 'Black and White Earth Mother Phantasmagoria' appeared in 1968 at 10 Kelvin Drive, Glasgow (belonging to Rosemary and George Singleton – they were back in contact) and 'Falls of Clyde Landscape' appeared at the Tavern, Lanarkshire in 1969. Also, two new radio plays, *Quiet People*[51] and *The Night Off*. But Alasdair did usually work at home, and he felt Inge was an excellent wife for a struggling artist, and a good mother too.

It would have been understandable if, at some point, Alasdair had decided to give up on the idea of being a novelist. *Lanark* was still nowhere near completion, and he had received little encouragement: the only recent exposure had been two chapters from the Unthank sections, 'Mouths' and 'The Institute', printed in the little-known *Scottish International Review* in 1969–70. But still he continued. Alasdair explains how he kept going, despite family problems and a weight of other work, showing up the connection in his mind between his working and private life:

I was writing *Lanark* continually. I never gave up on it. When I received that rejection from Curtis Brown, it did not occur to me to stop writing the book. I just thought, *That shows how stupid you were, Gray, to think you could get away without finishing it.* So I tried to finish it. In 1969 or 1970, my marriage was in a very bad way and . . . *ordinary life struck me as a nightmare.* It was then I wrote 'The

Institute' chapters of Book Three of *Lanark*. The cannibalism. The dragonhide. That all seemed perfectly natural. When I was writing these hellish sections . . . it was the only time I felt quite sane and straightforward and happy![52]

An incredible amount of work got done in the wake of the Spencer Curtis Brown rejection and the crucial *Under the Helmet* documentary – they were one of his most productive times. But it was a period that coincided with the fatal deterioration of his marriage and raised questions about whether Alasdair was able both to work and maintain personal relationships. Inge's affairs continued, either because she got no attention from Alasdair or because she had by now totally rejected him – most probably a combination of the two. Eventually it became clear that there was no chance of reconciliation. Alasdair claims it was he who left, but even that detail is not entirely clear.

DIARIES: Women, Mostly

12 August 2005: Sex and Lunch
Over lunch today we discussed Alasdair's sexual history. The conversation had its origins in this morning's work – sorting through transparencies for *A Life in Pictures*, including several of women – mainly Inge and Bethsy. Today he talked happily and at length about his sexual exploits while he checked I had the spellings right. He even counted off the conquests on his fingers:

> The only four times in my life I have successfully proposed to a woman was when I was drunk: the first time was in 1961, which resulted in marriage to Inge . . . the second was two decades later, in 1981, after the publication of *Lanark*, and that resulted in an eight-year partnership with Bethsy Gray. The third was with Mary Carswell Doyle,[1] now deceased, in the seventies sometime. Ha! Only three in and I've got them the wrong way round! Anyway, she was number three – *and number four was Morag – in 1989.*

He was very cheerful today, full of energy. We parted ways with me thinking that Alasdair was in good health, benefiting greatly from having taken several full weeks off from work. He told me of his immediate plans

for a short holiday with his son Andrew, daughter-in-law Libby and granddaughter Alexandra. He was going to spend the following few days with them on the Isle of Iona, though Morag was concerned there were no medical facilities close by for if anything went wrong. This, I was sure, was an over-reaction. It would be good for Alasdair to relax, in the company of his family, in attractive surroundings.★

29 January 2007: A Drink with Bethsy

Today I spent a very pleasant hour or two in Bonham's pub on Byres Road with Alasdair's ex-partner Bethsy Gray (no relation) and a couple of large glasses of white wine.

The first thing you notice about Bethsy is how full of life she is. Many found her relationship with Alasdair an unlikely one, as she seemed so different to him – very free, very positive, very relaxed. And that's how she still is. She makes jewellery in a workshop based in the West End's Starry Starry Night, and when I went in there to find her I saw her name painted on the wall in Alasdair's handwriting: her business cards are designed by Alasdair too, complete with a line drawing of her face. Since they split up Bethsy and Alasdair have remained friendly. The first thing Bethsy said to me when I arrived was, 'He's the nicest man I've ever met – I just couldn't take the drinking', and that's a fair summary of the conversation that followed. Our chat was also notable, and refreshing, because it included virtually no references to Alasdair's work, or fame. We talked purely about their relationship. How they met, the trips they took away together (sometimes to Scandinavia – Bethsy is originally from Denmark), the things they did in their spare time. 'I loved him so much,' she said. 'He thought I was so funny . . . we always got on so well! And we used to play Scrabble till it came out of our ears!' The Scrabble was a regular activity: Bethsy had two children so was often in during the evenings, and she remembers Alasdair coming over at all hours of the night, demanding a game. She says they only didn't get on when Alasdair was drunk:

'He would write all day every day,' she said, 'then he would go out to the pub. Often he promised he would come to my flat afterwards – but sometimes he just completely forgot. And you know, I would wait and wait and wait, and I got very annoyed with him sometimes. He

★ 19 August 2005: Wrong. Morag phoned to say that Alasdair took ill while away in Iona and had to be driven back to Glasgow by Andrew, and straight to hospital.

would turn up at my door very late, so drunk, and we would argue. I would make this face [makes very stern expression], but I would usually let him inside in the end. He didn't mean to be cruel.'

Today's interview was the warmest so far. Bethsy was keen to emphasise Alasdair's good points and was careful never to suggest he ever meant to hurt her feelings or be inconsiderate, but did say that sometimes it seemed he 'just wasn't thinking of anyone else'. The way she tells it, he was so caught up with his own thoughts it was as if no one else mattered – which is something I don't imagine Alasdair denying. It's a shame that his drinking (which was certainly heavier in the 1980s) and occasional thoughtlessness were reason enough for them to eventually split up, but I'm glad they are friends. Bethsy seems like she would be a good one.

6 January 2007: The Mystery of Inge

A conversation in the car on the way back from Alasdair Taylor's funeral. Alasdair just talked and I drove, eyes on the road. Soon he began to slip into serious talk about old friends, his first marriage, some brutal facts. This began with the repetition of the memory that Inge once seduced Alasdair Taylor, many years ago – 'Just for the morning, mind,' he told me, as we headed towards Glasgow. 'Just because she could.'

'Were you still married?'

'Oh yes. She had several affairs. Earlier ones lasted months, later ones years, with a few one-night stands. Once she came to me and said she wished to sleep with Alasdair – but he would only do it with my permission. I told her I would NOT give my permission, and if they became lovers I did not want to know.'

'And did it happen?'

'I don't know.'[2]

One of Inge's men was at the funeral today. That gentleman, now elderly with thick white beard and walking stick, was _____ whom Inge had left Alasdair for at the end of their marriage. (That relationship resulted in the ending of his marriage too, though he and Inge did not last.) Alasdair related this in a very matter-of-fact way, stating for the record that Inge didn't usually go for his *closest* friends during their marriage:

'But you were being walked all over!' I shouted. 'You make Inge sound like a cartoon baddie!'

'Not at all. She just knew what she wanted,' Alasdair chuckled, 'and knew how to get it.'

'I don't believe in this Inge,' I said.

Alasdair sighed.

'She made it very clear to me – from early on in our marriage – that I was a useless lover. It was no one's fault. That's just how it was. That is why it ended. She was not a bad person.'

'Yet she continued to hurt you. She sounds awful. Did you not realise what she was like before you married her? She obviously didn't want you – didn't she know that before you got married?'

'Remember, we only knew each other for a couple of weekends before we got married. I only discovered she was nine years younger than me when I signed our marriage certificate.'

'Why did you get married so quickly?'

'She came to visit me for a second weekend after the Edinburgh Festival – it was a Saturday night – and she said she would not stay unless I married her. So I said I would.'

'Why?'

'Well, I had always believed that the only purpose of love was matrimony. And I loved her.'

'But *why*?'

'She – had a lot of vitality. And she was independent. I liked independent women . . . She told me right then to phone her workplace to tell them she was not going in for her shift the following day – because she was marrying me. So I did. Her workplace telephoned her parents, who knew nothing about us, and telephoned the police, who came around to the house to find out what was going on.'

At this, Alasdair began to laugh, almost uncontrollably.

'She told them to go away – and they did – *even the police were afraid of her*!'

Underneath the laughter it was clear that what happened with Inge still hurt, especially as the effects were still being felt all these years later. Alasdair talked about her for the rest of the journey home, adding, as we pulled up to the house, that he had felt sexually inadequate for many years, even before Inge – and had told Andrew so – because of what Inge had told him. We pulled up outside the Gray–McAlpine home; car journeys were often where we had many of our most serious talks, but once the engine was off the conversations usually came to an end. We walked down the road for some lunch and talked about lighter things.

4 June 2007: Delicate Proposals

Got a letter today that has me thinking about proposals, and disturbing sleeping dogs. A few weeks ago Alasdair and I exchanged e-mails about his old flames, talking about his fictional women and who they were based upon. He told me he had proposed to several in his younger days, sometimes suddenly. I asked who the character of Rima was in *Lanark*: Alasdair's message said she was based on Margaret Gray (later Bhutani), who he described as 'someone . . . I was sweet on, though I never had the sex with her that Lanark has'.[3] In the same message he mentioned a woman called Mary Bliss (née Hamilton), now Dr Bliss. In 1959 Alasdair visited her with a question.

The two first met through Bob Kitts when Alasdair was nineteen: she and Kitts were both at university in London. Though he had been attracted to her for some time it was only in 1959 that Alasdair made his feelings clear: 'I surprised her by proposing marriage,' he told me, in a very matter-of-fact way, 'but she had engaged to marry someone else.'[4] You'd think he might have checked that detail first! O well, not to worry! His brief explanation of this seemingly important event said little about how it transpired, but the phrase 'I surprised her' suggested the two did not previously have a romantic relationship – perhaps Mary had no idea Alasdair was attracted to her. Certainly they wouldn't have seen each other much during his mostly Glasgow-based art school years, or Bellahouston trip the previous year. So why propose marriage? We already know Alasdair was an intensely serious man, in 1959 entering his twenty-fifth year still a virgin without romantic prospects. He was ready, or desperate, to marry. I wrote to Dr Bliss, asking what happened. She replied:

> I think 'surprised' is the right word for Alasdair's very kind proposal to me in 1959. I was surprised because I didn't think anyone would want to marry me as I did not think of myself as an attractive person. I was flattered as I liked Alasdair very much, but I couldn't think of myself as married to him, or to anyone else.[5]

The rest of Mary Bliss's letter showed she was a kindly, self-effacing person with many fond memories. She complimented Inge, saying she was 'a beautiful woman, who also became a life-long friend' and said of her relationship with Alasdair: 'I think she [Inge] proved to be far more of an inspiration to him than I ever could have, hard though their life

together undoubtedly was.' Mary said she regarded Alasdair as a 'member of the family' and said he remained 'one of my dearest friends'. But the beginning of her letter had confused me: her account of the proposal made no mention of another man. Could Alasdair have misunderstood her (no doubt very polite) rejection? I was nervous about pursuing the story – I didn't want to unnecessarily upset anyone so long after the original event – but felt I had to clarify what both parties remembered. I told Alasdair about Mary Bliss's letter and he replied: 'I don't quarrel with her memory. Shortly after that she was engaged to Tony Bliss and married him – I may have jumped to the conclusion that that was the case but she wasn't – I thought she was seeing this man in Cambridge but maybe not!'[6] And today I get a second letter from Mary Bliss who says: 'I was very fond of Alasdair but I had never thought of him as a husband and was surprised that he thought of me as a wife!'[7]

Which brings me back to thinking about those other mystery proposals. It saddens me to think that Alasdair was 'sweet' on a number of women who had no idea – like Mary Bliss – that he had feelings for them. Certainly he had infatuations, and many of these are documented in his intense diaries. After reading today's letter I was reminded of something Rosemary Hobsbaum said. As always she delicately worded her point, but made a clear connection between the proposals, Alasdair's lack of experience, his romantic inclinations and his appearance:

Yes, I remember him talking about Mary Bliss, a friend doing medicine. He talked about her with great respect. He certainly thought he had been in love with her. Veronica Matthews was another of the women he revealed he'd been in love with. She was surprised and embarrassed when he said so. He was very *very* ready to get married . . . Alasdair was really not physically attractive in those days. His eczema was so raw and he scratched and scratched at it. You used to have to take a Hoover to the floor when he left the room: he neglected himself.[8]

The struggles with asthma and eczema help create a picture of someone who felt nobody would be interested in him – a picture Eleanor Hind reinforced when she said the girls liked to pet Alasdair but none took him seriously. These experiences with Ann Weller, Margaret Gray,

Veronica Matthews and Mary Bliss make more sense of Alasdair's eventual, very sudden marriage to Inge. I'm not sorry I investigated the Mary situation but can't help feeling bad that for nearly fifty years Alasdair may have simply thought he was turned down by his friend because she was already engaged elsewhere, when in fact (despite having a lack of self-confidence similar to Alasdair's own) she just didn't want to marry him. Did he ever need to know that?

Tuesday 26 June 2007: Morag, at Home

The atmosphere was good in the flat this morning. I arrived at the same time as Helen, who was showing me drawings of the maps of Glasgow, Florence and Athens which Richard Todd was working on, and which will go on the inside of *Old Men in Love*, when Alasdair brought coffee and explained Morag was spending the day in bed (she's had knee problems recently), but was happy to conduct our chat from there – and Alasdair promised he wouldn't disturb us. After all this time it seemed strange to arrange a formal interview with Morag about her husband while the man himself worked next door: but ho hum – I've done several things for this book that I never planned to. We talked for an hour or two, in a relaxed way, and though it's possible that she may have been prepared for me, I felt I was experiencing a different, real side to her that was rarely seen. She told me about how she met Alasdair, talked about the early part of their relationship and discussed his work at length.

Morag first met Alasdair in 1989 in the Ubiquitous Chip pub, which is just a few minutes' walk from where they now live. Morag remembers she was drinking with mutual friends when Alasdair came to join their group partway through the evening. By the late eighties, Morag had been a bookseller in John Smith & Sons bookshop on St Vincent Street for the best part of two decades, so I wondered whether she knew Alasdair's work before they met, and whether she was a fan. Morag says she had 'only read a few short stories – not *Lanark* yet', and knew Alasdair more by local reputation than by his work. They talked until Alasdair was disturbed by a man who wanted to ask him questions ('That happens a lot,' says Morag, rolling her eyes), and Alasdair decided to leave to escape him. They met again on the street later that night, when Morag was leaving the pub. 'The same man was annoying him!' she remembers. 'So I intervened . . . and then we went to buy some cat food.' Very romantic. So what were her first

impressions? 'I knew people who knew him, and they said he was a
difficult man — a difficult man to work with. When I met him I
thought, *He's a very nice man. Why do people say that?* But that was before
I tried working with him . . .' And she laughed. For the next year or
two they moved between Morag's Hillhead flat and the one in St
Vincent Terrace, Finnieston, that Alasdair had recently been forced to
moved to by the Council: he was trying to get back into Kersland
Street at the time, but in the end that didn't matter because Alasdair
proposed and they agreed to remain in Hillhead.

The wedding itself was a quiet affair: they only told a few people
about it because they wanted to avoid any press publicity. 'Alasdair was
well known, and we were concerned that we might be greeted by
photographers,' says Morag. I find it hard to believe that the paparazzi
would have been interested in the event, but Morag happily admits to
hating being photographed (which might also explain why there's no
wedding photo in their home). Morag shows me the marriage certi-
ficate from 26 November 1991: you'd expect her to remember that
date because it was her forty-second birthday. Also the Registrar's,
apparently. I looked at the certificate and noticed I didn't recognise the
name of one of the witnesses. Was that one of Morag's friends, I asked?
Well, it was a complicated day . . .

They were due to wed at the Martha Street Registry Office in
Glasgow and arranged to meet the two witnesses, Andrew and a friend
of Morag's, in the Copthorne Hotel across the road, shortly before the
ceremony. But when Alasdair went looking for them, they were
nowhere to be found. As George Swan might say: *Consternation!* So
Alasdair was sent out on to the street to do the traditional thing
newlyweds do in a panic – grab a member of the public and get them to
be a witness. Margaret S. Beaton, good citizen, agreed, and Angela
Mullane turned up at the wedding too, so she was drafted in as Witness
B. The couple were married, and when they returned to the
Copthorne to celebrate they found Morag's friend there with Andrew,
who was frantically making phone calls, wondering if the wedding had
been abandoned. But no. So where did they find their original
witnesses? 'They were in one lounge,' says Morag, 'and we had been
looking in the other.'

After hearing how keen they had been to avoid marriage publicity, I
asked how Morag found the experience of being Alasdair's wife,
especially in relation to the attention he gets when they're out and

about. During our conversation she has alluded to many trips abroad together over the years where Alasdair has been invited – Iceland, Norway, Spain, France (Paris, several times), a lengthy tour of Germany, Austria – and I'm reminded just how many countries his work has sold in. But what did Morag think of entering that world after twenty years of local bookselling?

'It can be quite interesting . . . but it's a bit repetitive. Alasdair doesn't always read the same thing – though he often does – and the questions are usually the same. All the attention doesn't bother me . . . in the beginning I was a bit impressed, but I've got past that now. I do try to make a point of avoiding the cameras. These things usually involve cameras.'

'Is Alasdair sensitive to that when he's doing an event?'

'Oh he's usually far too involved . . . but I can look after myself!'

This leads us on to talking about travelling in general, and whether, at the age of seventy-two, Alasdair can continue with that kind of life. Morag sometimes comes across as rather stern and impatient with her husband, but it's clear from this conversation that it's out of genuine worry for his health. She's particularly concerned about him going to America and getting stranded, uninsured, in a hospital over there. 'I think he might be getting tired of doing events,' she says. 'He has numerous health problems. He won't remember but when we went to the USA it took him over a week to recover from jet lag on the way back.'

This sounds like Alasdair's work is nothing but trouble, but that's not Morag's attitude:

'I wouldn't ever want him to stop working,' she says. 'Because it's the best thing he can do for his health . . . Once, when he was in hospital after his heart attack the nurses at the Western [General Hospital] asked me to stop him . . . I explained to them, that was the worst thing they could do. When he's working, he's completely absorbed. I don't mind him writing and painting – though I don't like him going up the scaffolding at the Oran Mor!'

'What about the *amount* of work he does?'

'Of course, he takes on too many things – because he doesn't know how to say no, and because of money. Everything is still piecemeal, hand to mouth. Our only guaranteed income is the grant from what I call the Winnie-the-Pooh fund.[9] We've got that for five years – enough to know we're not going to starve.'

'So does he worry about money?'

'Oh no. He doesn't worry about money. He never has. *I* do that for both of us.'

There was one other thing I wanted to know though, which had kept coming up with Alasdair's previous relationships, related to the amount of work he does. Morag has been retired since 1993. As her husband is occupied most of the time, does that leave any time to spend together? Does Morag resent that he's happiest when absorbed in his many projects?

'It doesn't bother me that he works so much,' she says, shrugging. 'I do quite enjoy doing things by myself. I wouldn't want to do it all the time, but we do spend most evenings together . . . there's no point in me sulking around here when he's dictating a novel! And anyway, I was always used to going out to work during the day.'

Morag and I talked about the copies of Alasdair's old books that she sells, and she showed me some of the rarest. 'The Comedy of the White Dog', a pamphlet from the late 1970s, has only a few surviving copies, there are art prints going for £445 a time on his website (there is a slow trickle of collectors interested), and there are still a few copies in amongst the remaindered hardbacks of previous books and translations of Alasdair's best-known works in other languages. My favourite edition was a copy of *1982, Janine* in Russian, which featured a man in an all-in-one red leather suit and tie, complete with facemask sealed by a zip down the front. But when I imagined out loud what the booksellers of Moscow must have thought of it, Alasdair appeared from the lounge in a flash: 'That character isn't even in the book!' he shouted. So, still a little sensitive about having his artwork replaced then. I made to leave and noticed once more that the atmosphere was bright in here today.

4 1970S: LEAN
TIMES AND ALMOSTS

COMMISSIONS, FRIENDS

The beginning of the 1970s was a lonely time, but at least there was work; after the breakdown of his marriage Alasdair once again threw himself into it. In 1970 his short radio play *The Trial of Thomas Muir*[1] was broadcast by BBC Radio Scotland as part of their 'Here I stand' series, and more followed in the coming year. Drama was now a big part of Alasdair's income, though there was still occasional teaching work and the odd lecture. One of these led to the beginning of a long friendship which indicated the pattern of the decade to come. Previously, Alasdair's closest friends had been artists. Now, most would be writers.

In later years the poet Edwin Morgan became Glasgow's Laureate and eventually Scotland's Makar,[2] but by the early 1970s he already had a reputation as an experimental poet, widely travelled translator and academic at Glasgow University. In 1970, Alasdair Gray was invited to give a talk there. He needed any work he could get and was grateful for the opportunity, but Alasdair was not a typical university lecturer. He was unable to keep to the required topic, often getting caught up in lengthy digressions which he thought essential background that had to be taught first. Morgan still remembers the lecture clearly: 'He had this extra-ordinary series of gestures when he was speaking to students – and he did play up to that. He knew what people saw. His lectures were like scenes from a play and his conversation was similar. I got on with him straight away. His strange speech, his register, didn't worry me, I always enjoyed that.'[3] After this lecture he was not asked back on a regular basis – at least, not immediately. But he did become friendly with Edwin Morgan.

Around this time Alasdair first met the young Liz Lochhead, on a train on the way back from Edinburgh, where she had just celebrated winning her first poetry competition. The two became close friends. Liz had seen *The Fall of Kelvin Walker* in 1967 and has said Alasdair was 'already famous' around Glasgow School of Art, where she studied in the late 1960s. She describes his appearance at this time as 'very handsome, in a very untrendy way',[4] and has called his friendship

'the most wonderful present'.[5] They shared their writing often, and Alasdair sketched Liz several times, an experience she later wrote about in her poem 'Object'. She says: 'He was a generation older, and was a more experienced writer. I really looked up to Alasdair.'[6]

Alasdair tends to develop long relationships with those who have very similar interests to his own. Many of them have found him loyal, and this is in itself not unusual, but it is notable that a remarkably high proportion of Gray's closest friends are those who know his work. Strangers are sometimes put off by his mannerisms, exhausted by his conversation – eager, even, to get away. As Edwin Morgan says, chuckling quietly, 'For some, five or ten minutes is quite enough time in his company.'[7] But those who respect him anyway, those who understand his work or sympathise with it before they meet him, are more likely to give him a chance at the outset, increasing the likelihood of a relationship.

Though he was not always happy with the results, at least writing TV and radio plays reminded Alasdair that he existed as an artist, something that had been lacking during his marriage. Part of that existence was proving himself to others, his father, in particular. Alasdair remembers one evening when Alexander Gray visited his flat with a copy of the *Radio Times* in his hand, having discovered one of his son's plays was going to be broadcast. But though Alasdair was showing signs of 'succeeding', that wasn't always enough: 'I answered the door in my dressing gown . . . but the flat was . . . *not tidy*. He seemed to forget he was there to congratulate me and started shouting. He said I would not make anything of myself or be a good father as long as I was *a man who stayed in his pyjamas until dinnertime*. But I was pleased he noticed my play.'[8] Even when being told off, Alasdair still saw the best in his dad.

Unfortunately Alexander Gray would not be living close by for much longer. Back at the Holiday Fellowship (where he had met Amy Gray over forty years earlier) he met a woman called Lynn Carr and, in the grand Gray tradition, married her quickly, with the ceremony taking place on 5 June 1971. So, as it turned out, Alasdair's marriage broke down just as his father was getting back into one. Lynn lived in Cheshire, and Alexander moved there to be with her. (These developments may have explained why Alasdair chose now to ask his father to record his own family memories.) Meanwhile, Alasdair was living in Kersland Street alone: Andrew remembers 'both Alasdair and Inge's names were left on the lease – *for council purposes*.'[9]

That was the official line: the unofficial one was that from now on

Alasdair would 'supplement income by illegally subletting the spare rooms'[10] that lay empty now that he was single again, taking the advice his father had given him in 1965. One of the rooms in the flat was kept for Andrew, who was now shared between parents. Alasdair worried about the impact the split with Inge might have on his young son, already a nervous boy, but the single life brought a kind of freedom again. Freedom to do what, though? To hope once more for those things he thought the sixties might bring but never did? There were some encouraging signs.

New work came fast in the early 1970s. Alasdair was asked by Granada and the BBC to write for Scottish-only as well as British audiences, along with a few educational pieces as well: *Honesty* (containing elements of a later story, 'Houses and Small Labour Parties') and *Martin* (another story about a young man suddenly, tragically, proposing marriage to a girl who does not care about him) were both twenty-minute plays televised for Scottish schools in 1971, and *Dialogue* was performed alongside C. P. Taylor's *Blocks Play* at that summer's Edinburgh Festival. Shortly after this he aquired his first agent, Francis Head. She got him a great deal of work from 1972 onwards: over the next few years she secured commissions for more plays, made some crucial breakthroughs and sold several existing Gray works. The first of these were *Today and Yesterday*,[11] *Triangles*[12] (aka *Agnes/Mavis Belfrage*, which had been commissioned by the BBC in 1968 then rejected), *James Watt*,[13] *The Man Who Knew About Electricity*,[14] and later *Homeward Bound*[15] and *The Loss of the Golden Silence*,[16] both performed by Edinburgh's Pool Lunch Hour Theatre in 1973.

During this time occasional fiction surfaced as well, like 'The Crank Who Made the Revolution', a story about industrial beginnings as seen through the inventions of a small Glasgow boy in the early eighteenth century,[17] which was printed in *Scottish Field* in 1971. This showed a more confident, playful tone than recent work, which focused mostly on relationships breaking down. 'The Crank Who Made the Revolution' included the statement 'considered mechanically, a duck is not an efficient machine' – hard to disagree with – but then suggested improvements. It was reminiscent of the pretend school lectures Gray used to give and also of his brief cabaret days. During this time, Alasdair frequently moved house. After a short spell in Regent Moray Street, near Kelvingrove Park, he then lodged with Gordon and Pat Lennox in Turnberry Road while Inge and Andrew were in Kersland Street. He remained there for more than a year.

Meanwhile Francis Head continued to raise Alasdair's profile. As well as

the above works, new versions of older ones appeared, too, including a tour
of a stage version of *The Fall of Kelvin Walker* which, according to Alasdair's
friend Bruce Charlton, nearly saw a very different incarnation as well:

> The London theatre impresario Binkie Beaumont was also induced
> to consider *Kelvin* . . . for West End production (negotiations broke
> down after Gray could not be persuaded to supply a happy ending).[18]

The Nice Steady Life of Kelvin Walker, anyone? Perhaps not. Alasdair was
working furiously, cultivating a small reputation as a TV and radio
writer, but was anxious to return to his big work. Then, crucially, he
met Philip Hobsbaum, a poet and academic who quickly became
important to Alasdair.[19] Philip remembers that first meeting:

> [We first] met in Glasgow in a pub when I was drunk; I have no
> recollection of this encounter. Alasdair says that he was talking – who
> else would talk about this – about Sir Philip Sidney and rhetoric, in
> the Rubaiyat; apparently, I turned round and said to him, 'Your
> discourse is so interesting one would pay money to hear it.'

What followed was less polite. Hobsbaum was so amazed to hear this topic
of conversation in a West of Scotland public house that he cheerfully
joined the conversation, hoping to enjoy it. But the two men ended up
arguing loudly, embarrassing onlookers with the surprising voracity of the
exchanges between these complete strangers, who acted as if they were
fighting over far more than literature. Alasdair still remembers that first
meeting with great agitation, describing Hobsbaum as one of the few
people he had ever known who he had 'instantly hated, and sincerely
wished to be DEAD'.[20] It is hard to place the date of this first meeting, or
even the second one, which Philip remembered better:

> I next met him two years later, when Aonghas MacNeacail[21] was
> being a caretaker in a house on the Clyde, and suddenly the door
> burst open, and here was this wee man with a moustache and a
> pyramid of beer cans, who tripped over the rug and shouted 'Fuck!'
> as all these beer cans dispersed in three dimensions all round the
> room. That was my first remembered encounter with Alasdair Gray
> in 1970, since when we've been very close friends.

This is difficult to be sure about: 1970 seems too early – that makes the first meeting 1968 – but Alasdair doesn't seem to remember the pyramid of beer anyway, Aonghas doesn't remember it either, and seemingly everyone was drunk. Most of the time. Whatever the date, Gray says they next ran into each other in the Pewter Pot pub in the West End. Philip approached him as if they had never fallen out, said he had heard he had written a play called *The Fall of Kelvin Walker*, and would it be possible to read it? The following week Hobsbaum grandly pronounced that he believed it to be the best play written in Scotland in several decades and invited Alasdair to join his Group.

A GROUP?

Philip Hobsbaum came with a reputation: he had previously set up writing groups in other cities in the United Kingdom, including Cambridge, London and most notably Belfast, where he encouraged writers such as Seamus Heaney[22] in the mid-1960s. Heaney has since publicly credited those early group sessions as being crucial to his career. When Hobsbaum took up a position at Glasgow University he approached various writers with invitations to join a new group. Gray first met James Kelman and Tom Leonard at these get-togethers and made a number of other lifelong friends there (Aonghas MacNeacail, Angela Mullane[23] and Chris Boyce[24] also attended[25]). Alasdair has said the Group's way was an important influence on his own creative methods, calling this 'the best writing class I ever attended'.[26] Hobsbaum, a university professor with a Ph.D. in Literary Theory, remembered this period fondly in an interview where he also defended his methods:

> I do think of all the groups I've run that the Glasgow group was the best. For one thing, we [in previous groups] had never made much headway in prose fiction, but in the Glasgow group: Alasdair Gray and Jim Kelman! I regard these as two of the most prodigious talents in fiction. I'm amazed: they're both friendly with each other, they both live in Glasgow, and they're so different. George MacBeth said to me critically once, 'All your geese are swans.' I said, 'Well, it's just the reverse of reviewing and criticism: when it comes to books, treat the book as no good, until it proves itself otherwise. With students, assume they're good: let them prove they aren't.'[27]

If there was a positive atmosphere in the sessions, not all feedback Alasdair got was upbeat – he has written that he and Kelman were initially indifferent to each other's work.[28] But soon he thought Kelman was doing important work he could not do himself, and the idea of having a group of equal, contrasting talents advising each other appealed to him. Encouraged by the Hobsbaum way, he began to show *Lanark* to others he trusted, like Edwin Morgan.[29]

Alasdair has repeatedly written about Philip Hobsbaum's influence, notably in his Postscript to *Lean Tales*. In this, he describes what appears to be a coherent group, and in recent years the Hobsbaum Group has taken on rather a mythical quality. This 'Group' has been written about extensively, especially in academic circles, but interviews with key 'members' show the Group's importance has been exaggerated. Kelman, Leonard and Lochhead all believe it is wrong to overemphasise its importance: as Liz has said, 'He was important to us all individually but not as a group.'[30] Some of these knew or knew of each other already, and others had literary connections unconnected to Hobsbaum which they considered more important – for example, Tom Leonard considered himself already part of a group of poets, alongside Tom McGrath. They had published together, and were inspired by writers like the American William Carlos Williams. Liz Lochhead (who also identified more with Tom McGrath) has also been called a 'member' but she was not living in Glasgow for much of the period in question, and says that, though Philip was kind to her and she met Kelman at his house, she 'only went to a meeting there once'.[31] Kelman remembers:

> I have never really spoken about it with Alasdair but critically I don't think it [the Group] had much importance, not for myself anyway. Poetry was the main interest. I don't recall much interest in prose fiction. Sunday night is not a good time for a parent. I was also working shiftwork in a job where little distinction was made between weekdays and weekends, so I could not attend regularly anyway. I don't remember Alasdair as a regular. After a year or so I stopped going. I think the group was fading anyway. But I did value those Sunday night meetings; the company was fine and this early acquaintance developed into friendships with Liz, Tom and Alasdair, and to a lesser extent Philip, Donald [Saunders] and Aonghas.[32]

Anyone looking back on a city's literary history must be wary of

putting writers in all-too-neat boxes, and Gray has an occasional habit of making his past seem coherent when the reality is more messy and mundane. Kelman's memory suggests this may be another of those instances. However, it is fair to say that in this period, partly because of the Hobsbaum Group, many Glasgow writers came to know each other better, and work together more. And, while accepting that the Group was not important to some of the other oft-included names, it is important to acknowledge Alasdair's involvement, as he clearly valued it. Alasdair and Philip didn't always get on well socially – some others struggled with Philip, too – but most of those around at the time say he was a great facilitator. Taken in isolation, the few years of Group meetings resulted in a huge amount of good work by those who attended, as well as a crucial Gray breakthrough.

MID-SEVENTIES GLASGOW WRITERS

By the mid-1970s the writing community in Glasgow was showing some key signs of life. Liz Lochhead's first collection of poetry, *Memo for Spring*, had been published in 1972,[33] James Kelman's first book, *An Old Pub Near the Angel*, was published in America in 1973[34] and Tom Leonard's third collection, *Poems*,[35] appeared in the same year. Also in 1973 Quartet Books paid £80 (approximately £800 in 2008 equivalent) for an option on *Lanark* on the evidence of completed versions of Book One and Book Three, which gave Alasdair a much-needed financial boost, increased his belief and convinced some of his allies that his big book might appear one day after all. It was clear that something was happening in Glasgow. This sense was also created by the influence of another set around the poet and playwright Tom McGrath. 'There were two groups, really,' remembers Aonghas MacNeacail, who was involved with both at different times. 'Two centres of energy. One was Tom, who was very helpful to many of the poets in Glasgow at that time . . . and Philip. Both were important.'[36] But though Tom McGrath, a charismatic, multi-talented character, was a key figure for the likes of budding poets Leonard and MacNeacail, he was less so for Alasdair, who always returns to Hobsbaum when this period is mentioned.

By now Alasdair was doing regular events like the 'Lost Poets' nights in Edinburgh organised by younger writers Brian McCabe and Ron Butlin, sometimes reading out stories and half-written bits of *Lanark*,

some of which had already been published in early forms in various magazines such as *Lines Review*. These publications bore little resemblance to modern glossy journals – rare surviving copies prove production values were low. The places where *Lanark* first appeared in fragmented form were often just ten- or twelve-page black-and-white sheets stapled together, handed out at readings or sold for a few pence wherever possible. People knew Alasdair was talented but as Paddy Lyons, an academic and critic who had been recommended Gray's work by the poet Eavan Boland, recalled, 'nobody was entirely sure his work was going anywhere'.[37] He certainly had a reputation locally, but the plays had not been big successes. Also, the few who had read sections of *Lanark* had little to compare it with – what Gray was doing was too unlike his peers or recent Scottish predecessors, many of whom (like Kelman and Leonard) were breaking new ground by using local working-class language confidently, asserting the validity of that language. By comparison, Alasdair seemed very out of place – in some ways old-fashioned, in others quite radical.

There was another more practical problem, too. In the early seventies the prospect of anyone from Glasgow actually getting published seemed unlikely, though more so with poetry than prose. As James Kelman has said, 'writers of prose fiction can day-dream of earning money through their labours; few poets would harbour such fantasies'.[38] Alasdair was hard to categorise – he was poet and novelist-in-waiting, artist and playwright: the Scottish Arts Council had become aware of his work but, as Edwin Morgan remembers:

> They were uncertain about him. They weren't sure if he was serious. A lot of people weren't. Of course, when it came, *Lanark* changed everything. It changed everything for Alasdair personally, but also helped to change the landscape for Scottish writers. It is hard to imagine that time now. It was very difficult to get published in Scotland in those days, but Alasdair was determined. He knew *Lanark* was going to be the big thing, and that kept him going . . . he was desperate to get what help he could.[39]

There was plenty of that help from friends, and Morgan helped, too, recommending Alasdair to the Scottish Arts Council, resulting in a grant of £300 in 1973 (approximately £3000 in 2008 equivalent) to help write *Lanark*.[40] This was nowhere near enough financial assistance

for Alasdair, but according to Liz Lochhead he shared the money with writer friends anyway.

The Glasgow writers of this period influenced the next generation who followed them – first younger writers of the same period like Ron Butlin and then, years later, another set who outstripped their predecessors in terms of commercial success. One such example is Edinburgh's Irvine Welsh, author of *Trainspotting*, who was inspired by the Glasgow writers and drew strength from them. Let's fast-forward a bit. Welsh says:

> You do have things that chime strongly with you, because they're from your own culture. That happens in all sorts of literature. There's something about the choice of themes, and the furniture that goes around them. There's a long tradition of that in Scotland but people like Alasdair and Jim took that further. What I saw in literature when I was younger was the fiction of the upper classes. Some type of Oxbridge writing is put way up there – and it's basically just fiction from another culture. Alasdair, Jim, Tom Leonard: that was for *us*.[41]

Irvine Welsh was attracted by the work ethic Glasgow writers had then, and the fact that they represented the opposite of the aloof, distant, London publishing world. He describes the effect the Glasgow set had when he and his friends began to look for publication themselves:

> Rebel Inc [independent Scottish publisher founded in 1992] grew out of that really. People like Kevin Williamson,[42] Alan Warner[43] and me were very disparate writers, but we realised what the Glasgow writers had done in the eighties . . . we knew we had to publish ourselves, you know – finding strength from within this wee ghetto. Because there's a ghetto of a London fiction establishment that doesn't let people in. If you're writing from outside that culture, it's important you have your own support networks.[44]

Those networks have become more formalised since Alasdair's generation, and Welsh and Warner's in Edinburgh in the nineties. Scottish universities now encourage this process of 'clubbing together', providing an official home for growing talent, partly inspired by that DIY idea. Indeed, it was Philip Hobsbaum who jointly set up the Glasgow University course that Gray, Leonard and Kelman would end up teaching on twenty-five years later.

KERSLAND STREET, AND
THE END OF ALEXANDER

Alasdair was now back in Kersland Street in the West End, as Inge had moved out for good. This flat became notorious, with those who visited this Council-owned place on the third floor describing it as a lively centre of culture. A picture framer, a musician, various artists and unemployed stayed there – some charged a fee, some allowed to stay for nothing if they had nowhere else to go. The impression visitors give of Kersland Street is of an unclean but inspiring place filled with art – paintings and sculptures lying around on the floor, various pen scrawlings on the wall. (Including one where Alasdair wrote a proposed structure for *Lanark* as if it had just come to him there and then.) The flat developed a reputation: 'It was a little haven of culture,' says Dave Manderson, a regular visitor. Dave described himself as one of many who 'wouldn't assume to be counted as Alasdair's friend'[45] but spent considerable time in the Kersland Street flat, like many others who wrote, or painted, or wanted to. Alasdair was already a local personality by this time – a real artist, a playwright – a success in many people's eyes. Though he had no money and lived this basic, penniless existence, 'Everyone talked about him so admiringly. People were always talking about him – and he was so generous. He was like no one else I'd ever met. We all gravitated there . . . we had such respect for him. He meant so much to so many. Even if you didn't know him, you *felt* you did. And to us, he was completely synonymous with the West End.'[46] But Alasdair didn't feel like a success. He was experiencing his greatest financial struggle yet, just about staying afloat from job to job. The description Dave Manderson gives of Alasdair around this time shows how outsiders, drawn to Kersland Street by sheer force of his personality, perceived him:

> The impression you got of Alasdair was of someone who, though very generous, and warm, had a certain hostility about meeting people, because he had a great sense of failure. You noticed that straight away. He was almost like an archetype of poverty. Others admired him but it meant nothing to him because he had no money, and not yet the kind of success he wanted. I remember he had terrible teeth . . . holes in his boots, torn clothes . . . he just had . . . *nothing*. Yet he put homeless people up in his flat.[47]

Others testified to Alasdair's lack of money in this period, which may

seem strange given he had been churning out so many plays for radio and TV – but they weren't well-paid jobs, especially when each one took so much time and energy. (He had got the knack of writing to commission, but hadn't developed the same for deadlines, and never would.) Alasdair's records show that on several occasions he was paid just £50 to produce a script (approximately £500 in 2008 equivalent) that then had to be re-edited several times, over several months. Even after this extra work there was no guarantee of the play actually being produced. His situation wasn't helped by the fact that he couldn't take advantage of new opportunities, hear about the next job, make the 'right friends' – he was too far from media London, and had no money to travel there. At times it was literally a case of trying to find enough to eat. 'I had periods of depression,' he remembers now. 'Despite the work, my main income in the 1970s was money from lodgers. And there was not enough of it.'[48] Kersland Street regulars tell of occasions where Alasdair's friends found excuses to feed him, as – though he was never so poor that he could not afford a drink – they were concerned he wouldn't feed himself.

Donald Saunders was one of Alasdair's closest friends then, and he occasionally also took on secretarial tasks. Donald was part of a growing web of people around Alasdair who helped perform some function related to his work: because Alasdair could not or would not learn to type, and because he could not pay to have work done professionally, he relied on friends and acquaintances.[49] In the mid-1970s there was also Professor Andrew Sykes, a patron of Alasdair's art (later an adviser to Gray's hated Maggie Thatcher) who donated use of his office facilities, and there were several others, too. One of these was Flo Allen, who typed and retyped manuscripts, often waiting many months to be paid. Alasdair was drawing people to him, developing the skill of getting favours out of them.

By the mid-1970s, Alasdair's old friend Rosemary Singleton also knew Philip Hobsbaum. (Rosemary and Philip married in 1976.) Once again she was seeing Alasdair more, and was a regular visitor to Kersland Street. She remembers:

He had a whole stream of people passing through – people who'd walked out on marriage or been thrown out – he was surrounded by people who felt they were losers. Alasdair was very good company, he didn't carry gloom around with him, but there were certainly elements of black farce. I remember one of the lodgers had a radio playing at all hours so Alasdair threw the radio out of the

window, then in a fit of remorse threw out his own. It turned out it was a different person's radio! There were lots of comings and goings. It was a strange place, but it wasn't squalid. Whatever was happening there, all the parties, always seemed perfectly logical.[50]

This might have seemed a romantic notion to those who flitted in and out of Kersland Street but was not for Alasdair who, now forty, was fed up with having nothing for himself or his son, and very little to show for so many years' work. And it was too late to show either of his parents that he could make a comfortable living from making 'luxury items' like stories and paintings: now, neither of them would see the publication of the book he had been working most of his life to make. Less than two years after he remarried, Alexander Gray died. Mora remembers this happened on her birthday, 4 March 1973: 'The cause of death, as far as I can deduce from the writing on the death certificate, was *Acute myocardial impaction*, what we called a heart attack . . . He had a heart attack while clearing snow from the drive, was taken to hospital, appeared to be recovering and then had a second attack.'[51] Alasdair also believed his father was recovering; the two had enjoyed a conversation while Alexander was still in Intensive Care, about to be moved to a general ward. He died shortly after. Now, despite the busy atmosphere of his home, Alasdair felt more isolated than ever. What else was there to do but return to work?

A BIT OF *MCGROTTY*

Around this time Alasdair was working on *McGrotty and Ludmilla*, a play he conceived when Francis Head told him a series of TV plays based on nursery tales was being planned. Alasdair remembers his original idea for it: 'I imagined the Aladdin story with the hero a junior civil servant, wicked uncle Abanazir a senior one, and the magic lamp a secret government paper which gave whoever held it unlimited powers of blackmail.'[52] He was pleased with the idea, and had become used to working to commission, but often ideas evolved into something that didn't necessarily fit the original brief. If his work was then rejected, he was left with something he never intended to write that needed to find a home. In the weeks before his deadline for *McGrotty and Ludmilla* he tested it out on Kersland Street regulars, making changes as he went along. Alasdair thought nothing of reciting an entire play to virtually no

audience; on one occasion he delivered the whole thing to two friends, acting out every part in his political pantomime as if performing for hundreds. When it was a finished work, its nursery-like qualities were too subtle for some to notice and the TV producer didn't want it, so Alasdair was pleased when Francis Head successfully sold it to radio instead. *McGrotty and Ludmilla* was eventually broadcast by BBC London in July 1975, again directed by Shaun McLaughlin.

 McGrotty and Ludmilla is certainly a caricature, because of the nature of the commission, but it is also derivative. There are significant similarities between the main characters in this play and *The Fall of Kelvin Walker*. In different circumstances the author might have made greater efforts to distinguish this political satire from *Kelvin*, but this had to be written quickly, between other projects, and Alasdair needed money fast. Despite lack of funds Alasdair had spent much of the last few years writing the large Book Four of *Lanark*, so was he really concentrating on plays, or did he have his mind on other things? Some similarities between *McGrotty and Ludmilla* and *The Fall of Kelvin Walker* were almost certainly subconscious, but the 1975 broadcast version is almost like a partner piece to the earlier, more successful play, which also saw a naïve young working-class Scot suddenly getting into a position of great power, and falling in love, equally as suddenly, with the first woman he meets. The play has considerable charm as a pantomime, but is most successful when doing two very specific things: 1) portraying male politicians as pompous, shameless idiots, and 2) portraying female secretaries as intelligent mother figures blessed with the patience of saints.[53] *McGrotty and Ludmilla* wasn't fully realised as a play, but was more successful when recycled yet again, this time as a novella. By then, Thatcher was in power, and the political world of Whitehall seemed less like a silly pointless farce and more like a long, waking nightmare to old socialists like Alasdair Gray.

ANDREW AND SCHOOL

Andrew was eleven in 1974. He had been struggling at school, something his father partly put down to his parents' break-up, and found it hard to express himself, especially when under social pressure. He was often nervous around other children, who sometimes bullied him. Alasdair remembers: 'Once we were walking past another school – not Andrew's – yet he saw the children's playground and visibly shrank away from it. The

sight of a playground gave him such a sensation of horror that he could not face it.'[54] And his problems extended to the classroom as well. Andrew remembers: 'Once, Alasdair and Inge came to a parents' evening of mine – all the children had written pieces or drawn pictures which were up on the walls – and they couldn't find anything by me. They were quite upset by that and decided to move me.'[55]

They removed him from primary school to educate him from home. In this period, Andrew spent time with both parents, with Alasdair breaking off from his many projects to teach his son, sometimes at the flat, sometimes on the move. He educated Andrew in his own style – though his curriculum didn't include very much maths, and focused on the kind of subjects Gray Senior was interested in. Andrew remembers:

> Being schooled at home was fairly easy, fairly relaxed at first. I did go for one class a week, but apart from that I did everything with Alasdair: it was good for a while. He taught me cursive handwriting in the Victorian style, whereas schools weren't doing that in those days. They were experimenting in the seventies . . . Anyway, we went on some days out, too – we took trips to Edinburgh, which back then felt like going to London or New York – it was very impressive. He took me to the castle, the Royal Mile, and art was always there. He took me to galleries and things. But it got more difficult after I was twelve.[56]

That was because Alasdair knew he wasn't really giving his son the rounded education he himself had wanted to avoid. Cursive hand-writing, indeed! In the Victorian style! All this teaching was getting in the way of Alasdair's work, and was not a long-term option for Andrew, who was often travelling between his parents' homes. So he was sent away to school somewhere his parents thought would help him socially, and build his confidence. Kilquhanity House was an alternative school in the south of Scotland, not far from Dumfries. It was run along open lines, with unstructured lessons and few rules, as Andrew remembers:

> It was run by a man called John Aitkenhead, who modelled it on Summerhill in Suffolk [a progressive residential school founded by A. S. Neill in 1921]. I went to that school because I had a bad stammer and I was struggling at my previous school. It was a very flexible schedule – there were various tasks, everyone got a 'day job' [called 'useful work'] like chopping wood or something like

that – but you didn't really have to do anything you didn't want to.
We had weekly meetings which the students were involved with.[57]

Andrew was happier there, and stayed at this private school for the next
few years.

Kilquhanity may not have prepared Andrew for the outside world in
terms of providing him with useful exam results, but his father felt it
was worth it for the social difference it made. It was not typical
behaviour of the old socialist to send his son to a fee-paying school, and
Alasdair certainly didn't have the money to spare, but he and Inge
agreed there was not the necessary provision in the state system to help
their son: they applied for state assistance with fees but were turned
down at the last minute. Alasdair managed payments by taking on more
jobs and living off virtually nothing himself – which perhaps taught
Andrew that being an artist was not the kind of career he should aspire
to. He did make attempts at writing as a teenager, even showing
Alasdair's friend Chris Boyce a couple of versions of work in progress,
but in the end he decided it was not for him.

UP, DOWN, NEARLY, NOT

By 1976, Andrew's dad was nearly done with his *Lanark*. It was big, yes,
but Alasdair thought that might be an asset, not a drawback. The
following memory shows his writing pace was quickening as he got
closer to the end of the project, his focus more intense:

> In 1975 and '76 I was carrying manuscripts around and working on
> them in all kinds of places. I remember waking up on the living
> room floor of my friend Angela Mullane's house where I had fallen
> asleep for the usual Scottish reason [drink], and resuming work
> there and then because it was a quiet morning and none of the
> other bodies on the floor were awake. I couldn't do that now.[58]

Alasdair makes this sound like a calm, fun time from his youth when he
was sure good things were coming and words flowed easily. But this
description overlooks the age of the author (forty-one or forty-two), and
the ongoing frustration and messy nature of the writing process. In reality
the author was constantly, laboriously revising pages he already had

multiple versions of, some of which had existed for decades in various forms. Andrew noticed the way his dad worked: 'Everything took a long time. He wrote everything in longhand in those days, and that was even before Snopake [ink-covering liquid]. All mistakes were painstakingly covered over in sticky labels cut into bits, then he wrote over them.[59] He rarely had any back-up. There was not enough money.'[60] The lack of funds explained why Flo Allen was rarely paid, and why she only worked sporadically: mostly he wrote longhand. Anyone imagining what Gray had in front of him that morning on Angela Mullane's floor should not picture anything but chaos on paper, and lots of it.

Meanwhile, TV and radio work became less regular. A new play called *Beloved*[61] about Henry James Prince appeared on Granada TV as part of the 'Queen Victoria's Scandals' series in 1976, but Alasdair was unhappy it had been tampered with and insisted on having his name removed from the credits. He believes this may have stunted his drama career:

> I got a rehearsal script in the post and came to the conclusion it had been extensively changed, then someone else had tried to change it back. It was terrible! It was NOT MINE. My play had largely been based on documentary evidence. It was NOT supposed to be the kind of melodrama they had turned it into . . . I received the script on a Friday and saw from a note on it that there was a rehearsal in London on Monday. I COULD NOT AFFORD to go to London to attend it, and it was too late to make further changes. So I wrote on my letter to the producer – sarcastically – *Your political acumen in handling this matter is considerable*, removed my permission and sent it off quickly. Philip [Hobsbaum] was appalled. He probably realised this boded ill for my future as a writer for television.[62]

After this episode, Alasdair concentrated on *Lanark*. Despite its incomplete state there had been some more interest in that book now, and he believed it would appear soon. He continued publishing sections of it individually. By this time he had become friendly with Carl MacDougall (who he first met at Festival Late) and Carl was setting up a magazine called *Words*, which published new prose and poetry over the next few years, put on events and put into print early work by many Glasgow writers. Two chapters from *Lanark* appeared in issues one and six of *Words* in 1976 – Alasdair was paid £10 for each (approximately £100 in 2008 equivalent). Francis Head had several London publishers interested in the full

book by 1976, but all wanted it divided, similar to what Alasdair had originally suggested to Curtis Brown, only now into Books One and Three first, with Books Two and Four to follow in a separate volume. He refused. After all these years, why? Well, if you believe the man himself: '[M]y first marriage had collapsed in an amicable way, I had no need of money and was greedy for fame instead, so I refused them.'[63] But how can you be famous if you're not published? And he certainly needed money – this was Andrew's first year at Kilquhanity. The more likely explanation is that, despite his desperation, by now Alasdair really did think true fame was only possible if *Lanark* was published as one big, elaborate book which would impress readers even before it was begun.

If the book was going to impress, it would have to do so in spite of how neatly it fitted together. A footnote in the Epilogue by Gray's fake critic Sidney Workman hints at how the author's attitude changed on the question of format, despite the fact that he knew very well all his parts didn't go together perfectly. (This happened *within the text* of the book.) It is claimed by Gray that the character of Lanark is simply 'Thaw with the neurotic imagination trimmed off'[64] but Workman interjects with an inconvenient reminder: 'the fact remains that the plots of the Thaw and Lanark sections are independent of each other and cemented by typographical contrivances rather than formal necessity. A possible explanation is that the author thinks a heavier book will make a bigger splash than two light ones.'[65] Alasdair certainly had moments when he believed *Lanark* was more likely to have an impact as one volume, and moments when he thought he should split it up. But in July 1976 he decided it was best as one. He had to send it himself as Francis Head had become ill with lung cancer and died from it that month. This was a personal blow, but there was also a professional cost. There was now nobody working on his behalf. It made it more difficult to get attention: as Alasdair saw it, that was definitely the end of his career as a playwright. He sent the 'finished' version of *Lanark* to John Booth at Quartet Books and they turned it down. Too long, they told him. Too expensive to print. Would he not consider dividing it?

Despite a growing reputation as sometimes being difficult to work with, and precious about his plays, Alasdair did have some other work to be getting on with – he wrote his play *The Gadfly*[66] during a six-month period during which *Lanark* sat untouched and seemingly unwanted. Alasdair now says he 'sulked for half a year', subletting more rooms and painting. Art had taken something of a back seat during the Gray Play

Years, but he returned to it out of necessity: Andrew's school fees had to be paid, so he took a job as head of the art department at Glasgow Arts Centre in Anderston. He hated it and lasted three months before resigning his post: he wrote – '5th Feb 1977 – Leave Glasgow Arts Centre apart from afternoon old folks art class. (Not paid for it, but heartening and decent work).'[67] He was so angry about the treatment of staff by managers (and, in his perception, the apparent sacking of a number of them) that he even attempted an attack on the running of the place when he left, on behalf of those teachers who remained:

> It was a fiasco. Other members of staff asked me to draw attention to how rotten the place was being run. I wrote a detailed article and distributed it widely – I knew I was free from accusations of libel because it was all true – and I even sent it to the newspapers, and Lord Provost of Glasgow. But of course, nothing happened.[68]

This took up considerable time, and a large file of correspondence now at the National Library of Scotland shows Alasdair was angry about this for months afterwards. But when not angrily writing letters or distributing pamphlets denouncing the organisers of Glasgow Arts Centre, he used what spare time he had to build artwork around the text of *Lanark*. Andrew remembers that through much of this period his father was unable to make enough of a living to get by. This led to him working extremely long hours:

> He was almost always working . . . I never saw him short of a job, even when things were difficult – apart from maybe once. His lowest point was probably when he was nearly forced into a Post Office telephone job. He just couldn't get hold of any more cash. He was desperate, sometimes depressed – but never depressed when he was writing or painting . . .[69]

After the six-month sulk Alasdair had after the Quartet rejection, he sent his book to Canongate, the only Scottish publisher he was aware of.

Around this time, money was tight enough for Alasdair to be paid in meals for the 'Florid Jungle' mural he painted downstairs in the restaurant part of his local Ubiquitous Chip pub in 1977. This payment in food has become Gray legend but Alasdair has always remained matter-of-fact about it. He doesn't consider himself treated unfairly.

On the contrary, he maintains, the food was rather good. Soon after, things appeared to be looking up on the literary front. Stephanie Wolfe Murray, soon to become Managing Director of Canongate, Edinburgh, remembers how Alasdair came to the attention of this fledgling independent company, firstly because of her husband:

> Angus Wolfe Murray (one of Canongate's founders along with Robert Shure and me) discovered excerpts from *Lanark* in *Scottish International Review*, a magazine that I'm pretty sure was out of print by the mid-seventies. Angus was very impressed with it and started to make enquiries about the possibility of publishing it. He left the company though shortly after this so Charles Wild and I pursued it. It turned out that Quartet was interested in publishing the book but felt it was too long and wanted to publish it as 4 books. That was our opportunity to make our own offer and publish it as one book, which eventually succeeded . . .[70]

From Alasdair's end, he simply remembers Charles Wild at Canongate getting in contact to say he loved *Lanark*, that he and Stephanie Wolfe Murray wanted to publish it, and they were confident of securing funding from the Scottish Arts Council to help print it as a single volume. Applications meant delays, but there was hope. If he could just get by for a little longer, that might be enough . . . The following poem, 'Wanting', is from this period:

> I am new born
> I want to suck sweet and sing
> and eat and laugh and run and
> fuck and feel secure and own my own home
> and receive the recognition due to a man in my position
> and not have nobody to care for me
> and not be lonely
> and die.[71]

This poem, which was later published in *Old Negatives*, is still a Gray favourite. 'Wanting' appears serious, but in public he reads it in an increasingly frantic, comic way, his voice getting increasingly high-pitched until the final words are said in the voice of an old man feeling sorry for himself.

PEOPLE'S ARTIST AT THE PEOPLE'S PALACE

In 1977 Alasdair was delighted to get a steady job as Artist Recorder, working for Elspeth King of the People's Palace Museum. Over a short period Alasdair did more than thirty portraits of contemporary Glaswegians and streetscapes of Glasgow's East End as it was being redeveloped. He set about portraying his city's people in their natural settings: as with his murals, Alasdair greatly liked being an artist among people. One portrait was done in his local Pewter Pot pub, one in the BBC news gallery; Edwin Morgan was shown in his home. There was even one of Teddy Taylor, the Conservative Party MP. Some dealt with public figures, but most showed regular Glaswegians in their regular settings: the subtitle of the pen-drawing panorama 'London Road Looking West from Arcadia Street' (there were three of these) pointed out that four women in the picture worked at Templeton's carpet factory nearby. Well-known faces 'took their place with a construction worker, bartender, police constable, children and the unemployed in a set of drawings which were given a room to themselves in that year's "Continuous Glasgow Show" '.[72] The *Guardian* art critic Cordelia Oliver has not always been complimentary of Alasdair's art but she admired the range of his People's Palace work:

> Most artists, of course, are – or by their own limitations driven to be – content to specialise in one field of expression. They find, if they are fortunate enough, a way of working, a way of giving form to their vision, objective or subjective as it might be, which they can develop into a personal 'style' which then becomes familiar enough through repetition and greater expertise. But Alasdair Gray's all-enveloping imagination and intensely curious mind have together opened to him whole galaxies of subject matter which few, in our time at least, would even attempt to enter.[73]

It was exactly that all-enveloping imagination that appealed to Elspeth King. Alasdair's relationship with her remained strong, and later he would include her and the People's Palace in one of his most famous works, but unfortunately, in 1977, 'the wage under the government's Job Creation Scheme, while adequate for his own needs, was not sufficient to pay [Andrew's] school fees.'[74] He gave it up after only a short spell because he needed more money than the People's Palace provided – and because he had another job offer from Glasgow

University – though he did continue the People's Palace job in his spare time, unpaid, until it was done.

Around this period he visited Carl MacDougall, who he had also been painting.[75] He took the half-finished portrait along with him but also brought proofs for *Lanark*, which he had been editing. When Carl saw the Index of Plagiarisms – a long alphabetical list detailing everyone he had stolen ideas from – he asked Alasdair if he had considered using fake references. He says: 'Alasdair thought it was a great idea. But he thinks I said that I would like to appear in such a thing . . . [laughs] . . . I don't remember saying that! But once it was suggested we started setting each other off, laughing about the idea, which got dafter and dafter.'[76] The final version included some of their silliest ideas, such as the Robert Burns reference. He is included alongside this explanation: 'Robert Burns's humane and lyrical rationalism has had no impact upon the formation of this book, a fact more sinister than any exposed by mere attribution of sources. See also Emerson.'[77]

TUTORING IN A WESTERN EMPIRE

Philip Hobsbaum had the idea of bringing Alasdair to Glasgow University as a writer-in-residence. The position didn't exist at the time, but there was a small amount of funding available to the department and Hobsbaum, along with Paddy Lyons (who describes himself as 'merely the back-up boy'[78]) had Alasdair installed in the new post, which was loosely connected to the English Department. Paddy describes Alasdair's office in those days as 'nothing more than a broom cupboard',[79] in which he read the work of any student who came to him. The story of his dealings with one of those students shows how seriously he took the job.

Peter Mullan's encounters with Alasdair have been sporadic but illustrative. Mullan is now an internationally recognised actor, writer and director. As two prominent working-class Scottish socialists there are connections to be made between their careers, but the dynamic is the important thing. Mullan has lots to tell from the days when neither he nor Gray were public figures – he has never been a personal friend, but he has undoubtedly been near enough to see Alasdair in several different lights. Their first encounter was at the beginning of Mullan's undergraduate degree, during Alasdair's stint as Creative Writing Fellow in October 1977, when Peter was dabbling in poetry. He remembers:

I'd never heard of Alasdair Gray – none of us had – but I thought I was a poet, you know, so I went along. The first time I saw him, I chapped on the door, went in, and I remember him sitting there on his desk with a bottle of whisky in one hand – I don't know why but in my mind I have him cross-legged – and there was a mountain of books and manuscripts all around. Then there was that weird, high-pitched voice of his. Very strange. I remember understanding about four out of nineteen thousand words he said.[80]

Alasdair didn't rate Mullan's work, but he did see something he thought promising and invited him to an evening writers' group which Philip Hobsbaum attended but which Alasdair conducted himself. Mullan went along, though the two had little in common 'except working-class backgrounds and being part of middle-class institutions'.[81] Even the work they liked was different:

Alasdair was very supportive, but he was very enthusiastic about stuff I didn't rate. I thought what all these people were doing was decorative without substance, and hugely derivative. These were middle-class people who lived in books, and he seemed to fit into that mould. My world was politics, football, sex, history, philosophy. I felt I was ten years older than anyone there, and I didn't go again.[82]

The next Creative Writing Fellow after Gray was the playwright Marcella Evaristi.[83] Though Mullan says that at the time she was more well known than Alasdair, he remembers: 'She didn't have the same respect from the students, perhaps because of Alasdair's unusual enthusiasm.' Even though Gray had disliked his poems and shown himself to prefer work Mullan thought poor, there was still mutual respect.

SECOND PERIOD, AND FIVE FINE LETTERS

Gray not only tutored in the broom cupboard: he wrote, too. And it was enough space for him to be able to create the beginnings of what Bruce Charlton calls his 'second period' – the first being everything he made between the age of eighteen and the completion of *Lanark*. Charlton makes the distinction partly because this is when he embarked on a short story called 'If This Is Selkirk, This Must Be Thursday, Janine', intended

to be 'in the Russian manner, an inner monologue',[84] and other
ambitious pieces like 'Logopondancy' and 'Prometheus Unbound'.
The pick of these was 'Five Letters from an Eastern Empire'.

This short story is widely regarded as one of Alasdair's most accom-
plished. 'Five Letters from an Eastern Empire' is strong because it equally
balances Gray's two best talents: the ultra-serious and the ultra-playful.
This story of two poets living under a strict emperor's rule in a fictional Far
Eastern country was an ideal home for Gray's concise, understated, formal
language as well as his more fantastic, elaborate, tragi-comic side. In this
case, one complemented the other perfectly. For example, the description
of the emperor's palace: at first Gray appears to be describing the regime
neutrally, but in fact there are indicators of the response he wants. The
narrator describes the 'justice' system there:

> A shining black pagoda rises from the garden of irrevocable justice
> where disobedient people have things removed which cannot be
> returned, like eardrums, eyes, limbs and heads. Half a mile away a
> similar but milkwhite pagoda marks the garden of revocable justice
> where good people receive things which can afterwards be taken
> back, like homes, wives, salaries and pensions.[85]

Those punished are punished for ever; those rewarded are rewarded
temporarily. The difference between irrevocable and revocable justice
is small but crucial, and the narrator makes sure readers know it. One
syllable separates cruelty and kindness.

The plot is deceptively simple: the Empire has two poets, one tragic,
one comic, (Bohu and Tohu) who are kidnapped at a young age and
raised under a strict regime, with the plan that one day they will write a
single epic to glorify the emperor. The five letters themselves are mostly
penned by Bohu, the tragic poet, writing to his parents, who live in the
old capital, which is to be destroyed. Bohu wrestles with his poetic task
then rejects it, choosing instead to expose the emperor's regime for
what it is, though he is certain his poem will never be read by the public
for whom it is intended. Then he chooses suicide. The twist at the end
is Gray's cleverest trick, making a point about linguistic detail: instead
of being appalled at his treachery, the chiefs of the Empire are delighted
with Bohu's epic. They propose to change one syllable in the title
which will turn the meaning of the whole thing on its head. They will
even glorify the dead poet as one of the Empire's greatest citizens.

Bohu's poem is called 'The Emperor's Injustice'. By removing 'In' from the title, the chiefs have what they want.

'Five Letters from an Eastern Empire' proves readers cannot trust their information, especially that provided directly by the author. The title page claims it describes details of an obsolete nation: in fact, it contains lessons for current ones. Carl MacDougall has suggested the 'current nation' was Glasgow University itself:

> ['Five Letters'] seems to be about the business of being a writer in residence at a Scottish university, where, by and large, nobody has read anything you have written. Like many another with an office, financial security and time, Alasdair found the will was gone. He had nothing to write about and did what any sane man in a similar position would do; he read. And amongst Ezra Pound's Chinese Cantos he found the line: 'Moping around the emperor's court waiting for the order to write.'[86]

This makes the era sound duller than Bruce Charlton's vibrant 'second period', but Alasdair was in the job long enough to have sincerely felt inspired, bored, frustrated, excited, settled, unsettled, grateful – and inclined to write a jibe at the university. If Philip Hobsbaum realised the true meaning of the story then he shared in the joke, by helping to write 'The Emperor's (In)justice'.

Before the end of Alasdair's first year as Creative Writing Fellow he finally signed a contract with Canongate,[87] though even now there was more waiting. First a joint publication was set up with Lippincott in the USA; but then Lippincott got taken over by Harper & Row, resulting in more delay. Then Alasdair's American editors decided his punctuation was wrong throughout, changed it, and he went back and corrected it comma by comma: more delay. In the second half of 1978 Alasdair was still waiting for a definite publication date for his book. So he kept writing his fast-growing 'Janine' story and publishing locally, sometimes in unlikely places. One of these was through Duncan Lunan, who helped him to get a section of *Lanark* published by Gavin Roberts in September 1978 as editor of volume 1, number 2 of *Asgard*, the journal of *ASTRA*, the Association in Scotland to Research into Astronautics. Duncan remembers: 'It was the first fiction extract we published and there's only been one more since.'[88] Alasdair was keen to publish, anywhere.

The Print Studio Press was a writers' co-operative which worked from

its Glasgow base with a number of emerging names in the late 1970s. Its ethos appealed to Alasdair and he was keen to get involved. Print Studio published short fiction from Kelman, poems by Lochhead and a play by Leonard. There were others, too, such as Carl MacDougall and Brian McCabe. These were printed as twenty-four-page booklets, with each run at around six hundred copies. Alasdair joined the list with his old story 'The Comedy of the White Dog' – which is not a comedy at all, and involves a very dirty dog. As well as being one of his most quietly sinister pieces showing the darker sexual side to his writing, there were indicators in this republication of a two-decades-old story of the kind of things many readers would notice in Alasdair Gray's work in the coming years: a mixture of fact and fantasy, references to myth and classical literature, and a plot involving a bookish young man who suddenly proposes to a girl he hardly knows, then comes to the stickiest of ends. 'The Comedy of the White Dog' was printed alongside another old story, 'The Crank Who Made the Revolution', in 1979.

The next set of Print Studio Press publications was to include a writer of the next generation, Alan Spence, whose *Glasgow Zen* was advertised on the back of Alasdair's booklet (this became a bestseller some years later) and there was certainly a sense that there were enough writers producing good work to justify the enterprise – but they had difficulty getting reviewed by the press or accepted by bookshops. When they were accepted, they were rarely noticed because the booklets had no spine. Most of Alasdair's copies were eventually returned to him: instead of keeping every precious volume, Gray binned them.[89] Few believed in 1979 that his work was about to become valuable but Alasdair hoped for *something*. He wrote 'Awaiting' at the end of the decade:

> He was, and educated, and became,
> residing and remaining and intending,
> then on became in, and again,
> and later and later again.
> He still, and hopes, and intends,
> and may
> but is certain to –
> one day.[90]

Like 'Wanting', this poem was later published in *Old Negatives*, and also appeared in a more playful form in another book, *Unlikely Stories, Mostly*.

'Awaiting' suggests that this period was an uncertain one for Alasdair, but also hinted at how the poet enjoyed toying with his readers.

1979 was a whole year of unfulfilled expectation for Alasdair Gray: it was also the year of Scotland's devolution referendum. Gray had been a lifelong supporter of Scottish independence, and voted Yes to a Scottish Assembly on 1 March. The result disgusted him. It was close: 51.5 per cent Yes to 48.5 per cent No, with a turnout of approximately 63 per cent (only one-third of Scotland's population voted Yes). But 40 per cent of the entire electorate had to vote Yes to make the vote count. This outcome was a major event in Alasdair's life, and he says it resulted in a greater political element in his work – something which had a huge impact on his 'Janine' story. He even claimed that from this point on he no longer suffered from writer's block, though anyone who looks at his output during the 1970s will find it hard to believe he was blocked at all.

DIARIES: *Workalism*

Saturday 26 March 2005: Ex-Bishops and Tea

I have come to believe the definition of a workaholic is someone who wishes to labour when they are too unwell to stand. Alasdair James Gray, I was reminded tonight, is definitely one of these – he considers suddenly becoming an invalid an excellent opportunity to get things done. I confess to harbouring a shameful admiration for this stupidity, which will inevitably have consequences.

Alasdair phoned this afternoon and asked me to come over immediately. It is now 10 p.m. and while much of Glasgow is out celebrating the Easter Bank Holiday weekend I have just returned from four hours mainly spent typing a letter to Richard Holloway,[1] the ex-Episcopalian Bishop of Edinburgh, supporting Alasdair Taylor's artwork[2] and complaining about the lack of media attention a 1986 exhibition received. There were also letters of apology explaining non-attendance at events he couldn't go to because of the leg infection keeping him in bed, a charitable letter to the Saltire Society, an arrangement to record a radio programme and some discussion of resurrecting *The Popular Political Songbook*[3] idea.

On arriving, I asked about last week's working visit to Italy, but neither Alasdair nor Morag had anything positive to say about it. Every other event on the tour was a success but both only wanted to talk about the one that had been badly advertised, the rickety table they ate their dinner off,

the embarrassment of the booksellers who didn't know who Alasdair was or what he was doing there. Only when drinking tea – 'the cup that cheers but not inebriates!' – or dealing with the night's business did Gray cheer up. Tonight he was literally losing himself in work: sitting up in bed, piles of papers everywhere, dictating as he usually would from a chair – only in a vest instead of a paint-spattered shirt, extending a pointed index finger to the ceiling instead of at the screen. Alasdair's illness was only referred to when concerned friends phoned to ask after his health: 'Och, I'm fine, just fine. Finefinefine! Forgetit!' Then it was ignored again.

It was clear how unwell he was. While writing to a radio producer, asking him to come to the bedside with his equipment to record his voice, I realised we shouldn't be working at all, and that by obeying orders I was digging another small part of Alasdair's grave for him, brought ever forward by his stubborn refusal to slow down. Yet, what was the right thing to do? He doesn't need to be patronised by someone forty-three years his junior. Anyway, being bed-ridden seemed to make Alasdair happy. In this case, he was made happiest by using his status to advertise a friend who will not see recognition in his lifetime and may not get it afterwards.[4]

About halfway through our session Morag instructed Alasdair to 'put off as much as possible', but she also knew he couldn't be stopped. Moments later he insisted on going to the toilet himself – 'I don't like to burden other human beings with my whole body weight' he said – and I told him not to be a hero. This was my only statement of concern, but it didn't go down well:

'There's no danger of that!' he barked, virtually hopping to the bathroom, in considerable pain. 'I've never been one of those!'

I shall have to choose my phraseology more carefully next time. He avoids answering uncomfortable topics by paying close attention to exact wording.

Alasdair has an unidentified infection in his leg, originally mistaken for an eczema symptom, which has already taken him to hospital once this week and may return him there at the weekend. He should not be appealing to ex-bishops on behalf of other artists. He should not be making arrangements of any kind. He should be resting. When I left tonight he was starting to drift into sleep. In occasional, carefree moments, Alasdair claims a level of financial and critical recognition has brought him happiness; I am beginning to believe it has brought him to a guilty state whereby he feels he cannot complain about pain, but must instead write to the powerful of Scotland on behalf of those who cannot or will not speak for themselves

until he can no longer stay awake. This makes me feel annoyed and guilty, but I must trust him to make his own decisions. There's no guarantee I would be able to make better ones myself.

7 June 2005: New Strategy and Agnes

A few minutes after I left Alasdair's flat today, he phoned to suggest we take lunch together, to talk over some issues concerning my biography. It's strange that he should mention it at all – we've scarcely spoken about it recently, apart from when he asked, could I get on with this without bothering him too much please? I was free to use, borrow or steal what I liked, but he was too busy to think about it. That has always been the line. So I was unsure how to take this development.

Alasdair has a new strategy: over his usual minestrone soup, garlic bread and large glass of red wine (he doesn't need a menu; when the waitress heard he was on his way she put the order in without instruction), he explained he was going to give me a list of people from different eras that he thought would talk to me. This way, he hoped, 'you won't have to ask *me* any questions'. But the following hours were more productive than any traditional interview could have been. He gave me answers to questions I wouldn't have known to ask. Alasdair habitually divides his life into all-too-neat compartments of time that his life fits into: childhood, art school, Inge, Kersland Street, *Lanark*, Oran Mor. This is similar to the list of chapters he's currently re-ordering for the book of his life's artwork. He gave me names of people he thought would be useful while losing bits of minestrone in his beard, shirt, the table. He has an extraordinary memory for what he considers important. I don't think he's consciously trying to misdirect me, but hope to see past what he wants me to know.

The most striking thing about today's conversation was the amount of people he mentioned who are dead or dying. His matter-of-fact attitude to existence always seemed strange. I thought he might be hiding a fear of death, or blocking it out so the loss of friends and family would hurt less. But many of Alasdair's art school friends are gone now. Some of those closest to him are not well. One recently had a leg removed. One was on a kidney machine, another he mentioned may or not be still alive. He wasn't sure. They hadn't spoken to each other in a couple of years. 'But if he is still with us,' he said, 'I'm sure he'll be happy to talk to you.' The sheer number of deceased makes sense of his attitude, and reminds me why this book needs to be done in a messy, involved way now rather than in a tidy, distant way once the man and all his contemporaries are long gone. With

the mention of the first few dead friends Alasdair showed a little sadness, by way of a half-smile and glance into his minestrone. But no one can do the same thing ten times over one bowl of soup, no matter who has gone to the other side – so he calmly made recommendations in preference order: 'You'll need time for researching most interviews, of course,' he said, 'but some friends and acquaintances may not live much longer. [in a low, slow voice] Perhaps you should see them right away.'[5]

On returning to the house we found Alasdair had been asked to write a *Sunday Herald* review of his favourite Scottish book from a prepared list of the supposed one hundred best.[6] He said he would only do one if Agnes Owens qualified – he believes she is consistently neglected – 'perhaps because she is elderly and lives in a Balloch housing scheme' he told the journalist.[7] Her novella *For the Love of Willie* made the cut so he put the phone down, searched out his copy and began work. He spent the rest of the afternoon, at a rate slower than one word a minute, dictating a succinct 190-word review. The wish to do Agnes justice made him panicky about exact wording, even more than with his own work: while he fretted over one sentence I read several chapters of the novel. Finally we finished, and Alasdair felt better. I came home and fell heavily asleep, exhausted by inactivity.

15 June 2005: Rewrite

The day after. Arrived at 10 a.m. to discover Alasdair had misheard the directions of the journalist. It was 900 words, not 190. We spent the day rewriting the Agnes review.

10 November 2005: A Canary in Disguise

A message today from hospitalised Gray. My last piece of correspondence was an apology for a recent bad mood when I visited him a few days ago. In a postcard packed with health information (he was due to finally come out of hospital the following day) Alasdair summed up his latest period of illness, which reveals much of what he considers important: .

My Very Dear Sir Harry* –
 I will be home tomorrow, maybe for good. District nurse care and out-patient hospital should not deter writing and in-house painting. My recent three months of being hospitalised for all but

* RG's full name is Roger Paul Harry Glass. AG sometimes prefers to use 'Harry'.

two weeks have allowed a lot of useful thought & scribbling &
dictating to Helen Lloyd, the completion of an essay for a *Divided
Selves* art book (now accepted with thanks); good work and
research for 'Kidnapped' introduction, good ideas for *A Life in
Pictures* . . . I did not notice any bad mood imported with your
recent visit. Your habitual bright manner in company quite hid it –
a manner which, in Robert Louis Stevenson, so enraged his wife
that she once denounced him as a canary.

 Truly, AG.

As much as I would have liked Alasdair to notice my last bad mood, I
am too pleased to be compared with a denounced canary to be
bothered. How easily flattered I am. How stupid that is. And this list
of what Alasdair has 'achieved' in the last three months reinforces what
I have an unending capacity to forget – that he sees rest and recupera-
tion as things that get in the way.

17 November 2005: Stevenson and Melville
Phone conversation to arrange next meeting. Discussed the canary
reference. Gray then repeated Stevenson's conversation with Herman
Melville about the canary argument between him and his wife. It took
nearly ten minutes. If I wasn't sitting in a service station car park I
would have gone straight to the archives to check if he'd got it right,
word for word. Sometimes I think he just makes this stuff up.

21 November 2005: A Recommendation
Today Alasdair phoned my mobile to arrange our next meeting while I
was standing in the middle of a fierce storm, waiting for a bus:
 'I'm enjoying digging around,' I shouted, trying to hear myself above
the downpour. 'It's hard to describe . . . but . . . I er . . . recommend you
start a biography of someone. I've found your life to be a lot of fun.'
 'Fun?' he says, astonished. The reception cut out for a moment, then
returned. 'Well . . .' he continued, joining in at volume as if he too was
standing in the rain. 'The point is . . . *IT DIDN'T SEEM LIKE
MUCH FUN AT THE TIME!*'

9 December 2005: Seasons Greetings (Again), and New Ideas
I arrived for a day's file sorting to find Alasdair had left the flat a few
minutes ago, to duplicate his design for this year's Gray–McAlpine

Christmas card at Mail Boxes Etc, having forgotten he'd asked me to
come over. This meant him hobbling down the road, bandages and all,
in the freezing cold – a potentially life-threatening trip in icy weather.
At the door Morag explained Alasdair had been expecting me but got
distracted by the card design, then became sure I was coming on
Monday instead. I asked Morag if she'd like me to pick him up in the
car so he didn't have to come back up the hill – and to be sure he
couldn't escape from a few hours of giving me access to his files:

'He said he was just going to get photocopies, but I suspect him of
having . . . *other ambitions*,' she said suspiciously.

I found Alasdair limping along the street and ushered him into the
passenger seat, explaining that Morag was worried he might not come back:

'She thought you might have other ideas,' I told him. 'You know . . .'

Alasdair chuckled, eye twinkling: 'Are you suggesting I might have
visited a *public house*? Well. I see. How dare she. It's only 11.30! But . . .
the point is . . . I . . . *may* have thought about it.'

'Are you upset I came to get you?'

'No no no. It's just . . . I would have liked the exercise.'

So I dropped him six doors from his flat. How much exercise can a
man of seventy need?

Once inside the house he went straight to the archives, as agreed.
Most of the afternoon was spent with Alasdair sitting, bandaged leg up
on a nearby chair, with a pile of papers on his knee. The Gray cabinets
are stacked full, and though from the outside everything is neatly
categorised, on the inside they are anything but. Our current arrange-
ment (as he wants to have a diary-style document, extending the Magic
Red Box past 1986 to the present) is to hand me over any papers with
relevant dates on them – letters, posters, calendars, etc. – and we don't
mention I am going to use the evidence. Alasdair was delighted to
come across, under a pile of bills in the 'Personal Business' folder, a
letter concerning a criminal matter, with reference to Alasdair's arrest in
2001 when protesting peacefully[8] – he likes to have a good laugh at the
prospect of having a criminal record, and being considered a risk to
Queen and country. I pocketed the letter and we continued. Each
piece of paper Alasdair came across was a surprise. The 2001 letter from
the police saying they've decided not to prosecute was followed by an
emotional one from an old friend, followed by the schedule for the *Poor
Things* American tour of 1992. Each discovery set off another memory
in his mind, which could make him happy, or sad, or thoughtful. It was

like a mood lottery when his eyes met the next piece of paper. In the next two hours I got monologues on: the Hell sermon in *Portrait of the Artist as a Young Man*, Lucifer as God's first Prime Minister in Heaven, running out of money after *The Book of Prefaces*, and offending Muslim fundamentalists.* A while later he picked up the *Poor Things* schedule again: 'You'll come across these kinds of things yourself one day,' he said thoughtfully, flicking through the itinerary, past radio interviews, readings, lectures and visits to universities that constituted the tour. 'Then on another day you'll forget what happened . . . and on another, you'll realise the general public have forgotten it too.'

Since typing early chapters in the spring, I have been keen to get Alasdair thinking about his new novel. If I could operate him with strings I would make him work on it all the time. So whenever he mentions *The Gadfly*, his old Socrates play due to be converted into the first section of the new book, I draw out all the information I can. Alasdair reminisces at length about Granada's 'For God's Sake' series about religious trials this play was originally written for. He had written a play for it before about Henry James Prince,[9] but 'buggered it up',[10] and explained why he decided to write *The Gadfly* next, a play about Socrates: 'I thought, I'd rather deal with someone more humorous and relaxed in his views about God and the state and aw' that.' Nearly three decades later he is converting it into part of a novel. I asked Alasdair if there were any old plays he hadn't yet converted into fiction. He thought. He closed his eyes to concentrate. Then opened them and said in a tone suggesting he was rather surprised at this turn of events: 'I think I'm finally running out.'

'Do you still get any new ideas?'

'Some . . . but they come very slowly.'

'Have you thought about a new play?'

'I gave David McLellan [of Oran Mor Theatre] some of my old ones for consideration, but I don't like to embarrass him by mentioning it.'

'They only put on new drama. What about something new?'

'I have so many things to do . . . but I do have *one* idea. There's not much of it yet . . .' For twenty minutes he described an idea in great detail, then said, 'It's not ready.'

'It sounds bloody ready to me.'

* AG said of these press allegations: 'It was pointed out years ago that the Bible is not the story of very good men – all I did was repeat that.' It was particularly his description of Abraham as a man who prostituted his own wife that upset some Muslims and at least one senior rabbi.

I nearly pushed him round to the computer right there and then and said: 'Dictate!' But I'd forgotten that a few minutes before I'd wanted him to only work on the novel.[11]

Some say Gray's attitude to his career as a playwright is defeatist. He seemed genuinely surprised at the suggestion that anyone might be interested in his plays, but ten minutes later we were jotting down ideas for the book of plays he has never released. As well as the unreleased ones that were performed or recorded for radio or TV there's an opera libretto that has never been seen (called *The Rumpus Room*, also written in the 1970s) and a few other suggestions too. This week eight complete plays are going up on Alasdair's website, free. It hadn't occurred to him that anyone would be interested in paying for them. Sometimes his lack of self-confidence is staggering.

After writing a letter to his agent challenging her to get him a deal for *The Plays of Alasdair Gray*,[12] Alasdair seemed refreshed. He dug into an old file of family photographs and pointed out some favourites – I squinted to try and get a good look at the single surviving one of his mother, photographed wheeling baby Alasdair along the Ayr seafront with his aunties in 1935. But she remained a mystery. He said all his other photos of his mother were given to the National Library for safety, and nobody there seemed to know where they were any more.[13] But his mood was too good to be dampened by lost photos. When I left the flat after the day's work with a stack of paperwork and promised to be back next week, he seemed cheerful but also thoughtful. Perhaps once the door was closed he might begin that new play. Some *new* work – not a retrospective, not a reworking of an old idea, not a transformation of one form into another, but something entirely fresh.

11 January 2006: Organisations, and Hospitals, and Great Alcoholics of Our Time

Purchased Dictaphone this morning, on Gray's request: suspect he might actually want me to get his life *right*. A troubling development. We arranged a chat for today.

Alasdair's health is much improved. Though his leg is thin and weak, the infection has finally gone down and he is no longer bandaged. Soon he will return to work at the Oran Mor. This morning we sat in the lounge while Alasdair told me how *A Life in Pictures* has been going. Though the listing, scanning and reproducing of hundreds of pictures (over three hundred so far) bored me, I'm sad not to be involved in it

any more. The work seems to be progressing well – so Alasdair has focused on other frustrations. Standing in his hallway, ordering the incoming post for the other inhabitants in his building, Alasdair scratched his head furiously and stammered, trying with great effort to describe a disagreement between him and Canongate, with regard to being required to provide regular updates on *A Life in Pictures*:

'The problem with most organisations these days,' he said, 'is their preoccupation with the American model . . . where *assessments* are continually going on . . . to make sure that underlings are always on their toes. These remind them they're being watched. Managers need to have *developments* for weekly meetings . . . presentations . . . to consider the *Christmas market* – I wish they would just leave me alone to DO IT!' There is paperwork going back nearly a decade for this project, so it is understandable that Canongate want to know when the book will be finished. But Alasdair doesn't see it that way.

This grumble brought to mind a past negotiation over a proposal for *How We Should Rule Ourselves*, when Alasdair briefly thought Canongate wouldn't take the book[14] and offered it elsewhere, discovering in the process that publishers were not willing to just take his word that whatever he ended up doing would be good. He stomped around the house demanding, 'If they want proof of what I'm going to do then *they should look at the books I have written already*!' He has no patience with jumping through publishers' hoops or having to deal with practicalities, which is understandable after all these years. But it's amazing how many writers either have no knowledge of the publishing industry, or simply despise it. In a September 2005 session, when we were working with transparencies for *A Life in Pictures*, suddenly bored of numbering pictures, he stood, hands on hips and said:

'If I was a genius, I would have other people to do this for me!'

'Alasdair,' I said, '*I* am doing this for you. Partly.'

'Yes. Yes you are. But then . . . *WHY AM I DOING IT TOO?*'

In the car on the way to hospital today we listened to the Radio 4 programme *Random Edition*, which takes an old newspaper (today a Liverpool daily from 1924, the week Big Ben first chimed) and explores the stories in it. This was the time of the first minority Labour government, one of Alasdair's favourite subjects. He listened intently, bringing his ear closer to the car radio, though not the speakers. At the mention of the word 'endemic', he asked Morag what it meant, and as always, she knew. They both enjoy Morag as walking dictionary/thesaurus/proofreader,[15]

and she's usually more likely to know the meanings of things than he is. After settling on definitions of 'endemic' (a disease always present in the population), 'epidemic' (a disease rapidly spreading across the population) and 'pandemic' (it's coming to kill us all!), Alasdair's attention drifted back to the programme. At the mention of an 'eight-bob pension' the two of them argued about whether one bob was worth one shilling. Again, Morag was right. Alasdair sighed and said: 'Always making mistakes.'

The hospital appointment was encouraging. The doctor said it might be a year before Alasdair's leg fully recovers, but now only a stocking bandage is required, and he is limping less. So, to lunch. On the way we discussed Morag's *Lennox Herald* crossword-writing job. She's encour-' aged to relate clues to positive news recently documented in the paper. 'It would be better if she was permitted to write about the bad stuff,' said Alasdair, tickled at possible clues he preferred to the usual local fare: 'Reviled wife-beater, six letters!' he cried. 'Rats breed here, four letters!' Morag went to buy a copy of the latest edition from which to glean next week's puzzle, and returned. The headline on the front page was 'Addict Shoots Up in Cinema – Real Life Horror Show as Mum Looks On'. Not much to laugh about there, then.

Over lunch Morag explained her recent refused request for a pay rise, and how questioning the decision resulted in her discovery of what the other crossword writers at the same company got paid: £15 per week, £10 and £3.50 respectively. Morag gets £30.[16] This says something of her ability to fight her corner. Letters of complaint to book distributors; haggling with tradesmen who haven't turned up on time to fix the dishwasher; grumbling about the local supermarket's inability to keep to her exacting standards. Alasdair rather enjoys this quality in his wife. He is personally too eager to please to complain about day-to-day matters and gets the pleasure of surly, unbending objectionableness vicariously. At lunch (just the minestrone now – he is under strict instructions to lose weight; no buttery garlic bread, no red wine) Alasdair sat quietly while Morag talked. This is rare; hearing Morag's stories of the incompetence of pretty much everybody since the beginning of time, Alasdair slurped soup cheerfully, only breaking off to say 'Quite right!' on six occasions in seven minutes. Once food was finished we were back to the usual state of affairs, with Alasdair talking more than the rest of the lunchtime rush put together.

He's the great British History teacher I never had. We share an interest here, but where his head is filled with the details of hundreds of years of

international comings and goings, mine is just a bit of information about Nazis, Communists, a muddle of kings and queens and a lingering resentment that I was taught none of what I wanted to know. But because Alasdair rarely reads the news or recent books, I provide a very ordinary political update he might not always get elsewhere, and he replies with nuggets from the past which usually illustrate that not much changes – just the way society responds to the same old crap. I love a good political leadership contest, no matter the team, and while eating I excitedly told Alasdair about the recent one in the wake of the demise of Liberal Democrat leader Charles Kennedy, because of his alcoholism.

I try to avoid the 'A' word: Alasdair knows he can only drink so much or else he'll die (so won't be able to work!) and his current level is certainly lower than it used to be. Also, drink has never stopped him from being a writer or artist, at least not in an obvious way, though it has certainly affected some of his relationships. The drink might even help sometimes, though along with the many endearing Gray drinking anecdotes I have also heard some harsher ones that show up the more arrogant side of his personality. Sometimes I wonder whether I should address this issue. I might yet. I am aware of excusing the drinking as a standard part of being a writer.

After our Kennedy conversation, instead of talking directly about recent events (he is always happier dipping into the past), Alasdair pointed out that Britain's most popular politician, Winston Churchill, was an alcoholic for many years, and certainly was while a Prime Minister battling Hitler. In those days it was indecent to refer to such things. Now, in supposedly more understanding, therapy-obsessed times, it triggers political downfall. Skipping centuries mid-sentence, Alasdair explained the details of the Prime Ministerships of several alcoholics with their hands on the steering wheel of power as if he was there himself. I suspect he enjoys the little indulgences of Britain's past rich and self-important more than he disapproves of them. While Morag gazed out of the window (heard this one before?), Alasdair told, in great detail, how William Pitt the Younger entered the House of Commons one day with a hangover and tried to get through Prime Minister's Questions without vomiting to the side of the dispatch box, failing spectacularly.

After this story, there followed a series of political anecdotes about old boys' clubs, and politicians who fought each other in the Commons then got drunk together after work; gambling, fighting, sharing mistresses. Not too different from the twenty-first century, then – which is

his point. All Gray's political books open with an extended section dedicated to the events of history: we make the same mistakes repeatedly, he suggests. Margaret Atwood made the point when she wrote, 'Those whose houses burned, burned houses', documenting how Scots driven from their homes in the Highland Clearances promptly went over to Canada to do the same to others. For Alasdair too, the answer to most political questions is to be found in the lessons of history. So though listening to him discuss modern problems is sometimes like listening to a computer programmed to blurt random facts from the last one thousand years – most left unfinished, most bastardised – this behaviour actually makes some kind of sense. Alasdair finally comes to the end of an anecdote about corruption with the climax, 'And I can tell the honourable gentleman that I could not have been in the bar he suggests last night, because *I was in bed with his wife*!' All his stories are fictionalised to some extent, I'm sure. Could a perfectionist help telling an imperfect story if it would improve the punchline?

24 March 2006: Embrace the New

Today saw the arrival of Gray, at the grand old age of seventy-one, into the world of blogging. Once it was explained that he no longer needed to wait for publishers to release his work – he could put it to the world as soon as it was done! – before even! – he dived right in, using as his I-dent a stern self-portrait with caption alleging he has been captured 'in a mood of exceptional gaiety'. The Gray blog opens with a copy of a letter to Mr Brown, Chancellor of the Exchequer and Prime-Minister-in-Waiting, about tax, written on 6 March. It is now the 24th. Why no reply, Gordon?

30 March 2006: Nobody Takes Me Seriously

A few days ago Alasdair added two and a half thousand words of pro-Riddrie propaganda on to his blog. Today he added another telling piece, this time to Stuart Murray, about his recent cartoon book on street beggars in Glasgow. (Morag had given this to him.) It was a genuine reply to a request for help, but now when Alasdair realises he is saying something he wishes many people to hear, he asks Helen to put it on the blog. Three in a week now. There is a revealing ending to the letter, which started as an apology:

Alas, although sometimes referred to as an influential kind of chap, nobody in authority takes anything I say seriously. Fellow writers

do, but they have no political power and like me are mostly family
people whose erratic incomes amount annually to no more, and
sometimes much less, than the national average . . . I am sorry I can
only talk on your behalf but you have the copyright of this letter,
show it to anyone you like.

If Alasdair talks or writes about anything for long enough, he returns to
childhood, to politics, dreams of power. He must have read this book for
pleasure, but to Alasdair, everything, everywhere, all the time, is work.

26 September 2006: The Art of Directing Conversation

On 8 September I got a message from Alasdair requesting a 'business
lunch'. The e-mail read: '*Men in Love* is shaping into more of an
autobiography than I first expected . . . You had better absorb its
contents before shaping your biography.' This was then contradicted
by a lengthier message on the 11th:

> It was a slip of my tongue to say that *Men in Love* was containing a great
> deal of autobiography. I meant to say *A Life in Pictures*. The novel's
> autobiographical elements are only in using some people I know as
> acquaintances and correspondents of John Tunnock [main charac-
> ter]. He and I are both very literary Scotsmen but I have not extended
> pressing invitations to young things since I was one myself.

A phone message a couple of days later said that, actually, the *novel* was
getting biographical too now. Sometimes it's hard not to suspect he has no
idea what he's doing. This rumoured autobiographical work never
appeared, and today, when Helen arrived at the restaurant a few minutes
before Alasdair, she told me he would not be bringing it with him now
either. But lunch was a revelation anyway – astonishingly, he ate the
lemon in his water, rind included; remarkably, he recited an extended
passage of Burns *before* the first wine of the day; and at one point he shouted
'I was broadcasting my sexual frustrations TO THE WORLD!', causing
most of the people in the restaurant to turn around with either interest, or
horror.[17] It was not a wasted meeting.

Many who have known Alasdair well have, over the years, tried to find
ways of directing his conversation to save themselves hours of waiting for
him to get to the point. I have watched the eyes of even his closest friends
glaze over as one of his brief anecdotes winds its way slowly to an end,

turning into a lengthy story, then another – perhaps via a quote or an extended summary of an old play, replete with impressions – before he apologises, then sets off on another digression. This can be infuriating, and it's hard for others to get a word in edgeways, even to laugh, or encourage, or question. But for the Gray biographer these windings are essential ways to fill in the blanks of his life, as he sees them. When Alasdair has been concentrating on work, and is given a good opportunity to speak about it, listening to him is like opening up his brain and watching the contents spill gloriously on to the table. These thoughts were conversational stepping stones to discussing *Goodbye Jimmy*, due to be staged for the first time from 9 October in Glasgow, then for a week in Edinburgh, which he is very excited about. He explains how he has been greatly encouraged by finally getting his first play staged for ten years – 'I believe I can do that, now' he says, sounding surprised – and how he has since written another.[18] But trying to draw anything out of him with regard to his ambitions as a playwright is useless.

Twenty minutes after the start of the story of his awakening to drama, with much of his lunch still sitting cold and increasingly soggy before him, Alasdair finally got round to explaining that his inspiration came largely through listening to radio plays in his early teens – but that came via an exploration of various translations of Goethe's *Faust*,[19] comparing the Louis MacNeice[20] version he heard on the radio as a boy[21] to more recent ones, suggesting he saw flaws in all that he could repair in a new Gray version. As I wondered what he was leading to, Alasdair quoted by heart from MacNeice's *Faust* that he first heard nearly sixty years ago, then edited it as he went along, suggesting, for example, that references to theology could be omitted in a modern version, *as no one took that kind of thing seriously any more*. Alasdair suggested that by noting what the different English versions had in common, he could work out the meaning of the German, and go about translation backwards. He imagined much of the proposed text out loud, getting increasingly animated at the prospect of mastering the project. Then, he looked shame-facedly at Helen and said, 'But I know I must finish other projects first.' He could have simply said his new play had given him renewed enthusiasm for drama, which first started as a boy listening to the BBC. But that would hardly have been as much fun. He is still impatient to get on with new works. No tiredness, no cynicism, no been-there-done-that about him. Too many ideas, not enough time.

5 1980S: A LIFE
IN PRINTER'S INK

LANARCOSIS ILLUSTRATUS: *AN*
*ASSESSMENT OF **LANARK** IN FOUR PARTS*

Alasdair Gray now says his debut novel is grossly overrated – he claims it only dominates contemporary fiction in his home country because it came 'at a time when Scottish Universities were ready for it'.[1] When it was voted the Third Best Scottish Book of All Time in 2005 he said: 'Haha! Nonsense! I'd only put it about eighth or ninth!'[2] But the following investigation is longer than with any other Gray book in this biography. If what Alasdair says is true, then why give *Lanark* such prominence when there is so much else to address? Because whatever the author's opinion (and we should not be too quick to believe his protestations), *Lanark* is a unique achievement. It is his most popular and enduring work, its release was the crucial turning point of his life, much of the text documents that life and its publication represented the culmination of several decades of effort – a significant chunk of Alasdair Gray's time on earth. He wasn't ready for *Lanark* in 1951 when he created his alter ego Obbly-Pobbly, in 1958 when his chapter 'The War Begins' came runner-up in an *Observer* competition, in 1964 when Book One was rejected by Spencer Curtis Brown, or even in 1973 when Quartet Books optioned it. As a boy he had noticed his works were childish and wished for a life's experience in order to be able to represent a convincing life on the page. By 1981, he had lived, and was ready. Gray has called *Lanark* 'a Scottish petit-bourgois model of the universe'[3] but what does that mean? As one of Gray's alter egos grimly claims, all reports simplify and twist. So, at the risk of simplifying and twisting, here goes.

1: Story. *Lanark* is the story of Duncan Thaw, born into mid-twentieth-century Glasgow and transported in adulthood to Unthank, a hellish version of the city where he calls himself Lanark[4] when he can't remember his name. The unchronological story begins with the Un-thank strand (Book Three), introducing a cast of characters which will be partially replicated in both worlds. At the start we find Lanark searching

for love and sunlight, both seemingly rare commodities. Next, the story rewinds to Thaw's youth in Riddrie and at art school (Books One and Two) then skipping to the end (Book Four) with Lanark's big political opportunity. And, if the darting around in time isn't enough, the author has made Thaw/Lanark a very disagreeable character to spend four books with – he is a stubborn, guilt-ridden, humourless intellectual, self-pitying in the extreme, and is often too self-obsessed to even notice other people coming and going from his life. But at least he is created honest. Thaw/Lanark is certainly Gray's candid alter ego – but then, as Philip Hobsbaum said: 'In one guise or another, Gray is always his own hero, and personal experience is his raw material.'[5] If, despite all their faults, his heroes are lovable in some way, this comes from a kind of self-love.

Thaw and Lanark struggle in their respective societies because they will not conform unquestioningly to rules, but they do the same things for different reasons. Lanark is a man who does not want much from life: just a little brightness, a little affection, and occasional peaceful contentment, whereas Duncan Thaw has bigger ambitions. He wishes to escape his ordinary existence 'to write a modern Divine Comedy with illustrations in the style of William Blake'.[6] So when Mr Thaw excitedly describes a dull, workmanlike future as a professional to his young son, Duncan breaks down in tears. When he finds his art school dream is to be spoiled by compulsory still-life drawings and dry, uninspiring tasks, he reacts by opting out of formal training and paints the Seven Days of Creation on a Glasgow church wall for free instead, even when he discovers it will soon be knocked down. Nothing in his life seems easy or enjoyable:

> 'It's all examinations!' cried Thaw. 'Must everything we do satisfy someone else before it's worthwhile?' Is everything we do because we enjoy it selfish and useless? Primary school, secondary school, university, they've got the first twenty-four years of our lives numbered off for us and to get into the year above we've to pass an exam. Everything is done to please the examiner, never for fun. The one pleasure they allow us is anticipation: 'Things will be better after the exam'. It's a lie. Things are never better after the exam. You'd think love was something different. Oh, no. It has to be studied, practised, learnt, and you can get it wrong.[7]

Both protagonists grapple with having the bad news of life explained to them and both fail to accept it, but there is a key personality difference.

Thaw *thinks* life instead of living it, and Lanark *does* life without thinking it.

The cities of Glasgow and Unthank are the same, despite illusions otherwise. Describing Glasgow in the fifties, Alasdair has said he felt 'you had to reach out for all the light you could, because of the smog and long periods of darkness, especially during wintertime'.[8] The old, industrial Glasgow Alasdair saw then is very similar to the one he made in Unthank. The trams described there, for example, are 1950s Glasgow trams. The Elite Café, where the early action takes place, is based on 1950s Glasgow cafés.[9] Readers are reminded that the Thaw story is 'contained within the hull'[10] of Lanark's, so it is Lanark we finish the book with. His search leads him deeper into a relationship with a woman called Rima, who joins him on a long journey to a place where they might be happy. But they keep getting redirected, distracted, they keep making mistakes and disagreeing. Eventually, they separate.

Before the climax of the book, Lanark walks into a room and meets his author. (As Gray reminds us, this trick is not unique – one of his favourite authors, Kurt Vonnegut, used it in his novel *Slaughterhouse 5*.) They discuss the ending that has been planned and then begin a section where Sidney Workman, Alasdair's fictional critic, annotates the actual text of the book, inserting footnotes, analysing what 'the author' is trying to do, as he is trying to do it. Amongst this there begins something which has become one of Gray's most famous tricks, his Index of Plagiarisms. Supposedly written by Workman (but actually written by Alasdair, with Carl MacDougall), this is a long alphabetical list of which ideas Gray has stolen for his novel, and who he has stolen them from. Many of the key literary people in Alasdair's life – Morgan, Kelman, Lochhead, Leonard, Hobsbaum, Ure, Hind, MacNeacail – appear in the Index alongside the great figures of world literature, and some of Alasdair's popular favourites. Shakespeare, Kafka and Joyce are in there alongside those who shaped Gray's imaginative childhood life the most: Blake, Walt Disney, Joyce Cary. By putting these names together and quoting their work he is saying that he believes they happily intertwine, that *for him* they are equally important. Contemporary Glasgow is every bit as relevant as anywhere, anytime.

When the Index and footnotes end, so does the conversation between author and protagonist. Thoroughly deconstructed, confused and angrier than ever, Lanark steps out of the meeting and returns to the life which has been laid out for him, and the prison of the novel he has been

created to live inside. There is no happy ending for Lanark and Rima, but amidst the escalating political turmoil and Lanark's unlikely political role, they have a son called Alexander, and Lanark enjoys one moment of contentment with his son. By the end of the book he has become an ordinary, slightly worried old man 'glad to see the light in the sky'.[11]

2: Style. At first look, *Lanark* is confusing. It runs to four books, a belated prologue (later exposed as a separate short story), an epilogue (which comes before the end) and the Index of Plagiarisms (full of lies and in-jokes). It boasts stealing from everything from Shakespeare to the Bible, starts in the middle, features a mournful Oracle who speaks out of quotation marks and, as we've seen, contains repeated intrusions by a character called 'the author', Gray himself, portrayed here as an eccentric middle-aged man with a faintly nasal accent who wears 'an apprehensive, rather cowardly expression'.[12] It openly attempts to glue *1984* and *A Portrait of the Artist as a Young Man* together in a Glasgow setting; it is fantastic and realistic, elaborate in form and succinct in language, and is arguably Scottish literature's most ambitious, sprawling work.

Books One and Two are mostly an autobiographical account of Alasdair's youth – although these are exaggerated, there are exceptions, and he is always very careful in interviews to make clear that he had never hired a prostitute or committed suicide.* The Thaw sections alone tackle the biggest themes: family, religion, love, nationality, class, belonging – but Gray does not condescend to his readers: he stands beside them, looking at the words and pictures, as they do. Precision in language sets it apart, also precision of speech. Characters say exactly what they mean, no matter how hurtful or inconvenient that may be, something that has since become an indicator of much of Alasdair's best writing. Sentences are cut down to the barest elements and ordinary, short words convey maximum emotion. This creates a parallel universe – one where questions are answered directly and language is used for true communication.

Another stylistic feature is how Gray personifies Glasgow. He portrays his home as it is – ugly and beautiful, depressing and inspiring – a real city. When Thaw's friend calls it 'magnificent' and asks Thaw why people don't notice that, he replies:

* This 'admission' handily avoids the question of possible murder in the plot of Book Two. Is Gray trying to tell us something else?

'Because nobody imagines living here,' said Thaw. McAlpin lit a cigarette and said, 'If you want to explain that, I'll certainly listen.'

'Then think of Florence, Paris, London, New York. Nobody visiting them for the first time is a stranger because he's already visited them in paintings, novels, history books and films. But if a city hasn't been used by an artist not even the inhabitants live there imaginatively. What is Glasgow to most of us? A house, the place we work, a football park or golf course, some pubs and connecting streets. That's all. No, I'm wrong, there's also the cinema and the library. And when our imagination needs to exercise we use these to visit London, Paris, Rome under the Caesars, the American West at the turn of the century, anywhere but here and now. Imaginatively Glasgow exists as music hall songs and a few bad novels. That's all we've given to the world. That's all we've given to ourselves.'[13]

It is a testament to the effect of the book that this, one of *Lanark*'s most famous passages, may seem out of date to readers familiar with modern Glasgow. If that is true, it is partly because *Lanark* was written, received, and understood.

3: Release. *Lanark* was finally published by Canongate in February 1981, nearly thirty years between first idea formed and first copy sold. Alasdair felt transformed by the release of his book, which was dedicated to his son. He has said:

> For a while before I held a copy I imagined it like a large paper brick of 600 pages, well bound, a thousand of them to be spread throughout Britain. I felt that each copy was my true body with my soul inside, and that the animal my friends called Alasdair Gray was a no-longer essential form of afterbirth. I enjoyed that sensation. It was a safe feeling.[14]

The busy lunchtime launch took place on a rainy day at Sauchiehall Street's Third Eye Centre, 'which at that time was an incredible gallery with a reputation to match it'.[15] Many of the people in Alasdair's life were there, many of whom had known this book was coming for years, and a good number of whom would go on to make their own contributions to the cultural landscape in following years – alongside artists, publishers, agents, critics, broadcasters and novelists there were

also poets, musicians and comedians present – even Billy Connolly came along, which caused a stir in the room. Some who attended the launch were featured in the book, though they didn't know that yet. Alasdair's sister Mora came up from Hertfordshire for the event, too. Carl MacDougall remembers there was 'a sense of relief that it was finally being released – Alasdair had been let down so many times'.[16] There was relief for Canongate, too, especially Stephanie Wolfe Murray, who had invested hugely in *Lanark* and had almost as much to gain or lose from it as the author. The book was a massive risk, as Stephanie remembers: 'Canongate was a pretty impoverished company; we were always struggling.'[17] But she was delighted with how the day went: '[T]he book had had a reputation for years and now it was suddenly happening. I cannot think of any book launch that was more thrilling.'[18] But this thrilling new author was not too afraid of adverse reception to share a joke with his readership. The first edition of *Lanark* came with a bookmark (written by Donald Saunders, Gray claims) which read:

from
BOOKS AND THEIR TREATMENT
Your queries dealt with by
A Doctor of Literature

– I think I have caught *Lanark*. What can I do about it?
Distraught, Islington
– This is perfectly natural at your age. *Lanark* (*lanarcosis illustratus*, also known as Gray's Syndrome) is usually the result of careless contact with booksellers. First signs are the dilation of the pupils, sometimes followed by a painful parting with money. If caught in the early stages, there is seldom any danger of permanent disfigurement, but once the person becomes what we doctors call a 'carrier', the condition can be easily passed on. Indeed, minor epidemics are not uncommon.

Because it is widely regarded as a social disease, those infected may be reluctant to confide in even distant relatives. This is foolish. There is nothing to be ashamed of in having *Lanark*. Although it is what we doctors call 'incurable', many sufferers – acrobats, philosophers and popes – manage to lead a normal, healthy life. The important thing is to drink heavily and not to worry. If you do, see a doctor.

This bookmark showed the author's mischievous side – also the side that invited analysis. Gray had been waiting for this all his life. Now he wanted to be pored over, studied, discussed. Which he was. And no popes were harmed in the process.

4: Reception. It became quickly apparent that Stephanie Wolfe Murray's risk was going to pay off, at least in terms of critical reception, if not in monetary terms. (It was so expensive to produce that little profit was made.) There was considerable excitement about *Lanark* not only in the Scottish literary community but also elsewhere – the book was being published simultaneously in the USA and soon after it appeared in Sweden. There was major interest south of the border, too. In 1981 it was unheard of for a Scottish novelist to get widespread coverage in the English press: but *Lanark* got a whole page in the *Times Literary Supplement* in a review written by William Boyd, then a new author who went on to make a major literary contribution of his own. Boyd spotted the significance of the book immediately, calling it 'undoubtedly the best work of fiction written by a Scottish author for decades'. When Alasdair had dreamt about 'fame', he had meant that he hoped his book would become famous after his death: he never imagined it would happen in his lifetime, never mind within weeks of publication.

Anthony Burgess was one of the first to recognise the relevance of *Lanark*. He said: 'It was about time Scotland produced a shattering work of fiction in the modern idiom. This is it.' Latterly, this quote found its way on to the front of many reprinted editions. Some say it might have become something of a burden, but it would only be so if the book couldn't bear the compliment. Douglas Gifford praised it too, immediately, and soon after came official recognition. Gray won the very first Saltire Scottish Book of the Year Award, also the Scottish Arts Council Book of the Year, and Canongate won an artwork award for their presentation. (This created early tensions between author and publisher, as Alasdair had not been paid for the art.) Burgess felt *Lanark* should have won the Booker, too, and made public his annoyance that it only made the longlist, but this only further raised the profile of the book among those who felt it had been unfairly overlooked.

As important as the critical reception was, younger writers, particularly in Scotland, read the book and were inspired by it. Many of the generation to come would cite *Lanark* as a major influence. Iain Banks claimed it helped him create his famous novel *The Bridge*, and he was not alone.

Other future key literary figures were influenced and encouraged by this book when they were young, among them Ali Smith and A. L. Kennedy, who have since become public supporters of Gray. Ron Butlin describes how writers like him found this an exciting time for literature:

> *Lanark* made things seem possible. When we came across Marquez we thought, my God, the novel is not dead – a whole world opened up. That was localised with *Lanark*, a *Scottish* writer could do it. Alasdair was this living presence, from the older generation – there were ten, fifteen years between us – someone just on the cusp of being our generation *had done it. Succeeded.*[19]

Among Scottish writers it is hard to find one of note who has not praised *Lanark*. For example, Janice Galloway, now one of Scotland's foremost literary writers, later wrote introductions to editions of Alasdair's books, but in 1981 she was still some years away from her first publication:

> I'd always assumed that what my education had taught me was true: that my country was a toty wee place with no political clout, a joke heritage, dour people, and writers who were all male and all dead. Not so, the book said: on a number of levels, not so. I was so grateful I carried the thing around with me, even when I went out. I forgot meals, went by my stops on buses and had to walk, didn't care I couldn't sleep reading that book.[20]

For people like Janice Galloway, discovering *Lanark* was like getting permission to write. And it wasn't just west coast writers who were paying attention. Irvine Welsh remembers how it affected him when he was growing up in Edinburgh:

> I was amazed, by the language, the imagination of the writer, but also his complete control over the material. That was, you know – especially with such a vivid and extravagant writer as Alasdair Gray, that was amazing. Such exuberance – and ecstasy. *Lanark* is probably the closest thing Scotland's ever produced to *Ulysses*. What it said to me was, it would be fucking *great* to be a writer. . . . my life was in chaos then, I was in my early twenties, you know, everything was chaotic, and *Lanark* seemed to have a sprawling chaos to it.[21]

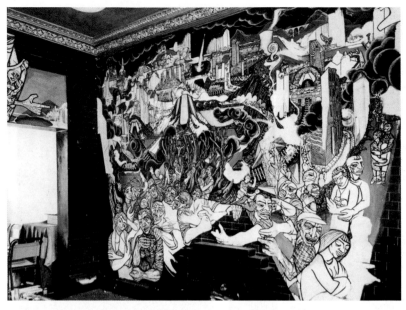

A work in progress: Alasdair's first mural, 'Horrors of War', in the Scottish – USSR Friendship Society, Glasgow.

King of Gibraltar, 1957.

With Robert Kitts, in Trafalgar Square. During Hogmanay 1953 the two decided they were both geniuses.

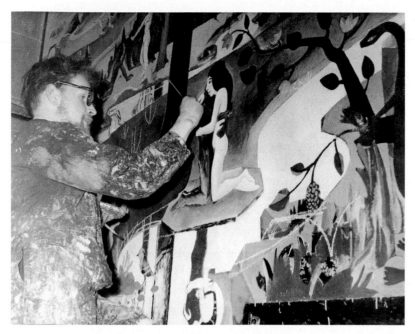

Painting Adam and Eve in Greenhead Church, Bridgeton.

Showing off early work.

Alasdair performing 'A Practical Lecture on How to Build Your Own Rhinoceros' at Festival Late, Edinburgh Festival, 1961.

Inge Sorensen,
Alasdair's first wife.

Baby Andrew Gray.

'I don't mind whose God I work for!' Alasdair's 1964 mural in Crosshill Synagogue, which was later dismantled.

Signing a book for Billy Connolly at the launch of *Lanark*,
Third Eye Centre, Glasgow, 1981.

With friends Liz Lochhead and Edwin Morgan in Berlin.

Oran Mor mural.

Preparing for his public, with biographer and glass of wine, at the Aye Write! book festival, Glasgow.

Advert for joint 1995 art exhibition shared by the two Alasdairs: Gray and Taylor.

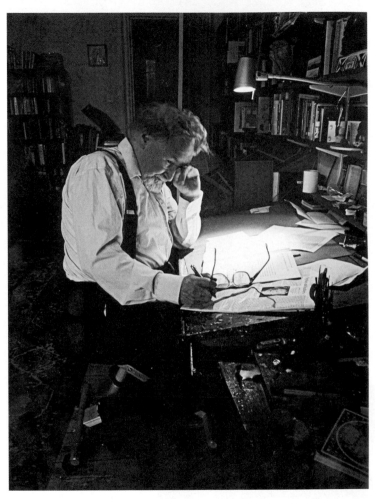

At work, at home.

subtle ways *his* world *had* been turned on its head. In the wake of its success he noticed he was being treated differently, with more respect, by people who had previously looked down on him, and though he was not entirely comfortable with this about-turn he felt he had earned it. There are few people who have known Alasdair longer than Katy Gardiner, the actress friend he met in Brown's Tea House a quarter of a decade earlier. She spotted this change immediately: 'He found women throwing themselves at him for the first time in his life,' she has said. 'And of course, that has an effect, in several ways.'[23] Alasdair had only had two very brief affairs in the whole of the preceding decade, which were both initiated and finished by the women in question, so this was a significant change. In 1981, for the first time in his life, he was involved with two women in a single week. Paddy Lyons, the academic who helped create the writer-in-residence post at Glasgow University for Alasdair in the late 1970s, remembers this, too. He was one of many who thought there was a difference in him because of his success: 'Alasdair totally changed after *Lanark*,' he has said. 'All of a sudden, all the merry widows of the West End were after him. He suddenly felt lucky, and became more outgoing in company.'[24] Which was indirectly why he began a relationship with one of Lyons' good friends, Bethsy Gray.

Like Alasdair's first wife, Bethsy was raised in Denmark but visited Glasgow and stayed there after meeting a man, David Gray, who she married. After settling in Scotland she ran her own jewellery shop in the West End of the city. But by 1981 the relationship with her husband had broken down. Bethsy remembers:

> My friends were trying to find someone to cheer me up. We were at a party, and Alasdair was there – I didn't know him then. One of my friends announced in the middle of the party, 'Who wants to paint Bethsy in the nude?' Haha! Alasdair came forward . . . I remember, he said – Me! Me! And there it was.[25]

Alasdair did paint Bethsy: all in the name of art, of course. In the wake of her own break-up, at the age of thirty-nine, she was looking after her two children in a flat near her Hill Street studio and 'trying to put life back together again'[26] – she found Alasdair 'a kind, genuine, good-hearted man most of the time'[27] and they became close quickly, though initially neither was interested in remarrying. Meanwhile, when she got the chance to join him, the success of *Lanark* made for an exciting life.

By now, many of Alasdair's social relationships had long been cemented, especially with people like Tom Leonard, with whom he enjoyed (and still enjoys) a very relaxed, understanding friendship. The two of them often walked round Glasgow together, talking as much about life as about literature. Tom came to value this friendship highly: 'When I think of Alasdair,' he says, chuckling, 'I just think of laughter. We always have such a laugh together. We always have.'[28] Aonghas MacNeacail remembers many nights at Tom's house after the pubs had closed, talking till the early hours:

> He was always that wonderful mix of intellectual authority and social eccentricity. Certain moments with Alasdair stick in my mind . . . One night, maybe in 1982 or '83, we were at Tom's house. Alasdair was sitting on the sofa, with his hands behind his head. He said: 'Some people say I'm eccentric . . . I don't think I am!' And then we noticed he had one red sock on, and one blue. It was like a staged event! He was always so much fun, but so unaware . . .[29]

These kinds of friendships with people he felt understood him made for a secure, settled day-to-day existence, a key stabilising factor when so much else was changing. Alasdair baby-sat for friends' children regularly, and often drew them while he was there, making presents of the results. Many of these can now be found in the homes of Katy Gardiner and the Hind family, and there are many other examples. One of Tom Leonard's favourite pictures is an ink drawing Alasdair did of his two sons when baby-sitting one night in 1982.

TICKLY PIE

In the summer of 1982 Tom Leonard, Liz Lochhead and Alasdair collaborated on a project originally for shows at Glasgow's Tron Theatre but which was revived for that year's Edinburgh Festival, by then a much bigger international event than when Alasdair had first taken part two decades earlier. There had been collaborations between the friends before, and Tom and Alasdair had been working together on a cartoon provisionally called *The Adventures of Nuthinty Say* earlier on in the year. Now all three decided to put together a revue called *Tickly Mince* which incorporated sketches, songs and poetry by each, with a full collaboration

in the final scene. They named themselves the Merryhell Theatre Company. Tom remembers that Alasdair designed posters to promote it, there were big houses every night at the Edinburgh Festival and a section was even televised by the BBC's *Pebble Mill* programme.

It went so well that they did it again in 1983, with James Kelman invited to join them for what became *The Pie of Damocles*. These revues, acted by Siobhan Redmond, Kevin McMonagle and John Cobb, were overtly political satires, including a number of savage critiques with a distinctly international feel. Alasdair and Liz both credit Tom with contributing many of the strongest of these. Other sketches are sillier: Tom's contributions included a piece called *Rangers Sign the Pope*, a mock-journalistic sketch which discussed whether the pontiff had enough pace to cut it in the Scottish League's premier Protestant team, and a song called *Nuclear Family*, which begins, 'A wish a hud married ma mammy/We'd a hud the reception at hame/Ma daddy's a bonny wee laddie/But daddy's are just no the same'. Kelman has said he was 'not thrilled' by his own contribution, but believed Liz and Tom's monologues and Alasdair and Tom's songs were 'brilliant'.[30] For his part, Alasdair resurrected some of his favourite characters, including a piece called 'Sir Hector Remembers', featuring Hector McKellar, a character from *The Fall of Kelvin Walker*. (Here, Sir Hector admits to being a mass murderer in a TV interview, then soberly congratulates himself for having coped with the trauma of it so well.) In the second year, Tom remembers the show being selected for Radio 4's *Pick of the Fringe*. When they asked if they could broadcast part of *The Pie of Damocles* the company agreed – on the condition that they included the scene which satirised the BBC itself. The BBC duly agreed, then ignored the request.

Both *Tickly Mine* and *The Pie of Damocles* are too varied to do justice to here, but interviews with the writers suggest that the general experience, and relationships between each other and the performers, were as important as the revues themselves. They were done on a shoestring budget, technical rehearsals were last-minute, Alasdair was making directorial changes right up to the wire, and none of those involved even remembers being paid. But it was still great fun for these friends to work together, and it was an exciting time. For his part, Gray was dedicated to the cause. One scene needed a sofa, so Alasdair donated his own, walking all the way to the Tron Theatre from his Kersland Street flat with the furniture on his back.

ANGUS AND *JANINE*

In the early 1980s there was a Scottish book prize called the Frederick
Niven Award, named after a now largely forgotten nineteenth-century
Scottish novelist. Alasdair won the final award for *Lanark*, beating Iain
Crichton Smith's *Consider the Lilies*. The prize was a four-figure sum, a
serious amount of money in the early eighties. But as Alasdair said: 'Mrs
Thatcher was fighting the miners at the time',[31] so he gave all the money
to them. The historian Angus Calder, one of the judges, remembers the
competition: 'It was a walkover . . . the others were good, but there was
just no competition. This book! Well . . . Like everyone else, I was
bowled over by *Lanark* when I first read it. I think I was in my house, I
had gone into the kitchen, with a view to eating something, but read all
of *Lanark* instead. It was just unputdownable. You saw at once how
good it was. It had the effect of redefining Scotland.'[32]

 In 1982 Angus was Staff Tutor in Arts for the Open University. He
had been impressed enough with *Lanark* to look for any excuse to ask
Alasdair to come and speak to his students. Gray accepted an invita-
tion to talk on the subject of George Eliot's *Middlemarch*. This was the
first time the two met. Angus found Alasdair's performance – done in
the style Edwin Morgan had noticed over a decade earlier – amusing
and inspiring, but his students, mainly adults keen to get the best
grades possible, did not hide their anger at being told so many things
that were not on their curriculum. Alasdair effectively gave a fifty-
five-minute lecture on the tradition of the European novel. Angus
recalls:

 He has the most fantastic memory for plots, so he was able to refer
 to many works specifically without using notes. But he didn't get
 round to mentioning *Middlemarch* until five minutes before the end.
 Only a small amount of the students realised they were watching a
 great man doing something special and idiosyncratic. The rest got
 . . . *rather annoyed*. Alasdair Gray, in public, is a loose cannon.[33]

This is one of many examples of how sometimes those who know
Alasdair's work indulge his behaviour, whereas strangers have no
patience with him. But Angus and Alasdair met for a drink afterwards
anyway. They discussed what Alasdair was going to do next, and Gray
explained he was working on his 'Janine' story, which had now grown

to twelve chapters. (He had recently confided to Carl MacDougall, 'I shudder to tell you, but I think I may be working on another novel.'[34]) Canongate had tried to raise some money for an advance by showing what existed of *1982, Janine* to an American paperback publisher, but they weren't interested. Then Alasdair tried to get a new London agent to sell it, but that failed, too. On learning that Canongate could not pay him much for a second novel, he didn't know what to do. Angus says:

> He stressed how grateful he was to Canongate for producing *Lanark* – this extraordinarily expensive, elaborate book, but, he said they had not made enough money from it to be able to offer him an advance for another novel – or, as he put it – to 'keep him in Marmite sandwiches' while he finished *1982, Janine*.[35]

Angus had recently been working with the editor Liz Calder at London publishers Jonathan Cape on his book *Revolutionary Empire*[36] and suggested Alasdair try sending her what he had so far. So he posted the loose sheaves to Liz in a box. She opened an untidily wrapped package to find the first twelve chapters of this new book, with the short note at the end, where the story ended suddenly, uncompleted: 'For Chapter 13, send money.' She sent £1000 and he was able to finish it.* Angus describes Liz as 'smitten' with Alasdair's writing. Stephanie Wolfe Murray remembers the anxiety at Canongate during this back and forth:

> We talked about it for ages, wringing our hands with anxiety . . . but we just couldn't afford it. However something tells me that at the last minute we decided to go for it but by then Alasdair had made up his mind. He was very nice about it but I guess he just had to go to them, although he promised not to desert us altogether and he didn't.[37]

Alasdair's relationship with Canongate had been far from smooth so far – there were often letters of extreme frustration between Stephanie and Alasdair – but it is a measure of her faith in his work that the relationship survived their inability to persuade him to stay with them for *1982, Janine*.

* LC still keeps this box in her Bloomsbury office in London.

UNLIKELY STORIES, MOSTLY

And Alasdair did do another book with Canongate – *Unlikely Stories, Mostly* – for which he did not need an advance, as the material was already written. For this project he wanted to collate old material, but in the most unusual way. What appeared in 1983 was a book that even now, twenty-five years later, is seen by many as a classic of the form, and is certainly one of Alasdair's best works. It was effectively a Greatest Hits collection, being the cream of Gray's fantastical short stories, with many of the pieces accompanied by images from lithographs Alasdair had done to accompany them.[38] The book started with 'The Star', which had been published in *Collins Magazine* over three decades before, going through his art school material ('The Cause of Some Recent Changes'), taking in his Glasgow University years ('Five Letters from an Eastern Empire') and going right up to the present, finishing with the two brutally short, realistic one-pagers at the end. (These were a nod to Jim Hutcheson, who had told him the stories and designed the jacket with Alasdair for Canongate.) There was no unifying theme but Alasdair did insist on a chronological order, starting with 'The Star', showing his development from 1951 onwards, and has since said he wanted key pieces included which 'showed the poet as bureaucrat, poet as aristocrat, and poet as democrat'.[39] Which indicates that he regards 'Logopondancy', 'Prometheus' and 'Five Letters from an Eastern Empire' as the keys to the collection.

Encouraged by the positive response he had received to the elaborate *Lanark*, this time Alasdair was even more ambitious about layout. The inside pages were intricate maps layered with Gray's handwriting and embellished with the book's characters, like Sir Thomas Urquhart, intermingled with people from Alasdair's life – Bethsy, depicted with wings on either side of her head, blew the sails of Urquhart's boat. A topless Mary Carswell Doyle, a previous girlfriend (briefly), pointed the way to the book's beginning. And as well as covering the inside of the work with his artist's print, Alasdair insisted on embossing the hardback boards of the first edition with three large thistles, the words 'SCOT-LAND 1983' and the motto he had recently found in a poem by Canadian poet Dennis Lee – 'work as if you live in the early days of a better nation' – this became Alasdair's most famous one-liner, and he still has to remind people it isn't his. In terms of layout, the page is sometimes divided down the middle, sometimes diagonally, and sometimes backwards in stories

such as 'Logopondancy', where Gray has the cheek to invade the three-hundred-year-old work of Thomas Urquhart and make it his own.

The Scottish novelist and short-story specialist Ali Smith remembers the impact this book had on her, stating: 'That Gray had reinvented the novel we knew, but that expectations of the story form, expectations of voice, and even expectations of the very notion of a book ("Erratum: this erratum slip has been inserted by mistake") could be so liberated was profoundly liberating in itself.'[40] The fake erratum slip is another message which shows readers that Gray does not always take himself seriously, and it has become one of his most famous jokes. Stephanie Wolfe Murray says now that perhaps Canongate were naïve in their handling of Alasdair:

> [J]ust before we released the book to the shops he phoned us one day and said 'I want to have an erratum slip inserted'. I said, 'Oh God! What's wrong? Surely we corrected everything. What do you want to say on it?' He said, 'I want it to say: THIS ERRATUM SLIP HAS BEEN INSERTED BY MISTAKE.' Of course we said yes immediately but it was a hell of a nuisance, having to get it inserted into every single book, and expensive probably, but well worth it. All of us thought so.[41]

Unlikely Stories, Mostly benefited from lessons learned with *Lanark*. That had been a publishing disaster in America. Ron Butlin has said: 'In the US, it was originally marketed as sci-fi and flopped: *Lanark* is no more sci-fi than Dante or Blake. American publishers rebranded it for their second edition, and it is now recognised there as a major twentieth-century classic.'[42] That is something of an overstatement, but certainly when *Unlikely Stories, Mostly* was published in America, this time they kept the presentation and marketing closer to the author's vision, which Gray took as evidence that only he knew the right course to take – not publishers, who were nervous of unusual books, and expense, and risk.

Gray was now beginning to attract attention from critics on both sides of the Atlantic, some of whom didn't quite know what to make of him. Some tried to put this book in a neat literary category but ended up attempting to invent a new one: others competed with each other to define it most accurately. Toby Olson, writing in the *Washington Post*, called *Unlikely Stories, Mostly* 'a wonder of ingenuity, a varied and rich collection in which Gray's abilities as a visual artist and illustrator are placed not only beside but within the products of his fertile imagination as

a writer'. The *New York Times Book Review* referred to: 'A dazzling command of rhetoric, a willingness to take large risks . . . gestures toward aesthetic and moral freedom, a melancholy and sometimes ecstatic rattling of chains, an insistence – through the example of their humour, power and beauty – on the transcendence of the imagination.' These quotes are dizzying, and confusing, but they are a representative sample of the salivating reception the book got. In the 1980s it was very unusual for a book of short stories, particularly one by a middle-aged Scot published by a small independent house, to receive any kind of attention at all. *Unlikely Stories, Mostly* proved *Lanark* was no fluke, and suggested that Gray was versatile in a way even fans of that book had not predicted.

So more party invitations came. *Unlikely Stories, Mostly* even won the prestigious Cheltenham Prize (now defunct), which contributed to a growing presence south of the border. And there was another big work coming – though that would not be received with the same unquestioning admiration.

1982, JANINE

1982, Janine was a surprise. Alasdair had taken most of his life to write *Lanark*, but its successor began as a short piece intended for *Unlikely Stories, Mostly* that expanded fast until it became clear that here was an entire book, not part of one. 'I knew the ending from early on in the process,' he said, 'It was just taking . . . rather longer to get there than I had anticipated.' Longer, that is, in words, not in time. Compared to *Lanark* it was fairly spat out. One early title, *If It's Tuesday, It Must be Dumfries*, suggested a narrator who was lost, or not paying attention, or wanted to forget something. But it didn't reflect the scope of the beast. It had been considered for *Unlikely Stories, Mostly*, but though this book contains sections of wild fantasy it is the darkest and most frightening of Alasdair's fictions because it is the one most rooted in the real world. It is also complicated, so is best dealt with in small chunks.

Story and Sexuality

Jock McLeish, an alcoholic Conservative who works for a security firm, believes he is a good man: he has always done as society has told him, he operates strictly within Margaret Thatcher's (and his mother's) require-

ments and has never intentionally hurt anyone in real life. But in his imagination he enjoys torturing women. For the duration of the book Jock sits in a hotel room thinking up humiliating sexual fantasies to put his cast of imaginary women through: Superb (short for Super Bitch), Big Momma and Janine must suffer and enjoy when McLeish wishes it. These fantasies are intended to distract him from the things in his life he wants to forget, but as the book progresses readers are increasingly shown the reality Jock is hiding from – he is powerless and has failed to take control of any part of his life, especially his relationships. All Jock's women have been stronger than him: his first love, Denny, his ex-wife, the occasional, brief affairs that have punctuated his loneliness since his divorce. And if one thing is obvious about Jock McLeish, it is his loneliness. Which is part of the reason why he preoccupies himself with imagining how many buttons are undone on Superb's imaginary blouse when she is stopped by the imaginary police and ordered to spread her imaginary legs.

In a moment of reflection, Jock remembers an ex-lover, Sontag. On one occasion in bed she noticed his fantasies were a kind of revenge on the real world, and tried to analyse them, but Jock resisted that. He now says: 'I wish she had been more of a prostitute. I would have paid Sontag anything to enjoy again in the flesh the illusion of ABSOLUTE MASTERY which real life has never never never allowed me in any way whatsoever.'[43] This is not a pornographic novel that degrades weak women. It is a bold one which celebrates strong ones, exposes men's reliance on them, and explores ways men cope with loss of power, or with never having it in the first place. It is not supposed to be sexy reading for men who want to oppress women. It is supposed to be disturbing. Irvine Welsh has also been accused of misogyny in his work. He has said:

> *1982, Janine* is an underrated Scottish classic. The way it deals with the sexual and political themes. There's this very traditional view in Britain of how you show sexuality. Some feminists, and these right-on male groups say, you know, everything has to be sugar-coated – fuck that. That's a way of *not* dealing with the issues, *sidestepping* them. Gray dealt with sexual fantasy in *Janine* in a really honest, open way. Jock's life is all about social and sexual repression.

The way Gray dealt with sexuality showed writers like Irvine Welsh that their work did not have to be sugar-coated. On the contrary, it

should not be. A decade later Welsh's novel *Marabou Stork Nightmares*, which also features a Conservative Scottish anti-hero, and experiments with form on the page, and explores the darker side of sexuality, took that idea to the extreme.

Origin

Though *Lanark* had a bigger impact and *Unlikely Stories, Mostly* is more fun, *1982, Janine* is possibly Alasdair Gray's finest, bravest book. It is also his favourite – something we should be suspicious of. Why does he like it so much? His argument is that he was pleased with this novel because the protagonist was so unlike himself, but that is certainly a lie. It is more likely that this trickster liked *1982, Janine* because he managed to cram so much of himself into the text without having to admit to it, something he could not avoid with *Lanark*. Here, he appeared to argue for a right-wing view of 1980s Britain in order to try to prove its opposite – exactly the kind of thing that would appeal. Also, he got to expand on *Lanark*'s filthy bits. (The abuse aspect had its origins in Alasdair's own sexual fantasies, which appeared very occasionally in his 1960s diaries, then disappeared for nearly twenty years before resurfacing as *1982, Janine*.) *Lanark* only hinted at darker, sexual inclinations which were now let loose. Will Self questioned this in a later annotated edition. According to Alasdair these imaginary abuses were parts of his imagination he had meant to keep secret:

> Gray himself has said, 'This particular story started discoursing of improper things: sex fantasies I had meant to die without letting anybody know happen in this head sometimes . . .' Can he be serious? After all, it's one thing to allow such 'imaginings' to spill on to the pages of a private journal, altogether another to labour over them and then publish.[44]

Self was right to be suspicious. So: *1982, Janine*. Mysogynistic? Pornographic? Spontaneous? Well, he does like to toy with us . . .

Reception

When *1982, Janine* came out in 1984 Alasdair was accused by parts of the Scottish literary establishment of turning his back on his home country by

switching to an English publisher. But he had not fallen out with Canongate over their inability to put out *Janine*. He accepted it as an inevitable part of working with small independent publishers and vowed that he would alternate his books, from now on supporting the Scottish one which had given him his first longed-for break, while also remaining loyal to Liz Calder at Jonathan Cape, who had sent him money when he had none. (When she became one of the founding directors of a new independent publishers, Bloomsbury, he followed her.)

In terms of the actual book, the argument some critics levelled at Gray when this book was released was that it was merely an author getting lost in his own fantasies – accusing Alasdair of being filthy-minded, basically, or of fiddling with buttons and big etceteras while there were more serious issues he was now expected to be engaging with. Perhaps the most famous quote at the time came from Anthony Burgess, who had previously been so excited about Gray: 'On the strength of *Lanark* I proclaimed Alasdair Gray the first major Scottish writer since Walter Scott,' he said. '*1982, Janine* displays the same large talent deployed to a somewhat juvenile end.' Some reviews (the worst ones were all made up by Alasdair himself, according to Stephanie Wolfe Murray[45]) could not quite believe that the same man who invented Unthank could possibly waste his time on this kind of book. But satire, comedy or tragedy need not necessarily be immoral just because it records immoral events or is told by an immoral narrator. In fact, Burgess himself tackled that misconception in his violent, nightmarish, controversial novel *A Clockwork Orange*, published over two decades earlier.

As well as being uncomfortable at points, and full of self-hatred, *1982, Janine* is sometimes difficult actually to *read*. Jock descends into alcoholic reverie as the novel goes on, spending more time wallowing in his life's memories and less time inventing tortures, leading to mental breakdown and an eventual suicide attempt: this is represented by the splitting up of the page, with different voices inside Jock's head (including God's) heading off in upside-down, diagonal, higgledy-piggledy directions. There had been unusual formations on the page in Gray's previous works but this took the process further. At one point Jock's mind is literally being squeezed on the page. He tries to calmly make sense of his life in the centre of the page while on the left God speaks to him very quietly, upside down, and on the right there is simply a procession of loud cries of anguish: COLD OO NO OO NO OO NO COLDER.

Real Politics Sex Connections

The sexual element and typographical play also serve another key purpose, which is to distract from what *1982, Janine* is really about: politics. Hidden in among Jock's sexual ravings are sections where he descends, not into memories, but to his view of early-eighties Britain, particularly Scotland. This stylistic approach was partly inspired by Hugh MacDiarmid's poem 'A Drunk Man Looks at the Thistle', which analysed an earlier state of the nation. A writer can get away with attacking his own country a lot more behind masks of character and drunkenness than would be possible in a dry essay. And this brings us back to Jock as compared to Gray. Though a Conservative, some of Jock's opinions are very similar to his author's, which made it easier for Alasdair to make Jock a convincing character.

The connection between the political and the sexual in Jock's mind is shown clearly in his complaints about the result of the Scottish referendum of 1979. He may be turning his political frustration into imaginary abuse and rape, but he is desperate not to make the connection between the two things – politics and sex – or else he would:

> feel responsible for every atrocity from Auschwitz to Nagasaki to Vietnam and the war in Ulster and I REFUSE TO FEEL GUILTY ABOUT EVERYTHING. Thinking is a pain because it joins everything together until my mother father Mad Hislop Jane Russell mushroomcloud miniskirt tight jeans Janine dead friend Helen Superb Sontag editor sad lesbian police Big Momma and the whore under the bridge surround me all proving that I am a bad man, I am what is wrong with the world, I am a tyrant, I am a weakling . . .[46]

1982, Janine was released during a time of high unemployment and the clash between trade unions and the Conservative government. Claiming to agree with parts of his father's Marxism, Jock says: 'Every intelligent Tory knows that politics is a matter of people with a lot of money combining to manage people with very little.' As in 'Five Letters' Jock describes what he believes in, but in a way that shows readers the author is trying to highlight how despicable he thinks this view is. The plain, temperate prose, the careful choice of words, suggests the author disagrees with his narrator.

There is one more issue, as hinted at earlier. Whereas discussion of

Lanark has often been mixed up with explorations of Alasdair's own life, critics and fans have rarely gone to *1982, Janine* for evidence of what Gray himself has experienced – but Alasdair's happiness with this novel may be partly because people have seen it as primarily a book of fantasy, where actually it is littered with the evidence of the author's experience, every bit as much as his debut. As well as heavily featuring Alan Fletcher under his real name and including other characters inspired by friends (the character Mad Hislop came directly from a Tom Leonard poem 'Four of the Belt') there is also an exploration of Alasdair's relationship with Inge. The largest chapter is realistic, and is based around a 1960s production of a play at the Edinburgh Festival, mirroring the author's real life (though, in the novel, the characters are performing a version of the Gray play *McGrotty and Ludmilla*). So Alasdair used the same creative tools to make this book as he did in *Lanark*, only he explored a different part of his real life, a different part of his imaginary one, and this time few noticed that he was again writing partial autobiography.

Renaissance, and Fun House Theory

Sometimes *1982, Janine* is talked about as if it was totally rejected upon publication. This makes for a more romantic story as the book is now enjoying a small renaissance, spurred on by Scottish female authors like Laura Hird and Liz Lochhead (who have championed it) and English male ones like Jonathan Coe who 'approached it through the mist of a complete ignorance of Scottish writing'[47] but later said it 'revived my flagging impetus to continue writing fiction myself'.[48] And it certainly came against some resistance, even before it was published. This from Alasdair's Magic Red Box:

> 11th Jan 1982: Letter from Peter Grose of Martin, Secker and Warburg Ltd. To Julian Friedman, Literary Agent, rejecting *1982, Janine*, saying '. . . I wonder if I shall be remembered in 20 years as the man who turned him down.'

Peter Grose was not the only one: there was certainly some nervousness about the book's contents, before and after publisher's acceptance. But it would be wrong to say that only other writers liked it at the time it came out. It was controversial, yes, and unpopular in some quarters, but it did have its critical supporters – often, abroad. Jonathan Baumbach

writing in the *New York Times* said: '*1982, Janine* has a verbal energy, an intensity of vision that has mostly been missing from the English novel since D. H. Lawrence.' J. A. McArdle wrote in the *Irish Independent*: '*1982, Janine* is not pornography but a thoughtful and sad study of the human predicament; to be trapped in a world where the little man, woman or country will always be exploited by the big bullies.' High praise for porn.

Alasdair invited readers to think he was really offending people, taking the opportunity to create damning criticism for the jacket, listing multiple negative reviews on the inside of later editions, many of which were certainly not written by anyone but Alasdair Gray. Most real-life critics went down the route of either dismissing *1982, Janine* as the author's immoral fantasy, or trying to justify it by suggesting it was an exposé of corrupted male sexuality. When asked, Alasdair did not hide behind convenient excuses. Speaking of the experience of writing a violent rape fantasy, Gray said he rather enjoyed it for its own sake. This makes the author sound disgusting – but if so, everyone who has ever written a horror film or crime novel or violent video game is also disgusting, especially if they enjoyed creating these. We do not usually make that connection between author and art, so why make it here? By avoiding easy answers, by suggesting it may be possible – and acceptable? – to do something horrific in imagination only, Gray recommends readers decide for themselves where the line of acceptability is. And that brings us closer to Jock. Do we sympathise with him, try to understand him, try to excuse and explain his imaginary life, or do we condemn him outright? These kind of questions make *1982, Janine* difficult reading. But for some this is what makes it great. Will Self has explained his view of how Gray's 'difficult' fiction works:

> You cannot accuse his prose of being anything but lucid and direct. The language is easy. The difficulty is in his ideas of *what is real*. There is a kind of unashamed declarity of what is embodied in fiction. His books are very difficult and maybe that is why they are not more popular. The reader is asked to suspend disbelief right from the off. Like in Kafka, who Alasdair has a great deal in common with: '*One morning, when Gregor Samsa woke from troubled dreams, he found himself transformed in his bed into a horrible vermin.*'[49] You just have to go with it. You are taken immediately into his world. You have no choice.[50]

Self has always taken the difficult route in his own novels which, like *Lanark* and *1982, Janine*, are novels of ideas. He admires writers like J. G. Ballard, and defends this idea of fiction being used to take the mind to places it cannot go with polite, easy narratives, protagonists and settings:

> This idea of naturalistic fiction being the best, most honourable kind – it's a creation of the literary heritage industry. We [Self and Gray] don't think art should be a direct mirror of life. If it's a mirror, it's a Fun House mirror. That doesn't mean his novels aren't coherent. That is part of their strength. Coherence between ideas, associations and their meanings.[51]

This debate about *1982, Janine* reflects a wider one in literature about what fiction should be, or what it should be allowed to be. But then, Gray has never been one for paying attention to rules.

KELVIN TURNS INTO A BOOK

By the time Alasdair's next novel was released on 21 March 1985, it was clear that the 1980s were turning into an exciting time for Scottish literature. Many of his contemporaries were releasing their most powerful work, signalling the scale of the country's cultural potential. According to the poet and academic Alan Riach, 'apart from the waves created by *Lanark* in fiction, Edwin Morgan's *Sonnets from Scotland* and Liz Lochhead's *Mary Queen of Scots Got Her Head Chopped Off* were doing similar things for poetry and drama respectively'. Then there was the impact of James Kelman's influential *The Busconductor Hines* and *A Chancer*, which unashamedly, powerfully, used the working-class Glaswegian voice on the page as it had not been used before. In the mid-1980s, as Riach notes: 'Scots writers were asserting cultural self-determination',[52] something partly attributable to pro-Independence artists reacting to the referendum at the end of the previous decade.

The novel of *The Fall of Kelvin Walker* (dedicated to Mora, 'finally a book by her brother which will not make her blush') was published by Canongate and generally welcomed. But not everyone shared Alasdair's enthusiasm, being puzzled by *Kelvin*'s lack of scope and size compared to Gray's previous publications. Some critics (and readers, too) wondered why he had abandoned the unorthodox experimenta-

tion of his first three books in favour of a straighter, more conventional
story in the realist tradition. Alasdair felt he was simply going back and
filling in the gaps – Canongate was willing to publish it (and he could
get a small advance this time) so *Kelvin* was a book he could easily
release by simply going back to the play script, leaving the original
dialogue and turning stage directions into prose around it. It made for a
neat and successful novella. But this was Alasdair's fourth book in five
years, and one published with no melding of word and picture, no
trickery. It came very soon after *1982, Janine* and *Unlikely Stories, Mostly*
and at a time when *Lanark*'s reputation was fast gathering pace. So next
to those books, little *Kelvin* looked smaller in more ways than its mere
size. When asked now, Alasdair said, 'I have absolutely no idea how *The
Fall of Kelvin Walker* was received. Did it do well?'[53] But he does
remember the first instance on home shores of publishers trying to
sideline his artwork in favour of a more populist image than his own
Blake-inspired naked upside-down man. He was not pleased, and still
remembers angrily how the Penguin paperback featured 'a horrid
cartoon of a stiff man being kissed by an amorous woman who was
nothing like the one in the book, next to a quote from Melvyn Bragg
calling it a "romp".'[54] Alasdair has no concept of the success or
otherwise of this novel, but has a detailed, accurate memory of an
image and quotation he has not seen for twenty years.

 Close to home, where his books had made a bigger cultural
impression, *The Fall of Kelvin Walker* was compared to the rest of
his output and found wanting, but there were good reviews abroad –
not least when it was released in the USA, in publications like *The New
Yorker* (which compared him to the American satirist Nathanael West),
the *Washington Times* and the *San Francisco Chronicle*, though Alasdair
seemed to enjoy the negativity most. On the back of the American
edition, sandwiched between compliments from the *Guardian* and
the *Times Literary Supplement*, was an attack from one Joe Ambrose.
Mr Ambrose called Gray 'the sort of writer who practises his speech for
the Nobel Prize in the mirror'. Now Alasdair's fans thought they knew
where to send the hate mail – but did a Joe Ambrose exist? It turns out
that he does, but faced with having to double-check quotes to find out
whether reviewers even exist, a biographer may be entitled to think
that the author was more interested in trying to create the *impression* of
being controversial than in actually being controversial.

LEAN TALES

1985's other Gray book was *Lean Tales*, published by Liz Calder at Jonathan Cape. The book was released on 9 May 1985 but the idea had first come about three years earlier, from a conversation with Quartet Books. Alasdair wrote in his Red Box that someone on the board of Quartet Books had said Quartet regretted having lost *Lanark*, and asked him to contribute to an anthology of Scottish short stories, with only two other authors in it. When asked who he would like the other two authors to be he said James Kelman and Agnes Ownes: 'though another and more crucial director questioned some of the stories I submitted, so I gave the book to Cape'.[55] Kelman says Bernard MacLaverty may have been supposed to be involved in the project, too, but did not have enough stories ready.

By this time both Gray and Kelman had literary reputations and had previously published collections of short stories; though Agnes Owens was less well known, both men were passionate about her work. Kelman and Gray had previously been instrumental in bringing her to public attention. They liked her story 'Arabella',[56] and Kelman had introduced her debut *Gentlemen of the West* (after Alasdair had failed to interest Canongate) to Polygon Press, who published it in 1984. Other Scottish writers were protective of her, and in 1985 some already felt she was not given the respect they thought she deserved. She was even portrayed twice on the jacket design, where the men were represented once, as if to reverse prejudice.

Alasdair's section in *Lean Tales* was a combination of old pieces intended for *Unlikely Stories, Mostly* deemed not to fit with the fantastical tone and sharp, negative fiction he had been persuaded to remove from *Unlikely Stories, Mostly* ('The Answer'). Kelman's part was supposed to be unified but was 'knocked awry' by the inclusion of the story 'Are you drinking sir?'. Kelman's whole contribution was strong, and he has since said he was pleased with the whole project: '*Lean Tales* is about my favourite book. Its design is my favourite, without question.' He remembers Alasdair receiving the working proofs through the post, including cover and design alternatives, and asking him to come over to discuss them. He says: 'We had a wee refreshment alongside it, as he worked out the finished thing, with comments from me.'[57]

Alasdair's standout piece is 'The Story of a Recluse', which is different from many others here because most of it is downright thievery. It had

previously been rejected as a treatment for a TV programme, but Gray got his revenge by printing it here. It is not initially clear what we are dealing with – this seems like just another Alasdair Gray story – but 'The Story of a Recluse' was originally an unfinished piece by Robert Louis Stevenson. Gray faithfully tells Stevenson's part, word for word, then breaks off to address the reader, explaining that the story has no ending, and exploring possibilities for how it might have been completed. He does this while discussing the evolution of the story form itself, plots typical of Stevenson's period and the expectations of his readers, who might know his work and hope for more of the same. After explaining ways good stories are put together – he deconstructs the form entirely in his exploration of what Stevenson might have done – like a magician pretending to do one thing then reversing the viewer's expectations, Gray turns the whole thing upside down in the last paragraph. It is Alasdair at his most devilish, and Stevenson would have to be one miserable dead author to disapprove from the grave.

The deception of 'The Story of a Recluse' works because it seems so naturally Gray. This is because his formal style has more in common with Stevenson than the writing style of friends Kelman, Owens or Tom Leonard; as has been noted by several contemporaries, Alasdair's work is, in many ways, traditional. Though forever accused of all kinds of modern-day crimes, Alasdair is actually far more a contemporary of Stevenson in the way he constructs a sentence. His descriptions of Stevenson's other works in what (in part) becomes an essay clearly shows both affection and respect. 'His imagination works best when he deals with Scotland,'[58] said Gray of Stevenson, many years later. The same could be said of Gray himself. Alasdair was so pleased with the results here that he tried once again to turn the story into a television play, submitting a typescript in November 1985. This time it was accepted by BBC Scotland commissioner Norman McCandlish and began filming, with a big budget, the following summer. Yet again, on release, Alasdair did not want to be associated with it. Directors had a habit of tinkering with his work, and he preferred to be in control. With television work, he was not, and he understood less about the medium, so was more vulnerable. In this case, Alasdair was persuaded to become a character in the filming (this was not in the original script) and also reluctantly to sanction elaborate stunts which he believed had no relevance to the story. This led to Alasdair publicly complaining about the TV version of 'The Story of a Recluse' and valuing the written version even more.

The reception to the publication of *Lean Tales* was mainly positive but several reviews accused the publishers of cynically cashing in on Alasdair's success, fattening up this book by two minor Scottish writers with Gray's old rejects and spares. Interestingly, when the book was reissued ten years later some reviews accused the publishers of cynically cashing in on *James Kelman's* success, fattening up this book of work by two minor Scottish writers with recent Booker Prize-winner Kelman's old rejects and spares. Neither of these was true, and *Lean Tales* still stands up as a strong, coherent work. Also, as a good indicator of what was happening in Scottish literature in the mid-1980s.

LANARK: A FILM THAT NEVER WAS AND PROBABLY NEVER WILL BE

The last five years had seen an incredible amount of work published – this was possible partly because there was such a backlog from the 1960s and 1970s. But now Alasdair didn't have any new story ideas and felt his most important writing work was done. So between promotional duties for recent books he spent the mid-1980s mostly working on non-literary projects. (It was around this time that he started talking publicly about a book called *Pottering Around My Shelves*, which much later became *The Book of Prefaces*: but he wasn't actually doing very much work on it.) He painted and drew a lot, particularly pen-and-ink portraits of friends, but also put a great deal of energy into a proposed film of *Lanark*. In 1983 he had been approached by a director, Sandy Johnson, and producer, Iain Brown, who wanted to make it.

They were not dealing with an ordinary writer. In many cases the writer will sell an option on their story for a period, and then step aside. Particularly in the literary fiction line, it is extremely rare that such projects ever go ahead, so most writers gratefully take the money for the option and try not to think about glorious exposure, red carpets, big rewards. But Alasdair regretted losing his career as a playwright, and had worked on projects before that had no guarantee of appearing. He told director and producer that he wished to be involved, they agreed, and then Alasdair painstakingly wrote and drew most of a storyboard for the proposed film with Sandy Johnson.[59] It was not unlike Alasdair to want control over the process, but his level of detail in the storyboard was remarkable. The panels included character sketches (thereby giving

very clear instructions as to how he wanted actors to look), full camera directions, and even musical ones alongside the script. These were all written by Gray, by hand.

This version was loyal to the novel, which may have been restrictive for a director and producer, but they never got to find out. The proposed film was never made because it was not possible to secure funding for it – and perhaps cynics would say that was always obvious. Why did Alasdair bother wasting so much time putting a storyboard together? At a proposed length of approximately three hours a *Lanark* film would have been hugely compressed, difficult to finance and difficult to pitch – even with the idea of an intermission, which was discussed as an option. From a commercial point of view it is difficult to see how this could have been a film which would have made money – it has no happy ending, two glum heroes (who would seem, to some, totally unconnected) and it is set in unlikely old Scotland – which, according to Gray himself, 'pleased and interested many film technicians but no financiers'.[60] It was not the kind of story you could shift, wholesale, to LA.

Perhaps Alasdair was naïve to hope the film would be made, but it is fascinating to see how he imagined it in his head – how he saw those images – and it would be harsh to criticise Alasdair, Sandy Johnson and Iain Brown for trying. At least they had a vision. Alasdair was determined that if this was going to be made it was going to be made his way: though it was not, Alasdair kept in contact with both Brown and Johnson, who wanted to make a film of another big Gray novel a decade later. Interviewers still ask if a film of *Lanark* will ever be made. He still wants to make something of his storyboard, which has since been published as a cartoon. If anyone is brave enough to try to make the film some time in the future and is interested in the author's intentions, they will not have to wonder what they were. His original illustrated script has been preserved in the National Library of Scotland Gray archive.

BETHSY AND THE MID-EIGHTIES

As Alasdair's working life became more frantic, so too did his personal life. His relationship with Bethsy experienced considerable troughs as well as peaks, and in the mid-1980s it came under particular strain. As

Rosemary Hobsbaum put it, 'Bethsy had to be very, very patient with Alasdair. And she was, for a long time.'[61] The most difficult period came in 1985 when Bethsy's son Christopher became ill with testicular cancer. Bethsy needed support and felt it wasn't there – 'It was almost as if he didn't understand what was happening,' she has said, 'but he must have done. I know he didn't mean to be cruel, but it was hard.'[62] The relationship did not break entirely, but it came close to it. Bethsy recalls that once Alasdair appeared at her home late one night so drunk that he literally could not stand, and she had to try and hide his state from her children while dragging him through her flat. On another occasion, he fell asleep in the road and had to be carried inside – she often felt embarrassed. But those closest to Alasdair believed she was good for him. And there was another issue. Katy Gardiner remembers: 'Alasdair looked terribly well during the Bethsy years . . . but I think she wanted to marry him and he still had this peculiar loyalty to Inge, as if they were still together . . . like he thought that one day she might come home. He used to say, "*Oh, I can't get married – I'm still married to Inge*".'[63] The shadow of Inge certainly hung over this relationship in its darker moments, and it must have been an extra strain as Bethsy had to contend with Alasdair's loyalty to his ex-wife as well as the drinking issues. The relationship continued and Bethsy's son recovered from his illness, but it was already obvious to some that Alasdair and Bethsy would not last.

While all this was going on, Alasdair was deeply involved in putting together his '5 Scottish Artists' exhibition alongside John Connelly, Alasdair Taylor, Alan Fletcher and Carole Gibbons, as explored earlier.[64] It took up a great deal of his time, as he took on much of the responsibility for organisation and administration, and he even had to persuade some of the others on show to stay involved – Carole Gibbons, particularly, who had done little exhibiting in the last decade, was reluctant to take part. But Gray pressed on, believing that if he didn't draw attention to their art it would receive none at all. Also, he felt he was in a better position to attract that attention now that he was a well-known novelist. It was at this point in 1986 that he chose to sell thirty years' worth of his diaries to the National Library of Scotland, which already believed he was important enough as a writer to warrant an archive. These diaries he sold included his most intimate thoughts from teenage years onwards, letters to and from friends, early drafts of *Lanark* and many other works, with the pages often featuring word and

picture together. The sale of the diaries brought in some much-needed cash Alasdair felt that he needed to make the exhibition work, but it also exposed the gulf that had opened up between the art and the writing. Now that he felt accepted in one of his forms, he wanted to be accepted in all of them.

SALTIRE SELF-PORTRAIT

In 1987 Alasdair was commissioned by the Saltire Society to write a short pamphlet about himself. This was an indication of how quickly his stature had grown in the six years since the publication of *Lanark*. Other writers who had undertaken the same job were more established literary figures such as Hugh MacDiarmid and Naomi Mitchison. But this painter didn't go about his self-portrait in the traditional way. He chose to begin with a medical diagnosis, giving the bare physical facts of his existence on the day of writing. He did not trouble his subject with flattery: 'According to the scales in the lavatory I weigh 13 stones and 7 pounds in my socks, semmit, underpants, bath robe, national health spectacles and false upper teeth: from all of which a doctor will deduce I am not in the best of health.'[65] But he doesn't dwell on that, instead concentrating on the reasons for his physical state, explaining it away with honest reference to his behaviour: muscular legs due to years of walking a lot, large stomach due to years of drinking a lot, shoulders hunched due to asthma. He even says he has small genitals – but it was revealing in more ways than that. At the start of the pamphlet Alasdair emerged as someone acutely aware of his own personality flaws, hardly interested in his better side. After the description of the physical, he progressed to an assessment of his behaviour:

> In repose the expression of the face is as glum as that of most adults. In conversation it is animated and friendly, perhaps too friendly. I usually have the over-eager manner of one who fears to be disliked. When talking freely I laugh often and loudly without being aware of it. My voice (I judge from tape recordings) is naturally quick and light, but grows firm and penetrating when describing a clear idea or recollection: otherwise it stammers and hesitates a lot because I am usually reflecting on the words I use and seeking to improve and correct them.[66]

Always editing, always self-aware, always with the brain ahead of the mouth. This is an insightful, accurate, unflinching description, but Alasdair is talking about a person he believes others find annoying, quietly suggesting he agrees with these imaginary critics. More than that, his description focuses on tics that he recognised but had not been able or desirous to change over the years: 'When I notice I am saying something glib, naïve, pompous, too erudite, too optimistic, or too insanely grim I try to disarm criticism by switching my midland Scottish accent to a phoney form of Cockney, Irish, Oxbridge, German, American or even Scottish.'[67] When discussing certain modes of communication, Alasdair admitted, he preferred to stick to these old methods of self-protection rather than expose his own true voice. So far so useful, and simple enough, too. Everything was analysed and criticised – when he looked at himself he saw faults, faults and more faults. But he went further than to criticise his mere physical state and social mannerisms. Within a page of self-analysis he was already into deconstructing the very essay he was writing – discussing how he was *going* to begin his pamphlet but couldn't, how he'd lost the documents he needed to do it. Were these disclosures simply ways to distract attention from things he didn't want us to see? He was more than able to divert attention when he wanted to.

After explaining the lost items needed to write the pamphlet properly, Alasdair explores the idea that he secretly gets what he wants in life by cultivating certain self-deprecating patterns of behaviour. Then, of course, he debunks it. Alasdair's assessment of his own behaviour only goes as far as putting forward some of the possibilities for who Gray is, then giving reasons why they probably are not true. Which does not help. After a few pages, it looks like the Saltire pamphlet is not a self-portrait at all, more like a clutter of thick black strokes covering the canvas so that the real person cannot be seen beneath. Referring to the reasons for his habitual losing of important things (documents, medication, money) over many years, he says only this: 'A psychiatrist once suggested these losses were caused by a hidden wish to attract proofs of love from those close to me. I doubt it.'[68] Via Freud and Edgar Allan Poe, two of his stock crutches, he puts his forgetfulness down to 'that sneaking appetite for disaster', as described in Freud's *The Death Wish*. Perhaps the psychiatrist was on to something – but as Alasdair reminded us, he also lost important things when no one was around. So, no definites there either.

But we are getting closer to the truth. After ripping his physical self to

pieces, then distracting readers with half-theories, Gray suddenly shows himself. Like Jock McLeish slipping out of fantasy into reality, like the voice in 'Statements from an Unceilinged Blood' where the mask drops and Alasdair finally speaks about his mother's death, the *Saltire Self-Portrait* follows the same pattern. Gray eventually questions the very reason for his existence: 'Meanwhile, what am I for?' he asks. 'What does this ordinary-looking, eccentric-sounding, obviously past-his-best person exist to do apart from eat, drink, publicize himself, get fatter, older and die?' Everything else in the pamphlet was a roundabout way of saying: *I have done what I wanted to. I don't know what to do next.*

This was written at a time when Alasdair was starting to be recognised for his novels but was still in significant financial debt, and was the only member of his family in Glasgow; Andrew was now grown up and serving up at RAF Kinloss in Morayshire, and sister Mora was settled in England with husband Bert Rolley and daughters Katrina and Tracy. He had been unmarried for over fifteen years, and his relationship with Bethsy was stalling. The person he described in his pamphlet was a middle-aged man, set in his ways, unhappy with many of the things he noticed of himself. The book he had spent his whole life working up to releasing was now done with – it's very possible that he was disillusioned with the whole business of the reason for his life. 'So what are you for, Gray?' Alasdair continues. 'Until a few years ago I wanted to make stories and pictures. While writing or painting I forgot myself so completely that I did not want to be any different. I felt I was death's equal.' So writing and painting were ways for Gray to distract himself from self-hatred. With age, that trick was becoming harder to pull off. After these restless sections of reflection, Alasdair then attempts the 'broad, quick sketch' the Saltire pamphlet was supposed to be, taking in much historical, chronological Gray family information, including an extended essay by Alexander Gray about the family history,[69] which takes up half the pamphlet. Then, an apology for the way the pamphlet has turned out. But if he really had all these regrets, why not just go back and change things? Probably because he wasn't sorry at all.

OLD NEGATIVES

Alasdair's first poetry book was finally published by Jonathan Cape on 23 February 1989 – another key part of executing his, now slightly

damaged, boyhood plan of publishing one of each type of book. *Old Negatives*, so titled because many verses were decades *old*, and negative 'because they describe love mainly by their absences and reverses',[70] was different in appearance and style from all Gray books so far. The hard-lined, black-and-white drawings on the jacket and inner sleeve were more like his Picasso-inspired adolescent efforts, early pieces like his 'Theseus and the Minotaur' from 1952, the year this book starts. (Each verse sequence refers to different parts of Alasdair's life, starting with 'In A Cold Room: 1952–7'.) It was fitting that the work written in his darkest period, often scribbled in notebooks on lonely nights, should be represented this way.

It is not unheard of for artists to write good poetry, or poets to create good art. J. M. W. Turner wrote 'The Sunset Strip'. The Nobel Prize-winning poet Derek Walcott was also a painter. And then, of course, there is Blake. To Alasdair this artistic intermingling had always made sense, but critics found it hard to understand, and many did not like Gray (as they saw it) turning into a jack of all artistic trades. He had always been one, but now the world of publishing was beginning to see it, and was confused. They wanted 'substantial' new works. No more slim books with slim sales! (*Old Negatives* may not have been published if the work had not been produced by the author of *Lanark*.) Of those who noticed it, not everyone embraced the work. Alasdair may have begun his creative life as a poet and always considered himself one, but to outsiders this seemed as if he was dipping part-time into yet another discipline.

The book was hard for some readers to understand: as we have seen in the 1960s chapter of this book, many of the verses were very directly about Alasdair's life. With poems named after Alan Fletcher, Andrew and a whole sequence named after Inge, readers had to know the cast of characters to understand them fully – and who did, apart from the author and a very small circle of friends? According to Alasdair *Old Negatives* was an 'intense, explicit, sharply focussed series of autobiographical sketches'.[71] He had always engaged in acts of partial autobiography, but this book was more open about the direct relationship between the poet and his experience than ever before.

In terms of presentation, the poems were lean, spare and didn't follow conventional poetic rules: to the untrained eye many of them just looked like prose chopped up into bits. So why express these ideas in poetic form at all? Alasdair might not have been adhering to the conventions

someone like his friend Edwin Morgan considered essential ('He'll never be a great poet,' said Morgan, talking about *Old Negatives*. 'Probably! You never quite know with Alasdair . . .'[72]), but the work demanded, Alasdair felt, for these poems to be written this way, without conventional rhythm or meter. They were sparse, with poems like 'Loneliness', 'Mistaken' and 'Accept, Reject' describing in disjointed, broken-up language a deeply damaged man – Alasdair himself.

There were some sympathetic responses to *Old Negatives*, but often from those who had an interest in Alasdair personally or willed him to succeed. Iain Crichton Smith felt unable to resist comparing it to Alasdair's big book. Asking whether the poems succeeded as poetry, he wrote in the *Scotsman*:

> Gray is a better prose writer than he is poet. I am not talking here about ideas: I am talking about the curious abstractness of the poems, and the way statements intrude. It seems to me that Gray has found in *Lanark* an objective correlative that is not to be found in the poems, in a sustained form that has its own imaginative parameters. Poetry, I think, works differently. Metaphor is its life. What metaphor, after all, is there for the void?[73]

When Crichton Smith explained 'how poetry works', he was doing it as a 'proper' poet, not one who produced one slim volume and then returned to other loves. Alasdair was finding it difficult to be accepted in all his manifestations. Why was he attempting so much? Was he already out of ideas, and just publishing for publishing's sake? These were questions that would come up again soon, when *Something Leather* appeared. But for now he was still finishing off that book, and living off the advance the chairman of Jonathan Cape, Tom Maschler, had given him to write it.

END OF THE EIGHTIES

By the late 1980s Alasdair's old poetry student Peter Mullan had turned from literature to drama, and begun a career as a television actor. Since their first meetings, *Lanark* had made Alasdair famous locally. Mullan says he remembers a party where he was alarmed to find Alasdair being plied with drinks by strangers:

They just wanted to be around a literary genius. You know, it didn't suit him. To see him in that state of misery – when he smiled it was more like a sneer – I felt he was being used, and I didn't like that he was playing up to it. I felt he didnae like himself by then. There was a lot of self-hatred. He obviously had no money, but he had these people at him all the time, looking for something. So he took the drinks and did a turn . . . I just said, you know, 'What the fuck are ye doin? You're better than this . . .' He glared at me for a very long time. That's all. No words.[74]

Mullan may have caught Alasdair at a particularly bad time, but the occasional fakeness he described was something that had crept in steadily over the decade, and he was not the only one to spot it. When writing *Lanark*, Alasdair had never considered how he might deal with attention. When it came he responded by socialising more, and drinking more, which Bethsy Gray blames for the end of their relationship. They broke up at the end of the decade. Peter Mullan again, on alcohol:

Particularly at that time, in 1980s Glasgow, a lot of great minds were drinking themselves into mediocrity. And with Alasdair, as with others, the booze helped him socialise . . . for artists that drink there's a great terror of giving up alcohol, because they think it creates manageable demons. What terrifies many creatives about sobriety is having to manage their real demons underneath. Even if they've not done anything bad, those are pretty hard to face.[75]

By 1989 Alasdair, now briefly living in a much smaller city-centre flat in St Vincent Terrace, was in his mid-fifties. In recent years the success of his debut had not been matched – much to the disappointment of his publishers. But despite these disappointments, the reputation of *Lanark* was growing at home, and abroad he had now been published in a number of languages he could not read. Looking back, Alasdair asked himself the question whether the time spent on *Lanark* was worth it: 'Not entirely. Spending half a lifetime turning your soul into printer's ink is a queer way to live . . . I'm sure healthy panthers and ducks enjoy better lives, but I would have done more harm if I'd been a banker, broker, advertising agent, arms manufacturer or drug dealer. There are worse as well as better folk in the world, so I don't hate myself.'[76] So: ducks are happier,

drug dealers are more harmful, and Gray sits uncomfortably in the middle, not quite hating himself.

DIARIES: Attention

Winter 2004/Summer 2005: Poor Things –
The Other Film That . . .

In December 2004 we broke off work on Alasdair's new novel to receive Iain Brown, a producer who, Alasdair said on seeing his guest at the door, had been preparing to make a film of Alasdair's novel *Poor Things* – for a long time. I didn't get to speak to him about this properly until Mr Brown had left, so while he was present I saw no reason to hide my excitement. Alasdair had spoken of his proposed *Lanark* film which never materialised, the script he worked on with Sandy Johnson in 1985 – and I knew that Iain Brown had been involved in that project too, but knew little else about either. Mr Brown, an affable man with an assured voice and fine moustache, appeared at Alasdair's door clutching a copy of Gray and Wilma Paterson's *Songs of Scotland*[1] under one arm and a bottle of whisky under the other.

'Time for a drink?' he asked, smiling.

Alasdair was expecting him but I had no idea he was coming. You never quite know who's going to appear at the door next in the Gray–McAlpine household, and I like occasional surprises.

Mr Brown announced that the money was in the post for the film of *Poor Things* and, given a new, enquiring face eager to ask questions, he explained to me that after many years of searching for funding, and many false starts, the filming of Alasdair's novel was to begin in earnest in April. Edit studios and actors were booked. Everything was guaranteed. This was well worth toasting! Morag came through from the bedroom and the four of us sat by the fire enjoying its warmth and drinking single malt. Iain took out a file of images of proposed film sets that were going to be used, proudly showing places in Kelvingrove Park, being lit in a way that seemed perfectly in tune with the tone of the book. Iain explained with great passion how previous attempts to make the film had fallen through because large financing studios wanted to make changes to the story. So, like with *Lanark*, they had waited. This seemed plausible. So many bad films had been made of good books, I stammered. I didn't want *Poor Things* to be another of

those, and said he must feel very proud. Meanwhile, Alasdair and Morag sat relatively quietly on either side of me, politely looking at the prints Iain handed round and answering questions when asked. I didn't give the others much of a chance to get a word in. When was the film due for release? Would it all be filmed in Glasgow? And who were the actors lined up? Iain said Robert Carlyle had accepted the role of McCandless, Helena Bonham Carter the role of Bella/Victoria and Jim Broadbent the role of Godwin Baxter.

'Perfect!' I said.

And I thought so. After an hour Mr Brown left the flat saying he'd be in touch soon with more details, and wished Morag and Alasdair a happy and healthy Christmas. We were all in good moods, I thought. I was nearly bouncing around the room, sure this project would be a wonderful one that would take Alasdair's work to a wider audience. It was even being made with Scottish money, which should please his instincts.

'Have you any idea who Helena Bonham Carter is?' I asked.

He thought for a moment.

'Not really.'

'She's a *very* good actress. Great! And perfect for Bella. Perfect!'

'Yes, Rrrodger, *so you keep saying.*'

'And what about Jim Broadbent? How did they get *him*?'

Alasdair looked at me with a slightly puzzled, blank, perhaps even slightly offended expression.

'He likes my books!'

'Of course. Of course. And Robert Carlyle? Bloody hell! Robert Carlyle! Begbie himself! He's a bloody Hollywood *superstar*!'

'I hear he has been in some good films. But I don't think I've seen any of them.'

I found it so hard to believe that Alasdair hadn't seen *Trainspotting* that I almost completely lost it.

Before we returned to work Alasdair calmly explained with a sigh that he did not think the *Poor Things* film would ever be made. Iain Brown, he believed, was an honest, good man who wished very much to make a film of his novel. Iain had even remortgaged his own home to finance the project in periods where otherwise it would have fallen apart entirely. But the actors that had been promised had been so for several years, and, Alasdair explained, he feared the cheque was no more in the post than it had been in 1995. Mr Brown had kept the film

options for most of that time, and last year asked to keep them, for £1000, convinced that one more year would get the thing going.

'I'm not entirely sure if that was sensible,' said Alasdair, scratching his head furiously with both hands, back and forth, back and forth. 'I probably should have refused.'

Eczema is aggravated by stress. Whenever he is annoyed, the first thing Alasdair does, without noticing, is start scratching. His sympathy for Iain Brown, knowing he had put so much into the project, allowing more time and more time and more time, had led him to refuse other offers that might have had more chance of success in favour of one that looked increasingly unlikely. Alasdair didn't want to discuss it. I didn't ask him about it again but did notice occasional jolly messages on the Gray answerphone from Mr Brown over the next few months that made it sound like everything was going swimmingly, and filming was about to start. But the April deadline passed with no progression. I wanted to be proved wrong, and was still hopeful.

Whilst in the car listening to the radio [end of summer 2005],[2] I was pleased to hear an interview with Jim Broadbent was coming up after the news, in which he'd be talking about his work and future projects. I pulled over on the motorway and texted the programme. Five minutes later, my question was read out on air:

'This is from Rodge in Glasgow,' said the interviewer. 'Please clear up a rumour if you can. Are you going to be filming a version of Alasdair Gray's *Poor Things* with Helena Bonham Carter and Robert Carlyle?'

'Oh,' said Broadbent, in the tone of a man who hadn't thought of something for a long time and was surprised to be asked about it. 'Sometimes . . . projects don't come off, for various reasons. I've started filming things before that just . . . stopped because the funding disappeared. These things do happen, unfortunately. I agreed to *Poor Things*, a long time ago, but I don't know what happened. I liked the book very much.'[3] The conversation then turned to a new theatre production in London, then his next film, then the one after that. I wondered whether Iain Brown was deluded in thinking that *Poor Things* was ever going to get made.

12 October 2005: New Jobs, Old Jobs

Alasdair phoned today to say he thought I would be relieved to hear he had employed somebody four days a week to do secretarial work

for him, as I was now a writer like him, and too busy to do the job. I was shocked and upset. I suppose I must have been letting him down when he needed me, or maybe it was just that the relationship had evolved, as all must. A couple of weeks ago he had written to me recommending I take my time with my writing and not promise too much to too many people – that was a warning I didn't spot. Once I had been a wide-eyed student looking for every possible moment with my hero. Now sometimes I got annoyed when he wanted me round at short notice, so it was a sensible measure. But I feared losing my contact. I realised I was replaceable. This thought had occurred to me a week earlier, when I was less worried, when I noticed *Something Leather* was dedicated to past secretary Flo Allen, with a reference to an unnamed previous one who would not type the word 'fuck' so gave the job up. I knew I was not special then. Now I feel it. No matter how much I know how sensible the decision is, I still feel jilted. How silly. I shall get on with my books, and see him every Friday, as he has asked. And I will pass on all necessary information to the new secretary, Helen Lloyd.

Thursday 16 February 2006: Slings, Arrows, Jokes

My piece was printed last weekend in the *Scotsman*. It was a feature detailing a brief history of my relationship with Alasdair, which also appealed for interviewees and information on Gray from those who might not exactly be on his Christmas card list.[4] It brought mainly useful responses, and since then there have only been a few nasty swipes at me for having the nerve etcetera etcetera, mostly from those who mean well and feel it's their duty to protect. So I bear no grudge. In a phone conversation tonight I warned Alasdair that people might soon start telling him of my crimes against him – but no amount of serious comment brought serious answer from the man himself. 'Oh, Caesar Gray am I!' he cried. 'Wounded, I am! Betrayed I have been! Die I shall! Will nobody come to rescue me from the [drops phone, continues talking, picks back up and continues as if undisturbed] slings and arrows of outrageous biographers . . .' If we do ever fall out over the content of this book it won't be because I tried to hide what I was doing.

After finally putting the phone down, Alasdair called me right back to titter his way through a joke a friend had just told him. 'You see . . .' he said, 'this is irrelevant . . . but the point is . . . it's my sense of humour . . . ha ha! Anyway . . .' He dived into the joke, delivering it

with gusto. Something about the Hoover Dam, the 1930s, the philosophy of thousands of slaves, and three elephants balancing on a man's head. I had no idea what he was talking about, but there was such pure infantile joy (and that's a compliment) in his voice that it seemed rude not to laugh when he was finished.

Sunday 13 August 2006: A Contemporary Secular Monk Seeks Adoration

Today's trip out is to Edinburgh, where the Festival is in full swing. The journey brought no major health problems, though some considerable shocks. Alasdair asked what on earth 'reality TV' was – and was horrified to hear the details. He shook his head, suddenly depressed, and said, 'Aye. I don't like to watch television.' (Which raises significant questions about how and why he wrote for the medium for so long.)

This summer Alasdair was not taking part in the official International Book Festival, but appearing instead at the Fringe event called 'Thirsty Lunch', which this year hosted James Kelman and James Robertson, Alasdair's old friend Angus Calder and man-of-the-moment John Aberdein,[5] proudly advertised as 'the man behind Tommy Sheridan's legal team'. The event was subtitled 'New Work' and the venue, a low-lit underground jazz bar, was full. Today we performed on the same stage for the first time. Gray signed books and chatted to fans before the event, and when the time came I went to help him up on to the stage – but he fairly leapt up on to it and grinned, very pleased with himself, as if to say 'Ha! I don't need anyone!'

For the most part the event went off well, though before the introduction was over Alasdair was already disputing the most basic facts about our relationship. The chairman, Stuart Kelly, introduced us and repeated an oft-used quote, telling the audience that Alasdair had once said to me, 'Be my Boswell!' The first five minutes of Gray's reading were then taken up with his memories of exactly how this biography came about, starting with the words, 'Now I don't re-member it like that . . .'

All I could think of was to shout, off-mic – 'And so it begins!' which got me off the hook for a while, but will not do so indefinitely. Alasdair stuttered for a little while, digressed into the details of our history, secretarial work – and then finally, realising he had gone on too long, sighed and said into the mic: 'Anyway . . . *we are friends*.' Why is it that

even when being corrected by him in public, I don't mind because I am so pleased and surprised to be referred to as a *friend*?

Later, a sit-down read-through of Alasdair's new play *Goodbye Jimmy* took place on the stage and afterwards Alasdair and Morag sat outside with friends enjoying a pint – between them.

'We are less likely to stay and get drunk this way,' said Morag.

The shared-pint trick worked and after one we prepared to leave. As they were finishing up, saying goodbyes, Stuart Kelly commented on how many good Scottish writers there were sitting around the one table – Alasdair, Angus Calder, Kevin Williamson, several others. As we left Alasdair played up to the crowd. Kevin Williamson was joking about how all writers really just wanted to be loved, and Alasdair was keen to respond. He jutted his chin outward, pressed a fist to his chest and proclaimed, at full volume so the whole of Chambers Street could hear:

'Not just loved, but admired! Not just admired, but adored! Not just adored, but respected! And not just respected, but *deified! Hahaha!!!!!*'

There was a smattering of applause and he turned to leave. Some of the audience from the event stayed behind for a drink and were looking on with thinly disguised pleasure, the expressions on their faces suggesting that the minute we were gone they'd be on the phone: 'You'll never guess what I just saw Alasdair Gray do . . .' It was a small gathering today, no more than sixty people, while across town fresh young things appeared to twice that number in a grander setting, but as we left I got the impression that few here would forget it.

19 December 2006: Singing and Sex

Alasdair was in a cheerful mood today. He sang through most work, giving a particularly robust rendition of the old Cockney music-hall song 'My, Ain't It Grand To Be Dead' which, he tells me, he learned from Bob Kitts. Stuck for a vocal reply, I tried a few lines of 'Nowhere Fast' by the Smiths, and Alasdair laughed at the bit that goes 'I'd like to drop my trousers to the Queen/Every sensible child will know what this means'. If in doubt, appeal to the old republican in him! When we stopped to put the kettle on he told me a story about one night when he performed the following song in the Clutha Vaults pub. It was on one of his favourite subjects – being bad at sex:

As soon as I could stand erect and walk without my mother
I never understood why people seemed to need each other.
Close contact is embarrassing – it chills me to the bone.
I quite detest the other sex. I also hate my own.
Yesterday a chap in a pub asked me, 'Have you never thought of
* going to bed with someone and lying parallel?'*
'Of course!' I said, 'Of course! Of course!' but –
I don't like it enough to practise enough to do it very well –
I don't like it enough to practise enough to do it very well!

The song then skips to another familiar Gray preoccupation. Here is the final verse:

One day with nothing else to do I entered politics:
they made me the Prime Minister in two thousand and six.
I had a brand new policy that everyone enjoyed –
It brought more weapons, more police,
a lot more unemployed!
We jettisoned the welfare state – we can't support the needy.
We're investing in Malaysia where workers aren't greedy.
The only industries we need are armaments and banks,
and as for foreign policy, we leave that to the . . .
The government of the United States of North America!

I didn't know he was performing a section from *Tickly Mince*. This was possibly my favourite moment with Alasdair so far. I wish I'd had a tape recorder. No, a camera. No, a video camera.

18 February 2007: Acting Up

Tonight I chaired an Alasdair Gray event at Glasgow's *Aye Write!* Book Festival, which takes place in the grand old Mitchell Library in the centre of town. I had been doing events of my own and had enjoyed the weekend, but the closer I got to the Gray one, the more nervous I became. Over three hundred people had paid to see Alasdair read from a book that nobody could yet buy and was not even finished, and though I'd shared a stage with him before, I had never had to *present* him, and did not particularly want to quiz him in public. Because, as I said at the start of the event, 'I have spent a fat chunk of the last decade asking Alasdair Gray questions, and he has spent much of it not answering them . . .'

I went to see him this afternoon – partly to check he'd remembered
the engagement, but also to deal with tonight's format. It seemed false
to be doing these kinds of things, as if I didn't know him. As if I wasn't
spending every day writing about the most personal details of his past
and was a mere chairman for a night. The *Aye Write!* programme had
once again exposed me as Gray's biographer, so I was also worried
about coming across as too much on side, or too aggressive, or, in fact,
anything in between. I'd been planning to give him a good grilling, but
was afraid to do it with a straight face. When I got to the flat, Gray was
thinking about the artwork for his new novel. He and Richard Todd
were standing in front of a line drawing, discussing Greek pillars.
Richard is in attendance at most Gray artistic endeavours now, resigned
to repeated change, ready for new orders, quietly getting on with it.
These days Alasdair does the designs but much of the actual drawing is
done by Richard. Between them they had until the following morning
to get the current job done, and time was, as usual, running short.
Alasdair and I discussed a trick he wanted to use tonight, then I left.

Gray performs even when there is an audience of one – himself – but
it's always interesting to see how he acts in unfamiliar company. A few
hours after our afternoon meeting we were sitting in a Green Room,
with a photographer snapping Alasdair from the corner of the room,
while Gray tried to remember two poems he wanted to read out,★
breaking off several times between writing lines down to remind me
that he wanted to keep the time for questions to a minimum. Shortly
after, we were ushered down to the hall shortly before the event was
due to start, and both chairman and author took a quick detour via the
Gents. As we faced in opposite directions at the urinals, Alasdair said, in
his familiar old Officer Class Voice, deep, assured, serious:

'I knew Shanks well, for sure . . . a fine fellow. *But Armitage? Less
so . . .*'

It was time to go on. As we walked out of the wings I put my glass of
red wine on the table in front of us, then went over to the lectern – and
Alasdair bellowed:

'That's his! Not mine!'

'Quiet, Gray,' I said into the microphone, trying to regain some sort
of composure. 'You will upstage me in good time. But not yet.'

★ These were 'Dictators' and 'Mind the Gap!'. AG introduced them as: 'Two poems
written in this century, but which also apply to the last . . . ' Which he meant
seriously, but the audience took as a joke.

Alasdair read at length from the novel; virtually anything he chose to do would have been greeted positively, but this partisan crowd seemed to laugh at everything he did, including the way he spoke, or hiked his trousers up to almost under his armpits, or scratched his head and occasionally genitalia through trousers. I wonder how patronising this response is: on one hand, it is perfectly natural to laugh at uncommon things, especially those done by socially awkward, endearing elderly folk who speak in a very old-fashioned way: and Alasdair's fans are certainly endeared to him long before they see him in person. But in certain moments the responses suggested something more – Alasdair fits the classic romantic view of the artist, who can be looked up at and down upon at the same time. What people see and hear is a bumbling man capable of genius, but, as in some one-on-one situations Alasdair experiences, this doesn't stop them from assuming he has no idea of how absurd he seems, sounds, is. A survey of responses conducted after the event with those who had not seen Gray in the flesh before brought an amazing set of compliments – several audience members described him as mesmerising – but these compliments were almost always followed by some kind of condescension.

Even this is understandable. It was exasperating to try and get him to answer the audience's questions, no matter how simple they were – on one occasion he even diverted on to the old topic of his dad's Readers' Book Club, detailing the plot of one story in full before being halted mid-flow – but if we are claiming him as a great mind, surely it's a foolish move to assume that Gray doesn't know what he's doing here. To me, he seemed to be playing up to the audience, or playing up to their idea of him. He knows what people see. And, addicted to the attention it gives him, he keeps up the act. One audience member even suggested afterwards that he might not even know how much of an act it was any more. 'He has become his own performance . . . but that's all right.' After all, it is a *performance*. On a stage! 'The lie which elevates us is dearer to us than a legion of base truths', said Pushkin, a Gray favourite. And if the Gray performance is a lie – either on a stage or in a Green Room or in front of a mirror – it is certainly one that elevates him, though in some ways it does it while pulling him down in other ways. As he meandered through a five-minute answer relating not a bit to its question, the audience laughed more and more: they had got what they came for. An entertaining, astonishing eccentric on form. I wrote on my pad: *Remember they are here for* him *only*. And I abandoned

the grilling I planned. Instead, I asked Alasdair only one question, which ended the session. He had always hoped his son Andrew would ask what follows, but as yet he hadn't done so. I said:

'And the question you asked me to ask you is this: are you driven to write this shite or are you just looking for attention?

He could hardly hide his delight at the situation. Alasdair's one-word answer was this:

'BOTH!'

And there was more truth in that than there would have been in a long and detailed reply.

20 February 2007: If All the Ladies Could Please Come Over Here . . .

Alasdair recently designed the cover and donated an old poem, 'A Sentimental Song', to an album of collaborations between (mostly) Scottish writers and (mostly) Scottish musicians, *Ballads of the Book*, a project I also happened to be involved in. He was initially unsure about it – he doesn't think much of the music the young folk make these days – but the last traces of his reticence have disappeared now he is getting attention. This afternoon *The List* magazine organised a Sergeant Pepper-style gathering of writers and musicians featured on the album.* This meeting took place at the Oran Mor, under Alasdair's big starry blue sky filled with naked figures and messages – many of the musicians hadn't seen the work before and pointed parts out to each other, some reading the words on the beams and asking questions.

Gray was in his element: he led everyone up to the highest point of the building – a platform from which the whole mural can be seen. As the photographer attempted to get the assembled to look vaguely comfortable, Alasdair tried to get them to sit in front of his depiction of Glasgow University, ordering around various members of the band Sons and Daughters and A. L. Kennedy to where he wanted them: 'I don't usually like to be managerial, but don't you think it would look good if – ahem – I don't mean to be sexist, but, *if all the ladies could please come over here. . .*' When the group was somewhat awkwardly arranged

* This gathering included members of the groups Sons and Daughters, De Rosa and Traschan Sinatras, and solo artists Lord Cut-Glass, Emma Pollock and Alasdair Roberts, as well as writers Hal Duncan, Alan Bissett, A. L. Kennedy, RG and, centre stage, AG.

for the next set of photographs, Alasdair took his place on the floor, one
of only two sitting at the front, more like the smallest in a team photo,
made to come down to the front to be seen – not a septuagenarian Old
Master keeping aloof distance from young pretenders. Alasdair was at
his most excitable, most uncontrollable, like a boy inviting a bunch of
strangers into his den and wanting them to play games *his way*.

As the snapping went on, he told Alun Woodward★ an anecdote
about his belief that all photographers take too many pictures and that it
was really better in the old days when you could take them slowly:
'Now they are like crocodiles . . .' he said, 'laying a hundred eggs in the
hope that one or two will turn into children!' And when the photo-
grapher attempted to make the contributors stand around randomly,
relaxed, Gray put his hands to his head, getting agitated at not being in
control. At this point he and I were standing close together for the first
time since arriving, and I was more aware of his behaviour than ever: I
felt as if I had to justify the way he is to people who were sometimes
amazed, sometimes amused, sometimes repelled by his many tics. As
the last photographs were taken, Gray suggested it might be a more
dramatic shot if one person was strangling another, with everyone else
standing around in horror:

'Well, if you need to strangle me – for Art's sake – I will tolerate it,' I
said, trying to keep my voice down.

'But I can't kill you,' he replied, whispering. 'My reputation is
dependent on you!'

'Which is why you might be best to put your hands around my
throat.'

I left Oran Mor with instructions to get 150-watt bulbs needed for
the Gray–McAlpine home. Apparently I bought the last lot a few years
ago, and they needed replacing.

★ Aka Lord Cut-Glass, AG collaborator on 'A Sentimental Song', ex-member of the
Delgadoes and a quarter of Chemikal Underground Records.

6 1990S: SUCCESS, MONEY, POLITICS

CHAINS OF HABIT AND GUILT

As part of a writers' exchange Alasdair visited Berlin, capital of a newly unified Germany in the spring of 1990. Plenty tied him to German literature: he had certainly been influenced by the best of it, Goethe in particular.[1] *1982, Janine* had also been published in Germany in 1987, so there were reasons to go. He stayed for six weeks, and this cultural swap was supposed to produce new work for a book called *Vier + Four*. But though he came up with the title, he only wrote one thing for it. When asked about it he simply said, 'I was . . . *unable to contribute further.*'[2]

He returned from Berlin with a single poem written on the plane, one of his most revealing pieces: 'First of March 1990'. You'd never know he was travelling to the 'most politically complex city in Europe'[3] when it was written. The poem showed Alasdair's lack of direction at this time, but also that he understood the man he had become. It brings to mind his Glasgow–Gibraltar journey of 1957, but this describes many more aspects of Alasdair's life in one, exploring how he felt about family, love, work, home, travel and success, in those moments in mid-air:

> am in sky to Berlin
> who only rest well when working &
> work best at home
> who avoid abroad unless pulled by lover[4]
> yet travel alone
> fearing travel may break habits keeping me whole
> remake me worse
> so why in sky to Berlin?
>
> discontent i fly
> not to life ahead but from all behind although
> not one of Scotland's unemployed
> not poor not friendless
> wifeless through choosing to be

> with independent son i like who likes me
> this brain body nobody's tools but my own
> why discontent?

Why? Because of pressures both outside the 'brain body' and in it.
Alasdair felt guilty, because of the growing gap between his own success
and that of artistic friends such as Carole Gibbons, Malcolm Hood and
Alasdair Taylor, but also from simply doing too much. The strategy of
multiple commissions was partly financial, but he was often unable to
complete them on time or to his own satisfaction. This poem showed
how he felt about the pressures of juggling so many disciplines, though he
was unable or unwilling to stop. Too many years' habit for that:

> don't use tools well
> from cowardice hide pride under meekness
> childishly keen to be liked promise more than can
> so guilty
> love and paint too little (once painted a lot)
> think and write too much
> booze to stop thought so fat
> should change

There's a real contrast here, between the experience of writing and
painting. By 1990 Alasdair had taken to describing words as more of a
chore than a joy, preferring the freedom he got from art. He complained
writing had taken over in a way he never intended: the *combination* of
words and pictures was always crucial. It's true that he used to paint more,
something he felt was peaceful, relaxing exercise, with soothing qualities
that tested body as well as mind. Writing too much on any given day made
sleep difficult – something he used to explain away why he so often drank
at night. (It knocked him out when the brain was tired but body was not.)
The poetry he produced during this time shows restlessness for change at
the same time as a reluctance to embrace it:

> HATE change always hoped each home
> where i came to live would be where i would die
> war marriage motor-way building divorce dry rot
> kept me starting anew all i could do
> to stop some things going away

was remake them in paint and words that also decay
ought not to try keeping
should glory in change

Here Alasdair makes his creative output sound like one long attempt to
preserve disappearing life — he always hoped that preservation would
bring freedom in the form of recognition, and enough cash to keep him
alive. But now even success was a trap:

HATE should HATE ought
words used by teachers who tell not show
who use others as tools
to kill appetite & imagination which do
the work of creation freely
once felt free writing a book only i needed then
now teachers tell children it ought to be read
does all free work leave a chain?

am chained by books I made some popular
sweet for the sour to be told they are suddenly sweet
kind heat sucks self to surface like sweat being licked
fees and fame fill belly & days until
one day am 55 my best work done
having promised too many too much
& running (no)
flying away[5]

At the poem's end he explores these multiple promises, ranging from the
design for his next book to his never-ending *Book of Prefaces*. (Which had
been optimistically scheduled for publication in 1989.) Then Alasdair asks:

& on this conscience
what in Berlin east or west
can break chains of habit & guilt letting me see
things wholly themselves
things not smeared with me?
he thought
coming down from the sky
to Berlin

It is not simply that Alasdair was writing a poem about guilt – he was also writing about *how he thought he shouldn't be*, especially when about to arrive in exciting, changing Germany. Everything was covered in Gray. It was all he could see, even when descending into 1990 Berlin. And so more guilt. This poem is the first place where Alasdair acknowledges the pressures of being a now-famous jack of all artistic trades. There is a real sense of exhaustion with being a one-man band. It is amusing then, after this depressing investigation, this exhaustion with writing, to find that in the decade after the fall of the Berlin Wall Alasdair Gray Plc published nine books. The first of these, *McGrotty & Ludmilla*, was published on 5 April 1990 by a new, independent Glasgow publisher, Dog and Bone Press. As with *The Fall of Kelvin Walker*, most readers had no idea it had been a play fifteen years earlier.

THE DOG AND BONE ADVENTURE

Donald Saunders, Alasdair's sometime secretary, had recently been working with him on *The Book of Prefaces* – typing, operating technology, liaising with Canongate. Alasdair's old friend Chris Boyce trained Donald to typeset on his home computer, then his wife Angela Mullane came up with a plan to pay Donald – by starting up a publisher. The new company could pay Donald to work on *The Book of Prefaces* and other projects the group thought worthwhile: this way Dog and Bone Press was born. Alasdair's dirty old white mutt became the emblem, Saunders the only full-time employee, and soon Gray found himself with the grand-sounding title of Artistic Director. Recently relations between Angela and Alasdair had been strained, and his involvement with Dog and Bone represented an opportunity to repair them:

> I took away her responsibilities as my agent, out of guilt. She had been operating on my behalf for some years without pay, and she always had a full diary. But she thought I was rejecting her, and was very upset. I had so many reasons to be grateful to Angel. I didn't know what to do. Then I thought, Aha! *The least I can do is produce a book for her!*[6]

So Dog and Bone had another new title. Alasdair converted an old play into a novella in one intense fortnight. When published, *McGrotty and Ludmilla* was dedicated to Angela Mullane.

A rush of books was released by Dog and Bone in 1990, mostly by the Gray crowd. These included *Blooding Mister Naylor* by Chris Boyce (who had published science fiction previously), *Lord Byron's Relish*, a cookery book by Alasdair's friend Wilma Paterson, and Donald Saunders' *Findrinny*, his first published collection of poetry.[7] There were big plans for another imprint, too. In the Spring 1990 catalogue Alasdair boldly promised the company would 'operate throughout Britain', and 'publish Gaelic writing under the imprint An Duilleag Bhan (The White Leaf)'.[8] But that never materialised. Dog and Bone needed money to launch itself into the busy publishers' marketplace, and even to make a small impact the finance was simply not there. As for Alasdair's novel, *McGrotty and Ludmilla* was advertised as a romance describing 'the making of the deadliest British Prime Minister since Margaret Thatcher',[9] the jacket was a portrait of Kevin McMonagle (McGrotty) from the cast of the 1987 stage version – a nod to this novel's previous life as a play. But the book was only really reviewed locally, and was mostly swallowed up by the fuss around *Something Leather*, the Gray book that closely followed it. It was difficult to get coverage in the newspapers, and distribution was a problem, too: one rep who tried to sell *McGrotty and Ludmilla* into shops said: 'It was my hardest sell ever. It was released by a small press, totally unknown, it has this strange title. Nobody really wanted it.' The reality of publishing was harsh. Gray's connections alone were not enough to guarantee column inches, even in Scotland.

Dog and Bone didn't last long. As well as the fact that no one involved had significant publishing experience, many of the authors were taken on because they knew the organisers (or *were* the organisers), not simply because of the quality of the writing. The books were promoted as affordable and accessible, and Alasdair usually did cover art and blurbs, but apart from him all the authors were unknown. Then Donald Saunders left to take a job abroad and the company stalled. The name would be used in the future, initially for typesetting, but Dog and Bone the publisher was finished.

A CITY OF CULTURE?

By now, Alasdair had spent a lifetime trying to draw attention to Glasgow – when it finally arrived, he found the form it came in highly unsavoury.

During the 1980s Glasgow was increasingly seen as a bleak, run-down place. The Clyde shipyards had been in steep decline for years, the old industries were dead or dying, life expectancy for Glaswegians was among the lowest in the UK and the city had a reputation for gang and football-related violence. The old Second City of the Empire had become, to some, an embarrassment. This made it a prime candidate for being Europe's next City of Culture in 1990, a title usually intended to kick-start regeneration in European cities which needed it. Angus Calder has referred to these projects as a 'sleazy repackaging of whole cities',[10] but in the 1980s the City Council was fighting a PR battle, as 'before Glasgow could start its economic and physical regeneration, it had to shed its "no mean city" image'.[11] This meant changing negative perceptions, highlighting what some were calling a new cultural renaissance brought about by the city's artists, musicians and writers – and most agreed Alasdair Gray was one of the most important of these. But Gray was not interested in promoting a sanitised view of his city, advertising it to tourists or celebrating the positive. He wanted to highlight problems.

In advance of the Year of Culture Alasdair was invited, with Philip Hobsbaum and Tom Leonard, to a meeting with an organiser who wanted their advice. She was arranging an exhibition called 'The Words and the Stones', intended to celebrate Glasgow's history, its writers, architecture, and counteract its bad reputation. But the three men would not tell her what she wanted to hear: Alasdair said the Year of Culture was about bringing in foreign investment for foreign profit, not benefiting local people. Tom Leonard was not impressed either. So the writers described what they thought was the true state of Glasgow, with all its difficulties, and organisers went elsewhere for information. But this didn't stop officials using Alasdair's name when they wished to make Glasgow look like a place where talents happily grew. Even years later Glasgow City Council's website still ties Alasdair in with the City of Culture. Speaking of the positive effects of the 1990 festival, it reads:

No longer could the character Kenneth McAlpin in Alasdair Gray's seminal novel *Lanark* dare to say that: 'imaginatively Glasgow exists as a music hall song and a few bad novels – for that's all we've given to the world!'[12]

Since 1990 Glasgow has tried, with some success, to reinvent itself as a cosmopolitan artistic centre – but the older generation who knew the

old city preferred it not to be replaced. Alasdair stayed away, as did other artists who aligned with the Worker's City movement, which argued that working-class Glaswegians were being ignored so the city could be advertised as a tourist-friendly, middle-class place just like Edinburgh. Gray made his feelings about it clear in his work. In his Dog and Bone catalogue he wrote: 'It is sheer co-incidence that for the "Year of Culture" 1990 our first titles are by Glasgow writers.' And in his next book, *Something Leather*, published on 12 July 1990, at the height of the City of Culture, the 'Words and the Stones' project was fictionalised as 'The Bum Garden'. Which shows what he thought of it.

SOMETHING LEATHER

For several years in the mid-1980s, Tom Maschler at Jonathan Cape had been asking after Alasdair's new fiction – in 1987 he sent him a single, unfinished story. Maschler wrote an excitable letter back asking if he could turn it into a novel. Without an agent, in huge debt and with little interest in writing a novel, Alasdair sent a reckless reply: he said he would try, but demanded a £30,000 advance for his trouble (a much bigger figure than any he had received before), also he wanted a third of the money immediately, a third in six months' time, and the final third on completion of this as-yet-unwritten book – not on publication, as is customary. Alasdair was amazed and delighted when Maschler agreed to these demands, but the size of advance put pressure on the project from the start: much of the money went on paying off debts and the writing itself proved a struggle. After *Old Negatives*, the short, unpopular book of poetry, what Maschler got for his money was a loosely linked book of stories that took the most unpopular aspect of Gray's output – leather and fetishism – and concentrated on it. On release much of the critical focus was on the sexual element, with enemies using it as further evidence that the author was simply a pervert, but the real problem with *Something Leather* was that it was an excuse for a novel instead of an actual one, something more or less admitted in Alasdair's concluding twenty-page list of apologies which made it sound like he regretted embarking on the project. In that promising short story he had invented one character, June – intelligent, honest, lonely, good-looking – and now had to make adventures for her that could fill a book.

Unable to find these, Alasdair resorted to the spares drawer. *Something Leather*'s epilogue admits the book contains versions of old plays *The Man Who Knew about Electricity* (now a chapter of the same name), *Sam Lang and Miss Watson* (now 'Mr Lang and Ms Tain') and *Dialogue* (now 'A Free Man With a Pipe'). Despite protestations on the inlay – '*Something Leather* . . . combines the amenities of a novel with the varieties of a short story collection' – few were fooled. This would not have mattered if the pieces were good, but this was largely material that had not made the cut for *Unlikely Stories, Mostly* or *Lean Tales*. *Something Leather* is now a book Alasdair jokes about disliking. Certainly Cape were unhappy with it, and with good cause. The relationship broke down totally and this became Alasdair's final book with them before he moved to join Liz Calder, who had left Cape to become a founding director of Bloomsbury in 1986.

Even the cover art was a problem. Alasdair supplied a black-and-white sketch of a stern-looking woman in leather skirt, fishnet stockings and white blouse, looking harshly outward. When the book was released in paperback by Picador they changed the Gray artwork without his permission (only the second time this had happened in Alasdair's career). They had replaced his sulky drawn female with a photograph of an actual live one in full leather get-up, looking distinctly more early nineties, more pliable, and quite possibly like a prostitute. Gray, horrified, disowned the edition.

LEATHER THEORY, AND RELEASE

The most interesting thing about *Something Leather* is not the story itself but the Epilogue, in which Alasdair argued that this book represented an end to previous work:

> A few years ago I noticed my stories described men who found life a task they never doubted until an unexpected collision opened their eyes and changed their habits. The collision was usually with a woman, involved swallowing alcohol or worse, and happened in the valley of the shadow of death. I had made novels and stories believing each an adventurous new world. I now saw the same pattern in them all – the longest novel used it thrice. Having discovered how my talent worked it was almost certainly defunct. Imagination will not employ whom it cannot surprise.[13]

Though he hoped his talent was 'only as dead as Finnegan, and would leap from the coffin and dance a new jig if the wake got loud enough',[14] he suspected it wouldn't. And, meanwhile, he once again fell quickly into debt. Whenever Alasdair had any money, he was hopeless with it, and the Maschler money was long gone. This also from the Epilogue:

> My state only depressed me because my parents had been working-class folk who, though not religious, avoided debt like the devil. I too could have avoided it by renting a smaller flat, using public transport instead of taxis, eating at home instead of restaurants, drinking alcohol four or five times a year instead of nearly every day. Alas, I felt nostalgia but no desire for the decent carefulness which had bred and educated me. I *wanted* to be a middle-class waster, but a solvent one.[15]

He may have wanted to be a solvent middle-class waster, but in order to finance it he would have to write more – something he had just said he could no longer do! Alasdair then described how his previous 'ending' in fiction was made into a beginning: the radical feminist writer Kathy Acker suggested he write something from the perspective of a woman, Gray spied one in high heels and leathers and off he went, to 'penetrate *What Every Woman Wants*, *The House of Fraser* and *Chelsea Girl*, with the guilty reverence I would feel in a mosque, catholic chapel or synagogue'.[16] So Finnegan didn't take much waking, then. He crouched illicitly behind a counter in the House of Fraser like some undercover fiction detective, took notes, then got back to work on *Something Leather*.

This time Alasdair did not need to make up bad reviews. There were plenty. Even a sympathiser, S. J. Boyd, wrote: 'The publication of *Something Leather* confirms beyond doubt what was already strongly suggested by *1982, Janine*: Scotland's leading literary light is a pornographer.'[17] So in the next edition, he tinkered. Even the inner art changed. Now aware of the negative response, Alasdair tried to explain it. The revised 1991 Picador edition (Gray jacket restored) finished:

> I finally acknowledge that it was a bad idea to call this book *Something Leather*. It directed the attention of half the critics who noticed the novel to Chapters 1 and 12, so they reviewed it as if it was mainly a sado-masochistic Lesbian adventure story. Had I called it *Glaswegians* they might have paid more attention to the chapters

from 2 to 11 . . . However, for excellent publicity reasons this book
will keep its bad name until it is forgotten.[18]

Had he called it *Glaswegians* and produced art concentrating on
boilerman, student and civil servant characters instead of hinting at
pimps, liberal headmistresses and leather-clad lesbians, critics might
have responded differently. But that would have only been covering up
real weaknesses. Even the chapter 'Culture Capitalism' was more of an
angry swipe at the Establishment than a considered comment on it.

CRITIC FODDER

After *Something Leather* and the Dog and Bone adventure, Alasdair was
once again short of money and, despite the fact that he had been promising
to stop writing for several years now, the practical business of continuing to
live and having to pay for it kept getting in the way of that neat childhood
plan. This was an interesting period, both in career and personal life.

In 1991 the first critical book, *The Arts of Alasdair Gray*, featuring a
series of essays on his work, was published. So now, to add to the fan
letters, schoolchildren's essays and Ph.D.s, Alasdair was in the peculiar
position of being alive, studied and 'important' enough to be written
about in book form, but not commercial enough to earn the same
living as many of the academics who admired him. Still, Gray was
pleased to be noticed, and opened part of his National Library of
Scotland archive for Robert Crawford, one of the book's editors, to
see. In the following decade there would begin a steady flow of critical
books, doctoral theses, essays and newspaper articles on the subject of
Gray, now almost universally considered a postmodernist, though he
always cried foul at that, claiming to anyone who would listen that he
was an old-fashioned modernist who learned everything he knew from
Alice in Wonderland. One critical work of the early 1990s was Beat
Witschi's *Glasgow Urban Writing and Postmodernism: A Study of Alasdair
Gray's Fiction* – and many others, with increasingly unwieldy titles,
followed. Alasdair didn't know whether to be pleased: his letter to
Robert Crawford on 13 June 1991 (later reproduced in *The Arts of
Alasdair Gray*) showed a man trying to convince himself – in the face of
all this investigation – to go on:

I have nearly finished a book for Bloomsbury called *Ten Tall Tales* ('Mr Meikle' is in it, for though starting soberly factual it goes dreamy at the end) also a novel called *Poor Creatures*, a 19th-century historical novel with a Glasgow 1881 setting*. Though undertaken mainly to get money to work on the anthology of prefaces**, I think these two books as honestly artful as my others. I say this in case there is time to briefly say so in *The Arts of AG*, so that it is still as complete in 1992 and 93 as in this year. You could maybe mention them in your introduction: or else print this letter as an illustration on the final page. I look forward to designing the cover,
 sincerely,
 Alasdair Gray
*publisher of this not decided yet. It was originally to be among the stories but Swole Up Enormous.
**oh for a scholarship to let me finish it in peace!

Despite works in progress, Alasdair sounded desperate here – for time, money and tranquillity. The two books mentioned had taken over his *Prefaces*, putting that book back even further, and even making him appear to question whether *Ten Tall Tales* (later called *Ten Tales Tall and True*) and *Poor Creatures* (later called *Poor Things*) were 'honestly artful'. Around this time, Alasdair was also talking about a joint political book with Angela Mullane, *The State We Are In*; no wonder he felt overwhelmed. The best he could do in these circumstances was to have some input into the *criticism* of his work. So *The Arts of Alasdair Gray* is partly designed by the subject, uses *Something Leather*'s wasp design and appears to come with the Gray stamp of approval – hardly ideal for a book of criticism. There is something depressing about the letter to Robert Crawford, especially the final anxious footnote – 'oh for a scholarship to let me finish it in peace!' In a letter to an academic, that reads like an appeal.

REMARRIAGE, REASSESSMENT

Alasdair had been living at Morag's West End flat while repairs were being done on his Kersland Street flat, and after a year or so together they decided to get married, which they did in November 1991. For someone who had always highly valued the institution of marriage, this was a real new beginning for Alasdair, giving him a kind of security he had not had

for a long time. With Inge now remarried in England, and over twenty years since their split, he was finally ready and able to remarry. Alasdair gave up Kersland Street and settled into a new West End home which had space for him to work. Alasdair's son Andrew, who returned to Scotland for the wedding, had now left the RAF and was living in America. A great deal was changing on the personal front. Meanwhile, in the wake of *Something Leather*, there was a general feeling among critics that perhaps Alasdair had been right when he predicted in his *Saltire Self-Portrait* that he had already produced his best work, and that everything after 1987 would be less interesting, less relevant, than what had gone before. The Dog and Bone adventure only marginalised him more. This makes it even more interesting that, in the following year, Gray was to have his greatest commercial success, which brought him right into the glitzy mainstream, as never before. Not quite yet, though. First, politics.

WHY SCOTS '92

In the year of John Major's surprise election victory, Alasdair completed his first openly polemical work: *Why Scots Should Rule Scotland* is a short book in the form of a conversation between the author and his Canongate publisher, Stephanie Wolfe Murray. This was originally aimed at General Election voters and was certainly ambitious but was seen as a strange move for a novelist. Stephanie remembers thinking it was a good idea, but worrying that the project was before its time. Alasdair presented it as a debate between the two of them, with Stephanie's voice rendered suspiciously similar to the author's own. She remembers 'working with him on the manuscript in his flat in Glasgow. My guess is that my "words" were a mixture of what I said and how he put it.'[19] The finished product, complete with long historical sections and many digressions, read like a scattershot rant which started out as Gray's History of Britain but descended increasingly into a fight to beat a deadline. The whole thing was done fast and didn't even appear until August 1992, several months after the election, because of a mix-up between printer and publisher.

Five years later Gray rewrote this book and described the first edition in damning language: 'I reread it carefully three months ago and found it a muddle of unconnected historical details and personal anecdotes with a few lucid passages with at least one piece of nonsense.'[20] Speaking of the few good reviews the first edition received, he said:

'The reviewers' kindness had been the condescension instinctively given to the art of children or half-wits.'[21] So let us criticise the next edition, not this one. For now: *Why Scots '92* was short, nationalist reviewers were nice, unionist ones were not, and it finished with Gray wishing for a country where 'Scots mainly live by making and growing and doing things for each other.'[22] We'll return to it in 1997. In the meantime, a major work. At last!

POOR THINGS

In the late 1980s Alasdair met the writer Bernard MacLaverty, who had arrived in Glasgow in 1986: by the turn of the decade they were good friends. The two first met in Tennent's pub, another relationship which started with an introduction from James Kelman, a pivotal figure in Alasdair's social as well as work life; there was also the Hobsbaum connection (Bernard had attended his Group in Belfast in the 1960s). Bernard's wife Madeleine became friendly with Bethsy and was invited to join Bethsy's friends for a regular Sewing Bee. One evening when it was Madeleine's turn to host the Sewing Bee Alasdair agreed to play chess in another room with Bernard. The chess-playing developed into a regular Thursday night occurrence. Bernard remembers:

> His chess style is eccentric – he launches into these weird moves – but it was a great opportunity to hear him and talk to him, for a coffee and a game, and to listen to music. We'd have symphonies and concertos, maybe a dram or two. No more than three games. He beat me, mostly.

This arrangement continued after Bethsy and Alasdair's relationship ended, and became more regular in early 1991 when Alasdair began to share new stories in progress from what would become *Ten Tales Tall and True* with Bernard before or after their now regular chess games. (Even when relaxing with friends, Alasdair still continued to work.) Bernard says that one day he appeared with a fistful of manuscript which he read out to him:

> It was three or four pages about a Victorian doctor in Glasgow. I was so taken by it – it was *so brilliant*. 'What a great opening for

something big,' I said. Next time he came back with another five pages, which he read to me. That went on – with me goading him – for a while. About five pages, every time . . . But then this is where his genius lies – once he has the start of a story, he has the ability to step outside it, to think bigger, to think about how the reader might experience it. The first story becomes a found manuscript, and another book starts.[23]

The two friends talked about the evolution of the book in their meetings, and, as Bernard puts it, 'there was a bit of back and forth about the Frankenstein thing'.[24] This refers to the fact that Alasdair partly took up one of his suggestions. Bernard takes no credit for the evolution of *Poor Things*, is modest about his own involvement – and certainly he was one of several Gray friends employed – others being Bruce Charlton (medical help), Angela Mullane (legal help), and Scott Pearson, Alasdair's latest secretary. But at the very least Alasdair found these sessions with Bernard very helpful, and the presence of an encouraging writer friend is always welcome. Speaking about the idea at the centre of the novel, Bernard says: 'First of all Alasdair thought, "How silly, how ridiculous", but then it went in! Initially we thought it wouldn't work – but Alasdair *made* it work.'[25]

Poor Things overtook the story collection it grew out of and was published by Bloomsbury on 3 September 1992, to good sales at home and abroad and immediate critical acclaim: that year it won the prestigious Whitbread Award for Best Novel and the Guardian Fiction Prize, too. Gray particularly enjoyed the announcement ceremony for the Whitbread, being able to attend with a friend he first met at writing groups in the 1970s, Jeff Torrington, whose excellent debut *Swing Hammer Swing!* won Book of the Year. *Guardian* judge Philip Hensher called Alasdair Gray 'an idiosyncratic, ingenious and entertaining writer'.[26] Summing up Gray's career since his literary arrival in 1981, Hensher said Gray had been 'in danger of becoming a figurehead rather than a substantial writer' – more evidence of the frustration expressed in the wake of his smaller, weirder books in the decade after *Lanark* – but here was a spectacular, bright return; as Jonathan Coe put it in the *London Review of Books*, *Poor Things* signalled a 'sudden resurgence of imaginative energy'.[27] Concluding his piece in the *Guardian*, Hensher made this book sound delicious: '[A]ny reader should be able to take immense delight from *Poor Things*. It is as irresistible as cream cake, and as nourishing as lentils; and no prize that we can confer upon it could possibly increase its

many and various merits.' Hugo Barnacle in the *Independent* and Lucy Hughes-Hallett in the *Sunday Times* agreed, as did many others, even *Newsweek* and the *Los Angeles Times*. So Gray returned to a kind of popularity, but a different kind. This was accessible in a way he had never been before. A Victorian pastiche with strong gothic elements, *Poor Things* was more fun than reading an Alasdair Gray book had ever been before. Though set in Glasgow it drew on a tradition readers outside Scotland could easily understand, and it did well abroad. Alasdair was even invited to do a fortnight-long American tour. He was now one of many Scottish writers making an impression in his home country and outside it. At the end of 1992 Douglas Gifford wrote: 'It surely can't be disputed now that we're in the middle of an extraordinary burgeoning of Scottish literature, strongest and richest perhaps in fiction.'[28] Gray's novel was one of the richest and strongest of that year.

The jacket of *Poor Things* is a Gray painting of the main characters: Godwin Baxter (a distorted portrait of Bernard MacLaverty*) sitting on a sofa with eyes closed and a single arm around Bella/Victoria and Archibald McCandless, each portrayed much smaller than Godwin, each hugging his side, sleeping. Around them is scattered evidence of medical experimentation, and these punctuate the chapters inside, too, as do portraits of key characters. A middle section contains scribbled diary entries with deteriorating handwriting. Gray's 'Notes Historical' section at the back of the book is decorated with maps of Glasgow, photographs of places where scenes take place and engravings which satirise the British Empire.

On the inside of the first edition Gray wrote two cheeky nineteenth-century-style blurbs, making one complicated book sound like two very different, simple ones:

BLURB FOR A HIGH CLASS HARDBACK
Since 1979 the British government has worked to restore Britain to its Victorian state, so Alasdair Gray has at last shrugged off his post-modernist label and written an up-to-date nineteenth-century novel. Set in and around Glasgow and the Mediterranean of the early 1880s, it describes the love lives of two doctors and a mature woman created by one of them. It contains many unsanctified weddings but (unlike Gray's last novel *Something Leather*) no

* Bernard MacLaverty did sit for this unflattering portrayal, but it was never intended to be realistic.

perversions – apart from those of General Sir Aubrey de la Pole Blessington, which are touched upon as lightly as the whims of a great national hero deserve. Nothing here would surprise Mary Shelley, Lewis Carroll and Arthur Conan Doyle, or bring a blush to the cheek of the most innocent child.

BLURB FOR A POPULAR PAPERBACK

What strange secret made rich, beautiful, tempestuous Bella Baxter irresistible to the poor Scottish medical student Archie McCandless? Was it her mysterious origin in the home of his monstrous friend Godwin Baxter, the genius whose voice could perforate eardrums? This story of true love and scientific daring whirls the reader from the private operating-theatres of Victorian Glasgow through aristocratic casinos, low-life Alexandria and a Parisian bordello, reaching an interrupted climax in a Scottish church. Unlike Alasdair Gray's last novel *Something Leather*, the good people thrive, while the villainous Duncan Wedderburn and General Sir Aubrey de la Pole Blessington get what they deserve.

In one way both of these were true advertisements, but in another they were deeply dishonest – which was an indicator for the whole novel.

The book represented a step up in Gray's games with his readers. Though advertised on the jacket as an Alasdair Gray novel, the inner sleeve states that this *Poor Things* was in fact the distinctly less catchy *Episodes from the Early Life of Archibald McCandless M.D. Scottish Public Health Officer*, merely *edited* by Gray. His introduction is a lie: it claims that the McCandless memoirs were found by Michael Donnelly (assistant to Elspeth King when Gray had been Artist Recorder at the People's Palace in 1977), and that this discovery has caused disagreement between Donnelly and Gray, who have differing views as to their truthfulness or otherwise. In this introduction, Gray sets out his argument for the sequence of events he 'believes' took place relating to the McCandless memoirs, proudly 'admits' to having manipulated the texts that follow, then leaves readers to work out whether they agree with him. The whole cover, blurb, introduction and even contents list is an exercise in doubt: the story to follow is the same. In this way, *Poor Things* has much in common with James Hogg's *Confessions of a Justified Sinner*, a classic nineteenth-century Scottish novel which also juxtaposed conflicting texts. Gray certainly knew

Hogg's book, and was unafraid to borrow the technique. But though he has always played with truth in his fiction, and though similar tricks have been done before, the trick has rarely been realised so successfully. *Poor Things* is one of Alasdair's best books. Interestingly, like that other Gray masterpiece, *1982, Janine*, it was a surprise.

FOURTEEN TALES SHORT AND FALSE

Alasdair's next collection came out on 7 October 1993, only a year after the hardback of *Poor Things* and just a few months after the successful paperback. Again, Alasdair gave his readers the impression that he had no intention of writing the book, thanking Tom Maschler and his new agent Xandra Hardie in the dedication for 'giving him the idea'. By now, Alasdair had made an art of the business of blaming other people for his output. What kind of story writer needs an agent or publisher to suggest he write a book of stories? Whatever the origin, this collection contained some strong pieces, and though there were the usual versions of past plays ('Homeward Bound', 'Loss of the Golden Silence', 'Near the Driver') it also contained fresh material, indicating how Gray's preoccupations were changing with age. Indeed, one of those preoccupations was age itself. As the author got older, so too, in general, did his characters – but his work was still full of lies. The first page contained an admission: 'This book contains more tales than ten, so the title is a tall tale too. I would spoil my book by shortening it, spoil the title if I made it true.'

Ten Tales Tall and True is most like Alasdair's contributions to *Lean Tales*, although it has some of the mischievousness of *Unlikely Stories, Mostly*. The inner artwork is reminiscent of Alasdair's 1950s diaries, where he used to sketch introductory pages to epic poems he planned, listing underneath which aspects of life the story was going to cover. In this book, readers are promised social realism, sexual comedy, science fiction and satire. Astonishingly, this is what they get. As for the stories themselves, they mix part-truth ('Mr Meikle') with fiction about or- dinary people going about quiet lives. 'Houses and Small Labour Parties' is one of the strongest of these,[29] 'Are You a Lesbian?' is another.

'Are You a Lesbian?' has a subtle uneasiness in tone and is repre- sentative of the collection as a whole, being a story about a woman who is interrupted while reading in public, and a man who won't leave her alone. Like Alasdair's short plays from the sixties and seventies, many of

the tales here are about ordinary domestic incidents, which may explain
why a particularly high number of the people in Alasdair's life get a
mention somewhere – Alexander Gray, Archie Hind, even Alasdair's
dentist, Mr Whyte.

One story, 'The Trendelenburg Position', uses Mr Whyte as the
inspiration for one of Gray's few mentions of sport in any of his books:
when he does refer to it, Partick Thistle Football Club usually appears,
too, proving that even football is political for Alasdair Gray. The dentist
talks while he's working, saying to his patient: 'Do you know about
Partick Thistle? It is a non-sectarian Glasgow football club. Rangers FC
is overwhelmingly managed and supported by Protestant zealots, Celtic
FC by Catholics, but the Partick Thistle supporters anthem goes like
this: *We hate Roman Catholics, We hate Protestants too, We hate Jews and
Muslims, Partick Thistle we love you.*'[30] This is a clue to Gray's own
preferences: but his 'liking' for Partick Thistle is purely to distance
himself from the religious 'zealots'. Alasdair has never had any interest
in football, and Andrew only took him to Firhill Stadium a few times.
Neither father nor son was inspired. When asked about his experiences
of visiting the ground, Alasdair replied: 'I found it interesting, from an
intellectual perspective. And I noticed immediately that football is like a
highly speeded up game of chess.'[31] That comment goes some way to
explaining why he is more suited to chess. The rest of *Ten Tales Tall and
True* contains many of these kinds of humorous details in spiky
anecdotes. But as a collection it does not dazzle.

1993 also saw some progress on *The Book of Prefaces*. The fiction burst
of the past few years had sidelined it instead of – as intended – enabling
it, and it was becoming clear to Canongate (who had missed out on the
huge success of *Poor Things*) that they weren't going to get the book
they'd been promised any time soon. So Alasdair promised Stephanie
another book. Which he then had to write.

DIARIES

*25 October 2005: Battering an Old Man In Bandages –
Attack on* A History Maker
I recently reread all Alasdair's works in chronological order, jotting
down things to ask him or those who knew him, marking out themes
to explore. There was just one book I didn't know: *A History Maker*. I

couldn't remember if I'd missed this out. When I read it again, I remembered why I'd forgotten. And I was not the only one who disliked this novel; no one I spoke to that knew Alasdair's work said they liked it. No one I interviewed hailed it, or even mentioned it. But *A History Maker* was recently reprinted by Canongate, eleven years after first publication, so there must be those out there who do.

A History Maker is set in a future Scotland where war games are played, strictly under the rules of the Geneva Convention – a panel presides over disputed results. Wat Dryhope (or, What Little Hope!) is the only senior soldier to survive a bruising draw with Northumbria, goes on to become the new reluctant army leader, then falls in love with an evil sexual predator who treats him cruelly. The characters are drawn so thinly that it's hard to care about them. Both dialogue and description are written ultra-soberly, so even though there is war, death, sex and love within, none leaves a mark. The bulk of the material was written fast. Though it had previously existed in a basic play form thirty years before, it needed a lot of updating: Alasdair attempted some of this, then aborted, rounding off with a fifty-page section entitled 'Notes & Glossary Explaining Obscurities', then a further postscript. But what good is that to readers who have been promised a futuristic war romp? There's not much romp to be had at all, actually, except the idea that in twenty-third-century Scotland sexual jealousy has faded to zero, and people happily share themselves around with very few nasty consequences. The device enables Wat to spend the night with twins. When *A History Maker* was troubling me most, Alasdair was in the middle of a spell in hospital. I visited him in the ward and left him with a letter headed 'An Ill-Timed Attack on *A History Maker*'.

I wanted to discover Alasdair's true feelings about this book as I got the strong sense, when going through the story, that his heart wasn't really in it. I also felt it had been written too quickly. I reminded him that he had once told me that he felt pressure to provide Canongate with a book, as he had failed to deliver *The Book of Prefaces*, which he had promised them years ago, and was now going to Bloomsbury (who were prepared to pay a further advance for it). My letter also reminded him of the blurb to *A History Maker*, which admits that it was borne partly out of the writer and critic Alan Bold's accusation that Alasdair's books weren't Scottish enough. These circumstances, I suggested to Alasdair, were not ideal to write in:

My argument is this: that the book is less convincing than your others because it was inspired more by the desire to respond than to create for your own pleasure. This, I think, has led you to relying more on your political opinions to fill pages and less on the story. When reading speeches by Wat Dryhope and others, whether in battle or in personal situations, I hear more of ALASDAIR GRAY'S SERIOUS VOICE than in any other book I've read by you that is advertised as fiction, fantasy or fact. That voice is cut off prematurely as the story comes to an abrupt end that feels like you had simply had enough of it.

So, you filled it out with your usual critic fuel. The Notes and Glossary in *A History Maker* make up nearly a third of the book, and you say yourself that the end section is a 'far too lengthy note'. Why not just shorten it then? Instead of abbreviating, you go on to give us a further postscript, to add to the prologue and postlogue. Most of these sections are opportunities for you to enjoy discussing some of your favourite historical topics; we get Gray definitions of Modernism, Postmodernism, Marxism etc., and why Communism failed in Russia . . . it seems here that you are trying too hard to prove something you did not need to, or simply don't care. Fifty pages of definitions of Scottish terms are not needed to assert the Scottishness of your fiction and yourself. The branch on the front cover, accompanied by the words 'TRY AGAIN' does that very well – and all your other works are soaked in it.[32]

Alasdair's handwritten reply arrived in the post a day later, the pages covered over with sticky labels where he had made mistakes, then rewritten his words, in squashed up or elongated shapes. His letter wasn't quite what I'd hoped for, but God knows the man was writing from a hospital bed:

Dear Roger, 17.10.05 [wrong date]
 I ain't at all upset by your letter about *A History Maker*, because I would be a fool to expect anyone who likes my work to like it all, and anyone who has enjoyed making a book must leave it to defend itself – an author's opinion of his work is of far less value than that of any other reader. However, I am glad to answer your questions.
DO YOU FEEL THIS WORK WAS RUSHED?
No. I may have worked fast on it – only an examination of contracts,

publisher's correspondence and delivery dates will tell how fast – but I cannot remember feeling rushed . . . [When I began writing the story in the 1960s] these were the days of hippy flower power and postulated a world of abundance and freedom after a green revolution. I wrote the opening battle scene – my disaffected hero, dialogue with the matriarch in the family living room and dialogue with the brother outside – his unsatisfactory subsequent dealings with his mistress and her daughter. After that the story became only an outline which contained no Delilah Puddock, space travel, neo-sapiences etcetera. The villainous clique who want to use Wat to restore historical warfare run by male governments with bombing of civilian homes etcetera are all televizers, and they succeed. When I planned this *Lanark* was less than half written, so anything familiar from later books pre-empts rather than repeats them.

DO YOU FEEL THIS BOOK WAS DRIVEN BY THE NEED TO SATISFY A PUBLISHER'S WANT OF A CERTAIN KIND OF BOOK?

No. I offered Stephanie Wolfe Murray a short science fiction novel I knew I could easily write and she was delighted. She never expected that.

ARE THE 'WORSE DEFECTS' THAN LACK OF POR-RIDGE YOU REFER TO ON THE INLAY REAL ONES YOU REGRET OR JUST THE USUAL GAMES?

They are just the usual games, though I enjoyed twitting Alan Bold a bit.

I think that answers all your questions. Putting the conclusion of the plot into the final notes was my way of swiftly ending the fable* without giving a lot of detail the readers could now (I thought) easily imagine if given clues they might enjoy hunting out. Having enjoyed answering your question[s] I now compose meself for sleep. I'm glad you met Helen[33] today (Tuesday). Send me any other questions you like, anytime.

Yours Truly

Alasdair

P.S. It is worth saying that I did enjoy writing *A History Maker* – no reason for a reader to enjoy it!

* But why did it have to be ended quickly? This conveniently avoids answering one of the key questions about the book being rushed.

I wasn't disappointed by Alasdair's pleasant rebuttal, and was interested to learn the original version of *A History Maker* was more in tune with the hopeful hippyness of the '60s than the cold novel version. Also, his assertion that the author's opinion of his own work is worthless is typical of the man's humility (I can't imagine, for example, Oscar Wilde saying the same), but I remain unconvinced about the book itself. It reads like it was knocked off fast to excuse the non-writing of another. Stephanie Wolfe Murray says she was generally pleased with it but at release time Canongate was close to going bankrupt, so they had bigger issues to worry about.

What's the point in tearing to pieces one Gray book for reasons of personal taste when the author has made so many others? Why not just pass it over as a poor futuristic fantasy and be done with it? Critics like Alison Lumsden (most famously in her oft-quoted essay 'Innovation and Reaction in the Fiction of Alasdair Gray'[34]) have suggested Alasdair's weakness is his need to politicise and moralise, while denouncing both: *A History Maker* is the most overtly political of Alasdair's fictions. And if I'm going to turn on my master, then surely I should be allying myself with the likes of Lumsden, Macdonald Daly and other critics who have said the quality of Alasdair's output is limited by his need to pre-empt criticism, and bring socialism and Scottish nationalism into everything, not able to let the reader decide for themselves what is best, instead slipping his damnable principles into every sentence. *A History Maker* comes across as a conversation between Gray and Gray, on politics and history, entertaining himself in the gaps with sexual perversions. The most interesting things in *A History Maker* are the smallest details. For example, Alasdair consciously includes James Kelman in a list of great Scottish writers at one point – as the book is set several hundred years in the future it is a bold statement of faith in the enduring nature of his friend's work – and this is an attempt not only to assert Kelman's talents but also help ensure his place in history by putting him in the same sentence as James Hogg and Walter Scott when discussing the Scottish literary canon. Indeed, he wants to challenge the parts of the canon he doesn't like, the parts of Scottish history he feels have been hijacked by sentimentality, like the battle of Bannockburn, or the myth of William Wallace (fighting the nasty English again), but is that worthy theory or entertaining fiction?

Alasdair admits to enjoying 'twitting' Alan Bold, but there is a serious side to his response. Writers are better when they are expressing themselves

freely than when going on the defensive. Alasdair crammed *A History Maker* with Scottish words, phrases and poems, to almost a comical extent, and it dampens enjoyment. Most great literature uses local place names and mannerisms and doesn't suffer for it – the problem here is that these inclusions seem *forced*. This reader could have done without dictionary-style definitions of words such as 'driech', 'feart' and 'scunnered'.

MID-NINETIES, DUNFERMLINE MURAL & MORE NEW FAMILY

Meanwhile, more *Prefaces*. The process of putting this book together had been even more complicated than the usual Gray books. By the time Joe Murray (who had typeset *Ten Tales Tall and True*) was given the job of rescuing *The Book of Prefaces* in 1995 it was clear that much of the technology Donald Saunders had used was now outdated, and everything had to be done again – a good indicator of the shape of the whole project. Joe Murray has written about his experience of working with Alasdair:

> [*He*] has a brain like a razor blade and can be thinking about three different parts of the book at once. It can be impressive to watch and frightening to deal with. *The Book of Prefaces*, by its very nature, was a difficult book to work on. Few sections of the book were typeset chronologically, there are glosses, or commentaries, running down the sides of many of the pages and most things had to fit into spaces previously allocated to them.[35]

This limiting way of working took much more time than simply writing the book and then printing it would have done, and the process was made more difficult again by Alasdair's habit of continually revising. Murray continues: 'The phrase "I have an idea" still makes me shudder.' *The Book of Prefaces* took another five years, during which time Gray produced another three books and two murals.

Alasdair also painted some key works during the 1980s and 1990s. Between 1983 and 1993 he had done fifteen covers for *Chapman* magazine, his favoured literary quarterly, and regularly contributed to G. Ross Roy's *Scottish Studies International* volumes. Then there was his '5 Scottish Artists' exhibition in 1986. He had, of course, done designs for many of his own books, too. He had also done covers for, among others, Agnes Owens' *A*

Working Mother in 1994 and extensive pictorial work for Wilma Paterson's *Songs of Scotland* in 1996. But most of these either adorned his own literature, came from connections with friends or were commissioned because of them. In recent times, the art had undoubtedly been marginalised. But between July 1994 and January 1996 Alasdair did his first mural in some years, for Elspeth King, his boss at the People's Palace nearly twenty years before. It was called 'The Thistle of Dunfermline's History' and was painted in Abbot's House Local History Museum.

Speaking of her plans for Abbot's House, Elspeth King said she and Michael Donnelly (the curator and historian who had also worked with her in the People's Palace) wanted to 'make the building a work of art in its own right'.[36] They hoped for 'a traditionally painted ceiling of the type which was very common in Scotland in the 16th and 17th century', and commissioned Alasdair to provide it, but without seeing a sketch of what he planned – as Michael Donnelly put it, 'it literally grew on the ceiling', changing constantly, with inscriptions turning into portraits and some portraits being painted over with inscriptions as the job went on. For the first time Alasdair hired an assistant, signwriter Robert Salmon, to work with him. They set about presenting the whole history of Dunfermline in one room, crossing hundreds of years, including over eighty portraits (one of Robert, one of Elspeth, many of historical figures, even one of football manager Jock Stein). Elspeth King has since praised the mural saying: 'It's a portrait gallery as well as being a decorative ceiling, it's a teaching piece, it's a timeline, it's a Mappa Mundi for Dunfermline.' This fine work married Alasdair's love of history, portraiture and preservation of local culture.

During the Abbot's House period, Andrew Gray got married. By 1995 he was a physiotherapist who had settled in the USA, where he lived with his new wife, Libby Cohen. Alasdair and Morag travelled to Connecticut for the wedding, which was a big event, with two or three hundred guests invited. Libby is from a large Jewish family, and several Jewish traditions were upheld during the celebrations. After the meal and speeches, Alasdair and Morag were both put into chairs, hoisted up in the air and then passed about the dance floor while traditional Yiddish music was played in the background. Some would have been shocked or afraid at this, but Gray maintains, 'I really rather enjoyed the feeling of being high up and helpless!'[37] Both Andrew's parents were present at the celebrations, and Alasdair was delighted to discover that Inge and Morag got on rather well.

MAVIS BELFRAGE

Nearly thirty years after the original play script 'Agnes Watson' was rejected then changed to 'Agnes Belfrage', an Alasdair Gray book called *Mavis Belfrage* was published on 16 May 1996 by Bloomsbury. The quarterly journal *Books in Scotland* ran a front cover displaying Alasdair's depiction of his heroine, with the caption, 'Who is Mavis Belfrage?'[38] The answer: Mavis was a Scottish version of Inge Sorensen. There is little doubt about that: on his website Alasdair even calls the play 'a true tale of the sixties'. In the cover design Inge is portrayed as physically attractive, unyielding in expression, with hard-edged nose, eyes looking off to the side as if hiding something, and is dressed in 1960s clothing. Her long dark hair hangs down and she sits upright; the illustration looks very like Inge does in a photograph taken in 1963 of her with Andrew on her knee. It is a little kinder. The character in the story is much like Alasdair's view of his first wife. But there is more to Mavis, and this book, than a simple telling of that marriage. *Mavis Belfrage* is a book about education.

The *Books in Scotland* review was written by Douglas Gifford, a distinguished academic and critic who was the only person to have reviewed every single Gray book and praised most of them. Here, Douglas said Alasdair was 'up to his old tricks' – a polite way of saying he was lying to us. On the hardback boards, Gray admitted the book should have been called *Teachers: 6 Short Tales*, so had yet again led readers hoping for a novel into buying short stories. Alasdair always presented his books as neatly categorisable things when actually they were complicated. This didn't usually present problems, but the response to *Mavis Belfrage* was a muted, frustrated one – some reviews were written by fans who felt it lacked many of the things that made Gray Gray. This was a book with the fantastical, the unlikely, ripped out. Responses were littered with sympathetic but downbeat appraisals. Gray's fiction had always dealt with ordinary things; they had just not been noticed before among all the buttoned flaps and tomfoolery that other works had been dressed up in. No dragonhide, no leather skirts, no false accounts here. For once, Gray *wasn't* tricking his readers when he said on the blurb that this was Alasdair Gray's only straight story about love. The events in the accompanying stories, like 'A Night Off' and 'Mr Goodchild' (yet another short sexual comedy based on an old, unbroadcast play) were similar to Alasdair's day-to-day experiences. As in *Ten Tales*, here were pub settings, broken relationships, political

conversations between strangers, and the stories of repressed or frustrated teachers. Alasdair had taught, begrudgingly, on and off, for many years, and many of his friends had made a career of it. Almost as much as his Riddrie upbringing, his experiences of the classroom helped mould him. The first sentences of *Mavis Belfrage* make clear his opinion on changes to the education system:

> Publicly funded learning was once greatly valued in Britain. The minimum school leaving age had been raised to sixteen. New schools and colleges were built and old ones enlarged. Folk who would have missed university courses in other decades were helped to them by government grants. A solemn young Scot called Colin Kerr went to a famous South British university where he won a fairly good second class philosophy degree. This would have finished his education had he not met Mavis Belfrage.[39]

Though primarily political, this last statement is what made the book a romance for Gray: though *Mavis Belfrage* was tragic, hopeless and contained little happiness or comfort, Alasdair thought it was romantic because a man was educated by a woman in a way more worthwhile than his official one. (A return to Alasdair's 'men who thought life a task they never doubted' – had he forgotten this was the old template?)

Douglas Gifford claims that in Colin and Mavis we are revisiting 'the emotionally and socially insufficient protagonists of Gray's fiction; and their difficult relationships with headstrong, introverted, or dangerously extroverted women'.[40] This issue infuriates and fascinates readers of Gray's novels – Lanark and Rima, McGrotty and Ludmilla, McCandless and Bella, also Colin and Mavis. All couples are brought together suddenly, unromantically, with brief excitement on the part of the man being followed by frustration with and/or rejection by the woman, who often struggles to tolerate him – the story, as Alasdair saw it, of his first marriage. *Mavis Belfrage* represents a final attempt to resolve that relationship in his mind. Was Mavis really such a bitch? Or was she a liberated, modern woman who knew what she wanted and was unafraid to complain when it wasn't provided? Alasdair explained how he feels about having strong women in his fiction: 'I'm not interested in weak characters – I prefer people with a sense of controlling their own lives.'[41] But he presents his many fictional Inges as if his experience of love and marriage is a universal one, when in fact it is most unusual.

Tension over Mavis's true nature provides the rest of the story, along with the effect her insistence on utter freedom has on her young son (a plain reproduction, with little fictionalisation, of Andrew Gray as a boy). The background of 1960s politics, with references to Enoch Powell's immigration speeches, makes readers ask questions of Colin, who feels it is better, safer, to retreat from political opinions into his fantasy world. But his weakness turns to strength later in the story and this is not what Mavis, the strong woman, wants at all. She wants him indecisive, dependent.

Mavis Belfrage, like *A History Maker*, was converted into prose many years after the initial creative rush, which makes it seem, in places, more calculated than emotionally engaged: and it was yet another that was born as a play. The fact that Alasdair had not been commissioned to write any plays since 1978 suggests that he may have had a point about the end of his career as a playwright – yet surely if he had simply asked Xandra Hardie (his latest agent) to find him play commissions, she would have done so. In 1978 he was virtually unknown, and may have made some enemies over the production of *Beloved*, but after *Lanark* his reputation as a playwright was outscored massively by the success of that one book, which should have provided him the freedom to return to drama. In recent years stage adaptations of *Lanark* and *The Fall of Kelvin Walker* had been performed, and then there were productions of *Tickly Mince* and *The Pie of Damocles*, also *McGrotty and Ludmilla*. He had not been without drama. But Alasdair had not been commissioned to write new plays for some years, which made him feel unwanted. So he spent much of the time since *Lanark* taking his old, neglected plays and adapted them into prose fiction. Until he was approached to write a play again.

WORKING LEGS: A PLAY FOR PEOPLE WHO HAVEN'T BEEN ASKED TO WRITE ONE RECENTLY

In 1996 Forrest Alexander of the Birds of Paradise Theatre Company in Glasgow, which trains disabled actors and tours both commissioned and adapted productions, asked Alasdair to write something new for the company. This became *Working Legs: A Play for People Without Them*. Alexander didn't know Alasdair had written plays, and, like most people aware of his work, considered him primarily a novelist. In the

endnotes of *Working Legs*, in a section entitled 'How This Play Got Written', Gray explained:

> Had I only written prose fiction I would have rejected Forrest's suggestion. However, in the days of a long-forgotten Labour administration I had seven radio, eleven television, four stage plays networked or performed, and was a highly inefficient minutes secretary of The Scottish Society of Playwrights, a small trade union started by C. P. Taylor and Tom Gallagher. My career as a professional dramatist ended in 1978 with the death of Francis Head,[42] my London agent, but I still felt able to write plays so Forrest introduced me to the company.[43]

Alasdair was pleased to take up a new commission despite being many years behind on *The Book of Prefaces*, which was growing all the time – but not without detailing his pre-*Lanark* career and its untidy end in the printed version of the new play. There is more than a little resentment in Alasdair's tone here of the fact that his career as a playwright had stalled, and he felt so few people knew he had one at all that it was worth saying exactly what he had done, just in case it got forgotten completely: meanwhile, he included this CV-style detail alongside the printed play. But the Birds of Paradise request reversed that negativity and Alasdair threw himself into the writing process, collaborating with company members at weekly meetings, where they were encouraged to contribute ideas, adding to the one Alasdair had at the beginning: 'The play must have strong parts for as many disabled actors as possible, so should be set in a world where the able-bodied were a pitiable minority.'[44] With his reticence about giving up control of so many aspects of his work, it may seem curious that Alasdair should collaborate on a project like *Working Legs*, but this is an example of his principles in action. Adapting to the physical and economic demands of the company, including actors in the writing process, weekly meetings to discuss ideas: Alasdair enjoyed the experience, though it was written very fast and he made no money from it. The very fact that it existed as a playbook, printed by the temporarily revived Dog and Bone imprint, showed he was proud enough of the result to want it to survive.

There were further indications of Alasdair's satisfaction with the project. One was that the next person to write for Birds of Paradise was Alasdair's old friend Archie Hind, who had hardly published at all

since *The Dear Green Place* in 1966, and was certainly recommended by Alasdair. (Archie's production, *Playing For Keeps*, appeared in 1998.) Another sign was that Morag herself made an appearance as a character in the book version, the only occasion in the Gray canon where this happens in an obvious way. A cartoon of Morag in the part of 'Meg from the Supply Office', severely staring out at the reader, is next to a description of her as 'a small dour efficient woman who says as little as possible and talks fast when forced to talk'.[45] More telling than this seemingly unflattering portrayal is the fact that Meg, a secretary (more efficient secretaries!), is the only sensible and intelligent person in the whole company.

Working Legs is a farce about the benefits system. Like his other political plays, it centres around a Scot who becomes famous, in this case Able McCann, a 'hyperactive man' in a world of the wheelchair-bound. Elsewhere, Prime Minister Humpty Dipsy makes a case for the status quo. A newspaper editor suggests putting a mother of newborn twins on page three, topless. A woman called Miss Shy yells unshyly offstage. Most characters are two-dimensional, and names like Bland (for a bland person), Suave (for a suave one) and Thrust (for a thrusting business-type) do not help viewers or readers engage. As usual, hero and heroine fall in love for little reason, and the finish is pure pantomime: the whole cast say the words 'The! End!' in unison.

Alasdair had spent much of the 1990s on political works of various kinds. In its own way, *Working Legs* was another. 1997, the year of this production, was the final one of eighteen years of Conservative rule in Britain. In the only example so far of a Gray book dedicated to a stranger, the point is made on the first page, next to a picture of Alasdair's old dog: 'To Baroness Thatcher and all the Right Honourable Humpty Dipsies who have made our new lean, mean, efficient Britain.'

MORE *LEGS*, BRIEFLY

On 2 May 2003 Alasdair called me to the house 'to work on new fiction', which he titled: *Working Legs – A Novel for People Without Them*. Below is the entire text from that day, one part world-according-to-Gray, one part explanation of how the *Working Legs* world came to be:

Human beings seem to be the only animals who can imagine more worlds than the one where they live. Many religious people would

be miserable without faith in a heaven above where the best of them will be eternally happy, and an underworld where the worst will be eternally tortured. Socialists want a world of more liberty, equality, fraternity than exists just now; Conservatives want a world almost like this one but where they enjoy more power.

There are also some thinkers who believe the universe is so vast that it contains every world that is physically possible, including millions of worlds that evolved exactly like our own up to the point where the histories diverged. In three such worlds (for example) the meteoric shower that killed the dinosaurs missed our planet. In one the dinosaurs prevented the evolution of more intelligent creatures, in another species of smaller lizard evolved skilful hands and self-conscious brains, in a third people exactly like us evolved in spite of the dinosaurs and exterminated those it could not domesticate.

This daring theory also allows worlds where societies grow as recorded in our own history books until Buddha or Jesus or Mohammed are born female, or steam engines are invented and patented by the Chinese, or Mary Stuart inherits the throne of England and makes it Catholic again, or Napoleon wins the battle of Waterloo. Imagine instead a world where, shortly before the end of the nineteenth century, through a disease that the science of the time could neither alleviate or cure

And there the text ends: he dictated for an hour or so, then we left the flat for the afternoon and he never worked on the piece again.

WHY SCOTS AGAIN

Also in 1997, the revised and greatly extended version of Alasdair's 1992 political pamphlet was published. It was his first coherent non-fiction work, demonstrating his capacity as a radical historian; another title could have been *Gray's History of Scotland*. The front and back covers presented flags of twenty-one independent nations from Iceland to the United Arab Emirates. Some of these are hardly examples of healthy democracy, but Alasdair was pointing out that each of their population sizes was similar to Scotland's.

The introduction to *Why Scots 1997* is bold. Alasdair derides his last version, denies being anti-English, and once again sets out his argument

for inclusive Scottish Nationalism. He says: 'My argument is not based on differences of race, religion or language but geology. Landscape is what defines most lasting nations.'[46] Then, he gives examples of the kinds of states he wants Scotland to emulate – Scandinavian ones, mostly – which he argues are best because they are independent, unlikely to get involved in nasty wars, big enough to utilise their own natural resources but small enough for citizens to feel part of a meaningful democracy. According to Gray, the smaller the state, the closer it gets to the Athenian example, where local culture has a better chance of survival and voters are closer to their politicians. This is not a nationalism which believes Scots are somehow 'one people', or superior in any way to those in other places. For him, it is the most practical way to make socialism work.

This book is part succinct history of Scotland, part socialist philosophy, and there is no doubt that Alasdair showcases his ability to compress hundreds of years of complex events into a few understandable sentences. It is one of his primary talents. But *Why Scots 97* is also funny, partly because of the format. Again, Gray sets himself up as 'in conversation' with Stephanie Wolfe Murray (though by 1997 Jamie Byng was running Canongate). Gray does most of the talking, but each time he gets too emotional, passionate, irrational or digresses too far from the point, Stephanie pops up to drag him back. This is certainly a ploy to break up long periods of historical context with the odd line of light relief. 'You're starting to rave,' she says at one point, interrupting a lengthy digression. 'Have a cup of tea and calm down.'[47]

Why rant on about the Norman Conquest for three pages only to be told off for doing so? Because though he knows some readers will find historical details boring or irrelevant, the basis of Alasdair's argument is historical – and no matter how unpalatable that may be, he insists on only addressing current issues once he has summarised the last thousand years. So before a modern view (which only appears in the last few paragraphs) we get assessments of feudal and clan systems of government, Tom Paine's *Rights of Man*, the history of the British Labour and Conservative parties, and a furious account of the bribe that led to the Union between Scotland and England in 1707. But this isn't just a cheap jibe at England. First, Gray tells the story of the Darien Adventure (or disaster) which led to the Union, pointing out that it was a Scottish financier, William Paterson, who led Scotland into crippling debt by trying to set up New Edinburgh in an uninhabited part of Panama. According to Alasdair, Scottish colonialism, and the

resulting bankruptcy, was why Scotland's parliament voted itself out of existence. This way Gray argues against anti-Englishness, or romanticising Scotland's past. He is arguing that all nations should be free to make their own mistakes. Since 1707 the Scots have not been free to do that. As the pamphlet races towards its end (again, facing a printer's deadline, again, intended to be a bigger, better book), Gray finally gets to modern Britain, predicting that if devolution occurs, then Scots will merely have 'what Billy Connelly calls a *pretendy* parliament: a big London firm's branch office where local complaints get stifled by the locally complacent. It will only be a step nearer democracy if Scots refuse to let it rest at that.'[48]

PRELUDE TO *PREFACES*

In 1998 *The Book of Prefaces* was still not done. Previously, Bloomsbury had been paying Alasdair £1000 a month to write it, but this arrangement could not go on indefinitely as there was a finite advance under contract: the completion date had already been moved several times. Out of cash, and with the threat of a 'final' deadline approaching, Alasdair called in favours. He involved many of Scotland's best writers in his process, asking them to take on certain Prefaces themselves. Now something of a well-connected elder stateman, Alasdair turned to many of those he had inspired with *Lanark*, like A. L. Kennedy and Janice Galloway, as well old friends like Liz Lochhead and Aonghas MacNeacail. In fact, Alasdair used people from every available corner of the literary world – academics, critics, fiction writers – even those from the other end of the political spectrum, like the writer and philosopher Roger Scruton, with the aim of deflecting criticism once the book was finished. With no funds available he offered to include a portrait of each contributor in the final version of the book as payment, and it is a measure of Alasdair's popularity (or ability to squeeze out a favour) that all agreed. These requests were made regardless of whether the writer Alasdair approached was an expert on who they were supposed to be commenting on. It made little difference: once the pieces were given to him, Alasdair re-edited them all anyway. (Despite the fact that this upset friends who offered assistance in good faith, he could not help himself.) But he was still moneyless, and months from completion. Around this time he met Colin Beattie.

Colin Beattie is a Glasgow entrepreneur who has become known for the decor of the pubs he owns. Alasdair has written that Beattie 'likes converting them to the needs of their neighbourhoods by employing local architects, tradesmen and artists. His former pub and headquarters, the Lismore, has the best recently designed Scottish stained glass windows.'[49] In the late 1990s Colin was looking for a new site on which to build a late-night café for artists. He applied to buy a site at the bottom of Byres Road, and asked Alasdair to design a series of stained-glass windows for it. Alasdair wanted to do five, each showing a Glasgow writer:

- James Kelman, next to a bus (referencing his novel *The Busconductor Hines*)
- Liz Lochhead, at Kelvinhall Carnival (image taken from a previous Gray portrait)
- Tom Leonard, next to his piece 'Mr Endrews Speaks'
- Edwin Morgan, in front of Glasgow University, and
- Susie Boyd (*EastEnders* script writer, also Alasdair's actress friend Katy Gardiner's daughter), with her cats.

Colin was keen to get template versions of these quickly, but Alasdair explained that, though short of money, he was reluctant to take on more work until after *The Book of Prefaces* was done. So Beattie immediately sent Alasdair a cheque, up front, and asked when the portraits could be done by. The application for the artists' café failed (Partick Housing Association bought it instead and built on the land – it has since changed hands again, having been turned into flats) but Gray and Beattie did collaborate again, with remarkable results. The entrepreneur soon turned his attentions to a much bigger project which, after the turn of the century, would become the site of Alasdair's most ambitious mural to date.

In the meantime there was still the problem of finishing *Prefaces*. Alasdair tried to get funding from several sources. The British Council suggested he send off his CV to places like Newcastle Brewery, a merchant banker in Edinburgh and several other commercial interests, asking them to sponsor him. Alasdair felt like he was begging for scraps from the Establishment: 'I thought, *How long have I been in this game? How has it come to this?* I didn't give a damn who sponsored the project but I was sick of taking examinations – so I wrote to Colin Beattie saying, "I'd rather beg from someone I know than someone I don't". He sent me £8,500 in post-dated cheques, one a month, to enable me to live while I finished.'[50] Which he did.

GOD: FICTION'S GREATEST CHARACTER

During this time Alasdair also wrote a contribution to Canongate's series of personal responses to the books of the Bible, introduced and explained by writers as diverse as Mordecai Richler, Peter Ackroyd and Joanna Trollope. Gray took on the Books of Jonah, Micah and Nahum in his usual style, summarising how he believed the various bits of the Old Testament got glued together in a few succinct sentences. He used this platform, as all others, to argue his political views, making the process sound more like a history of publishing than the beginning of the world:

> The editors [of the Old Testament] arranged these books in chronological order of the subject matter, producing a story of their people from prehistoric times and making their God the strongest character in world fiction. It began with a second-century BC poem telling how he made the universe and people like a poet, out of words, followed by a fifth-century BC tale of how he made man like a potter, out of clay. It then showed God adapting to his worshippers from prehistoric times to their own.[51]

He pursues this 'fiction' theme in the rest of his essay, describing his lifelong favourite Bible story, the Book of Jonah, as 'a prose comedy about a Jew who wants God to leave him alone'. He continues, 'Believers and unbelievers have argued pointlessly about the truth of Jonah's book because they did not know great truths can be told in fantasies.'[52] And, not content with labelling those who discuss literal truth as idiots, he progresses directly into a quote from Tom Leonard's 'On the Mass Bombing of Iraq and Kuwait', attacking John Major's policies during the First Gulf War a full eight years after the events occurred. (But only a few years before they occurred again.) For Gray, all stories have the same worth if they are told well, whether true or invented. He finishes his Jonah, Micah and Nahum essay saying, '[T]his world ruled by greed is hatching one ruled by revenge. Old and New Testaments should teach us to reform our ways for our children's sake.'[53]

Some religious groups were not pleased with God being described as 'adapting' to his people, shifting historical events for effect, or of being accused of being a fictional character. Though Gray had been getting away with these kinds of sweeping statements for years, he was now doing so to a much bigger audience, some of whom were expecting

something more traditional. Canongate's *Revelations* became a huge seller, but was controversial, too. This became so serious that when Alasdair received a postcard saying I AM WATCHING YOU Morag was seriously afraid. Until they discovered this was a friend's idea of a joke.

END OF A CENTURY

Gray's twentieth century ended with him in bed, with flu, desperately trying to finish *The Book of Prefaces* before the third millennium kicked in. The last ten years had been his most prolific yet for publications, and he finally had a small but growing reputation as a portrait painter, partly due to the success of books which showed his style to many who were not familiar with it. After an initial dearth of energy in the early 1990s and considerable disillusionment with writing, Alasdair stumbled upon *Poor Things*, which took his critical and public popularity to new heights. After another creative dip he became an accomplished writer of non-fiction, resulting in newfound status as social commentator and elder statesman of Scottish culture. He also supported Scottish Nationalism in two polemical histories called *Why Scots Should Rule Scotland* – and at the end of the 1990s he followed his Abbot's House mural with another in the Ubiquitous Chip, this time on the stairwell. Speaking about its subject, Alasdair said: 'This was the closest I got to the painting of the garden of earthly delights, the peace mural that I never quite got round to painting in the Russian friendship society.'[54] The work took him into the new millennium. But what next? Yet again our man entered another decade saying he had nothing much left he wanted to do. No outstanding work to be completed. A lie, again, to be forgiven.

DIARIES: Health

Wednesday 30 March 2005: A Protected Patient
Yesterday, Jo from Canongate's publicity department called about an interview with the *Scotsman*. When she said she had been leaving messages at home but was getting no reply, I was sure Alasdair was either in hospital or lying dead in bed. So I phoned Morag, who was thankfully on her way to the hospital, not the morgue – Alasdair's leg

had got worse, he had been diagnosed with cellulitis on Monday and
taken straight to Gartnavel infectious diseases ward. They didn't know
how serious it was yet. I postponed his interview, called the ward to
find out his room number, asked what on earth cellulitis was and tried
to arrange a visit. They wouldn't tell me anything, and said that if my
enquiry was urgent I should come to the hospital.

On the way there many scenarios crossed my mind. He'd had a heart
attack. He'd fallen reaching for the phone calling to ask me to correct a
mistake I'd made on a letter. He'd tripped over books I'd left at his flat
and hit his head. This fear was made oppressive on arrival when the
ward nurses were less than friendly. They hardly spoke, and wouldn't
even confirm that they had ever had a patient called Alasdair Gray. No,
I wasn't a relative. No, he wasn't expecting me. I became convinced
that Alasdair was breathing his last, only days after we'd worked late
into the night. The receptionist also told me nothing, and was unhappy
about me insisting on going through to the ward unattended. So it was
surprising to be welcomed in the corridor by a smiling, red-faced nurse
who clearly knew who I was, and more so to be led straight to
Alasdair's room, where I found him happily sitting up in bed, in stripy
pyjamas, holding Morag's hand.

'Oooh, hello, Rodger! Come in!'

The sister gave Alasdair an injection in his wrist (which he didn't
even notice) and explained why I'd found it so difficult to get through
the security system:

'We've had a number of famous people in this hospital over the
years,' she said while gently reattaching Alasdair's intravenous drip.
'You know, footballers, politicians, that kind of thing. You wouldn't
believe the stories the papers write about people in here. They make up
anything . . . *really*. We had to check with Alasdair that you weren't the
paparazzi!'

She lifted Alasdair's head and puffed up his pillow: 'Such an eminent
Scot needs to be protected, you know.'

The paparazzi have no interest in elderly artists who have not
married models, but at the words 'eminent Scot' Alasdair extended
a single finger to the heavens as if this was a perfectly natural suggestion.
When the nurse had finished speaking he said, 'The front page of
tomorrow's *Daily Record*! *Gray Has Bubonic Plague!* Haha! What a way
to go! *Oh, what a way to go!* Glass, take down my last words, will
you . . .'

Alasdair Gray's laugh is uncontrolled, straight from the depths to the outside world – enough, probably, to kill off some of the more sensitive patients in surrounding rooms. It rang happily throughout the ward. Next to him, Morag shook her head as he laughed.

'Sorry my dear. I'm boring you.'

Morag adopts the demeanour of long-suffering wife who sees faults where others only see the Gray-who-can-do-no-wrong. I suppose I add to that. She seems to be acting as a counterbalance to the cuddly treatment he gets from everyone else. As Alasdair and I chatted she seemed to disapprove of nearly everything he said or did.

Towards the end of a conversational digression, something to do with *Lean Tales*, Morag looked at me and shook her head once more, which Alasdair spotted, turning his head to me and lifting up the book he was reading about Robert Louis Stevenson:

'I'm afraid Morag may have heard that one before. The point is . . . somewhere in this book . . . I won't be able to find it now . . . but the thing is . . . Stevenson says something about marriage. You know, sort of . . . "Marriage is, at its most basic level, a friendship recognised by the police." Haha!'

He adopted one of his alter-ego voices – this time the oft-used London Gentleman of Advancing Years – saying very slowly and deeply: '*I think that is perfectly true.*'

Morag managed one more shake of the head, but they were still holding hands. Meanwhile, nurses kept returning, moving silently around us, not wanting to disturb such high conversation. Alasdair hardly responded to his treatment, and never complained – his unshakeable belief in the NHS seems to make treatment hurt less. When the nurses had gone, Alasdair asked if I had visited him in hospital before.

After Alasdair's heart attack in 2003 I visited him daily in Glasgow's Western General, took him the usual hospital things, and sometimes ferried Morag there and back. But when he asked me to take dictation the day after the attack, I took my little stand. I wondered then if he would remember the episode a year later – sternly insisting he not ask me to work while he was ill, telling him he'd have to find another assistant if he wanted to sabotage his health that way – and wondered also whether it would bother me if he didn't remember it. I now know it does, and that I am kidding myself about my role. Not only do I care greatly for Alasdair, but I also wish him to care greatly for me. I thought

I'd got past that. Seeing he really didn't know the answer to this question – had I visited him in hospital before? – I feigned mock horror in order to disguise actual horror. I then explained my fierce dedication to his state of health and, imitating his London Gentleman voice, made it known that if I chose to I could make up this entire biography because he wouldn't know truth from lies. He again broke into wild laughter. Morag unpacked envelopes, notepaper, pens, laid them on his table, and we both left the hospital.

3 April 2005: Due for HANGING

Alasdair spent another couple of days in hospital, then was discharged. When I visited him at home he wanted to talk about planning *A Life in Pictures*. We checked his wall diary, seeing 14 May circled. According to his capitalised notes, he was due for HANGING at an art gallery in the mid-afternoon – something that, I suggested, would make his appointments on the 16th and 18th somewhat difficult. He chuckled and then began a cough he found difficult to stop once started.

Tuesday 5 April 2005: Malcolm Hood's Funeral

Soon after Alasdair's release from hospital his art school friend Malcolm Hood died. Alasdair insisted on going to the funeral at Kirkcaldy Crematorium. If I drove him, Morag said, at least she would know he wasn't struggling on to a bus somewhere. Perhaps, she suggested, I might persuade him not to stay long after the service. I promised to do my best, and said I was happy to take him, but also said he would probably do what he wanted. Alasdair hobbled to the car.

On the way there we talked about the things that usually occupy his mind when given a long car journey, an open road and one person to talk to: books, plays, paintings, relationships, sex, politics – always jumping between topics. His mind works like a lottery system that can switch, with ease, between them all, with little regard for stuffy old irrelevances like sentences, finishing off ideas, and often little regard for the listener. As I tried to negotiate the roadworks and Alasdair's vague directions – 'go towards Edinburgh, Rodger, over a bridge, then left'* – he chatted at length about a Tom Leonard play, his school reports, happy art school days with Malcolm Hood and others – but he wasn't his usual self. In the

* AG does not drive, and works only to the unreliable compass in his head. He only attempted driving once, and crashed into a wall, believing cars work like a ship's rudder – turn wheel in one direction and the car moves in the opposite.

small sighs and occasional looks between the laughter there was real sadness. In recent visits to Alasdair Taylor in hospital I had seen a strange, quiet melancholy in my boss that rarely showed itself in any other part of his life, and it was this that was reappearing, stronger, today. Mostly he forced himself to be cheerful, even when discussing his friend's suffering, which he did in a straightforward manner.

Malcolm Hood was an art teacher who preserved a dry sense of humour despite suffering with paralysis for the last years of his life. Latterly the condition even prevented him from drinking water, though it made him perpetually thirsty. Alasdair said this painful detail made him more hopeful than usual that the minister would 'not go on about the *Glory of God* too much'. He was not in the mood for the Glory of God. We arrived at the crematorium and parked:

'Would you like me to come inside,' I asked, 'or should I wait for you here?'

He opened the door and struggled out of car, saying: 'No, come along. At funerals, half of the people don't know each other anyway.'

Once out in the open air, waiting in the car park, the loud, bold Alasdair Gray had gone completely and been replaced by a timid man who introduced me as his 'young driver friend' and spoke about the weather, the formalities, whether we should go inside. When I left him for a few moments he stood alone, looking lost and confused. Soon after, a friendly man who had known Malcolm for many years approached us, explained proceedings, and mused on how much he'd be missed. He smiled politely as we filed inside.

'I would have been visiting him today,' said the friendly man as we shuffled into the hall. 'I've always gone to him on a Tuesday. I don't know what I'll do next week.'

'Well . . . isn't it a lovely day,' replied Alasdair, seeming not to hear properly. He looked across the room where, instead of a fourth wall in the hall, there was a large ceiling-to-floor window letting in bright sunlight.

Alasdair chose a seat directly in front of the minister, and while waiting for the service he started to read through the two-page booklet with dates of birth, death, and Malcolm's full name on the cover. He said in a surprised, childish tone:

'I didn't know he was a year older than me.'

'And look,' I replied, pointing. 'His middle name was Gray.'

'Oh yes, I didn't know that either. Or perhaps I forgot it.'

He indicated something on page two. 'Oh, that's good. I'm pleased we're doing that hymn – I like that one.'

Alasdair sings a lot, especially around the house. Usually when repeating lines from his favourite political operas, he takes the artform seriously. When in sillier mood, like when repeating his old wireless favourites, he affects a different tone, rolling the 'r' sounds and adopting a Cockney accent. Today he sang in the voice that usually came out for comedic purposes. He couldn't sing the hymn meaningfully, so sang it in the only way he could. After the service, Alasdair said he thought I'd done 'pretty well for a Jew boy', but confided that he'd found it difficult to sing 'How Great Thou Art' with real spirit, knowing Malcolm had not been religious, and how much his friend had suffered. I mentioned his singing style, and he said he had not noticed it, but wouldn't put it past himself to try to joke his way through a funeral.

After the service we attended the wake at a nearby hotel at which we sat across from two pleasant art teachers who were also friends of Malcolm's. Two ladies we sat with said they had some of Malcolm's paintings in their homes. The rest, they said, were going to the hospital where he had spent the end of his life. They discussed the Victorian design of the wallpaper with Alasdair while eating sandwiches and drinking coffee, occasionally turning to me and asking a question or two. When conversation ran out he concentrated on eating biscuits, letting the crumbs sit on his lap, undisturbed. I failed to bring Alasdair home early, and we left at the end of proceedings.

On the return journey Alasdair talked quickly and nervously. First there were the usual things – certain motifs show up in both work and conversation, and the talk on the way out had reminded me to look out for them. He explained that schoolteachers told him to 'stop thinking' about English, art and history, and to concentrate on maths instead (this story is a favourite of his) – 'And I'm still bad at numbers'. He often gets these wrong, mainly when dictating letters. On recent correspondence he has been referring to a novel called *2005, Janine*, and another called *Lanark: A Life in Ten Books*. For a man who hates numbers, he puts a lot in his book titles. Another regular story is that he is convinced his father was proud of him, but, because of his upbringing, where boasting was not acceptable, he could only show his pride by complaining to friends and neighbours of his eccentric son who did 'all this silly writing and drawing', while secretly smiling inside. Each of these old stories was

wheeled out during our journey. It felt like he needed to repeat them. They are touchstones for who he is, as much as the Butler Act, or his Riddrie.

These motifs were the beginning of more revealing talk. Alasdair likes to discuss his father – his background, job, ideals, home library and quiet encouragement. After basically retelling the start of the Thaw section of *Lanark* while looking out of the window, Alasdair explained how Alexander Gray was a widower for twenty years, then 'rashly remarried', moving to Cheshire. Then Alasdair said his father left his body to medical science, as he will do. His father's arrangement – decided because Alexander Gray was so horrified at the cost of Amy Gray's funeral – suited everyone, until the University of Manchester phoned his stepmother one day years later to explain they had used all the parts they could, and what would she like them to do with the leftovers? She didn't know, so she called Alasdair, who also couldn't imagine what to do. As we arrived home, Alasdair explained his similar arrangement with Glasgow University's scientific research department: 'I hope they don't close the department before they decide what to do with my spare parts,' he said lightly. And then he got out of the car.

28 June 2005: We All Must Die

When I arrived at the flat this morning, Alasdair was upset. Not long before, he had received a phone call from Rosemary Hobsbaum to say that Philip had fallen into a coma and was not expected to come out of it. Rosemary explained there was no point in visiting as Mr Hobsbaum would not be in a state to recognise anyone.

Though he had been unwell for some time, having a leg amputated the previous year, the shock of Philip Hobsbaum falling into a coma affected Alasdair instantly. He paced the room, picking up papers he didn't need and putting them down in the same place, opening and closing the fridge several times, sitting at the computer, laughing at an unimportant e-mail that had come in, muttering 'Ach . . . we all must die' over and over, dragging out the word 'die', then returning to the fridge to pour a couple of pints of tomato juice, which he drank in one go. He realised he was getting nothing done and went to his own regular doctor's appointment half an hour early.

The doctor's surgery concentrated his mind on dark themes, and he found it impossible to continue on work after he returned. Even the appearance of a previously lost painting, 'Spring Onions', of Marion

Oag (sitting at a table with a copy of *Pippin's Post* comic), was not enough to cheer him. He asked me to come through to the lounge and retrieve a painting off a high wall, saying: 'It is the last thing I will ask you to do today. I am useless.'

The painting in question was begun in 1976. Alasdair explained, pointing to the figures in the picture (Philip and Rosemary Hobsbaum, surrounded by the poets Byron, Shelley and Keats), that it was an unfinished wedding present:

'Earlier this year,' he said, exhaling heavily, 'I restarted work on this painting in the hope of making an anniversary present. But, with the news that Philip is not expected to wake up again, there doesn't seem much point. Ach . . . perhaps it can be a memento for Rosemary. She is the only one still alive in this picture.'

The picture had been started nearly thirty years earlier, at the beginning of their married life together. He would find it difficult to forgive himself for not finishing it in time for Philip's death. I left him to finish the painting.

26 October 2005: Back in Hospital, Dazed, Wrong
Alasdair has been ill since August. It is now the end of October. These diary sections were intended to be upbeat accounts of the nature of being and working with Alasdair Gray, but increasingly they are becoming updates on his health, and he has not been well enough to show those cheerier sides of himself fully. There might be moments, days, visits to the ward that make me feel he is getting better, but these are always followed by setbacks. There's no way of contacting Alasdair at the hospital because the ward phone is broken. (He has been hobbling, bandages and all, down hospital corridors to the nearest public payphone in the building just to keep in touch with Morag. This phone has been broken for two weeks.)

According to Morag, who sounds more frustrated each time I speak to her, the hospital are currently trying to find a way to send Alasdair home, and have him treated by visiting nurses as an out-patient, without greatly affecting his overall health too much. This is a common problem for NHS hospital wards. If people won't hurry up and get better or die quickly so somebody else can have their bed, then how will all the necessary targets be met? Last time, Alasdair lasted five weeks of not getting better or worse – a long time in an infectious diseases ward – before they sent him home. A month later

he was back in there. It's now been a couple of weeks again, and though there are some positive signs – yesterday the doctors reported his leg infection hasn't got to the bone yet (though that sounds like the postponement of bad news rather that the reporting of good) – they need to find a way to 'encourage progress'. That is, to get him out. I don't know what happened to the recent idea of using maggots to eat away at the dead tissue. Meanwhile, there's the usual dilemma. Morag said that during Alasdair's short period recovering at home he was asked to do a reading event at Oran Mor. We discussed the difficulty of doing this without making him feel even worse, and I realised I was no different from all the hangers-on and promoters who wanted to use him for different things he found difficult to say no to. Recently I'd asked Alasdair something else, a bigger, personal favour, and until today had convinced myself I had done nothing wrong.

My fiction publishers recently had an enquiry from *Dazed and Confused* magazine, saying they were running some features on established writers supporting the work of new writers, also with a view to introducing the work of the more established ones to the magazine's young readers. They wondered if Alasdair and I would be interviewed on the subject of each other's work. I wanted to do it, and made myself believe that Alasdair might too. Though I'd never asked him to publicly support me before, I decided this was the time. He was perky that day, but was still in a hospital bed, and I sold him the idea, saying 'Sir, we have been noticed in LLLondon!', telling him 'The kids read it!' when he asked what kind of magazine this was. I now think he agreed to please me and because he probably didn't know how to say no. I have never managed to get the balance right between: 1) not pressurising him into doing things that are beneficial for others, and 2) respecting him enough to explain every offer that comes in and trusting him to make the right decisions.

31 October 2005: Death Fantasy

Today I'm working in the northern Scottish town of Elgin, but more than ever Alasdair is in my thoughts. Earlier, looking out on to the picturesque lake outside the library, I had one of my occasional jealous fits that come about when I think about not being secretary any more, and about how I would feel if he were to die in hospital while I was

here. Then I got angry. Alasdair will only be appreciated when he's dead, and even then it won't be what he deserves. We'll get all the usual sentimental nonsense where commentators will cut out anything uncomfortable in the obituary. The usual parasites will say how 'important' he was. They'll probably name a Glasgow building after him. Some politician he hates will stand up in the Scottish Parliament and say, 'Alasdair Gray himself would have approved of the following legislation!' Why am I focusing on his death and its possible aftermath when he is alive and working on *A Life in Pictures*?

1 November 2005: Making Up

Letter from Alasdair, which must have arrived while I was in Elgin but is dated 28 November. He skips cheerily from subject to subject, explaining first that the proposed maggot and honey solution for his leg is in limbo – 'they can't get the right honey' apparently – but how many types can there be? The plan is still to return him home for periods, though the ulcers are as they have been for several weeks now. In today's note he explains he's not done with political work: 'One day, I would like to combine all my Scottish non-fiction writing into one big book of essays, editing out repetitions. We shall see.' As for *Dazed and Confused*, he put my mind at ease:

> I did not think that your suggestion that I see a journalist – even a *Dazed and Confused* one – was impertinent cheek. I DO refuse what I don't want to do, if there is no moral obligation on me. I saw the journalist's visit as a diversion, knowing that nothing a journalist gets printed about me matters a damn, however entertainingly queer I am painted. Morag, mistakenly (like most women who have loved me) thinks me a big softy. (When I resist them on certain matters they do not therefore see me as hard or tough – just selfish.) I will attend the Oran Mor do ONLY if I feel fit enough. I would like the outing. But it has taken me a lot of effort to persuade her that I will refuse it if I want to, ruthlessly.
>
> It was good to hear from you,
> says Alasdair.

Maybe we overestimate our effect on him: but I was pleased though to find plenty of fight in the letter.

3/4 November 2005: Medical History

Arrived home from night out to find this e-mail. I have been back in Glasgow only a day since a short book tour. Seeing Gray tomorrow. Now receive this:

> Dear Boswell,
> The enclosed medical history may be filed with other materials for possible use in our forthcoming Life of Gray.[1] It will not only be useful but poignantly touching if I fail to recover from my new treatment.
> Yours truly,
> Alasdair (And Hi from Helen)

Attached to the e-mail was a one-thousand-word account of Alasdair's illnesses from 1934, going right up to today. Without thinking, I sent this reply:

> dear johnson –
> e-mail from boswell, 3 a.m. morning of 4/11/05, returning from night out celebrating launch of novel by alison miller, 'demo', that proves glasgow people in 2005 STILL GIVE A SHIT. a political, brutal, beautiful piece about the war in iraq which takes in the same themes of your story, 15 february 2003, from ends of our tethers. have faith, good Gray – new writers know your work and respond.* it upsets me to return home to find you have sent me this medical history – i don't want to hear there is any chance you may not recover. i will visit you as soon as possible – tomorrow. but thank you for this – i'll keep it safe. for ever. hello to helen, rodge x

Note to self in the morning: no more emotional e-mails to be sent while drunk.

Saturday 5 November 2005: A Night In

Went to visit Alasdair in hospital, the sound of fireworks going off outside as I entered the ward. You can see inside his room through blinds as you walk down the corridor – as I peered in I could see him leaning to one side. He seemed half-asleep, or just far away in thought.

* Alison Miller would be quite right to wince at this barrage of nonsense. Few facts are to be found in this entire e-mail: AM has not read '15th February 2003'.

When I see him he always dives straight into conversation, finding
Hello's and *How are you's* an unnecessary inclusion – like a stray extra
syllable or adverb that can be deleted.

'Hello, Alasdair, how are you?'

'I, er, didn't mean to alarm you.'

'Pardon?'

'You know, the er . . . the point is, the em, the *medical history* I sent you.'
He pointed skyward.

[low, slow, clear voice] 'I shan't be dying.'

'Good,' I said. 'I'm sorry. I should have thought before sending my
reply.'

'No, you shouldn't! But there it is . . .'

I moved some books and sat down. After an update on his proposed
maggot and honey treatment (I'm increasingly convinced this is a joke)
Alasdair drew out of a drawer the latest pictures for inclusion in *A Life in
Pictures*, saying several times that he was feeling cheerful about the
writing sections, without actually seeming cheerful at all. This may be a
projection of my own sadness at seeing him still cooped up in that
room, or the fact that it was a sociable night of the year to be inside.

31 December 2005: Ian McIlhenny

Today was Ian McIlhenny's funeral: Ian was one of the old Festival Late
crowd, and Alasdair has just written his obituary. In it, Alasdair
described Festival Late as a place which 'in 1961, changed a lot of
people's lives'[2] – Ian met his wife Frances there, and Alasdair met Inge.

It has been a difficult year. Several good friends have passed away,
and while reading Ian McIlhenny's obituary I realised that each time a
friend of his dies, somebody asks Alasdair to write about their life. That
is an honour, but it is also a burden, to have to write something that will
soothe the family and do justice to the person that has been lost. No
wonder he's always asking aloud if he will be next. In the text, Alasdair
referenced Ian's Scottish CND connections, his protests against the
nuclear base at Dunoon and said of Ian and Frances, 'Like nearly
everybody in Scotland who takes the arts seriously they lived by
teaching', in that way he writes which can be intensely personal, while
making a sly political score at the same time. The obituary, peppered
with touchingly personal memories, opened and closed with mentions
of Ian's popularity and friendships. I wanted to interview Mr McIl-
henny for this book. I'd not yet contacted him.

6 March 2006: Bedside Kicks

Today's biography interview was conducted by the Gray–McAlpine bedside. Without any apparent shame, Alasdair explained he had suffered with an asthma attack last week, recovered enough to get drunk on Friday, and was now suffering a setback that had left him back on antibiotics. Though breathing was difficult, and coughing inter-rupted speech regularly, he insisted I open some wine, sit, and said he was happy to talk. Besides, he wanted to ask a favour. Glasses were laid out and we began.

We discussed which parts of *Lanark* got written in the years of his first marriage, his living conditions in times of most poverty, divorce, a single meeting with the avant-garde writer BS Johnson in the mid-1960s, a new play idea and then how the new novel was coming along. The previous title has now been reverted to. Alasdair suggested to Liz Calder that if she didn't choose between the two main candidates then he would have to flip a coin. So she chose *Men in Love*, and *John Tunnock* has become merely a character again. This cheeky approach to titling tickled him greatly. When describing abandoning responsibility, his eyes seemed to say, 'I am being devious, I know it, and I love not having to make decisions!' Which is a peculiar attitude for someone who has made a life's work of agonising over the most precise details.

When he's in a good mood Alasdair likes to read aloud. He picked out a notebook and began to read from 'a wee two-act thingy called *Goodbye Jimmy*', which appears, from the explanation and dialogue, to be mainly a conversation between someone called Jimmy (who may well be Satan) and someone called The Head (almost certainly God). A quick tot-up of current projects brings this list: *Men in Love, A Life in Pictures*, book of Gray plays, Oran Mor ceiling, previous unnamed play last described at Christmas, proposed book on environmental futures with Joe Murray, and now *Goodbye Jimmy*. We can only pray the *Popular Political Songbook* doesn't drift back into his thoughts.

Today Alasdair asked me, rather bashfully, to stand in for him at a reading at Edinburgh University on Friday; he doesn't want to let a friend down, and would I read from *Men in Love* on his behalf, then answer questions? My making plain that I thought students hoping for an eminent Scotsman would be disappointed to find themselves being addressed by an unknown Englishman made no difference. He laughed at the prospect of me dressing up in wig and overalls, and told me not to worry. I agreed. Was this selfish or selfless? While I'm in Edinburgh

there's also a portrait he wants picked up of Paul Henderson Scott and his wife. Mr Henderson Scott thought the portrait made it appear like he and his wife didn't entirely like each other. No matter, said Gray. He'd pick up the original, chop the thing in half, remove Mrs Henderson Scott and reframe it as a single portrait! And down went more wine for us all.

6 January 2007: Alasdair Taylor's Funeral

Alasdair promised to provide directions for this morning's journey, but was soon too busy making a case for the defence for Walter Scott's fiction to do that.[3] At regular intervals he interrupted himself to say something like, 'Ahem! . . . That is . . . I talk too much! . . . [gently] – I mean, where are we, Rodger?' But even as these words were being spoken he was already halfway to his next anecdote, rushing on, perhaps to avoid the obvious topic. Alasdair Taylor was one of his very closest friends, and his death has hit hard. Towards the end of his life, Alasdair Taylor could not speak and was in continual pain. During hospital visits he would listen for a while, then tap Gray's hand softly and Gray would say, 'Do you want me to go now?' The most recent occasion was last week. But there was very little emotion on show this morning – literary anecdotes kept more dangerous topics at a distance. We arrived early at William Wallace Funeral Directors (yes, really), took seats by the door, and Alasdair sat with a fixed merry expression while people approached him, reminded him who they were and asked after his health. James Kelman arrived and sat near Alasdair. The service started.

There was little religious element today. First, Alasdair Taylor's son-in-law spoke, telling lively stories showing how unusual, warm, positive he was – and talked of Alasdair Taylor's talent for constantly being amazed by the world, seeing things others took for granted. This reminded me of visiting him in hospital a couple of years ago: Gray had taken an art book along, thinking this would be less exhausting to share than conversation. I was the driver and had not met Alasdair Taylor before. But between flicking through the book he kept beckoning me in close, pointing at Gray, mouthing the words, 'The best, the best.' Which made Gray very annoyed. 'I am NOT. I am NOT the best at anything,' he replied. He was always telling himself off on the journey to and from the hospital, having an argument with himself. Today Gray was due to say a few words about his old friend. He began speaking in

quite a businesslike way, about Alasdair Taylor's upcoming travelling art exhibition, how many great artists remained unrecognised, how it was no shame to be unknown, especially in Scotland. Still no emotion. But as he was finishing his voice began to break, and during his final sentence – 'He's no' deed yet – no' in the minds of those who knew him' – Gray began walking back to his seat, trying to get there, to finish, before he got too upset to continue. On the way out I asked if he was okay, but he looked at me incredulously: 'Of course!' he said. '*Why not?*'

We followed the procession to the cemetery, falling in behind the coffin halfway up the hill. Alasdair commented on the name of the road, the Anglo-Saxon origins of the word 'hearse' – and when his friend's body was being put in the ground, he looked out over the water to the Isle of Arran clearly visible to the west, saying: 'I have never seen an island look so – *sculptured* before.' Better to take a nice wee walk up and down a hill and gaze at the beauty than have to think about yet another friend dying. Alasdair refused the offer of a dram – he's off the drink this month, he says* – paid his respects to Alasdair Taylor's daughters and we went back to the car.

14 February 2007: And JUMP!

Exciting news: today the great man attended his second session of – oh, yes! – *aerobics*, at Gartnavel Hospital. The first session was conducted in ordinary Gray garb – jumper, shirt, trousers, shoes – but Helen's recommendation is, if he can't locate a pair of shorts, to convert himself into his artist's overalls for the occasion, as it might help him feel more sporty. Every time it seems there are no more Gray surprises, along comes another. He writes! He draws! He does star-jumps! Is there nothing the man can't do?

* He didn't last the month, or week.

THE BOOK OF PREFACES

The Book of Prefaces, Alasdair's most ambitious work of non-fiction, was finally published on 22 May 2000 in Britain and shortly after in the USA. He claimed to have edited and glossed the contents himself, but said he could not finish 'before the third millennium AD without help from a host of good writers working without pay'. After all this assistance Alasdair still had regrets about the finished product – he even criticised specific illustrations he would have improved, given more time. 'I sympathise with Bloomsbury for stopping me continuing to revise for another year or two,' he wrote in the Editor's Postscript. But his excuses made it sound like it could have taken much longer. If not for copyright problems preventing the inclusion of twentieth-century favourites like Vonnegut's *Slaughterhouse 5*, the book would have been even bigger than its 640 pages. Still, despite restrictions, false starts and financial difficulties, Alasdair was happy to have finally completed the book he was amazed no one had got round to writing before – and poor Joe Murray was pleased too.

Gray claims *The Book of Prefaces* is a two-hundred-year-old idea by William Smellie,[1] merely expanded and developed here – but really it was inspired, like so much else, by Alasdair's upbringing. In the introduction he describes the Acts of Parliament that gave him the education necessary to create this book which, among many other things, also contains an essay on his early family life. (It was now common practice to weave Gray personal history in with the history of literature.) The jacket of *The Book of Prefaces*, replete with Gray portraits of everyone from Swift to Eliot to Mary Wollstonecraft, is extraordinarily elaborate. Quite independent from content, *The Book of Prefaces* is a stunning visual artefact. The inside pages provide a clever contrast to the outside, being portraits of Gray's helpers: some known, some unknown. This is another example of Gray's Socialism in art, giving Shakespeare and Jan, Joe Murray's partner, the same space on the page.

The book is mainly made up of introductions to famous works by some of the greatest English language writers since the fourteenth

century. These introductions are written by the authors themselves, with highlighted side notes by Alasdair, providing context in his usual style. In several additional sections he explains his reason for creating this book. He writes, 'Few great writers have not placed before one of their books a verbal doorstep to help readers leave the ground they usually walk on and allow them a glimpse of the interior.'[2] Also, prefaces can be a place to defend the work to follow. In a section called 'Seeing Great Writers in a Huff', Alasdair writes: 'Prefaces to first editions usually try to forestall criticism, those to later editions counter-blast it.'[3] Which is also his way of justifying the many introductions, postscripts, endnotes and downright defensive essays which have been published either side of his own works. The prefaces here often include exactly the kind of thing Alasdair had been up to for years: Keats's preface to *Endymion* was initially rejected by his publishers for being too self-critical, Gray tells us; Shelley replied to reviews of his previous book in the preface to *Prometheus Unbound*. This was another way of Alasdair aligning himself with the masters. In fact, here was a *whole book* of Gray aligned to the masters – the culmination of all those occasions where he had copied their methods, lined himself up next to them in his stories, or changed their original texts. Now he could literally publish on the same page as Urquhart or Stevenson: and then criticise.

Many respected writers and critics queued up to praise *The Book of Prefaces*. Peter Ackroyd, writing in *The Times*, called it 'a memoir and memorial to past times', and said of Alasdair's commentaries: 'A door to each decade is opened and a great light shines through.' Ian Sansom lavished praise on it in the *Guardian*:

> [*The Book of Prefaces*] has almost nothing in common with any book written by any living author. Its affiliations are with the tradition of the commonplace book, with the 18th-century dictionary makers, with the Victorian encyclopaedists . . . It is egalitarian in ambition and aristocratic in execution. It should be bought and fondled by anyone who is tired of the tasteless swill, the cheap hype, the hustling, the glad-handing, the chit-chat, the back-scratching, second-guessing groupthink that sometimes goes by the name of Contemporary British Literature.[4]

Sansom rightly aligns *The Book of Prefaces* with the best dictionaries and encyclopaedias, but this is not a straightforward educational book – as

always, Gray makes rules that suit him, then breaks them. Adam Mars-Jones, writing in the *Observer*, noticed what he was up to: '[T]he double or triple bluff is a favourite Gray device and shapes one of his blurbs here: "Do not let smart children read this book. It will help them pass examinations without reading anything else", a delicious truth disguised as an empty boast, disguised in turn as a sober warning.'[5] Gray had been found out, but instead of attacking him for his manipulations, critics admired him for it.

The multiple bluffs are evident in every aspect of the book, even in Gray's choice of texts. For example, in Nathaniel Hawthorne's preface to *Twice Told Tales* Alasdair reminds readers that this is Hawthorne 'at his craftiest and most ambivalent'.[6] (Hawthorne pretended to be an obscure, unknown writer when he was already hugely successful.) Here, Alasdair is saying, *Writers toy with their readers. Writers are liars. Writers can't be trusted. It has always been this way.* The whole book is a direct communication with the reader. Gray directly explains what he believes *The Book of Prefaces* to be at its very end:

> I consider this anthology a memorial to the kind of education British governments now think useless, especially for British working-class children. But it has been my education, so I am bound to believe it one of the best in the world. I no longer think social improvement inevitable anywhere, but still believe (as my dad and granddads did) that good co-operative working brings us closer to liberty, equality, fraternity: the only state in which we are happy and sane.

In these final lines, Gray admits his prejudices, argues for them anyway, then ends by stating exactly what he believes makes human beings happy, as if this is a fact no one could dispute. This bold confidence in the validity of his own opinions makes *The Book of Prefaces* a highly political, highly charged argument for a very particular kind of education: Alasdair's own.

The Book of Prefaces was always trouble, and continued to be after publication. The Public Lending Rights Office enquired whether this 'Editor' could be considered the sole person deserving of making money from it. (After all, sections had been written by Geoffrey Chaucer and Archie Hind.) But despite Gray sidelining himself in the main text, he did not bend when it came to payment. After a spiky letter explaining his contribution he rounded off: 'I am the only person – apart from

Bloomsbury – with a claim to make money out of this work, and I believe I have earned 100% of its public lending right.'[7] After seventeen years he felt entitled to this, though in the end it hardly mattered. In a later paperback review Nicholas Lezard said: '[E]very literate home in the country should have this. They won't; but they should.'[8] He was right. *The Book of Prefaces* was a critical success, but a commercial disaster.

SIXTEEN OCCASIONAL POEMS

In the same month as *The Book of Prefaces* was published, Alasdair printed a very limited-edition run of another new book, *Sixteen Occasional Poems 1990–2000*. This slight collection includes little of note, and half of it had already been published accompanying prints by his old friend Ian McCulloch.[9] But it does begin with the revealing '1st March 1990' and finish with 'To Tom Leonard', a short, positive dedication lifted from his recent Ubiquitous Chip mural. The non-McCulloch part of the book is split into two themes: 'Selfish Last Verses' and 'Faith and Politics', two titles Alasdair imagined when scribbling corrections and additions with a view to collecting all Gray poetry together in 2005. The publication of *Sixteen Occasional Poems* suggested Alasdair was still preoccupied largely with political themes, and was now publishing everything he was producing, like a collector who wants to have a complete record of output, regardless of quality. As for the publisher, it was released by Morag McAlpine. Morag, now retired, was running a Gray shop from their flat, selling books, art prints and Gray rarities to shops and directly to fans, through his new website.

THE LAST OF INGE

In recent years, relations between Alasdair and Inge had improved. Since their marriage Inge had married twice more and divorced twice more – but she always kept in contact with her first husband. Since Andrew's wedding and the birth of Alexandra, a granddaughter, she had even become friendly with Morag and the whole family had spent one pleasant Christmas in a small Danish town, Ejby, in 1997. (Andrew, in particular, was 'happy they were talking again'.[10]) So when Inge wistfully said she would like a short holiday in Glasgow, Alasdair and

Morag invited her to come and stay. But when she arrived she was seriously unwell. Alasdair remembers:

> On the second day she could not leave bed. Morag and I had arranged to sleep on a mattress for ourselves on the living room floor, but Inge's horror of sleeping alone soon became so great that, with Morag's permission, I went back to sleeping with my first wife, who never returned to Manchester. Then Andrew came from the USA and took over the care of his mother, sleeping beside her bed and letting me return to my wife in the living room. With his help she entered two Glasgow hospitals for treatment, then rented a flat where she lived for two months more, looked after by a trusted friend and often visited by others.

Inge was too sick for this to have had sexual connotations; but still, it was an incredible strain on Morag. It was also a pressure on Alasdair, who felt he had been trapped into doing Inge's will yet again. But though she clearly needed comfort, it is hard to believe that he could not have just gently refused her request. Shortly before Inge died Alasdair composed 'Inge Leaving',[12] a poem about recent events:

> She seems to like me now, there's no denying,
> whose contempt used to give me dreadful pain.
> Will death undo the burden of her dying?
>
> Nine married years ended in rage and lying;
> thirty years later we're in bed again.
> She seems to like me now, there's no denying
>
> yet rules once more by reckless defying
> the courses I consider the most sane.
> Will death undo the burden of her dying?
>
> She never thought it false to be relying
> on people she regarded with disdain
> but seems to like me now, there's no denying.

In these verses, Alasdair is amazed at Inge's complete change of attitude towards him: 'She seems to like me now', he writes, as if he can't quite believe it. But Inge's 'reckless defying' echoes Alasdair's frustration at

their married life. A version of this poem appeared in *Chapman*, where it was printed alongside more recent the 'Being with Morag':[13]

> 'Be up. Be out. Be off!' I to me say
> so softly there is no need to obey.
> Warm smoothness is a quality of you,
> enjoying which undoes all need to do.
> Warm smoothness is a quality of we
> who lie enjoying it, content to be.

'Being with Morag' is not passionate but starkly contrasts the two marriages, with Alasdair presenting the second as a simple, affectionate understanding. A previous version ended 'almost content to be'. Almost, because no pictures can be painted, nor books written, when lying down.

VOTE GRAY/ARREST GRAY

In late 2000 Glasgow University's Scottish Nationalist Association united with the Students' Socialist Society and asked Alasdair to stand for Rector of Glasgow University. This position is usually contested by celebrities – the previous Rector had been the actor Ross Kemp, who did not turn up to his inauguration ceremony, never visited the university and eventually resigned in November 2000. Afterwards, some believed a Glasgow-born artist would be a move in a more honourable direction. But Alasdair's campaign was disorganised, with adverts for his candidacy sporting a bad quality black-and-white photocopied image of him looking downcast and not very electable at all. In fact, looking perfectly criminal. The leaflet made much of Alasdair's local connections:

> *Scotland's most acclaimed literary personality.*
> *VOTE GRAY ON 28TH FEBRUARY*

> *Alasdair was born and bred in Glasgow and is a graduate of the city Art School. A well-known, well-liked and respected author and artist, his writing is internationally recognised as some of the most influential of the twentieth century. He is a spirited performer and communicator, with a keen sense of outrage at social injustice. Alasdair is a former Writer-in-Residence at the University's English Literature Department and has remained loyal*

*to his home city, **living in the West End**, making him ideally located to be Rector of Glasgow University. If elected Alasdair will –*

- *Campaign for the **re-introduction of a decent living maintenance grant** for students and the complete **abolition of Tuition Fees***
- *Hold **regular surgeries** for you to air your concerns*
- ***Oppose any unreasonable rise** in membership fees to the Sports and Recreation Service*
- *Get the **best possible deal for students living in Halls of Residence** if the management rights are transferred to an independent Housing Association*
- ***Fight against any bad landlords** within Glasgow*
- ***Stand up for you** at meetings of the University Court.*

VOTE GRAY ON 28TH FEBRUARY

The list of commitments showed Alasdair was prepared to promise himself into a busy job, but students never got to witness the sight of this candidate going toe to toe with Glasgow's bad landlords. Greg Hemphill of the comedy series *Chewin' the Fat* was elected instead (after a third count), with Gray beaten narrowly into second and Stuart Murdoch from the Glasgow band Belle and Sebastian in third.

In the same month as this Alasdair found himself attracting a different sort of attention. He had attended several recent anti-nuclear protests at Faslane, the home of Britain's Trident submarine fleet, on a few occasions going along with A. L. Kennedy, a more experienced Faslane campaigner and friend who remembers Alasdair's arrest on 12 February 2001, in polite circumstances:

The whole set-up at Faslane is very peaceable – the protestors assemble, the police are there, the police ask them to leave, they don't leave and after a few hours, those who are going to be arrested and want to block the base for a long period tend to chain themselves together and on to objects and then the police slowly and gently cut them free. And during that period if you loiter off the pavement and certainly if you sit down on the road, you'll be arrested . . . Alasdair stood with us and then decided that he would be arrested, as well as protesting and so he went and sat down in the road and was almost immediately lifted up by a couple of cops and led away, to warm applause.[14]

Gray was charged with breach of the peace and spent a few hours in jail alongside another pensioner who regularly attended protests. On release he told BBC News that the new Scottish Parliament should get rid of Scotland's nuclear weapons. When asked why he refused police requests to move, virtually guaranteeing his arrest, Alasdair said: 'I did not want to disappoint my supporters.'

UNLIKELY MURALS, MOSTLY

In July 2001 a twenty-five-minute documentary, *Unlikely Murals, Mostly*, was broadcast on BBC Scotland. Along with *Under the Helmet* (the 1964 Robert Kitts documentary that hinted the subject was dead) it stands as the most useful account of Alasdair's large artistic works. This film, directed by Kevin Cameron, began by explaining that Alasdair had recently been restoring and altering his old 'Jonah and the Whale' mural in what used to be Rosemary Hobsbaum's home (recently discovered by new owner Sian Holding when she removed old wallpaper to redecorate). But it also described his very first mural in the Scottish–USSR Friendship Society and took in several other Gray murals rarely seen by the general public. In the documentary, proprietor of the Ubiquitous Chip pub Ronnie Clydesdale was interviewed about the Arcadia-themed mural on the stairwell in his pub, as was Alasdair's assistant Robert Salmon, who remembered spending two weeks painting a tree as part of it, which Gray then decided he no longer wanted. ('That's just Alasdair,' he shrugged, in the manner of a man who has experienced something similar many times before and since.) This film was nominated for a Scottish BAFTA, and is valuable not only because it explores the history and meaning of Alasdair's murals, but also because it shows the detail of several of his best. If these are ever destroyed, the film will be a crucial record.

Alasdair said he did not appear as a 'talking head' in the documentary because he preferred to provide a voiceover while viewers looked at his art. This was a defensive strategy but it worked: as the camera panned his restored 'Jonah and the Whale', Alasdair discussed not only past work but also hopes for the future. He said he liked the idea of spending his old age restoring murals he'd done as a young man but a reflection towards the end of the programme suggested greater ambition:

My ideal would be a gigantic mural in the new Scottish Parliament which would have in the foreground a frieze of all the kinds of people who make up modern Scotland, all the races and nation- alities and trades and professions. And behind, a kind of panoramic view of Scotland itself, showing all the kinds of landscapes with images and representatives of the various major towns and cities and the industries that still remain here.[15]

By the time *Unlikely Murals, Mostly* was broadcast the cost of the Parliament building was already escalating into a public scandal, and there was no chance of a Glaswegian muralist being employed to paint its walls; Alasdair knew this particular project was unlikely. However, he still hoped for one more major artistic work before the end of his life.

CLASSIC SCOTTISH WRITING

Also in 2001 Alasdair published more non-fiction, *A Short Survey of Classic Scottish Writing*, as part of a new Pocket Canongate series. This was packaged in a box set beside volumes by six other major Scottish writers: Kelman, Spark, Stevenson, Burns, Scott and Hogg, along with a set of specially commissioned covers by Scottish artists such as Douglas Gordon, and postcards of the jacket designs. This small book, which Alasdair called a 'hopscotch survey', skipped expertly over several hundred years of Scottish history and, as Judy Moir (then of Canongate) noted, it charitably included references to nearly all the books in the Canongate Classics series apart from Gray's own, assessing everyone from Barbour to MacDiarmid along the way.

Two complaints about *Classic Scottish Writing* are: 1) it repeats past Gray work, and 2) it is yet another book with a Scottish-only focus. Alasdair dealt with both head-on in notes either side of the text. He admitted (but did not apologise) in the Foreword, 'You will find passages here that you have read before. My mind has not improved with age so I cannot describe the same things again in better words',[16] and in the Afterword he defended the appearance of yet another Scottish Gray publication: 'This book may suffer from Scots Wha Haeism, a habit of hinting that the best things come from MY nation. This is a bad habit when it leads to demeaning other nations, but good when it gives folk confidence they need to work well with local material.'[17] He had learned from previous

political outings to bookend his Scottish histories with gentle reminders
that the author was also interested in the rest of the world. He finished: 'I
admire above everyone else Jesus Christ and Tom Paine who were
derided and rejected for refusing to identify with any national group
smaller than humanity. Having concentrated on Scottish writing for the
duration of this book I will now spend a long time enjoying books from
other lands. Thank goodness so many exist.'[18] But he was unable to
concentrate on other places for long.

At the time of this fine but virtually ignored book (which was largely
overshadowed by publicity over the specially commissioned artworks
which were also used as the jackets of each book in the series) Alasdair's
standing was at an all-time high in the wake of the critically well-
received *Book of Prefaces*, and the still-growing reputations of his novels,
particularly *Lanark, 1982, Janine* and *Poor Things*. These and several of
his others were appearing in the unlikeliest places: by 2001 Alasdair was
translated into not only old European languages like French, German,
Italian and Spanish but also Japanese, Russian, Polish, Lithuanian,
Czech, Swedish – even Serbo-Croat – a very different situation from
1977, when he last worked at Glasgow University. At the age of sixty-
seven, he got another job there.

THE THREE PROFESSORS

In 1995 Philip Hobsbaum and Willy Maley set up a creative writing
Masters course at Glasgow University: in 1998 it joined with Strath-
clyde University. In its first few years this developed a reputation for
helping students towards publication, and it entered its most productive
period at the turn of the century. As the course grew in stature and size,
it needed more experienced teachers to mentor new writers.

As creative writing has become a more accepted academic discipline,
teaching on these courses has become a way for many fiction writers to
finance their own work while helping the next generation along: and
not only younger, less distinguished writers take up these posts. Even
the most prominent, like Martin Amis (who became Professor of
Creative Writing at Manchester University in 2007), who do not need
the financial boost, have found reasons to join up. Some academics and
fiction writers believe writing cannot be taught, but Alasdair has made
his position clear:

[W]ords are no more mysterious to a professional writer than sounds to musicians, their bodies to footballers, living flesh to surgeons. That these professionals train under experienced practitioners is taken for granted and required by law. In the same way an older writer can speed the learning of a novice by showing a thriftier use of language and more things to do with it . . . [H]alf the learning in a course comes from the novice being, often for the first time, in a community of writers: people of different sexes, ages, social classes and even nations who, having the same aims, encourage each other by example and by sharing ideas.[19]

Alasdair's opinion is not surprising: he had personally benefited from creative writing groups in the 1970s, as he had benefited from his own 'community of writers', especially with the likes of Liz Lochhead (to whom he had read bits of *Lanark* and *1982, Janine* in draft form), Bernard MacLaverty, and of course James Kelman and Tom Leonard, now all elders in a Scottish literary landscape they helped to form.

In the summer of 2001 the Glasgow/Strathclyde course advertised for a new Chair in Creative Writing, a post in which Gray, Kelman and Leonard were all interested. Alasdair remembers:

[F]or all three of us the job had one major snag. A full-time professor of Creative Writing would not have the time to creatively write. Then Marie, James Kelman's wife, pointed out that for thirty years we had been friends who sometimes worked together, and if we offered to share equally the professor's title, work and salary, the university might employ all of us since it would get three notable writers for the price of one.[20]

So Alasdair, Jim and Tom accepted the job jointly, with Alasdair telling anyone who would listen that he was doing this because his parents, who so wanted him to go to university, would have been proud of him becoming, however late in life, one third of a professor. The deal was undoubtedly a coup for Glasgow: the event was covered in several newspapers, and was described as a 'dream team' to BBC News by Willy Maley, convener of the course. (Philip Hobsbaum had recently retired.) And the list grew. In the 2002–3 academic year, Liz Lochhead and Janice Galloway were employed as tutors, too. One writing course now boasted many of the country's best writers – but there also needed

to be an academic element. (It was, after all, a university course.) This created tensions between the new writers and the university teachers who shared the running of it.

As one of the young writers attracted by the course, I was as desperate to learn, also as impatient, as desperate to publish, as anyone who attended it. This is a difficult period in Alasdair's life for me to assess. I was helped by many of the teachers, so I cannot be impartial. My experience was good and I was too preoccupied with myself to notice tensions among the staff. But these certainly existed. The main tension was over how to run the course – some felt there should be no requirement to do an 'academic' essay, some felt there should be no need for 'marking' at all. (Alasdair certainly believed giving a 'mark' was unimportant but, then, he did not enjoy marking and struggled to keep up with paperwork.) This was not just a simple clash between 'artists' and 'academics', as Zoë Wicomb and Margaret Elphinstone, from Strathclyde, are both respected fiction writers, too, and most of the 'writers' had previous experience of working within university environments – for example, Kelman had taught at the University of Texas. The issue is a wider one that applies not only in this one situation but in many. As Creative Writing has become a more integral part of university culture, it has also become more commercially minded, with greater pressure to have higher student numbers and a greater emphasis on getting agents, getting published, getting paid. James Kelman has said this leads to less emphasis on the art itself:

> We [AG, TL and JK] approached the Creative Writing course at Glasgow University as working artists which is what we are. Many academics would regard that statement as derisory, also presumptive, they see us as charlatans. Glasgow University is no different from universities in England or the United States, Creative Writing courses are being transformed into academic disciplines. Artists are being disciplined into becoming academics, and the focus on art is side-lined. Artists who resist are frozen out. Agatha Christie or Stephen King is as 'valid' as Tolstoy.

As well as favouring different teaching methods, there was also a clash of personalities, which some of the teachers have since spoken about publicly. James Kelman has talked of his unhappiness with the way he feels he, Alasdair and Tom were treated, sometimes by other teachers, sometimes by students, several of whom complained about them. Tom

Leonard believes the issue was one of respect, and has referred to noticing some students making fun of Alasdair publicly: Kelman and Leonard both say they feel there was a general lack of respect for what they were trying to do. But there is a real difference of opinion among those involved, both teachers and students, over even the most basic details of this period.

In 2004 a book of work by Glasgow/Strathclyde Creative Writing students past and present, *The Knuckle End*, was published, with an introduction by Alasdair, who gave his account of the three-professors period. (The introduction itself became controversial, as several students complained at the tone of it, also disputing some of Alasdair's 'facts'.) In it, he wrote that he feared they 'entered the Creative Writing Course like bulls entering a crowded mini-market',[21] but then went on to justify this intrusion. Kelman acknowledges that memories of the time will naturally be different, but says the problems were more than just about interference:

It is true that we tried to 'interfere' with the course. We sought to improve it on behalf of the students. Some of them were as uncomfortable with this as the academics. It was salutary to discover that the majority preferred the academic approach. They saw the course as the means to an end: the M.Litt. degree in Creative Writing. But they would have come to respect what we were up to, eventually.[22]

Willy Maley does not disagree with this, but after Kelman's interview with the *Herald* in August 2007, in which he commented on this period, Maley has replied to these accusations. He disagrees strongly with some of the things Kelman has said about the creative writing course:

He told me at the time – in June 2002 – that the students on the course 'weren't fit to kiss the dust on Alasdair Gray's feet'. This after some negative feedback from some students. That remark astonished me, till I realised that he wasn't talking about Alasdair at all, but about himself. No doubt both Texas and San Jose [universities] have better resources than Glasgow – and perhaps they also countenanced Kelman's refusal to write references for students – but it is Kelman's definition of art that is fundamentally flawed in my view. Alasdair sees artists as the servants of art, and teachers as the servants' servants.[23]

Clearly Kelman–Leonard–Gray had a very different idea of how to support aspiring writers from that of their colleagues, and some of their

students – so this arrangement was inoperable in the long term. It lasted nearly two years, then the three-way professorship broke up. This period is now generally perceived as a troublesome one that most teachers of the time would prefer to forget, but 2001–3 saw the publication of several highly regarded books by ex-students that made it appear as if being touched by the course was a sure guarantee of success. These, along with the Gray–Kelman–Leonard publicity, brought even more hopeful new writing students to Glasgow.

After Alasdair left, much changed. Partly as a result of recent difficulties, Strathclyde University split with Glasgow to set up its own undergraduate Journalism and Creative Writing course, Tom Leonard became a part-time tutor and host of popular weekend poetry groups, James Kelman taught again in America and Liz Lochhead also moved on, later becoming Glasgow University/Glasgow School of Art's writer-in-residence. Janice Galloway remained until 2006. The current trend in creative writing courses is for larger numbers, less one-on-one time with students, more group sessions and more practical help with getting published. This suits some, but it was not what Alasdair Gray wanted to be involved in.

PAINFUL INTERRUPTION

In recent years Alasdair's health had taken a dip: since 2000 the eczema that he had suffered earlier in life had reappeared. He has said, 'It took a holiday of several decades – then went back to work.'[24] The eczema mainly affects his legs but also his arms and neck; Alasdair had to take more regular breaks from work when either eczema or asthma or both got too bad, sometimes needing several days in bed to recover. This was irritating but not serious until, one day in summer 2003, after suffering tightness in his chest, also sudden fatigue and shortness of breath, Alasdair had a minor heart attack, brought on by angina.

Once he knew he was going to live, Alasdair reverted to usual behaviour: he was sitting up in bed dictating letters and scribbling notes. He considered this health-related development to have been predictable, unremarkable, and of little consequence – he even kept it from some of his friends. 'I'm on bonus time now!' exclaimed Gray joyfully, from his hospital bed, as if he was delighted to have an excuse to behave as he wished. He had also suffered a stroke, though he didn't know it straightaway. When the topic was discussed publicly for a piece in the

Sunday Herald, Alasdair remembered: 'It was just these two fingers [index and middle finger on right hand], on which I depend greatly, weren't responding. I was having to use my whole arm to write and to draw.'[25]

Doctors prescribed Pravastatin Sodium, Aspirin, Ramipril and Securon pills daily to prevent clotting of the heart, and diagnosed a mild form of diabetes: no insulin, but Alasdair was now under strict instructions to change his diet in order to keep daily blood sugar level between 4 and 8. Doctors advised a slower work regime, too, also less heavy drinking. This whole episode was a real scare – even if the most frightening thing for Alasdair was the possibility of not being able to paint any more – but as soon as his strength returned, and the hand recovered from the effects of the stroke, he did go back to work, using the timing of the heart attack to 'retire' from his professor job and take on something entirely different, which would not have pleased his doctors had they known about it.

ORAN MOR MONUMENTAL

In 2003 Colin Beattie, the owner of Glasgow pubs who had commissioned Alasdair to design stained-glass windows at the end of the 1990s (for his planned artists' café in Glasgow's West End), acquired another building he had great plans for. He bought Byres Road's Kelvinside Parish Church and wanted to turn the 150-year-old building into a multi-purpose arts centre called Oran Mor, meaning 'The Great Music' or 'The Grand Melody' in Gaelic. Alasdair first heard about the project when on a short holiday with Morag, and has said: 'I remember thinking at the time, *I wonder if he wants a mural for it?* Then, *No Gray! Er, shut up! Wait to be asked!*'[26] He did wait, and Colin did ask, and work began on the most ambitious artistic job of Alasdair's life in autumn 2003 while a full renovation of the premises was taking place around him.

For the mural job Alasdair hired his biggest team yet, including his longtime assistant Robert Salmon and also Richard Todd, a young sculptor and writer who came to Glasgow specifically to be taught by Gray and Kelman at Strathclyde/Glasgow universities. Richard was Alasdair's tutee in 2002–3, and greatly impressed Alasdair with his short stories.[27] When he discovered Richard also painted, Alasdair employed him immediately, without even seeing his work – one day he simply entered the fruit and veg shop Richard worked in and announced that he was hired. (Richard says, 'I think he considered it a bit of a rescue job.'[28]) This could have led to

problems, as Richard admits that then he wasn't really a painter at all, more of a sculptor, but once they started working together (first on the Jonah restoration) Alasdair found him 'excellent at fine detail, especially architectural detail',[29] and, despite frustrations at having continually to repaint sections every time Alasdair changed his mind, Richard didn't mind 'being the limb of a genius'.[30] Soon other assistants left, some out of frustration with Gray's methods, and only Richard, Robert and Alasdair remained.[31]

Donald Macleod of the *Scotsman* photographed Gray early in the process. He arrived to find a man in skaters' kneepads, on all fours, at the top of sixty-foot-high, shaky-looking scaffolding, painting at an awkward angle, surrounded by wall scribblings and bits of stuck-on tape. Donald knew from past experience that his subject didn't pose so just told him to continue as normal. While taking pictures he asked what had inspired Alasdair to draw the star-speckled night sky that was slowly appearing. What drove the great man to do this vast work? Alasdair sat up, took the *Ladybird Book of Stars* out of his pocket and handed it over.*

That was not an entirely honest answer. Since then he has explained the mural in a piece about Oran Mor called 'An Account of the Building and its Décor'.[32] In this he describes the themes of the work, also sketching out plans for unfinished parts and how Alasdair's big idea quickly changed from an initial ceiling mural to one which spread to auditorium side walls, gallery ceiling and floor, spiral staircase and even entrance porch. (Since his heart attack Alasdair has been looking for ways to record his intentions, especially on big projects.) The Oran Mor mural is still a work in progress, but it is possible to analyse the parts that are complete, or partly complete.

The ceiling of the auditorium is a dazzling blue-and-silver night sky containing Milky Way, planets, moons, stars and clouds. It is divided into twelve by arched beams, with each section displaying a month of the year and sign of the zodiac, including Sagittarius the Archer, whose face is based on Robert Salmon's, and Orion the Hunter – whose face is based on Richard Todd's. (Richard didn't object in principle to this, but was disappointed by the size of naked Orion's bulge, being smaller than that of a nearby cherub.) Gray's sky mixes together different religions and belief systems, suggesting a place at once religious and free of religion, depending on the wish of the viewer. He created a heaven-

* AG seriously claims to have taken his astrological knowledge from this tiny book – but now complains that in it, they 'got astrology wrong' – so now his sky ain't exactly right either.

like image similar to ones he used in previous murals, but wanted to avoid excluding those who do not believe in a heaven at all.

The three gallery ceiling panels contain a series of questions, some similar to ones posed in the introduction to Alasdair's *Book of Prefaces*. There he provided different answers dependent on the questioner, but here the same answers exist for all. The inspiration for this section (and several figures) came from a Gauguin painting showing people of all ages, as Alasdair points out: '[P]ondering birth, life and death in a jungle clearing. It is called *Who Are We? Where Do We Come From? Where Are We Going?*, questions we ask when able to talk, and which religions, philosophies and sciences are made to answer.'[33] The gallery panels read:

Q: *Where Do We Come From?*
A: *Life is Rooted in Death's Republic.*
Q: *What Are We?*
A: *Animals Who Want More Than We Need.*
Q: *Where Are We Going?*
A: *Our Seed Returns to Death's Republic.*

Each of these pairs is surrounded by relevant images – one contains Adam and Eve hugging, which is another nod to Gray's lost works. (This same likeness was prominent in Greenhead Church, fifty years earlier, also in his painting 'The Garden of Eden', and suggests Alasdair *is* spending his old age returning to old works – just as with his literature.) The gallery walls are crammed with symbolic images showing everything from Roman Colosseum to Glasgow's Kelvingrove Park to Trident submarine to the smallest of animals, using the theme Alasdair has made the central one of his mural painting – democratisation of art and artistic space. As in *Lanark*, modern characters and times blend in with faraway places and other civilisations. World-famous buildings are portrayed next to local spots. Icons of history sit next to unknowns.

Partway through the process, work on the eastern gable of the auditorium was affected by the intrusion of ventilators required because of health and safety regulations, but these are now covered. The design for this part shows what Alasdair calls a 'stormy dawn'[34] showing sun, rain and a double rainbow with a 'black athletic silhouette'[35] which can be interpreted as being Superman, Jesus, Zeus or Jupiter (more optional religion) directly facing Mother Nature, who appears on the opposite wall. The plan is to add multiple mirrors each with five portraits painted

on, of everyone from the original financier of the building, to Colin
Beattie, to the renovators, to the current staff.

Alasdair's is a vast, busy, cluttered mind, and in Oran Mor he has
created a vast, busy, cluttered mural, with many startling images
competing for the viewer's attention. This effect is duplicated in the
entrance porch which shows lions playing bagpipes below the words
'The Grand Melody', and above white floor tiles displaying 'Hello' and
'Goodbye' – Gray motifs from so many books – welcoming visitors in
twenty-four languages. (Even this is a political statement of equality:
Chinese is carved near Tibetan, Hebrew near Arabic, and Serbian near
Croatian.) These messages are represented in a new Gray script which
he calls 'tapered Roman capitals', or Oran Mor Monumental, a mix of
traditional pure Roman and Gill San Serif typefaces. Like Alasdair's
skull with cherub inside, like his dog and bone, this has since become a
standard Gray marker: he later used it for the jacket of *Old Men in Love*.
All work bleeds into all other work, all the time.

Oran Mor opened in 2004. Though not everyone in the area
welcomed the change of yet another church into yet another public
house, it instantly became a centre for artistic activity, won numerous
awards and is now one of the West End's main attractions, home to a
thriving theatre and music venue, whisky bar, restaurant, pub and also
Gray's auditorium, which is used for parties, conferences and weddings.
By the end of 2007 the design was still spreading slowly, and showed no
sign of nearing completion. Alasdair finished his account of the Oran
Mor decor on a defensive note: '[O]ver the next few years visitors will
see more and more decoration, and maybe enjoy it, but will ask the
question Pope Julius put to the decorator of his private chapel, "When
will it be finished?". Of course he was given the answer ambitious artists
have used since the stone age: "When it is done!"'

Oran Mor has provided inspiration for other works, too. When
Alasdair was commissioned to paint Edwin Morgan by the Saltire
Society, also in 2003, he used the template for his previous intended
stained-glass window, where Morgan was pictured in front of Glasgow
University. Alasdair painted the sky in the Oran Mor style and called his
piece 'Edwin Morgan: Glasgow to Saturn'. This shows a faintly smiling
Morgan resting hands on walking stick. The finished painting was given
to Alasdair's old friend as a present, then hung on his bedroom wall.

THE ENDS OF OUR TETHERS

In recent years Alasdair had concentrated mainly on political writing, writing about other people's writing and teaching other people how to write. But he wasn't going to stick to his oft-broken promise of writing no more fiction. While professoring Alasdair had been steadily collecting material for *The Ends of Our Tethers*, another short-story collection. On the evidence of the first few pieces he made a deal with Canongate in 2002 (it was their turn again) and finished it in spurts over the next year. It was published on 3 October 2003 and, as had become standard, in America shortly after. It was dedicated to Agnes Owens, 'one of our best', and included a brief defence of her work in the End Notes.

The general theme of *The Ends of Our Tethers* was 'growing old'. The progression into a new stage of life, that of 'increasingly old Glasgow pedestrian',[36] suited Gray – even in family photographs of little Alasdair holding a beach ball in swimming costume and glasses, he looks like an OAP in waiting; advancing years suited his personality, and gave him licence to behave as eccentrically as he liked. He had been referring to himself as in decline for fifteen years, only now, some were expecting it, too. I visited Alasdair when he was designing the jacket for *The Ends of Our Tethers* at his artist's desk: this shows three bearded, grey-haired, naked men being pulled left and right by red-eyed, horned skulls. 'Folk don't expect much from us old buggers,'[37] he told me, giggling.

Like its predecessors *Ten Tales Tall and True* and *Mavis Belfrage*, *The Ends of Our Tethers* mainly consists of domestic-based stories, dealing with issues more relevant to those who have been alive longer, seen more, made more mistakes. The UK blurb made the author's own personal evolution clear: 'Since 1981, when Alasdair Gray's novel *Lanark* was published by Canongate, his characters have aged as fast as their author. *The Ends of Our Tethers* shows the high jinks of many folk in the last stages of physical, moral and social decrepitude – *a sure tonic for the young*.' If *Lanark* documented the journey from youth to old age, with the 'land lying over' the narrator at the end, here was a collection which started shortly before that point. The trickery was still there, but it was more subtle. Everything was shorter, crisper, more understated. No more the uncontrolled splurges in three or more columns as in *1982, Janine* – better these days to be angry quietly. These stories gently suggest patterns of human behaviour; they point out the despicable ways human beings treat each other, misunderstandings

between the confused. Instead of the usual mass of Critic Fuel, the book just finished with the dedication, credits and three short 'jokes' discarded from an earlier draft.

I typed many of these stories while Alasdair dictated. The blurb suggests it is comic, and in places that is true. The author certainly thought they were funny when he wrote them, and one or two more serious pieces didn't make the cut because they didn't fit. But there is nothing safe about them. Among what Alasdair calls 'dry wee biscuits' like 'Sinkings' (the tale of a young boy rudely turned away from a richer friend's house), 'Property' (a frosty anecdote about ownership of great parts of the country by the few), and '15 February 2003' (a straightforward account of the Glasgow march against the proposed invasion of Iraq), two of Gray's best short stories, which would make it into a discerning *Selected Short Stories of Alasdair Gray*, are to be found here: 'Job's Skin Game' and 'Aiblins'.

'Job's Skin Game', a modern take on the biblical story of Job, was initially broadcast on BBC Radio Scotland in January 2003. This was Gray's first attempt to come to terms with the recent aggressive return of his eczema, being a re-imagining of the biblical tale, with his modern-day Job suffering from an extreme form of this same skin disease. The story was also Alasdair's first response to a world in the wake of September 11th 2001. He put that event in a wider perspective, suggesting it was not the most cataclysmic disaster in world history. Crucially, he did it in a very personal, sympathetic way, from the perspective of Job, a man who here loses two sons when the World Trade Center collapses. The story begins: 'For God's sake don't believe what my wife says: I am still one of the luckiest men who ever walked the earth.'[38] It is one of his best.

'Aiblins' is the tale of a self-important, naïve young poet, Luke Aiblins, who challenges his writing teacher to get him published. (This story is based on Gray's experience teaching Ian Bamforth, a student from his first stint teaching at Glasgow University.) But instead of playing with the texts of others Alasdair used his own, ridiculing the work of his fictional poet by printing his own 1950s efforts, directly lifted from his teenage diaries. This was a particularly revealing inclusion, as noted by Nicholas Blincoe. In his *Daily Telegraph* review, Blincoe said of these poems: 'Though ridiculous, they show an astonishing facility for the decorative side of language, the whole lyrical razzle-dazzle of internal rhythms, alliterations, assonance and

other technical feats.'[39] He also said that Alasdair's speaking voice was closer to this 'gushing and childish' side, which he had since learned to control on the page, and was well controlled in *The Ends of Our Tethers*.

Some thought this collection weak – notably Allan Massie in the *Scotsman*, who called it 'scraps from the bottom of the drawer',[40] and Mora, who has politely suggested that her brother 'might have been repeating himself for money',[41] but these are not representative responses. (Indeed, it is Gray himself who has spread the 'scraps from the bottom of the drawer' quote, contributing to a falsely imbalanced perception.) Certainly there were many positive reviews. In the *Guardian*, Irvine Welsh warned readers not to hope for the wild, experimental Gray, but explained this other side, the one with the 'more controlled and low pressure' approach leading to a 'beautifully realised, thematically consistent' collection.[42] Michael Standaert praised it in the *San Francisco Chronicle*: 'What Gray manages is to transfer the cranky wisdom he has gathered through his 70 years into clear-headed observation of modern life – marriage and relationships as well as the isolation, loss and the failures which come from these interactions – and steadily dissect them with a mischievous eye.'[43] Ali Smith, once inspired by Gray and now a much more popular writer, also provided an appropriate quote for the hardback, saying *The Ends of Our Tethers* was 'full of sadness and good strong anger and unbelievably inventive with both'. Which it is.

A DECLARATION

In the early 2000s Alasdair was more preoccupied by politics than ever. As well as being known for writing nationalist pamphlets and getting arrested at anti-nuclear protests, he was also regularly called upon by the Scottish press to comment on political matters: he had become one of Scotland's elder statesmen, one of its foremost 'celebrity socialists', and was often invited to speak publicly alongside people like his old poetry student Peter Mullan and the then leader of the Scottish Socialist Party, Tommy Sheridan. But he was happier writing than speaking about politics.

In 2004 Alasdair communicated with Tommy Sheridan over the wording for a proposed Scottish Declaration of Independence. At the time Sheridan was in a position of relative strength: his party had recently got their best ever result, gaining approximately 10 per cent of the vote in 2003's Scottish parliamentary elections. Gray has never been

a member of the Scottish Socialist Party, he and Sheridan have never been friends, but they did communicate by post several times. Even before the SSP's political meltdown in 2006 there was little chance of this becoming law, but the fact that Alasdair should take the time to attempt a one-page Declaration of Independence for Scotland shows his ambition. The following is from one of Alasdair's letters to Sheridan:

> We, the undersigned, want Scotland to be a republic where people of every trade, profession, faith and origin work for each other's welfare.
>
> We believe this state needs a parliament elected by Scotland's people, and recognising these people as its only sovereign.
>
> We believe this parliament's members and agencies should be the servants, not masters, of Scottish citizens, through a written constitution that promises everyone the right to freely vote, speak and assemble; the right to protection from injury, theft and invasion of privacy; the right to know all the doings of its government and its agencies, with all the sources of its members' incomes, since a public servant's income is the business of the public.
>
> We believe that, under this constitution, Scotland's parliament should have complete control of Scotland's revenues and use them –
>
> 1 to negotiate as an equal with other governments
>
> 2 to defend the health, property and safety of life in Scotland by acquiring or limiting land or properties within Scottish borders that are owned by corporations or government agencies outside them
>
> 3 to work to make public housing, transport, education, legal aid and health care as good as any purchasable by private wealth.
>
> None of these requirements has priority.
>
> **We do not want an independent Scotland because we dislike the English, but because we want separation from that union of military, financial and monarchic establishments calling itself Great Britain!**

This draft shows just how comfortable Alasdair was with creating history. He wanted to bring James Kelman into the process, too, though their politics were not always the same. As Kelman remembers it, they were 'asked to put together a small statement at the time of the opening of the Scottish Parliament, for the alternative event organised by the SSP and

other left wing people',[44] and Alasdair developed the idea afterwards. But a final version was largely rejected by the Scottish Socialists: this above draft reads more like part of an *actual* declaration than a proposal for one. When asked, Alasdair said 'They only used a few lines of what we wrote . . . I did see their final draft. I thought it was a bit lame.'[45]

GRAY AT SEVENTY

In December 2004 another documentary, *Alasdair Gray: 0–70*, was broadcast on BBC Scotland to celebrate Alasdair's landmark birthday. This was again directed by Kevin Cameron, who had previously made *Unlikely Murals, Mostly*. Trailers for the programme promised that in it Alasdair would be interviewed 'by his harshest critic', but this was not a real interviewer catching Gray off guard: this was the man interviewing himself, a tactic he had recently used in a 'Tailpiece' he wrote for the twentieth-anniversary edition of *Lanark* (allowing him the opportunity to say what he wanted while avoiding the inconvenience of having to answer questions he'd rather not). Part of *0–70* is made up of praise from those who know Alasdair well (Edwin Morgan, Liz Lochhead, Mora Gray), also younger admirers (including the artist Lucy McKenzie). These interviews are intercut with shots of Gray talking about Riddrie and shots of the Oran Mor mural, which he says has 'already pleased far more people that I ever expected to please with my painting'. (That is certainly not true. He hopes to please millions.) There are also shots of his Scottish–USSR 'Horrors of War' mural being covered over by private developers, and Gray footage from the 1960s onwards.

For the meeting with himself, Alasdair the interviewer dressed up. He slicked his hair with gel, scraped it to the side, shaved off his goatee and even wore a suit to mark him out from the other Gray superimposed on the opposite side of the screen. The interviewer was blunt and went straight to sore spots, but the real Gray always gave himself the last word. When labelled a piss artist, Alasdair did not deny it but said this had not stopped him 'working hard and well'. Later in the interview he admitted his friendly manner in company was a way of manipulating people. (Not a terrible admission.) And at the end, when labelled a failure in England, he reminded the interviewer that many English reviewers, also European and American ones, had generally been kind to his books. After this last exchange the interviewer did bite back, but only with old quotes from

the back of *1982, Janine*. This is frustrating for anyone wanting the truth. After all, these were not quotes Gray had hidden in the past. On the contrary, he had insisted on their repeated publication, and had fabricated some of them to appear like a rejected outsider. So viewers didn't really get anything exclusive or dangerous from the 'interviewer' except the concept itself. But it was still fun to watch, and showed Alasdair did not always take himself seriously.

The seventieth-birthday documentary brought Gray right up to date. At the end of it Alasdair talked about the pleasure Oran Mor brought him and described this recent period as 'just about the happiest time of my life'. He continued: 'This of course is partly due to me having a second wife that can put up with me more readily than my first one could.'[46] There is something in that, but a Liz Lochhead interview in the same programme was more revealing.

> [H]e used to talk about *the pursuit of the golden silence*. About writing all his words, and getting rid of all of them, and being able to paint freely. I don't suggest for a minute that he's not writing anything big at the moment but I don't know what that is and I don't think it's burdening him . . . I think he's enjoying the freedom of being a painter, with apprentices under him, doing this great work.

This memory from the early days of their friendship shows Alasdair always had one eye on the future, even if it did not work out exactly as intended. The great, neat plan may have broken up over the years, but Alasdair felt lucky to have his Oran Mor job and was determined to make it his best mural yet. After Oran Mor was open to the public, work had to become sporadic – short bursts when no events were on – but this suited Alasdair, who always worked at many jobs at once anyway, and had several spells of ill health. It also enabled him to begin work on the wall portraits at home.

HOW WE SHOULD RULE OURSELVES

With recent dreams of painting the Scottish Parliament building in mind, also the aborted declaration draft of 2004, it is not surprising that Gray soon returned to political work: another book for General Election time. But given the lack of success of his 1992 and 1997

efforts, this time he approached the project a different way. He decided to focus his argument on republicanism, taking in all the nations of Great Britain, and this time took on a collaborator. There have been many Gray collaborators over the years, but he had only officially shared authorship of a book once before, in *Lean Tales*. This time, he felt he had good reason to do it.

In 2003 Adam Tomkins, an English author of books on republicanism, became Professor of Public Law at Glasgow University. He moved to Scotland partly because he 'thought there might be opportunities to do something political in the field of constitution'.[47] When the Scottish Socialist Party boycotted the opening of the Scottish Parliament in October 2004 (because it was being officially opened by British royalty) Tomkins was invited to make a speech at their rally on Calton Hill. 'This was unusual for me,' he has said, 'as I'm not a member of the SSP, I'd never done anything so bluntly political – and it's the only time I've done public speaking of that nature.'[48] But despite inexperience he impressed at least one person in the audience. Alasdair attended, and afterwards wrote asking if he was interested in writing a book together. Adam replied that he was 'currently on holiday in the People's Monarchy of America', but suggested a meeting in the New Year. (Alasdair liked this turn of phrase a great deal.) Adam now admits he didn't entirely understand what he was getting into: 'I wish I'd known a little more about Alasdair, and the Alasdair Gray phenomenon,' he says. 'I didn't realise what a rollercoaster I was on.'[49] That rollercoaster began with 'a conversation which was 80 per cent Gray, and 80 per cent irrelevances',[50] where the two thrashed out their argument: at this stage, Tomkins didn't even know whether Alasdair knew he was English, and didn't realise his Englishness was seen as an asset.

The collaboration was not easy. 'The biggest tension,' remembers Tomkins, 'was whether we were advocating a Scottish republic or British republicanism.'[51] This is crucial. Tomkins is not a Scottish Nationalist, and it may seem strange that the two were able to work together at all with such a fundamental difference of opinion, but it did not get in the way of progress. Alasdair was too fond of the idea of collaborating with a radical English academic half his age to let this put him off, and Adam was happy as long as he did not have to advocate anything he did not believe in. Their differences did not stop them both arguing for abolition of the monarchy and the return of key powers to Parliament: any political differences simply made both

authors seem more like intelligent specialists who were open to debate. Their jointly written introduction argues that the UK is not a democracy, aims to 'set out an agenda for republican constitutional reform'[52] and marks the position of the authors. Proposals were laid out in Chapter 5, 'Republican Reform':

1. We want all of the Crown's prerogative powers to be abolished and, where necessary, replaced with legislation.
2. We want current freedom of information laws to be repealed and replaced with legislation that would secure genuinely open government.
3. We want our parliaments to be reformed so that all are democratically elected and so that all are able to operate freely, without the constraints imposed by party loyalty.
4. We want the Crown and the queen to be removed from the constitution, with the monarch's powers being transferred to the House of Commons.

The division of work explaining *why* this is what the authors want naturally suggested itself. Alasdair largely took on the historical sections of the book, with Tomkins tackling the contemporary.

The writing process was frenetic, with both authors working separately on their individual chapters, together on introduction and conclusion. Though Alasdair never got round to editing Tomkins' chapters, he did invite the younger man to make corrections to his own side of the text, which he did. (Adam deleted, among other things, some clumsy references to Ulster and an extended coda about a recent council meeting reported by local paper the *Lennox Herald*.) This left a more succinct political work than Alasdair's past solo attempts, contained fewer digressions, and was more convincing because, though extreme in places, it provided a balance between general historical points and specific modern examples from the law courts. Alasdair struggled to complete his parts in time, and took breaks for naps during the job's final days. On the day before deadline he fell asleep in his chair and I had to call Adam to apologise, explain that Alasdair had run out of energy and ask him to finish his parts off. Adam then had a matter of hours to complete the chapter 'The Making of Britain', which had come to a stop mid-sentence, around 1939.[53] But, despite the speed of the project and these struggles at the end, the end product had a great deal to commend it. And

because 'republicanism replaces independence as the principle rallying cry',[54] this was new ground.

Alasdair hoped getting Adam Tomkins on board would make him seem less like a grumpy old anti-English nationalist and make the book more popular, especially outside Scotland. Right down to images of English rose, Scottish thistle, Welsh leek and Irish harp on the jacket, he aimed to appear less hostile to non-Scots. But lessons had not been learned from previous political books, which were also rushed out. On publication, only three weeks before the election, it was difficult to get attention and, despite Canongate dropping the price at the last minute, the book was hardly noticed. Alasdair was unhappy with the final product, but he wasn't complaining about the content – much of his contribution was recycled or tweaked material from other non-fiction works anyway, and he was happy with Tomkins' contribution – he was talking about the *presentation*. He thought the book flimsy, the type size too small, and believed no one would be able to take such an object seriously. There is a real contrast here between Alasdair's perception, mainly aesthetic, and his more practical collaborator, who had a keener eye on the political aims and how to achieve them.

For Tomkins, the aims of *How We Should Rule Ourselves* were clear: 'It was supposed to be recklessly ambitious – it's not a policy document. We were trying to shock the political establishment, put some left-field issues on the table. We were standing on the political sidelines, shouting very loud.' But though it had little direct impact, Tomkins says that some of the issues raised have since been discussed more widely, and collaborating with Alasdair was worthwhile:

> Given the circumstances I think we did a good job. Politics is historical. You cannot fully grasp the current state of affairs without having a clear understanding of history, and the way Alasdair writes history is beautiful. He makes it clear that history is made and not given. Still, if we did it again I would change a lot. I would abbreviate the history section as it diminishes the political impact – it's beautiful, but ineffective. I would also insist on a different publisher if the project was repeated. Canongate are a Scottish publisher and Alasdair is Scottish – so the book was seen as Scottish and was totally ignored in London. Being ignored by the London press killed it. I would take the project up again, but I would insist on a London publisher, and release it four months before the election.[55]

But is a repeat likely? Adam says: 'I bumped into him in the street not so long ago. We chatted for a while, talked about the next election [May 2007] and he said he was going to vote SNP. I said, "We can't do anything together then, I hate the SNP." But it was good to see him.'[56]

RECENTEST STATES

2005 was another year broken up by ill health – Alasdair was in and out of hospital for much of it – but he still pressed on with his next novel and made further plans for *A Life in Pictures*, which he had been promising for a long time, but which, like *The Book of Prefaces* before it, kept being put to the back of the queue. Canongate had hoped to put it out in 2006 but it soon became clear that this was unrealistic. Alasdair's paintings were owned by friends and collectors all over Scotland (some outside it) and it was a major, expensive job trying to track them down and get transparencies for inclusion in this new book. When Helen Lloyd began working for Alasdair at the end of 2005 she took on the project, liaising with Helen Bleck, Alasdair's editor, at Canongate and a typesetter, Sharon McTeir. It was slow work, and Alasdair's advance was eaten up many times over by the expense of making reproductions of his paintings, but this project was of central importance for Alasdair's plan of collecting all of his works together.

During 2006, while juggling *A Life in Pictures* and the new novel, Alasdair saw another opportunity. He realised that, as artist-in-residence at Oran Mor, he had a good chance of getting some drama accepted at the successful lunchtime theatre they were running. But the series, called 'A Play, A Pie and a Pint', only performed new work. So he wrote some.

DIARIES: Current States

9 October 2006: Hello Jimmy
Today saw the debut of Alasdair's first new play in nine years. In a typically succinct blurb which advertisers may have wished to be longer or more excitable, Gray described *Goodbye Jimmy* thus: 'Someone called Satan, here called Jimmy, tries to persuade God to stop humanity destroying itself. God refuses to intervene.' The programme reminded the audience that, though known for other work, Alasdair Gray had been

getting this sort of thing staged for nearly forty years – it made no mention of any Gray book apart from *The Book of Prefaces* and no mention of his mural two floors above. All of which suggests Alasdair is still prickly about his career as a dramatist. But today he looked happy, like he needed no more recognition than a play on home turf. Taking one of the few free seats, two rows from the back, Alasdair sat next to Morag in his paint-spattered blue overalls and leant forward, chin resting on clenched fist. He sipped a lime and soda, mouthed some lines and frowned at others, as if realising they needed to be gotten rid of for the next version. He claims this play – a two-man piece with God as Scottish headmaster and Jimmy as anguished Irishman – was finished on 18 September, only three weeks ago. Since then he's had more ideas for it.

Goodbye Jimmy is a return to some favourite touchstones. Prometheus. Scandinavia. Socialism. Bible stories. (Here, God denies causing Noah's big flood, as he denies destroying Sodom and Gomorrah.) Alasdair uses selective examples from these familiar sources to make the earth and its people look absurd: they don't learn the lessons of history, they don't look after themselves, they don't learn from each other, they won't work with each other. This is a bleak picture that suggests there is little hope for earth's future, but this sums up the message of the play: all is useless – however, it is important to know why.

When put into the context of the world's history as explained by the Head, the current spiteful little modern wars Jimmy complains about in the key parts of the dialogue seem like small news. ('Ah yes, I had high hopes of the USA,' says the Head wistfully, lamenting its current state. Only someone who has lived for hundreds of years could have seen it right from the nation's birth.) Jimmy pleads with him to speak to the people of earth directly, but God has an answer for that one. He sighs and says: 'They would treat me as a rogue virus.' That is, people see what they want to, and as they have twisted the Ten Commandments, so they will twist whatever else he tries. Sure of this, God dreams of starting up a new world where things will be better organised, and the flaws of the current one can be repaired. However, at the end of the play, God shows he does care about the people of earth. He knows his concern doesn't change anything, but he can't help himself. In this way, Gray's God/headmaster character is similar to his author. Alasdair has often stated publicly that he takes political action out of guilt. *Goodbye Jimmy* is another example of that.

Alasdair's plays have been criticised for being weaker than his fiction.

His characters are two-dimensional, some say – mere mouthpieces for Gray's opinions, who cannot be believed by intelligent audiences. It is harsh to generalise all his drama, the best of which contains perfectly rounded characters, but in this case it is a relevant point. *Goodbye Jimmy* doesn't always feel like it needs to be a play: the story might work equally well, if not better, on the page. In this production the more experienced actor Sean Scanlon (the Head), is more believable than John Mulkeen (Jimmy) – but the problem is in the script. Jimmy is described in the actor's notes as 'careworn' but his constant angst is exhausting, and at times he seems more like a narrative device than a real character, merely there to prop up God's monologues. These drag, and the audience is cut out of the dialogue, instead of being invited in. The Head's histories of the universe are delivered as if they cannot be questioned, but that doesn't always work, especially when some of the issues are such topical ones: the environment, oil, the recent Iraq War.

Goodbye Jimmy finished with God's mother calling him a 'silly wee man' (even God has to answer to his mum), and then the lights came up. On being asked what he made of the performance, one punter sitting directly behind Alasdair left the theatre saying: 'Well, that was at *least* a thousand times better than *Working Legs*!' Mercifully, the playwright didn't hear that back-handed compliment: he'd already returned to his scaffolding, running out of the theatre before most of the audience had vacated their seats. After *Working Legs* Alasdair thought he might not write a play again. This one has gone well enough for him to have begun work on another straightaway.[1]

11 October 2006: Follow-Up Jimmy

Alasdair phoned early to arrange discussing *Goodbye Jimmy*, and to apologise for escaping after the play: 'I had too many friends there,' he said, 'and was afraid they would all come up to me and tell me how marvellous they thought it was, whether they thought so or not.'

At lunch we talked about the play. Alasdair still thinks of it as a work in progress, though a performance was going on across the road as we discussed it. Alasdair considered cutting down the monologues, and told me about the influence of Brecht on his plays, and on *Goodbye Jimmy* specifically. I brought a newspaper cutting and asked if he'd like to read an analysis of the current version: 'I do not care about critics!' he thundered, snatching the day's *Metro* out of my hand and poring over the details of the four-star review.

Alasdair now says *Goodbye Jimmy* is not done. It's a shame that it's running in Glasgow and Edinburgh for the next two weeks, but this doesn't concern him – only that there is a final, definitive version. (Though Helen says, 'I believe that, with Alasdair's work, *nothing will ever come to an end*.') He asked whether I could wait for revisions before sending a new copy to Dublin, with a view to asking about a possible Irish production. He wants to rewrite it with the Head as an Irishman – as he describes it, 'Like a friendlier Ian Paisley.'[2]

12 March 2007: The Entire History of the World

Gray is still, despite having entirely run out of time and money, writing *Old Men in Love*. When I asked Helen whether he was finishing off Tunnock's life history – the last version promised a few more chapters – she laughed and said yes, there was still some of that, but she was currently witnessing a rather large diversion.

'He is now writing the history of Byres Road,'[3] said my informer, 'from the Big Bang onwards.'

'And where are we up to?'

'The Himalayas have just sprung up.'

'Any sign of humankind yet?'

'Oh no.'

Recent Gray e-mails to Bloomsbury appealing for extra time and please please MONEY have not been replied to for a couple of weeks. In the meantime he goes on, compressing all history, while spectacularly failing to hold back the hands of time. It is now two and a half months past the absolute deadline, Alasdair is skint, and is summarising the timeline of existence on this planet, as best he knows how.

21 March 2007: The Gray World Tonight

Today Alasdair was back in bed, ill. He had agreed to do an interview with Radio 4's Paul Moss from *The World Tonight* programme, and insisted on going ahead despite his chest infection. The piece was on whether there was a new Scottish confidence in the air, whether that was connected to the recent success of certain Scottish artists, musicians and writers, and whether all that could be linked to a greater desire for independence. (The Scottish elections are coming soon.) This is natural Gray territory, and usually he enjoys discussing these things, but tonight he was as angry and frustrated as I have seen him in years.

Paul Moss's gentle, respectful questioning took place at the end of the Gray bed, with Alasdair half sitting up, head resting on the back wall, arm resting on head. The microphone may have made Alasdair uneasy, but he has experienced these things many times before, and though he doesn't like being interviewed he surely likes being heard: which is why it was strange to see him so agitated. As the questions kept coming he got increasingly worked up: '*Are you seriously asking me . . .?*' he said, on several occasions, banging his fist on the wall and making mattress, bed frame and journalist rattle. '*Do you really want to know . . . ?*' When Alasdair is angry his face goes a deep shade of red and he waves his arms frantically; even the tips of his fingers respond, fizzing and darting quickly back and forth as he speaks. 'The better-educated lot fuck off down to London . . .' he spat, discussing Scottish artists, then reining in his anger and replacing it with a rarely used spiteful sarcasm. 'Of course, we have no industries left any more . . . we ruined or sold them all off . . . *but what would we need those for?*' The answers now seemed to be unconnected to the original questions, and descended into some favourite grumbles. 'There is no *pleasure* in modern art,' he complained at one point, going on to lament how he and his contemporaries had been ignored. This was inconvenient for the programme (though Moss was gracious afterwards, and somehow managed to get a quote) but the most concerning part was Alasdair's apparently deteriorating state.

Though he jokes about being a very lucky jack of all trades, Alasdair simply cannot work enough to get by just now, so despite being seventy-two he works as much as, if not more than, ever – which is part of the reason why *Old Men in Love* won't be as good as it should be. It's not finished! This is how he works: Alasdair makes a financial arrangement to secure some income, is set a timetable, then, every time, is surprised to find he can't work to it. All of this would not be so serious if the worry, stress and pressure of providing was not making him ill. Illness then necessitates a break from work, which puts on more pressure when he returns to it. And so on.

Midgie Silence and Play Theory: 21 April 2007

Today was the last Glasgow performance of Alasdair's second Oran Mor play, *Midgieburgers*, tagged on to an oldie, *The Loss of the Golden Silence*, one of the finest of Alasdair's series of relationship dramas written in the early 1970s. This play was also included mainly because the new one was too short, so a partner piece had to be found.

Alasdair asked me to pick up Agnes Owens in the car and meet him in the venue, but when we got there Alasdair was nowhere to be found. I finally tracked him down at the bar, holding a large whisky in his hand and wearing a bright, excitable expression. Despite being dragged in all directions by strangers and friends, Gray was in party mood. He took me aside and said he had discussed previous performances with director Paddy Cuneen[4] during the week and was hopeful that today's performance would be better than the earlier one I'd seen. This time the placemat programme was even briefer: 'Alasdair Gray born in 1934, studied mural painting and design at Glasgow School of Art and has since lived by writing and painting things.' The playwright was getting more confident.

The marked contrast in style between today's performance and the one I saw on Monday belies a wider issue at the heart of much Gray drama for actors and directors. On the first day, all three actors seemed unsure and the audience was smaller, being a sleepy Monday. With a few exceptions, the jokes in the script didn't get much of a laugh and most of the lines were delivered flatly, as if both pieces were naturalistic kitchen-sink dramas intended to be thoughtfully considered, quietly understood. Today, with the venue bulging to capacity and a bubbly, weekend atmosphere transforming the place, every joke was received with uproarious laughter and even straight speeches were chuckled at. But there was more going on than simply a case of good crowd/bad crowd. The actors were certainly happier, now settled into delivering the play more like a panto – which went down very well on this occasion. But at what cost? This is the dilemma for many actors of Gray plays: whether to portray real people, or caricatures. In *Midgieburgers*, the story of a miserable couple who receive an accidental visitor to their home, the character of Jack (the visitor) came across as particularly cartoonish: his lines had been delivered with serious aggression before, but now they were exaggerated and made camp. This made for slicker, more upbeat lunchtime fare, but it raises the question of what Alasdair's plays are *supposed to be*. Are they kitchen-sink dramas in the tradition of Pinter? (No, not enough silence.) Are they political pieces in the tradition of Brecht? (Alasdair says he is influenced by Brecht, but the characters seem to represent little but themselves.) Are they panto-mimes? (No, too many wordy monologues for that – and no 'He's behind you!') So what are they?

On one level they're simply fragments of the more eccentric side of

daily, usually domestic, life. In this case, the open door on stage between the two domestic scenes that make up these two plays seems to represent a wider connection: both plays deal with themes of silence, and that old Gray favourite, crumbling relationships between men and women. But looking at his plays as a whole, one theme unites all: they each deal with the conscious world, where most good drama deals with the unconscious, with the gaps between what characters say being as important as what they do. Not so in Gray drama: he is dictatorial, and does not hide it. His dramatic characters say exactly what they think and feel, which leaves less space for audiences to imagine what may be going on underneath the surface. On the page this strategy can be effective – part of the charm of his fiction is the directness of the speech – but on the stage it is tougher to make this work. It is hard for viewers to relate to the unnamed female in *Midgieburgers* or enjoy imagining what she is thinking or feeling as she sits there knitting – because she so bluntly states it. The same goes for the unnamed male, who states his problem openly at the very outset of the play. He says, 'Early retirement has made me . . . an appendage. I ought to cultivate something.' Even the intruder, Jack, states everything plainly, without ambiguity.

At the bar after today's performance, the atmosphere was celebratory. Many of Alasdair's best friends were there, and Alasdair and Morag stayed till late talking, with Alasdair being bought drinks from all angles. I didn't feel as cheerful as the backslappers. Like *Goodbye Jimmy*, this will almost certainly go to Edinburgh for a week and then be forgotten. These plays, whatever they are, should be tested elsewhere.[5]

3 May 2007: Independence Day?

Just voted. Replied to Alasdair's last e-mail, and asked why he had done nothing for today's Scottish election. He and Morag only find a TV to turn on every few years, on election night, and I wonder if he will be waiting nervously on tonight's result or carrying on as normal, sure that whoever wins, nothing will change. In Alasdair's recent Radio 4 interview from bed he shouted in frustration about how the 1979 independence referendum was lost because it was not won by a big enough majority: 'The horse won by a nose,' he cried, 'but a nose was not enough!' How could he not care about today?

7 May 2007: Arselickers

There's still no clear government. Nobody quite knows who to blame
for the mess of 100,000 spoilt ballot papers in this country of only five
million; the SNP have the slenderest of leads over Labour; the Socialists
in the Scottish Parliament were all kicked out; the Liberal Democrats are
refusing to join an SNP coalition until they promise not to hold the
referendum on independence Gray so wants. Meanwhile, Alex Sal-
mond, SNP leader, used his first speech to (mistakenly) quote Alasdair:
'Work as if you live in the early days of a better nation,' he told the
crowds and television cameras.[6] Meanwhile, Tony Blair is in his last days,
one of the foremost Scots in Westminster has just resigned as Home
Secretary rather than serve under the one who is about to take over the
UK, and I think of that Jock McLeish quote about the horse from 1982,
Janine about the '79 independence referendum:

> Well, a majority of the Scots voted as I did, even though politicians
> from both big parties [Labour and Conservative] appeared on
> television and told us that a separate assembly would lead to cuts
> in public spending, loss of business and more unemployment. But
> the usual sporting rules for electing a new government had been
> changed. 'If you win the race by a short head you will have lost it',
> we were told, so we won the race by a short head and lost the race.
> Then came the cuts in public spending, loss of business and
> increased unemployment and now Westminster has decided to
> spend the North Sea oil revenues building a fucking tunnel under
> the English Channel. If we ran that race again we would win by a
> head and neck so we won't be allowed to run it again . . .[7]

I have heard Alasdair say this in interviews, almost word for word. But
2007 polls show that now a separate assembly exists, a majority of Scots
are against independence: one of those is Prime Minister-in-waiting,
born in Fife, currently residing in 11 Downing Street, impatiently
waiting his turn. So will Brown's Scotland still be the cowardly nation
Jock labels them in Thatcher's days?

> The truth is we are a nation of arselickers, though we disguise it with
> surfaces: a surface of generous, openhanded manliness, a surface of
> dour, practical integrity, a surface of futile, maudlin defiance . . .
> Which is why, when England allowed us a referendum on the

subject, I voted for Scottish self-government. Not for one minute did I think it would make us more prosperous, we are a poor little country, always have been, always will be, but it would be a luxury to blame ourselves for the mess we are in instead of the bloody old Westminster parliament. 'We see the problems of Scotland in a totally different perspective when we get to Westminster', a Scottish MP once told me. Of course they do, the arselickers.[8]

Apart from small concessions to Jock's character (Alasdair does not believe Scotland is doomed to always be poor) these could be the author's words. Perhaps he will think of his nation differently if they vote in bigger numbers for what he wants in future elections.

There has been a dual SNP/Scottish Socialist poster in the Gray–McAlpine front window for several years. Neither of those parties have got exactly what they wanted from this process, though Alex Salmond has been filmed several times in the last few days saying that no longer can Scotland be taken for granted as an obedient, Labour-voting, Union-supporting place.

15 May 2007: If I Can Help It

Alasdair phoned today, very talkative, to discuss the election and everything that's come after it. He is feeling optimistic, he tells me, and has written a piece called 'Scottish Politics Now', which he hopes his most recent agent Zoë Waldie will be able to get printed some-where – a response to arrival of the new Scottish Nationalist govern-ment – although the piece itself sounds more like he's telling Alex Salmond how to do his job. The mention of recent writings leads him into thoughts of how he's happy to have more extra time to finish off *Old Men in Love*, shifting the date of the death of his hero to the time of the Scottish election, 2007 – which in turn leads him to talk about how he's adapting an old design for the new cover of the novel. I stand on the steps outside Glasgow University and try to find pen and paper in case he should say anything that sounds important enough to take down. And then he says: 'I never do anything original if I can possibly help it, Rodger! Nothing at all! Haha!'

28 June 2007: Irvine Exhibition, and Nearly the End of the Line

Tonight Helen drove Alasdair, Morag and I to Harbour Arts Centre, Irvine, where a posthumous celebration of Alasdair Taylor's art is taking

place. In the back of the car before we left Glasgow, Alasdair and I shared a bag of crisps he should not have been eating (because of his diabetes), and he muttered 'I hope I don't get too emotional.'

'You did well at the funeral,' I said. 'You got a little upset at the end, but you were fine.'

Alasdair stared straight ahead and said nothing.

'You gave a speech, remember?'

'I have no recollection of that.'

Usually Alasdair doesn't mind too much when he has forgotten something, no matter what it is, but he seemed visibly upset at this news. I didn't know what to say.

The Harbour Arts Centre was full of friends and Alasdair Taylor's family. Tonight's exhibition included a couple of speeches about his art, slides showing him at work and with friends like Jim Kelman – and then Gray gave a reading of his friend's writings, mainly memories from his youth. (He didn't get too emotional.) Then there was time for visitors to look around, and Alasdair took me and Helen on a tour of the work on display. He enjoyed talking about the pieces, some of which had been borrowed from his home. One of these was 'Madonna and Child', a piece made of mounted wood planks (Alasdair stroked it while describing the texture, then almost knocked it off the wall), and there was another which has been borrowed from Alasdair's hallway. This painting of white and lilac spirals looks entirely abstract, but is in fact a portrait of Andrew Gray. 'That is how he saw Andrew,' said Alasdair, laughing. 'I don't know what it means, but I find it . . . *comforting*.'

After the event Helen drove us all home and Alasdair reminisced about Alasdair Taylor. As always he didn't shy away from the darker sides of their relationship. I had heard the stories before but everyone seemed aware that Alasdair was spilling out very personal memories in front of me and eventually Morag cut him off, saying: 'Alasdair, remember. *You are talking to your biographer*.' I don't blame her for that – I would have done exactly the same thing myself – but as she said it I realised I might be coming to the end of my usefulness.

15 August 2007: Bottoms
[Recording events of 1 & 14 August 2007]

I arranged to pick Alasdair up from home at 9 a.m. on 1 August. We were going to Edinburgh for the day – he was meeting Helen Bleck and Sharon McTeir at Canongate about *A Life in Pictures*, I had

arrangements of my own, and we were doing an event in the evening: me introducing Alasdair at a reading for SUISS, Edinburgh's International Summer School. On arrival I saw I had woken him up, but despite being in pyjamas he looked like he hadn't slept in days. The last time we spoke he said he was finishing the artwork for *Old Men in Love*, then sending it to Bloomsbury. That was a week ago. Alasdair now explained, wearily, that he had not been able to complete it on schedule and had been working through nights and failing to sleep during days. This had gone on until yesterday when Helen was despatched with the art on to a London-bound plane to hand-deliver it, as a courier wouldn't have caught the post to Italy, where the books were being printed just in time to make it into shops by 1 October.

'I am feeling . . . *slightly deranged*,' said Alasdair, retrieving a manuscript from the floor of his lounge. 'Would you like to be God for the day?'

I said I had no idea what he was talking about but explained that we were late and if he didn't put some shoes on soon then we would certainly miss his meeting. He found them, wobbled out to the car, and talked like a man half-asleep all the way to Edinburgh. The odd half-word here and there. The odd random statement: 'It occurs to me that I am now very old – how marvellous!' he said, several times. When we arrived at Canongate's offices I was nervous about leaving Alasdair alone, but we were so late that I had to run to make my own meeting on the other side of town. So I arranged to see Alasdair later on, phoning Canongate once I'd left to make sure he had a number for me, just in case. We weren't meeting until 4 p.m.

When Alasdair arrived at our meeting point, the front of the National Library of Scotland, he was drunk. He stumbled in the direction of my car, arm in mine, until he decided to hook his arms over the side of a bridge and attempt a description of the history of the building below. Then he held up the printout in his hand and said:

'The point is . . . I'd like you to . . . I mean . . . are you familiar with Goethe's *Faust*? You see – *I want you to read the part of God*.'

I had been hearing about his imitation of Goethe's *Faust* for some months: now Alasdair showed me the text while holding on to the bridge. There were two parts, he said, for God and the Devil. In iambic pentameter. Alasdair could not stand unaided. How were we going to get through a performance of anything? And how were we going to fill four hours until the event started?

'How much have you had to drink?' I asked.

'I have been to . . .' replied Alasdair, grandly, *Deacon Brodie's Tavern*. I met interesting people there . . . [remembering something] . . . I think they may have asked me to leave.'

'Have you eaten?'

'Today? Oh no! Do you think I should?'

After a short rest he attempted to move again, and we gripped each other's arms as we headed slowly towards my car on High Street. It's pedestrianised, but there is very little room to move – August is Festival month in Edinburgh and the madness was well underway. High Street is famous for performers, people flyering the thousands of shows on offer, competing for attention. Between the spray-painted mime artists, the buskers and the army of people selling tickets, there seemed no way through. Alasdair fell, wailing quietly about old memories, Inge, Andrew, how he no longer felt able to work properly. I dragged him upward harshly, too harshly perhaps. I was angry. Could he not have stayed out of a pub for just a few hours? Should I have kept him with me through the afternoon to make sure he stayed sober? Since when were things so desperate?

Alasdair had to sit down before he passed out. I put him at the nearest table, in a noisy restaurant on the Royal Mile, trying to think of what to do. I went outside, called Helen Bleck at Canongate, explained the situation, said we were about to eat, and could we come back to the office afterwards so Alasdair could rest? Was there anywhere he could sleep? Maybe a couple of hours would steady him – and it would give me time to cancel the evening engagement. If I could do that. After all, it's not my place to cancel things, is it? When I returned Alasdair was already drinking a large glass of red wine and had ordered pizza. Helen Bleck called back with help: upstairs from Canongate is the office of *The List* magazine. The head of *The List* is Robin Hodge, who used to work at Canongate in the early eighties. The relayed message said that Robin owned a flat just yards from their offices, respected Alasdair Gray hugely, and was happy to provide him somewhere to rest, anytime.

But first we had to get through a meal. In between mouthfuls he talked about some of his usual subjects, but more aggressively than before. Not aggressive towards me, but as if he was struggling with himself – trying to understand himself or simply to get the words out.

'It occurs to me more and more,' said Alasdair, not for the first time since we sat down, 'that my father consciously *constructed* me. The point is, when I think of the Readers' Book Club, that's what I think he was

doing. I want you to find out about all those books . . . Is there a record? I remember – *Ernest Hemingway* . . .'

After the meal we left the restaurant and I decided that, unable to bring the car on to a pedestrian street, it was better to simply go down High Street to Canongate's offices – it was only a few minutes' walk. Surely we could manage that. Couldn't we? When we got back out into the bustle of a bright Festival day, it became quickly apparent that we couldn't. Alasdair's legs weren't going to be able to cope with the downhill slope. But rather than buckle under him, they responded by attempting a run. 'The food has – *given me energy!*' he exclaimed, darting between performers and punters, only just missing several children and a man selling the *Big Issue* – which had a headline saying 'Exclusive Alasdair Gray Cover!' above Alasdair's picture of a man with a serpent coming out of his head. I ran past him. I was amazed to find that I was now chasing Alasdair Gray down a hill.

He tripped on the cobbles and went flying, head first, arms down by his side like a diver unafraid of hitting the pool head-first. At that moment I was certain he would die, skull splattered over High Street like a watermelon dropped from a great height. How was I going to explain that to Morag? Events slowed almost to a stop. His life – everything I had learned about him in person, in books, from friends, his work – all of that flashed before my eyes, as if it was me, not him, who was about to end. Suddenly I felt angry – because I knew he felt nothing – he was too far gone for that – and because I was afraid of having to explain how I let him kill himself.

Soon after I lay on the road underneath him, elbow throbbing. Alasdair was dragging himself up by a chain attached to the skip we were lying beside, and it took us a few moments to disentangle ourselves. He got up, brushed some rubble off his shirt and asked me if I was all right. Yes, I said, trying to work out what had just happened. He fell on me, or I tripped, or I tried to catch him, but if so it was purely instinctive. Maybe I didn't help at all. I don't know. What I do know is that I immediately felt I must have overreacted, because once up off the ground Alasdair seemed suddenly chirpier. Healthier, almost. He moved forward, going to cross the road in front of us, saying:

'You know Rodger, sometimes I think that women's bottoms are *the only thing in the world that matters.*' He looked upward. 'And then, on other occasions, I think that the sky is blue and *that* is all that matters . . . Have you ever seen the sky?'

He staggered the rest of the way to Canongate's offices, and we went inside. Helen Bleck appeared, went to get Robin Hodge, and he showed us into his flat. Robin then told Alasdair which chair he could sleep in, gave us his house keys, made tea and said he was going out. We should make ourselves at home. All very matter-of-fact.

By now I was visibly shaking and had descended into panic, replaying the fall in my mind, feeling sick. I trusted none of my emotions and at one point even convinced myself that I may have dived under Alasdair unnecessarily so as to appear heroic, or so he might be indebted to me. I suspected I was capable of this. Over the next two hours, while Gray snored loudly, waking only to count the days of the week then go back to sleep, I tried to calm down. I was unable to contact the organisers of the night's event so called Bill Swainson, my editor at Bloomsbury, instead. Bill talked me down, listening to my rant about how I didn't think I would be able to finish my Gray book, how Alasdair was in steep decline — overworked, too old to cope, unable to stay away from the bottle. Two hours later, Alasdair woke up, looked around this beautiful flat he had never seen before and said: 'Good morning. What city are we in?'

'Edinburgh,' I replied.

'Excellent. What are we doing here?'

'You are supposed to be doing a reading. Very soon. I have been unable to cancel it.'

'No need for that. Shall we go?'

I felt I had no option but to agree. He stood, steadied himself, and began to walk.

Amazingly, he seemed much stronger for a couple of hours' sleep. Had I been deluded in thinking he was on the edge, more than, as he'd said, 'a little deranged'? Or was he putting on his performance face, getting through it, trying to be polite? We took a taxi to the event, where the unsuspecting organisers were delighted to see Alasdair, explaining they had a large eager crowd for him. I said we might need to keep an eye on his health but was shown to have misjudged the situation as he steadily returned to his usual self. Not long after I had been on the phone to Bill, in bits, I was standing on a stage introducing Alasdair as if everything was fine. Soon after that I was standing at the front of the stage, alongside him, doing a dry read-through of his modern imitation of Goethe's *Faust*, playing the part of calm God to his agitated Devil, called Nick:

GOD [RG]: Faust is bewildered. Life and art is born
from those whose inner selves are most torn
apart by pains that will not let them rest
before they reach the highest and the best.

NICK [AG]: In fact, reach you? How lovely! What if I
prevent that? How about it? Let me try!

Though unfinished, his *Faust* has great potential, and quite apart from
quality Alasdair loves playing the parts. We'll do it in London as well, I
think – a thought which made me smile between moments where I felt
stupid for having worried so much, for letting him go ahead. His voice
was not as strong as usual. I worried he could collapse and have a heart
attack at any moment, but he answered questions brightly and was not
fazed by any query, even when asked accusingly about misogyny in
Lanark. Gray gave a cheerful reply, complaining: 'When I finished the
book, I was only fifty! I had very little experience of women!'

After the questions he signed books and chatted to fans for an hour.
One student had come especially from Holland to meet him. I had to drag
him away from yet more red wine to take him home at 11 p.m., when he
just seemed to be warming up. On the journey home he talked non-stop
about: plans for his *Faust*, *Old Men in Love*, and said as we reached the
house, quite suddenly, 'You must write what you *like*, you know. People
will find out anyway. And it's only a life . . . and . . . And it has struck me
recently that . . . my father *constructed* me . . .' I didn't feel like I could
write anything about Alasdair Gray again. That was a passing feeling.

I didn't see Alasdair for a fortnight, and our only correspondence was a
single card I sent saying I knew he probably wouldn't remember much of
the day, but that I was seriously worried. I urged him to take time off. Visit
family, friends, take a few days to do nothing. I was nervous about popping
round yesterday (14/8/07) to give him back the *Life in Pictures* papers he'd
left in my car but actually it was good to see him. He looked fine. We
discussed 1 August briefly, he asked after my elbow (injured in the mutual
fall), he said he only recalled several bits – the pub, the reading (he thought
his delivery was 'a bit halting') – and we laughed. Alasdair also explained he
had recently made a pleasant visit to his old school friend George Swan,
who he had not seen for over forty years, and then said, in a shy way: 'I have
spent several days in bed since I saw you, and have even gone a few whole
days without alcohol. I would like to do more of that.'

NOT DEAD YET! A
HAPPY ENDING, OF SORTS

DIARIES

September 2007: Current States

Recent weeks have been hectic. Alasdair has had an exhibition on at Glasgow's Merchant City Festival, he's been giving interviews, working on his *Faust*, and there's been a brief heart-attack false alarm too.[1] Whilst Helen was on holiday I even spent a few days in my old secretarial role, typing another new beginning to *A Life in Pictures*: I last did this task two years ago, with similar results. I also typed a new version of Alasdair's Jonah play, first written in 1956 for puppets – he remembered parts of his original, made up others and occasionally consulted the Old Testament for a detail or two. The experience of being back at Gray's bedroom computer, awaiting the next word, wondering if it would ever come, took me back to where this project started. Now I'm nearly at the end of it. On 1 October *Old Men in Love*, Alasdair's first novel in over a decade, is finally released. I've never seen a big Gray promotional push before, and am curious about how it will be received, so most of this final chapter will cover the events on a short five-day tour to promote it. But before reception, the novel itself. After the thirty-year on-off gestation period, the last-minute changes, repeated mistakes and corrections, did Gray finally get it right?

OLD MEN IN LOVE

Like several past books *Old Men in Love* came about because in 2004 Alasdair was out of money and, now no longer a salaried professor, realised he would have to write another book to get some. (Paintings never brought in enough to get by, and much of his Oran Mor money went on paying his secretary.) 'Nae new ideas, nae worries!' he told me

at the time. Why? Because despite years of raiding the back catalogue
he still had three 1970s plays he planned to turn into a historical trilogy.
This new book, originally conceived as *Three Men in Love*, would show:
1) the love between Socrates and Alcibiades in ancient Athens (based
on Alasdair's play *The Gadfly*); 2) the love between painter Fra Filippo
Lippi and a young nun, Lucrezia Buti (based on an aborted play); and 3)
the love between the priest Henry James Prince, his God and entire
congregation (based on Alasdair's play *Beloved*, the fuss over which he
believes stunted his career as a playwright in the late 1970s).

At first Gray thought he could expand on these originals – in early
sessions he read aloud from the old *Gadfly* script, adding light and shade,
turning play into prose as he went along, as so many times before. But
he soon got stuck. Research had been done on these subjects decades
previously and was incomplete. There were holes in Alasdair's knowl-
edge about Socratic Athens, nineteenth-century England and especially
fifteenth-century Florence. The prospect of spending the next couple
of years studying these places, or actually checking historical facts, left
him depressed. While in hospital in 2005 Alasdair even considered
deleting the Filippo part entirely (he only had three chapters of it),
toying with the title *Two Men in Love* in order to avoid study. He didn't
want to learn anything, he wanted to *get on with it*. And now he had to.
A Bloomsbury deal provided £1000 a month until a deadline of 31
December 2006. He needed to come up with a way to convincingly
finish these three stories or a way of not finishing them at all.

So aspiring writer John Tunnock was born: he was to be the glue
that held the other stories together. Gray made Tunnock a mild-
mannered ex-headmaster of a Glasgow primary school, who led a quiet
life until his last days, had a brief but invigorating series of affairs with
'young things' and then died, leaving behind a stack of papers intended
to be part of a grand historical trilogy called *Who Paid for All This?*.
Tunnock never got to finish his masterwork but the papers were found
by his rich American cousin, Lady Sara Sim-Jaeger. These papers
comprised a series of diary entries describing early life and recent days,
some letters and bits of the trilogy. No endings, though. Wondering
whether they were valuable, she gave them to Alasdair Gray, described
here as an author known for his editorial work on the papers of one
Archibald McCandless in a well-received book called *Poor Things*. Gray
offered to step in and make sense of what was left behind. (Or so he
would have us believe.) The chaotic genesis of this book was similar to

the disaster of *Something Leather*, and Alasdair turned to the same Flann O'Brien quote used at the front of that: 'One beginning and ending for a book was something that I did not agree with. A good book may have three openings entirely dissimilar and interrelated only in the prescience of the author, or for that matter one hundred times as many endings.' This let Alasdair arrange Tunnock's posthumous bits as he wished.

But the material here was stronger than in *Something Leather*, and there were several convincing themes: money, love, politics, and the inter-twining of all three. Also, by tapping into his richest mine – himself – Alasdair created a truly entertaining narrator. John Tunnock is undoubt-edly another version of himself, but different enough to be distinct from Jock, Thaw, Kelvin and the others. He is significantly older. He lives in the modern West End of Glasgow, which Alasdair has never used so explicitly before. He is a daydreamer who, with age, finds the world an increasingly odd, unfamiliar place. To make Tunnock, Alasdair used memories of his own past frustrations and those grand childhood literary plans of his to invent a man who has little practical knowledge of the world but a vast historical knowledge he intends to use to dazzle the world. (Just like Gray, at nine years old.) It can be tiresome to read about a writer writing about a writer writing – which is what Tunnock is – especially an old writer who gets involved with women a quarter his age. As one *Old Men in Love* review has noted, this fantasy has been a feature of recent novels by Philip Roth and J. M. Coetzee, too: so Gray isn't the only ageing genius who likes imagining dirty old men getting lucky. But one thing saves Tunnock from dullness: his humour. Alasdair greatly enjoyed writing Tunnock's diary sections, and his sense of fun shows through.

In *Old Men in Love*, Tunnock's process is Gray's process. Having created a deluded hero, Alasdair began to see other possibilities for his new character, also routes around problems. Whenever he ran into trouble writing the histories he simply inserted a diary entry with Tunnock complaining that he'd *run into trouble with the histories*. These practical decisions dominated throughout. Even the title was decided on a practical whim: until February 2007 it was *Men in Love*. But when making the jacket with his Oran Mor lettering, Alasdair found the composition of these three words on the page unsatisfying: also, he wanted to use the letter 'O' somewhere. (He likes the letter 'O'.) That's when he thought of calling it *Old Men in Love*.

This methodology can be frustrating. Apart from the fact that readers might want to know the end of any of the stories in this book, all of

which remain incomplete, there is also the factor of sheer size. Though the Socratic sections are satisfying, there is precious little of the fine Florentine part (the least well researched), and too much of Henry James Prince (the most well researched). They are imbalanced simply because Alasdair's original play scripts were of different sizes. He could not expand the Florentine section and would not abbreviate the Prince one, leaving *Old Men in Love* somewhat lopsided. But the actual writing itself is superb and, by showing four hugely different societies, Gray demonstrates how similar they all are.

The local cast in *Old Men in Love* is large. It features the Scottish Literature Department of Glasgow University, a putative letter from Gray's friend and historian Angus Calder, disguised appearances by Angela Mullane, a section lifted from Alasdair's own childhood in *A Life in Pictures* (cut and pasted by Helen on Gray's request) and an excerpt from his '15th February 2003' story about the anti-war march in Glasgow, last seen in *The Ends of Our Tethers*. Add to that steals from *The Book of Prefaces*, his political pamphlets, references to *Chapman* magazine, Kilquhanity House School, Byres Road's Tennents pub and a host more Gray favourites (more pornography, anyone?), the end result is a bizarre cocktail which is Alasdair's life, career, books and interests all rolled into one, a jumble of the things that have filled his head over these past seven decades. Finished just eight weeks before publication (and Alasdair is still talking about expanding one section for the next edition), it's a miracle *Old Men in Love* isn't a total disaster. Amazingly, it's his best fiction since *Poor Things*. Why?

Alasdair knows one of his strong suits is writing dialogue for intellectuals with big ideas above their station, and many of the men in this book are exactly that. Though their stories are very different, the absurdly large job that Tunnock undertakes has something in common with the unlikely tasks of Socrates, Filippo Lippi and Henry James Prince – also with the jobs Alasdair himself has taken on over the years, despite intimidating size, lack of financial sense, lack of realistic prospects – like Greenhead Church, *Lanark*, Oran Mor. The creator of these clearly understands the single-mindedness necessary to make them, but as a whole *Old Men in Love* argues against such single-mindedness. This lesson is contained in a scene of terse dialogue between Socrates and long-suffering wife, Tippy, about how Socrates earns his living. She asks:

[T]: 'What *do* you teach those pretty young boys you keep meeting?'

[S]: 'I teach them not to be so sure of themselves, Tippy.'

[T]: 'They *like* you for that?'

[S]: 'The reasonable ones do.'[2]

But this does not help: Tippy needs practical answers to real problems, and Socrates, though revered outside his home, has been no use inside it. Even in enlightened, so-called 'democratic' Athens, Tippy has no voice – she must look after their child and accept what her husband tells her, though he admits to being a philanderer who gets money from friends only when his wife begs him for it:

> In a voice mingling tears and laughter she said, 'They call you the wisest man in Greece!'
>
> 'They know no better, Tippy. I can't teach you anything because you know only facts.'
>
> 'Yes. Women can never escape from those.'
>
> He bent down and buckled on his sandal, telling the boy quietly, 'Please be kinder to your mother than I am.'[3]

This passage suggests readers should be sure of no one in this book, least of all its intellectual heroes. Even small, seemingly insignificant details are shown to be falsities. (We discover later that Socrates could not possibly have buckled a sandal at this point in history – buckles hadn't yet been invented.) What Gray argues against in the many sections of *Old Men in Love* is the kind of utter self-belief and conviction that leads people to reckless behaviour, whether that be waging war with Sparta, taking advantage of young models, claiming to be the earthly incarnation of Jesus Christ or, in the case of Socrates, giving up the family business in favour of wandering the streets and flirting with handsome boys, in search of truth.

Gray sees history in the broadest sense. He may miss some of the daily details of political life and is sometimes wildly, comically, out of touch (his 2007 'Scottish Politics Now' essay spoke about Margaret Thatcher as if she was still in office), but by ignoring those immediate events he diverts energy into one of his greatest talents – providing a wider, cooler, longer-term perspective, something which suits a character of Tunnock's age, and is welcome in the modern Glasgow

sections of the novel. This is particularly evident in the scene where Tunnock enters his local pub to see the Twin Towers falling. His friend likens the atmosphere in Tennents to 'the delight of mobs in Berlin, Paris and London who in 1914 cheered the start of the first great modern war'.[4] Gray never misses an opportunity to remind readers that history repeats itself.

Old Men in Love is a mess. It's unfinished. It contains a distinctly Scottish-sounding American aristocrat. Fans who have bought previous Gray books may feel a sense of déjà vu reading sentences they have paid for at least once before. But the book has charm sentence-to-sentence, it's extremely assured, and as a whole it's truly impressive. Which is why I got annoyed at the ending, a supposed critical essay on the work of Alasdair Gray by his fictional critic Sidney Workman, who last appeared in Lanark. This blunt piece comprehensively attacks every aspect of Gray's work, methods and even personality, accusing him of being a second-rate writer, a liar and a devious trickster who misleads readers and critics for sport. Alasdair sent me this attack as part of a then 'complete' manuscript of Old Men in Love in January 2007 (six months before the book was actually finished) and I wrote back complaining, in a frustrated letter headed 'A Fight With Sidney Workman'.

I began by asking why he wanted to include 'a comprehensive ripping apart of the work of Alasdair Gray in what is "bound to be the last long novel" he ever writes',[5] and said the Workman 'critique' suggested he wanted to 'piss on his own achievements'.[6] I then expressed reservations over whether this strategy was his way of defending the fact that he knew Old Men in Love was not really finished, and completed my letter saying, '[H]ow are we supposed to know what Alasdair Gray really thinks of his own work? He is too busy dancing about in the mud to give us a straight answer!' I hoped I would get a straight answer soon.

DIARIES

24 January 2006: Bloody Devious Old Bastard
Just put the phone down: I'm relieved Alasdair is still talking to me, but can't help but think the devious old bastard has dodged the issue again. I've spent much of last twenty-four hours worrying about being cut off. I should have known better:

RG: Hello? Alasdair?

AG: Haha! Rodger, are you there? I have rrreceived your letter! And, well . . . I'm delighted!

RG: Really?

AG: Yes . . . I was hoping readers might jump to the defence of the novel!

RG: [*Trying pathetically to display sense of humour*] Well, mazeltov, sir. Job done.

AG: Yes . . . you might notice some surprising changes from the version you . . . [*coughs*] have read, when you read it again. But then, well, I hope you'll like it anyway, Rodger. And I'm so pleased – aha! Ahem! [*Descends into coughing fit*]

RG: Are you okay?

AG: Yes . . . [*cough*] . . . The point is, I wanted to show the antagonists I could do it better than they could. [*Quieter, more considerate*] But I hadn't intended to cause pain. [*Brighter again*] I mean, haha – I'm not laughing *at* you. Have I caused you *paaiin*, Rodger?

RG: [*Sarcastically*] Oh yes – I feel too much, Alasdair. That's me all over. Don't you think?

AG: Ha! Well, yes! Of course!

RG: [*After a short silence, an attempt at business-like*] So, Gray. Do you intend to actually *answer* my accusations? You don't, do you?

AG: [*Sounds shocked*] Oh God, NO! Hahahahaha . . .

And there, after another cough, the conversation ended. Over the following months, *Old Men in Love* was finished, and printed, and plans were made for its release . . .

OLD MAN ON TOUR

During the summer the fantastically named Digby Halsby at Midas Public Relations (brought from a recent, slightly more glamorous job with actress-turned-author Pamela Anderson) was hired to advertise the news of Alasdair Gray's new novel, scheduling a series of events and interviews in England and Scotland over a period of about a month. On a five-day trip during launch week, it was arranged that Helen Lloyd would shadow Alasdair, drive him around, pay for everything, get receipts and generally look after him. (Alasdair doesn't own a bank card,

is unable to use a cash machine and admits to easily getting lost. Morag fears for her husband's safety when he is not accompanied.) When the plans were proposed, Alasdair asked me to perform the *Faust* intro- duction with him at four events, starting with the Wigtown Book Festival, where I had also, by chance, been invited to read. Gray's request gave me an excuse to come along for the whole trip, take notes, ask any final questions and play God again: so we set off early on the morning of Saturday 29 September for five days of what Alasdair has since called 'the *Old Men in Love* publicity binge'.[7] Morag came on this first leg of the trip, too, so there were four of us in the car.

Wigtown is a quiet old market town in south-west Scotland, re- energised since becoming the country's official book town in 1998. Though small, it is home to many second-hand and antiquarian bookshops, most in and around the square which accommodates the main tent during festival time. In the last few years this festival has built up a reputation quickly: this year's festival was opened, not without controversy, by the new First Minister of Northern Ireland, the Reverend Ian Paisley. Gray was due to perform in the same spot on Saturday lunchtime. We arrived an hour before Alasdair's event, accepted the goodie bag given to all writers (a Wigtown book token, Galloway Lodge pickle, Solway Mist beer, and – to Alasdair's pleasure – some local whisky, too), then ate lunch. A quick slurp of soup, and to work.

Stuart Kelly was again the host of this Gray event. As he wrote in the *Scotland on Sunday* a week or so later, 'Nobody really gets to interview Alasdair Gray; rather, the occasional journalist will be given a one-off, private performance of the Alasdair Gray Phenomenon'[8] – the spirit of these private performances is very similar to public ones. Kelly chose the sensible 'gentle prodding' route, suggesting ideas or themes and then watching Alasdair wind up and go: this usually lasted until he ran out of energy or stopped and said something like 'STOP RAVING, Gray!' But in among the rambling, mock impressions and intellectual digressions, today Alasdair did reveal something of himself, and of his work. At one point, while discussing the political elements of his fictions, he said: 'It's very important that a book be entertaining . . . I would hate to have folk think, *Oh God, here we are back to contemporary politics!*', then later, 'I don't want to add illustrations that the reader could imagine for themselves. I only like to add wee embellishments . . .' And later again, 'A writer ought to take account of the world he

lives in . . . but the older I get the more it feels alien to me . . .' Each statement came wrapped in the usual nonsense, but showed Gray knows exactly what he is doing, especially when portraying himself as an innocent bystander: also that no matter how selfish he portrays himself, he is always thinking of the reader's experience. Politics must be mixed with pure entertainment, illustrations must not encroach on imagination, and a writer has a duty to respond to the world, no matter how strange it seems.

Alasdair doesn't always notice he is giving bits of himself away – he thinks most interviews are the same, and he's just giving slightly different versions of the same life. But between the repetitions there is usually something more. Today he was cheerful, even when signing books for the long queue of fans, some of whom he suspects are selling signed copies on afterwards for profit. Afterwards he chatted with other writers, had a few drinks, spent his book token on an old Penguin paperback and was ready for going back to his hotel by late afternoon. Helen took Alasdair and Morag to the Kirroughtree Country House Hotel, which was so grand that she took photographs of the staircase on her phone to show her mum when she got home.

In the lounge of the hotel the following morning, Alasdair was clearly enjoying the rare luxury. 'Just like home!' he boomed, in his cod-American accent. 'This place is *just like home*!' Then he stood to accept the bill, perusing it quickly as if, no matter the figure, it couldn't dent his vast wealth. Gray nodded at the surprisingly high tab and passed it to Helen, who then had to work out whether it was possible that quite so much had been spent on dinner and drinks. It had. Alasdair may shun extravagance at home but rather likes being treated like a lord when away from it. His chauffeur settled the bill and he strode out to the car, ready to be taken to London.

The journey took most of the day. Between naps and reading breaks Alasdair gave chirpy versions of pretty much every journey he'd taken to and from London since 1959. Hitch-hiking with posh girls, going to a Glasgow Group art exhibition in Leicester Square, taking a taxi to the BBC to discuss *Kelvin Walker* – we got it all. And, once in London, Alasdair got another burst of energy. We met Iain Brown in the garish hotel bar then went for dinner, where Iain, upbeat and friendly as ever, told us he had a meeting with Channel 4 the following day about *Lanark*, and I felt guilty for having written about my doubts over whether any Gray book would ever appear on screen, big or small. (I

still hope it will, but still doubt it.) Alasdair was feeling more positive, though. At one point he exclaimed, 'Well, it has only been twenty-three years . . . *it could happen at any moment!*', then returned happily to his dinner. Even after Iain went home Gray still had more energy, reading his book in the hotel bar until late.

The first stop on Monday morning was the Bloomsbury offices, where Alasdair was parked in a chair and politely instructed to sign 250 copies of *Old Men in Love*. Helen and Digby opened them ready for him then put them in boxes for sending to shops when they were done. Alasdair's expression while signing these was one of tired resignation, and he said once that each time he came back to Bloomsbury, or to London, everything seemed to have changed since the last time he was there – which led him to take very little notice of anything. *How the world of publishing has changed*, he seemed to be thinking. But he got through signing quickly, chatting all the while, mostly about his home city. Which was why one copy got signed 'Alasdair Glasgow' instead of 'Alasdair Gray'. That went in the box with the others.

After a series of interviews there was a break in the schedule so, after lunch with Will Self (where he talked at his friend extensively about Alan Fletcher and Carole Gibbons), Alasdair suggested that he, Helen and I go to the National Gallery. As we arrived he spotted the sculpture 'Alison Lapper Pregnant' on the fourth plinth in Trafalgar Square and, having never seen it before, stopped to take it in. This sculpture of a disabled woman with phocomelia has been contro-versial but Alasdair said, chuckling, 'I think it's quite lovely. Nobody complained that the Venus de Milo had no arms!' He was very pleased with that comment.

Inside the gallery, Alasdair was clearly in his element. If anyone ever made a Gray statue, his state while looking at these paintings would be a good one to capture:

Attire – *long grey raincoat, brown corduroy trousers, socks and sandals, pyjama bottoms visible over new white shirt (one of four bought for trip, this one replete with stain acquired at lunch with Will Self), braces, hair made wet by rain, thick spectacles with black rim.*
Expression – *cheerful, naïve, hands on hips, half-smile, slightly absent-minded, wandering from piece to piece.*
State – *content.*

Not tidy, not bold, not assured, but very, very Gray. Later he grew more animated, and when I joined him in front of a painting showing the beheading of Lady Jane Grey he gave a detailed, passionate summary of royal Tudor history. At the Hogarth series *Marriage à la Mode* (perfect for Alasdair's tastes – busy character pieces, full of humour, decrepitude, corruption, and a story, too), he explained the events in each. Later he grew excited by blues and yellows in the skies portrayed in sixteenth-century paintings by Titian and Savoldo: 'I want to do the Oran Mor arches like that,' he said, almost skipping with glee. He wore himself out and later snoozed in the gallery café, waking up just in time to go to his book launch at the Riflemaker Gallery in Soho. In the taxi on the way there Alasdair said: 'My friends Marion Oag, Pete Brown and Rosemary Hobsbaum have been invited this evening. I do hope I don't have to talk to too many strangers.'

The main launch for *Old Men in Love* had only a select group of invited guests in attendance – some art critics, some literary journalists, some writers, some publishing industry folk. After an introduction, Alasdair was due to read surrounded by Francesca Lowe's artwork on the walls and his own story 'The Magic Terminus', created as a companion to the art, writ large, literally, on the ceiling. When the time came Will Self did the introduction with a typical linguistic flourish, praising Gray's work extensively. With Alasdair, he said, 'the maker and the made are 100 per cent the same thing'. He went on to say that he didn't know how this new novel would be received – and that he believed it didn't really matter. Then Gray began. Bits of the novel, then joint *Faust* (with greater drama – Gray now doing a Nazi salute when Old Nick enters the fray), then back to signing and mingling.

Tonight, in trendy, bustling Soho, Alasdair looked incredibly out of place among so many young things, especially the women in PR, or working for publishers, or employed by various newspapers and magazines, who kept approaching him. He had met a number already throughout the day and always smiled politely, but with each new introduction he behaved more awkwardly. It is a rare thing to see him wordless but tonight he often didn't quite know what to say or even where to look, when surrounded by so many beautiful, confident, intelligent women: his eventual response was to act formally, as if he were on a night out at the opera, or visiting Buckingham Palace. (Not that he'd be seen there.) On occasion he even bowed before someone

he was being introduced to, and this demonstrated just how distant Alasdair's life and experience is from those he was meeting.

He looked especially out of place next to Francesca Lowe. She is a genuine fan of *Lanark* and has clearly been inspired by his writing, but Alasdair's inability to turn away anyone who expresses a vaguely art-related interest in him has led to this very strange combination. The widely advertised e-mail 'collaboration' between the two was minimal, and Alasdair had certainly not thought much about it until he walked in the door of the Riflemaker. As far as Gray was concerned this was simply the launch for his new novel. When this exhibition and launch was organised it was suggested that Gray and Lowe could do something together. New Gray verses might complement Lowe's paintings best, it was said, but Alasdair couldn't think of any, so he wrote a short new tale instead. 'The Magic Terminus' is a story about a man who fails at several jobs, and it uses many of his usual crutches: libraries, politics, imaginative freedom – and not much story. It is nothing to do with the paintings it was written to accompany. Alasdair was not reading 'The Magic Terminus' tonight, though of course parts were visible on the ceiling. It was not possible for visitors to read the whole story, at least not without getting dizzy, but perhaps the idea was to get a general effect. More style than content.

Francesca Lowe is in her twenties, tall, elegant, and only left art school recently; she is able to command up to £40,000 for a single piece. Her images, often acrylic ink and gesso on linen, are night-marish, extreme, chaotic – her piece 'Glutton' is of a naked red woman in anguish with a pig's head and a spine on her chest; her 'Irrational Blooms' has a naked woman in a mask, holding a pipe, riding a rocket. All her 'Terminus' pieces have already been sold. The gallery even printed 1000 exquisite colour booklets displaying Lowe reproductions and containing Alasdair's story, which shows considerable investment in the 'collaboration': though the exhibition includes no Gray pictures, both names are equally visible on the front. Still, the contrast between the two artists could not be more stark, the irony being that though Lowe searched out Gray, it is the younger artist who is more well known, and Alasdair could never dream of having Lowe's popularity, or of making the kind of money her piece 'The Tree of Life' sold for. A glass cabinet in the Rifle-maker showed promotional material and press clips – a recent *Dazed and Confused* article on show about Alasdair and Francesca was being

referred to in conversations around the venue tonight, rather cruelly, as the 'Beauty and the Beast' photo shoot.

After the event we went to dinner with Pete Brown and others at a nearby restaurant, where Gray was on top form, both good and bad. He dominates conversation, and his explicit honesty when it comes to talking about his past is disarming: over an hour or two the table was treated to a summary of Alasdair's entire masturbation history, and the story of the collapse of his first marriage. Helen, understandably, kept her eyes on her dinner. Drink flowed throughout the night and any offers of payment from Alasdair's guests were responded to with the now familiar refrain: 'Nonono! BLOOMZZBURRRAAAAYY! Er, BLOOMZZBURRRAYY will pay, *surely*? I, er, *I believe they have made some money . . . from a young magician . . .*' One finger to the sky, invoking the gods, he acted as if no cost was too great for the publisher of Harry Potter to bear. After the meal, it was back to the hotel bar again . . .

Tuesday began with a series of interviews. Some of these were *Old Men*-related, some not: as Alasdair is rarely in London, as much as possible was being crammed in while he was there. The morning was hectic, and Alasdair increasingly responded by taking no responsibility for anything at all. He preferred to be politely ushered between commitments, free of having to think about any of it. But on another afternoon cultural trip, this time to Sir John Soane's Museum of art and architecture, Alasdair was happier. (He considers his visits to London to be excuses to look at art, and anything else in between is unfortunate.) Soane's museum contained many artefacts that captivated Alasdair, and there was more Hogarth for him, too, but it was exhausting: after a late lunch and a couple of large whiskies in a pub round the corner, Alasdair fell asleep again, and Helen did, too. I watched the bags and picked up a nearby free paper, finding a particularly uncomplimentary photo of Gray on the Books page beside the headline: 'I've never had an original idea in my life!' I failed to hide this from him when he woke up. Next, on to the BBC.

The afternoon interview with Mark Lawson for Radio 4's *Front Row* was frustrating for Alasdair's backers. This programme was particularly important for promotion as Radio 4 are the only major network radio station prepared to deal with him now – partly because so many consider him 'too Scottish' for their mostly English audience, and partly because he is so tough to edit into digestible chunks. This doesn't trouble newspaper journalists because they can piece together a story after an

interview, try and make sense of him in their own time, but for TV and radio Gray is more limiting: he does not answer questions directly, he makes no concession to the medium, he doesn't care how he sounds to those who don't understand his mostly local-to-Glasgow references.

About half of the *Front Row* interview focused on trickery, and Sidney Workman's critical Epilogue was analysed. Though the novel has many things to commend it, the self-criticism at the back is the most obviously unique element: this interview showed that though Alasdair enjoyed adding the Epilogue, in the short term he has actually just taken away attention that would otherwise be turned on the issues in the actual story – the philosophy of Socrates, the inner secrets of the Church, Scottish independence. But these didn't get a look in. When challenged about abusing his own words under a pseudonym, Gray defensively replied that he only did it 'to show they could stand it'. But also because he cannot help himself. He is not writing for today's audience, for charts, sales, publicity and the London publishing world. He truly believes his books will be read in hundreds of years, and none of this circus matters. But in the meantime fewer people can access Alasdair's work because he makes it so difficult to *let them in*. He sounded positively aggressive at times, bored at others, but most of all weary. All the drinking over the last few days couldn't have helped either. 'He blew it,' said Helen, as we left. Alasdair noticed his entourage was displeased and, standing in the rain as we tried to hail a taxi, said under his breath, 'Same old shit, Gray, same old shit.' (NB: the *Front Row* interview was recorded but never broadcast.)

I don't think Alasdair entirely understood why he was going back for another night at the Riflemaker, but there was to be a reading and public interview. In the taxi on the way we had an argument about whether he is anti-English – I still think he comes across that way sometimes, even if he doesn't mean to – and this became an argument about why Alasdair wants to insert an extra section into *Old Men in Love* for the next edition proving why Scotland's geology is so different from England's. (This in turn became an argument about Highland and Island independence: for the record, Gray is in favour of that, too, if the inhabitants want it.) But the Riflemaker was heaving, and Alasdair cheered up considerably when we got there. He is better in busy, warm galleries among admirers than in empty interview rooms talking to people he cannot see.

The audience was mostly young, and local. The Riflemaker Gallery

has a large, knowledgeable following, and there was a real sense of excitement – much more like a launch than the night before, which had been distinctly polite and low-key. Alasdair was interviewed at length, mostly focusing on *Lanark* and his artistic style, as teenagers sat at his feet, looking up at him. On the subject of his artistic style, Alasdair went into some revealing digressions, much like at Wigtown. He said that when he looked at some of his very earliest paintings, he saw in them something he wished he could recreate – a freedom he felt he had lost since. 'I am so . . . *controlled* now,' he said. After one lengthy answer an organiser interrupted and suggested Alasdair read from *Lanark*. He refused, saying, 'Having spoken about it so much, I now feel rather sick of it!' Then he began to read from a new, unfinished sea shanty he's calling 'The Ballad of Ann Bonny'.[9] This frustrated the organiser, but is exactly the kind of thing fans love him for.

In recent days I'd noticed myself taking on some of Alasdair's verbal tics, imitating him without even realising it. I'd also noticed myself using Gray words, Gray facial expressions and slipping into his impressions when following him around: especially his Gentleman of Advancing Years. I'd even been dreaming in Gray. And yet, hovering at the back of the crowd, I began to wonder what I was doing, still hanging around. Was I even able to see anything relevant any more? While Alasdair talked to the interviewer about his long-gone Riddrie, I realised that I had probably said all I could about Alasdair Gray. I set out to make an honest portrait of the artist as an old man, to draw readers and viewers to his work, and to assess that work. Once I had attempted that, it was probably best just to step away. After the event and a strange meal (one of Alasdair's more eccentric fans insisted on joining us and quizzing him, at length, on Chinese history), he was shattered, and headed straight to bed. The following day saw meetings with his agent, lunch with publisher and friend Liz Calder, and then home – a mere nine hours' drive. Which didn't bother Alasdair at all. He had a book to read, and took breaks to sleep on the back seat, which he insisted was very comfortable.

ENDING: 1 JANUARY 2008

In the few weeks after returning to Glasgow, Alasdair showed remarkable positivity and energy. He carried on to the next round of inter-

views, to more *Old Men in Love* tours, next to Edinburgh, to photo shoots, TV interviews – and eventually back to writing. He even attempted a trip to The Hague for the prestigious Dutch 'Crossing Borders' Festival – his first planned trip abroad in several years. (Though he lost his passport in a taxi on the way and never made it.) Three months after the release of *Old Men in Love* this new novel is being widely hailed as Alasdair's best work in a long time: he has been called the 'Clydeside Michelangelo', also 'Glasgow's Dickens'. A feature in his beloved *TLS* made him so happy that he carried it around in his jacket pocket for days. It seems Alasdair has reached 'national treasure' status now, with most of his faults being indulged as the harmless eccentricities of an Old Master. Even a rare negative review in the *Observer* was mostly unhappy because this wasn't a 'real novel'. But after *Old Men in Love*, what next? *A Life in Pictures*, certainly. *Faust*,[10] probably. Next year, Alasdair's *Collected Plays*,[11] a *Collected Short Stories* and a *Collected Poems*[12] if he can secure a publisher. With age, he's speeding up, hoping to tie all loose ends before death. (It has been a long life – there are lots of ends to tie.) Also, his new art agent is talking about an ambitious Gray exhibition and has already put images of hundreds of his pictures on her website. What else? He wants to edit an unpublished novel by the late scientist Bill Hamilton, too, though it may be hard to persuade readers he isn't joking – he is, after all, the Author who cried Editor. He'll finish his Oran Mor mural, if he's spared, and if time can be found. Then? Not retirement. 'It is done,' Alasdair wrote, at the end of *The Book of Prefaces*. 'Ended. Finished. Complete. Thank goodness, for I think goodness is god's kindest name.'[13] And now I'm done, too. Goodbye.

THE END

END NOTES AND CRITIC FUEL

In autumn 2008 a man approached me in a bookshop with a copy of this biography behind his back. He explained he'd been an Alasdair Gray fan since 1981 and was interested in my version of his life. But he wasn't going to buy a £25 hardback if I was one of those authors who inserted extra chapters into paperback versions of their books, swindling hard-working people like him into getting both versions. I promised not to add anything, said I sympathised because I couldn't afford to buy my own book in hardback either, and where would he like me to sign? If that man is reading this now, I apologise unreservedly. I meant never to write about Gray again. I didn't. But he still lives, and things have continued to happen. Who could have predicted it?

In summer 2008 my novel *Hope for Newborns* was published and I enjoyed being a novelist again, sometimes amongst people who had no idea who Alasdair was and couldn't care less. When the biography was published in September I wrote one more piece about recent events ('A Life of Loose Ends', Scottish Review of Books, *Vol 4 Number 3*) detailing the completion of *Fleck* and the sudden fascinating rise in value of Alasdair's artwork since Sorcha Dallas became his agent. Then I told anyone who'd listen: 'I'm looking forward to being simply an Alasdair Gray fan again now.' But habits are hard to break and books are not just for their authors. I was pleased by the general response to *A Secretary's Biography* and surprised by the level of critical interest in Gray, but already felt distant from the project. On returning to the text I wondered who this naïve, childish writer was who got distracted by personal details and wrote postcards to his subject that read more like love letters. I saw much I wanted to correct and still cringe at some basic mistakes I'd like to correct. But this book was always meant to be a focussed emotional engagement, not an encyclopaedia. Luckily, most readers appreciated that.

One of the readers was Alasdair. He'd been claiming recently that he wasn't going to touch this book, cleverly avoiding bothersome journal-

ists asking for his opinion on it. But in a move that Gray fans enjoyed, the self-critical author publicly criticised his critic in *The Guardian* (20/9/08). Some commentators felt Alasdair's review was overly-critical. Others thought he'd been dignified, displaying a remarkable level of understanding and affection for the project. Readers can make up their own minds about that, but the review was a reminder to me that I'd been dealing with a real life, and that was always bound to have consequences.

Last December Alasdair sent me a letter of 'correction notes' he described as 'half petty, half less so'. In response to a 340-page book I was relieved to get only six pages back, especially as the issues I'd worried about most barely registered with him at all. Small factual notes were easy and quick to correct (he pointed out he'd been on holiday to *Iona*, not Skye, in 2005) and this paperback tinkering had always been planned as Alasdair refused to read the book-in-progress. So that was fine. Alterations in this edition are so slight that even close readers may miss them. But we disagreed over bigger issues too. Alasdair thought I'd been overly-critical of Inge, feeling I fixated on his first wife's influence, also seeing too many versions of her in Gray fictions where the truth was really more complex. In his letter Alasdair said Inge was 'an excellent wife for a struggling artist', 'a good mother to Andrew', and he wanted me to make that clear. I have made a few changes to reflect Alasdair's own view of events he was involved in, without compromising either the spirit of this book or my own research.

In his review Alasdair predicted we'd remain friends despite this book, and we have, though naturally meeting less frequently now. I work as Writer in Residence at Strathclyde University and am working on my next novel, while he continues to pursue his multiple projects at the old desk with Helen at his side. Besides, I'm getting a bit old now to be hanging around a man 43 years my senior, hoping for attention. I'll see him next at the launch for *A Gray Play Book* in March I'll be queuing to get my copy signed with all the other fans then I'll leave the poor auld bugger in peace.

Rodge Glass, February 2009

ABBREVIATIONS

L – Lanark: A Life in Four Books
USM – Unlikely Stories, Mostly
82J – 1982, Janine
KW – The Fall of Kelvin Walker: A Fable of the Sixties
LT – Lean Tales
SSP – Saltire Self-Portrait
ON – Old Negatives
SL – Something Leather
ML – McGrotty and Ludmilla
WS92 – Why Scots Should Rule Scotland (1992)
PT – Poor Things
TT – Ten Tales Tall and True
AHM – A History Maker
MB – Mavis Belfrage
WS97 – Why Scots Should Rule Scotland (1997)
WL – Working Legs: A Play for People Without Them
BP – The Book of Prefaces
16OP – Sixteen Occasional Poems 1990–2000
CSW – Classic Scottish Writing
ET – The Ends of Our Tethers: Thirteen Sorry Stories
HWS – How We Should Rule Ourselves
OMIL – Old Men in Love
PAG – The Plays of Alasdair Gray, since retitled A Gray Play Book
LP – A Life in Pictures
5SA – '5 Scottish Artists: A Retrospective, 1986'
MRB – Magic Red Box

NOTES

PREFACES

1 Professor in English at Glasgow University, playwright, critic. Co-founder of Glasgow University's Creative Writing Masters course. High Master of bad puns.
2 The book referred to was Anthony Grafton, *The Footnote: A Curious History*, Harvard University Press, 1997.
3 Rachel Seiffert: novelist, author of *The Dark Room*, Heinemann, 2001, and *Afterwards*, Heinemann, 2007. Graduated from Glasgow University creative writing course.
4 Alan Bissett: author of *Boyracers*, Polygon Press, 2001, and *The Incredible Adam Spark*, Headline Review, 2005.
5 www.archives.gla.ac.uk/about/dunasten/may2002/pubtour.html, pub tour of Glasgow.
6 AG painted a mural in the Ubiquitous Chip pub nearby, and was a regular there. It would have made sense for him to be in his usual haunt in the days before the opening of the nearby Oran Mor.
7 My friend Ross McConnell gave this to me; I think he said something along the lines of 'If you're going to live in Scotland, you should really learn something about it.' But now that seems too convenient to be accurate.
8 This book – *Revelations: Personal Responses to the Books of the Bible* – included chapters by, among others, the Dalai Lama, Bono and Nick Cave. This 1998 edition Morag referred to, reprinted in 2005, is one of Canongate's most controversial books to date.
9 Peter Mullan: multi-award-winning Scottish actor, writer and director, whose credits include Ken Loach's *My Name is Joe*, his own *The Magdalene Sisters* and the black comedy *Orphans*.
10 Alan Jamieson has written prose and poetry as Robert Alan Jamieson, mixing the two in *A Day at the Office*. Also wrote several other books during the 1990s. Professor on the Creative Writing M.Sc. at Edinburgh University.
11 James Kelman: friend of AG's since 1970s. Major figure of twentieth-century Scottish literature. Won the Booker Prize for *How Late it Was, How Late* in 1994.
12 Tom Leonard: poet, critic, activist and close friend of AG's since 1970s.
13 From *Buddha Da*. Already a short-story writer (*Hieroglyphics*, 2001) but her novel was not yet published.
14 From *The Cutting Room*. Had been signed up by Canongate but her book was not yet published.
15 From *Negative Space*. Had been signed up by Picador but her book was not yet published.
16 I suspect this was because he had forgotten how many hours he was scheduled to do.
17 At this stage the book was called *The Ends of Their Tethers*, which eventually became a more personalised *The Ends of Our Tethers*.
18 Richard Todd was another student of the M.Phil. course during AG's time there, and has been his assistant at Oran Mor ever since.
19 These plays included *MB*, *KW*, *Sam Lang and Miss Watson*, *Homecoming*, *Dialogue* and *WL*.
20 Will Self, in Phil Moores, ed. *Alasdair Gray: Critical Appreciations and a Bibliography*, British Library 2002.
21 Christopher Hibbert, ed., Introduction to James Boswell, *The Life of Samuel Johnson*, Penguin, 1979. Wilson was editor of *Vanity Fair*, critic, reviewer for *The New Yorker*. Argued for 'socially responsible' fiction.

22 Boswell critic. Felt his fame had outstripped his master. Also referenced in Hibbert, Introduction to James Boswell, *The Life of Samuel Johnson*.
23 Review of *PT, Scotsman*, 5/9/92.
24 Graham Caveney, review of *MB, Arena*, 1/5/96.
25 Ibid.

1 1934–45: EARLY YEARS, WAR YEARS, WETHERBY

1 *SSP*, p. 9.
2 Ibid.
3 Glasgow Fair is an annual local holiday exclusive to the city of Glasgow. Though observed less in AG's later years this was the major holiday of the calendar for many families in the early twentieth century.
4 *SSP*, p. 9.
5 MRB.
6 Phil Moores, ed., *Alasdair Gray*, p. 31.
7 RG, interview with AG, 6/3/07.
8 From 1/8/07 draft of AG's introduction to *LP*. Since updated.
9 Perhaps this is one reason why AG insists on paying his secretaries well, values the job highly and has used several in his fiction. But, then again, he values the job so highly that he won't do it!
10 Ibid.
11 From 1/8/07 draft of AG's introduction to *LP*. Since updated.
12 Ibid.
13 Ibid.
14 MG interview with RG, 7/04/07. Frank Worsdall, *The Tenement: A Way of Life*, Chambers, 1979, describes many of these types of homes, typical of 1930s working-class Glasgow.
15 Unpublished interview with Louise Jones, 2000.
16 From draft 29/8/07 of AG's introduction to *LP*. Since updated.
17 Ibid.
18 AG says he recalls reading cheap editions of Orwell and Flann O'Brien novels earlier than most children because they dropped through his letterbox. This also neatly fits his idealised view of the Holiday Fellowship, and of what can come from Art for All.
19 Louise Jones, 2000.
20 'Mr Meikle', *TT*, p. 154.
21 'Mr Meikle', pp. 154–5, *TT*.
22 Ibid., p. 155.
23 *L*, p. 121.
24 RG, interview with AG, 7/4/07.
25 RG, interview with MG, 29/1/07.
26 RG, interview with MG, 7/4/07.
27 From AG's draft to *LP*, chapter one: 'Family Photographs', 1/8/07 version. Since updated.
28 RG, interview with MG, 7/4/07.
29 From Phil Moores, ed., *Alasdair Gray*. A book of contributions by others on AG's work, this includes his Personal CV.
30 AG interview with Christopher Swan and Frank Delaney, August 1982. Published as Addendum to *SSP*, p. 16.
31 Grayblog, 27/03/06. Since updated.
32 Phil Moores, ed., *Alasdair Gray*, p. 33.
33 Taken from the RG Gray files. Part of a comment article AG wrote for the *Guardian*, April 2005.
34 More from the *Guardian* comment article, April 2005.

DIARIES: Old Family, Old Friends, Old Papers

1 *L*, p. 191.
2 'A Small Thistle', *LT*, p. 244.
3 'Portrait of a Playwright', *LT*, p. 250.
4 Ibid. p. 253.
5 'Portrait of a Painter', *LT*, p. 259.
6 Ibid., p. 262.

2 1946–59: AMY GRAY, SCHOOL & ART SCHOOL

1 AG, feature on Kelvingrove Museum, *Herald* magazine, 17/6/06.
2 Ibid.
3 AG, replies to questions by Christopher Swan and Frank Delaney, August 1982. Reproduced in *SSP*.
4 'Mr Meikle', *TT*, p. 156.
5 RG, interview with MG, 7/4/07.
6 E-mail AG to RG, 29/4/07: 'He [George Swan] is my oldest and closest surviving friend from my third year at Whitehill Senior Secondary School in 1948, through my art school days until about 1961, which is the last time I saw him. We would still be meeting if he did not live so far from Glasgow, and if Inge had not been unpleasant to him. But he and I never quarrelled and I think of him as still my oldest friend.' In May 2007, after an initial e-mail, the two spoke on the phone, and in August 2007 they met for the first time in several decades.
7 Letter from George Swan to RG, 27/5/07.
8 AG, in 5SA, 1986.
9 *TT*, p. 157.
10 *TT*, p. 160.
11 Ibid.
12 *TT*, p. 161.
13 *WS97*, p. 97.
14 MRB.
15 RG/AG conversation during car journey from Glasgow to Edinburgh, 13/8/06.
16 From *Author's Postscript Completed by Douglas Gifford*, 2001, *USM*. AG either couldn't be bothered with finishing this postscript or just wanted to see what a critic would make of his work.
17 RG/AG lunch and interview, 12/08/05.
18 Ibid.
19 Ibid.
20 MRB, autumn 1951.
21 *TT*, p. 159.
22 *L*, p. 197.
23 *L*, p. 203.
24 'Time and Place', *ON*, p. 13.
25 'Predicting', *ON*, p. 14.
26 According to AG's friend the actress Katy Gardiner (who owns the original lithograph of this poem), these lines were dedicated to Veronica Matthews, a girl AG was attracted to as a teenager.
27 RG, interview with Ian McCulloch, 4/6/07.
28 From 'Unfit', *ON*, p. 33.
29 RG, interview with KG, 30/8/07.
30 The original title 'Elite' was taken from the name of an ice-cream seller in Riddrie. Brown's was the main venue used to inspire the café in the novel, but in later years the crowd also went to the Classic Cinema Café in Charing Cross, once the owners of

Brown's became less willing to allow students to stay without spending much money. According to Katy Gardiner, the Elite in *Lanark* 'contained elements of both places'.

31 Sludden is the outgoing, gregarious character in *L* who always seems to be in a relationship with most of the women in the group, and goes on to be Provost Sludden later in the novel.

32 MRB, 1953.

33 This exercise was fictionalised in a scene in *Lanark*. In real life, Alasdair's resulting painting 'Beast in the Pit' did have three figures, but had a huge gap with a large tree root in the middle of the picture as a statement of annoyance about being asked to do the exercise in the first place.

34 *82J*, p. 222.

35 Ibid.

36 RG interview with CG, 22/8/07.

37 Ibid.

38 Ibid.

39 Official 1957 members: Douglas Abercrombie, Bill Birnie, Marjery Clinton, Alan Fletcher, Carole Gibbons, Alasdair Gray, Jack Knox, Ewen McAslan, Ian McCulloch, James Morrison, Anda Paterson, James Spence, James Watt. The Group has had more than thirty members in the fifty years since.

40 This word was used by Ian McCulloch in his interview with RG; also appears in the title of his wife Margery McCulloch's essay 'Young Artists in a "Philistine Society"? Making it New in Glasgow 1956–1969' but does not necessarily represent the view of the whole Group.

41 RG/AG art conversation, car to London, 30/9/07.

42 AG's Intro to 5SA, 1986.

43 RG, interview with CG, 22/8/07.

44 Ibid.

45 *LT*, p. 180.

46 Ibid., p. 181.

47 Ibid., p. 184.

48 Ibid., p. 186.

49 Ibid., p. 188.

50 After this date, AG spoke more openly about the following events, including a 2007 interview with BBC Radio 4.

51 RG/AG interview, 23/8/05.

52 From 'Alan Fletcher: An Appreciation', printed as part of 5SA, 1986.

53 RG interview with CG, 22/8/07.

54 'Lamenting Alan Fletcher', *ON*, p. 38.

55 AG, e-mail to RG, 29/4/07.

56 Ibid.

57 From *ON*, p. 39.

58 From AG's Introduction to 5SA, 1986.

59 Stanley Spencer (1891–1959). Artist from Cookham, Berkshire, who studied (1908–12) at Slade School of Art under Henry Tonks (1862–1937). Painted Christian religious scenes, set in his home village, also a series of works portraying Glasgow shipyards.

60 RG/AG car conversation, on the way to London, 30/9/07.

DIARIES: *Art*

1 At the back of *BP*, the *TLS* gets blamed for some of AG's opinions.

2 This was *Under the Helmet*, the 1964 BBC documentary by AG's friend Bob Kitts about AG. See Chapter 4.

3 Painting of Gaz MacAllister and Sarah Eckfort. Much to her annoyance (and Alasdair's), MacAllister later tried to sell the completed portrait back to Morag, not knowing she was AG's wife.

4 This is an edited version of an RG piece in the academic journal *The Drouth* for their 2006 'Image' issue.
5 Joe Murray, 'A Short Tale of Woe', in Phil Moores, ed., *Alasdair Gray*, pp. 237–8.
6 From AG interview with Laura Hird, May 2005, for Pulp.net.
7 Charles Rennie Mackintosh (1868–1928): One of the late-nineteenth-century 'Glasgow Four', including Margaret MacDonald (later CRM's wife), her sister Frances and CRM's friend Herbie McNair. They developed the 'Art Nouveau' style showcased in the Willow Tea Rooms in Glasgow and the Glasgow School of Art.
8 EK, in 'Art for the Early Days of a Better Nation', Phil Moores, ed., *Alasdair Gray*, p. 93, quoting from *Gray Matter*, 1993, directed by Donny O'Rourke, for Scottish Television.
9 From draft of introduction to *A Life in Pictures*, 29/8/07 version. This quote was inserted after the original diary entry.
10 This group has also been referred to as the 'New Glasgow Boys'.
11 Now renamed the Centre for Contemporary Arts.

3 1960S: MARRIAGE, FATHERHOOD, FAKE DEMISE

1 RG/AG interview, 29/8/07.
2 Ibid.
3 The reviewer was probably Cordelia Oliver.
4 This refers to one of many paintings of Carole Gibbons.
5 From *The Bulletin*, review by Kim Redpath. Also a column entitled 'Art in Scotland' called his command over scraper board 'wholly admirable and expert'.
6 This story was later included in *LT*, 1985.
7 MBh e-mail to RG, 9/9/07.
8 Letter from George Swan to RG, 27/5/07.
9 RG interview with Rosemary Hobsbaum, 10/5/07.
10 Ibid.
11 From *Daily Herald*, 22/1/61.
12 RG interview with Carl MacDougall, 23/7/07.
13 Leaving his girlfriend Denny behind, the young Jock McLeish goes to Edinburgh, where he meets his eventual wife, Helen.
14 From Alasdair Gray's Personal CV, in Phil Moores, ed., *Alasdair Gray*, p. 37.
15 From AG, interview with Paul Taylor in the *Independent*, 15/8/95.
16 RG, interview with Carl MacDougall, 23/7/07.
17 From AG, interview with Paul Taylor in the *Independent*, 15/8/95.
18 Conversation between RG and AG, 28/6/07, on a trip to Alasdair Taylor's posthumous art exhibition. In *82J* it is strongly suggested that Helen and Jock only go ahead with their wedding because they feel unable to return their presents.
19 RG/AG interview, 29/8/07.
20 Unmarked scrap of diary, 1962.
21 This is a skin condition which appears in Unthank sections of *L*. Has some properties similar to eczema but is scaly, reptilian, cold, and spreads over time.
22 Iain Crichton Smith, review of *Old Negatives* in the *Scotsman*, 5/3/89.
23 Unmarked scrap of diary, 1962.
24 Ibid.
25 'Married', *ON*, p. 46.
26 Ibid.
27 'Mishap', *ON*, p. 47.
28 'Mishap', *ON*, p. 47.
29 Portrait now owned by Bernard MacLaverty, given as a present by his friend and AG's ex-partner Bethsy Gray. The back of the painting reads 'Alasdair Gray, in his early twenties'.
30 'To Andrew, Before One', *ON*, p. 49.

31 *Lines Review*, a small literary quarterly, published 'Unfit' and 'Vacancy' in winter 1962–3 and summer 1963.
32 From a public interview with AG at the ICA, 1986.
33 Ibid.
34 RG/AG interview, 29/8/07.
35 RG/AG interview, 26/5/06.
36 MRB, 1964.
37 RG/AG interview, 29/8/07.
38 RG interview with RH, 10/5/07.
39 *The Dear Green Place* won the *Guardian* Fiction Prize and the *Yorkshire Post* Award for Best Book in 1966.
40 *KW*, p. 3.
41 Ibid., p. 22.
42 Ibid., p. 103.
43 Ibid., p. 63.
44 Ibid., p. 122.
45 RG/AG conversation, 1/8/07.
46 Andrew Gray refers to both his parents by their first names. He explains: 'I called them Alasdair and Inge from when I was about seventeen – I wanted my freedom! Inge wasn't very impressed with that . . .' RG interview, 6/3/07.
47 RG interview with Katy Gardiner, 30/07/07.
48 William Gray went on to be Lord Provost of Glasgow (Convener of the City Council), 1972–5. AG's knowledge of someone in this position helped inspire Book Four of *L*, where Lanark himself suddenly becomes Lord Provost of Unthank.
49 Pete Brown appears in a 1975 anecdote which forms the beginning of AG's story 'The Great Bear Cult', *US*, p. 44.
50 From AG interview in *Cencrastus* magazine, 1983, with Glenda Norquay and Carol Anderson.
51 *Quiet People* was initially received coolly by Stewart Conn at BBC Radio Scotland, who asked AG to make a series of changes to the script. He says, 'So I left it a few weeks, changed a couple of words, and sent it back to him! Of course, he loved the second version – and it was accepted!' RG/AG interview, 29/8/07.
52 RG/AG interview, 6/3/06.

DIARIES: Women, Mostly

1 Mary Carswell Doyle features in a couple of 1980s paintings, along with her son. She is also to be found in cartoon form in *USM*.
2 Later contradicted. On 28/6/07 Alasdair said he knew it had taken place, because Alasdair Taylor told him years after the event.
3 AG e-mail to RG, 29/4/07. They met in their regular café in Glasgow when AG told Margaret not to move: he was sketching her.
4 AG e-mail to RG, 29/4/07.
5 Letter from MB to RG, 14/5/07.
6 AG/RG conversation, 31/5/07.
7 Letter from MB to RG, 4/6/07.
8 RG, interview with RH, 24/5/07.
9 Morag was referring to the Royal Literary Fund, which is partly financed through profits from A. A. Milne's work.

4 1970S: LEAN TIMES AND ALMOSTS

1 This was a forty-minute educational piece set around the time of the French Revolution, based on the real-life trial of the Glasgow-born legal reformer. An early version included interruption by a 'critic', cut in final version, being deemed 'too experimental'.

2 The Makar, or National Poet, is appointed by the Scottish Parliament: Edwin Morgan was appointed to the post in 2004. 'Makar' is a Scots term for 'poet'.

3 RG interview with EM, 12/3/07.

4 RG interview with LL, 17/10/07.

5 Ibid.

6 Ibid.

7 RG interview with EM, 12/3/07.

8 AG/RG telephone conversation, 10/09/05.

9 RG interview with Andrew Gray, 06/03/07.

10 Backseat car conversation, RG and AG, while eating illicit bags of crisps, 28/06/07. (Crisps were not allowed on AG's diabetic diet.)

11 Additional series of three twenty-minute plays for Scottish BBC schools series.

12 Sixty-minute TV play networked by Granada.

13 Ten-minute TV play for Glasgow Schools Service.

14 Twenty-minute TV play networked by London BBC magazine *Full House*. This appeared in short-story form in *TT*.

15 This appeared in short-story form in *TT*.

16 Ibid.

17 'The Crank Who Made the Revolution', *USM*, p. 38. The story of Vague McMenemy, a poor Cessnock boy ahead of his time.

18 As usual, Alasdair got his revenge for the rejection in a story, years later. Binkie appeared in *82J* under his real name. He was portrayed as a man in decline.

19 Philip Hobsbaum: published several volumes of poetry in the sixties and seventies, including *Coming out Fighting* (1969) and *Women and Animals* (1972), but turned more towards literary criticism in later life.

20 AG version of this story told to RG over dinner, 26/3/07.

21 Aonghas MacNeacail, aka Black Angus (because of his black hair), aka Angus Nicolson: poet and critic in Gaelic and English, member of PH's Group. Gets several mentions in the Index of Plagiarisms in *Lanark*, each of which simply directs the reader to another version of his name.

22 Seamus Heaney: poet, Nobel Prize for Literature winner, 1996. Author of many books, including *District and Circle* (2006).

23 Angela Mullane: also known as Angel, AG's lawyer, later entered into the Dog and Bone adventure with AG in 1990. Married Christopher Boyce.

24 Chris Boyce: later published a novel, *Blooding Mister Naylor* (1990), with AG's Dog and Bone publishers.

25 Other members included Donald Saunders, Jeff Torrington, Robin Hamilton and Anne Stevenson.

26 AG, public talk at Glasgow University, 1988.

27 Published in *The Dark Horse*, summer 2002 issue. British–American poetry magazine founded in 1995.

28 AG 'received from James Kelman critical advice which enabled me to make smoother prose of the crucial first chapter', *L*, p. 499, Sidney Workman's footnote 13.

29 RG interview with EM, 12/3/07: 'He had to feel you were the right person to show work to – but then he would open up. If he thought you were the wrong person, in conversation too, he would clam up.'

30 LL, e-mail to RG, 29/5/08.

31 RG interview with LL, 17/10/07.

32 JK, e-mail to RG, 15/10/07.

33 *Memo for Spring*, Reprographia, 1972. Winner of Scottish Arts Council Book Award. Big influence on a young Ali Smith who said she 'realized that she was Scottish and a girl and a poet, and that such a thing was possible'. Smith says if she hadn't read it then she may not have become a writer herself.

34 *An Old Pub Near the Angel*, Puckerbrush Press, 1973. Kelman was published in the USA before he was published in Scotland, after meeting a publisher at PH's home.

35 Tom Leonard, *Poems*, E. & T. O'Brien, 1973.

36 RG interview with AMacN, 27/7/07.

37 RG interview with PL, 31/1/07.

38 JK, e-mail to RG, 15/10/07.

39 RG interview with EM, 31/1/07.

40 See *L*, p. 482, where it is called 'sponsorship' during the Epilogue, when the author is telling the story of how his big book came to be.

41 RG interview with IW, 13/10/06.

42 Kevin Williamson: founder of Rebel Inc magazine, which merged with Canongate in 1996. Published early work by Irvine Welsh, Alan Warner and Laura Hird, and edited the famous collection of stories *Children of Albion Rovers*, Rebel Inc, 1996, which included Welsh, Hird, James Meek and others.

43 Alan Warner: author of novels *Morvern Callar*, Vintage, 1995, and *The Man Who Walks*, Jonathan Cape, 2002. Contributed to *Children of Albion Rovers*.

44 RG, interview with IW, 13/10/06.

45 RG interview with DM, 2006, exact date unknown.

46 Ibid.

47 Ibid.

48 RG/AG interview, 29/8/07.

49 This was admitted in the eventual Epilogue of *L*.

50 RG interview with RH, 10/05/07.

51 E-mail, MG to RG, 6/7/07.

52 *ML*, p. 126.

53 *ML* is one of several 1970s plays AG wrote which heavily feature secretaries. AG always made them efficient, direct and vastly superior to their bosses in every way – maybe a nod to Flo Allen, who typed many of these works, to Margaret Bhutani, and to AG's father, who had typed up his earliest works. See also *Sam Lang and Miss Watson*.

54 Backseat car conversation, RG/AG, 28/6/07.

55 RG interview with Andrew Gray, 6/3/07.

56 Ibid.

57 Ibid.

58 *L*, p. 572.

59 He has retained the technique to this day, employing it whenever he has ideas and there are no secretaries around.

60 RG interview with Andrew Gray, 06/03/07.

61 This was later incorporated into *OMIL*.

62 RG/AG interview, 29/8/07.

63 *L*, p. 572.

64 Author's explanation, *L*, p. 493.

65 *L*, p. 493.

66 Story of Socrates in ancient Athens. Later incorporated into *OMIL*.

67 MRB, 5/2/77.

68 RG/AG interview, 29/8/07.

69 RG interview with Andrew Gray, 6/3/07.

70 RG: e-mail from SWM to RG, 20/8/07.

71 RG: 'Wanting', *ON*, p. 58.

72 Cordelia Oliver, 'Alasdair Gray, Visual Artist', in Robert Crawford and Thom Nairn, eds, *The Arts of Alasdair Gray*, Edinburgh University Press, 1991, p. 33.

73 Ibid.

74 Bruce Charlton, 'The Story So Far', in Robert Crawford and Thom Nairn, eds, *The Arts of Alasdair Gray*, p. 16.

75 This portrait couldn't be part of the 'Continuous Glasgow Show'; MacDougall moved to Fife in 1976.

76 RG interview with Carl MacDougall, 23/7/07.

77 *L*, p. 486.

78 RG interview with PL, 31/1/07.
79 Ibid.
80 RG interview with PM, 1/8/06.
81 Ibid.
82 Ibid.
83 Marcella Evaristi: playwright for television, radio and the stage, including *Commedia*, Salamander Press, 1983.
84 Accession 9417, box 1, notebook 53, National Library of Scotland.
85 'Five Letters from an Eastern Empire', *USM*, p. 106.
86 Introduction by Carl MacDougall to 'Five Letters from an Eastern Empire', p. 105, *The Devil and the Giro: Two Centuries of Scottish Stories*, Canongate, 1991 (1st edition, 1989).
87 Signed on 28 March 1978, negotiated by AG's friend and lawyer Angela Mullane.
88 E-mail, Duncan Lunan to RG, 8/6/07.
89 JK retained some copies through a lottery system – two writers received copies of booklets by others in the co-operative. JK's copies still exist today, after he returned them to AG many years later.
90 'Awaiting', *ON*, p. 59.

DIARIES: *Workalism*

1 Ex-Bishop Richard Holloway has written many books including *Godless Morality* (1999) and *Doubts and Loves* (2001). He is also a critic and TV and radio presenter.
2 This letter went into detail about the Arts Council's past treatment of Alasdair Taylor, and appealed for financial support. This and support from Kelman resulted in aid to help pay for storing AT's work.
3 Originally *The British Popular Political Songbook*, this was first promised on the inside leaf of *AHM* in 1994. Indefinitely postponed because of copyright restrictions and American publishers' reservations post-9/11, but AG still occasionally talks about returning to the idea.
4 In March 2005 Alasdair Taylor was seriously ill. He died on 1st January 2007.
5 Three of the people AG mentioned on this day didn't live to see 2006.
6 Publicity for *The List* magazine's *100 Best Scottish Books*, List Publications, 2005, edited by Professor Willy Maley. Ron Butlin reviewed *L* for it.
7 This is the exact wording used in AG's dedication to AO in *ET*. Example of AG quoting himself.
8 See Chapter 8.
9 Nineteenth-century English founder of Christian religious cult called the Agapemonites. Referred to himself as Elijah. The play was 1977's *Beloved*, later included in *OMIL*.
10 RG/AG, conversation, 9/12/05.
11 This play was never discussed again.
12 AG eventually took up the mantle himself, dealing directly with Liz Calder at Bloomsbury, then (on Morag's advice) Gavin MacDougall at Luath Press, who published *A Gray Play Book* in 2009.
13 These were later found in the Gray–McAlpine home. Much joy. Many apologies to the National Library of Scotland.
14 There was no contact for several days, which AG thought meant they weren't interested in it, but no. Canongate is now a bigger and busier company than in 1981. He can no longer contact the boss whenever he likes.
15 Morag always proofreads his work, regardless of whoever else has done it. She likes exactness: punctuality, in services others provide, in behaviour.
16 Later in 2006 Morag's job came to an end when the *Lennox Herald* replaced all local crosswords with one national one, to save money.
17 This refers to embarrassment at early, adolescent poems AG recited in *Under the Helmet*.
18 This play was originally titled *Talk Tactics*, then *Midge Fritters*, finally *Midgieburgers*.
19 This version of the tragedy about Johann Faust is the most popular about the sixteenth-century alchemist also fictionalised by Wilde, Mann and Bulgakov.

20 Louis MacNeice (1907–63), Irish poet and playwright, part of 'thirties poets' group which included W. H. Auden, Stephen Spender and C. Day Lewis.
21 AG remembered this version was first broadcast in 1949, part of a six-part Goethe centenary on BBC Radio Third Programme, as one of its evening drama broadcasts.

5 1980S: A LIFE IN PRINTER'S INK

1 L, Tailpiece, 2001 edition, repeated by Sidney Workman in the Epilogue to OMI.
2 AG/RG conversation, 15/10/05. This refers to The List's 100 Best Scottish Books of All Time, ed. Willy Maley. Winner: Sunset Song by Lewis Grassic Gibbon.
3 AG interviewed as part of BBC's Omnibus programme, 1983.
4 He saw the word on a sign – Lanarkshire is the Scottish county which includes Glasgow.
5 Philip Hobsbaum, 'Arcadia and Apocalype', in Phil Moores, ed., Alasdair Gray, p. 5.
6 L, p. 204.
7 Ibid., p. 174.
8 RG/AG interview, 14/11/05.
9 AG claimed in an e-mail to RG, 13/7/07, that the Elite is based on the Classic Cinema Café (or Newscine, as some called it), but has in the past referred to it as Brown's Tea Room. Friends such as Rosemary Hobsbaum agree with this view. Katy Gardiner believes the Elite contains aspects of both places.
10 L's Table of Contents says there is an: 'INTERLUDE to remind us that Thaw's story exists within the hull of Lanark's'.
11 L, p. 560.
12 Ibid. p. 480.
13 L, p. 243.
14 Ibid., p. 573.
15 E-mail, SWM to RG, 20/8/07. Now called the CCA, or Centre for Contemporary Arts.
16 RG interview with Carl MacDougall, 23/7/07.
17 E-mail, SWM to RG, 20/8/07.
18 Ibid.
19 RG, interview with RB, 24/10/07.
20 Introduction to L, 2001, by Janice Galloway.
21 RG interview with Irvine Welsh, 13/10/06.
22 RG/AG interview, 29/8/07.
23 RG interview with KG, 30/9/07.
24 RG interview with PL, 31/1/07.
25 RG interview with BG, 29/1/07.
26 Ibid.
27 Ibid.
28 RG interview with TL, 26/7/07.
29 RG interview with AMacN, 27/7/07.
30 JK, e-mail to RG, 15/10/07.
31 AG/RG conversation, 15/10/07.
32 RG interview with Angus Calder, 22/2/06.
33 Ibid.
34 RG interview with Carl MacDougall, 23/7/07.
35 RG interview with Angus Calder, 22/2/06.
36 Angus Calder, Revolutionary Empire: The Rise of the English-speaking Empire from the 15th Century to the 1780s, Jonathan Cape, 1981.
37 SWM, e-mail to RG, 20/8/07.
38 These lithographs, still available as limited edition prints, include: 'The Star', 'The White Dog', 'An Eastern Empire' and 'Domestic Conversation'.
39 RG/AG interview, 29/8/07.
40 Ali Smith, e-mail to RG, 15/1/07.
41 E-mail, SWM to RG, 20/8/07.

42 Ron Butlin, review of *Lanark* in *The List*'s *100 Best Scottish Books of All Time*.
43 *82J*, p. 33.
44 WS Introduction to *82J*, p. xii, Canongate, 2003.
45 SWM, e-mail to RG, 20/8/07: 'I think all the negative quotes were made up. I thought some of them were stupid, some funny. But we went along with them because he's a special case, a one-off and most of what he did was so special (beautiful designs in silver or gold foil on the cloth, etc) that it was worth putting up with things I might not always have chosen myself, and anyway, who was I to interfere with the creative process . . .'
46 *82J*, pp. 56–7.
47 From Phil Moores, ed., *Alasdair Gray*, '1994, Janine', p. 59.
48 Ibid.
49 This is the first line from Kafka's novel *The Metamorphosis*.
50 RG interview with Will Self, 13/8/06.
51 Ibid.
52 RG interview with Alan Riach, 15/2/06.
53 RG/AG conversation, 14/8/07.
54 Ibid.
55 MRB, 10/11/82.
56 Both AG and Kelman visited AO's writing group during the seventies, noted the quality of her work and gave advice. JK, e-mail to RG, 15/10/07.
57 JK, e-mail to RG, 15/10/07.
58 RG/AG hospital conversation, 15/10/05.
59 AG and SJ went to Minorca for a fortnight to write this, though the storyboard was unfinished.
60 See http://www.alasdairgray.co.uk/Lanark/a.htm.
61 RG interview with RH, 24/5/07.
62 RG interview with BG, 29/01/07.
63 RG interview with Katy Gardiner, 30/8/07.
64 See 5SA analysis, in 'Diaries: Art', pp. 82–4.
65 *SSP*, p. 1.
66 Ibid.
67 Ibid.
68 Ibid., p. 2.
69 This was written by Alasdair's father in 1970–1 at his son's request.
70 *ON*, inlay.
71 Ibid.
72 RG interview with EM, 13/3/07.
73 Iain Crichton Smith, review of *Old Negatives* in the *Scotsman*, 5/3/89.
74 RG interview with Peter Mullan, 1/8/06.
75 Ibid.
76 From AG interview with AG, *Sunday Herald*, 2002.

DIARIES: *Attention*

1 *Songs of Scotland* was a book edited by Wilma Paterson, designed and decorated by AG, Mainstream Publishing, 1996. The two worked together on Dog and Bone's publication *Lord Byron's Relish*, which Paterson wrote and Gray illustrated.
2 This show was presented by Phil Williams on BBC Radio Five Live.
3 Paraphrase. No pen in the car.
4 'Bring Out Your Skeletons', *Scotsman*, 4/2/06.
5 Winner of Saltire First Book Award 2005 for novel *Amande's Bed*, and has been a candidate for the Scottish Socialist Party.

6 1990S: SUCCESS, MONEY, POLITICS

1 Christopher Harvie in Robert Crawford and Thom Nairn, eds, *The Arts of Alasdair Gray*, p. 16. '[He] "implags" Goethe in *Lanark*; [and] the McLeish–Denny relationship in *1982, Janine* has its parallels with Faust and Gretchen.'
2 RG/AG interview, 29/8/07.
3 *OP*, Postscript.
4 Until 1989, Bethsy. Since 1989, Morag.
5 'In Sky to Berlin', *OP*, p. 1.
6 RG/AG car conversation on the way to London, 30/9/07.
7 DS had been writing and publishing poetry in journals and magazines for twenty years, and was also the author of *The Glasgow Diary*, Polygon Press, 1984, illustrated by AG.
8 Dog and Bone catalogue, Spring 1990.
9 Ibid.
10 RG interview with AC, 22/2/06.
11 From http://www.glasgow.gov.uk/en/AboutGlasgow/History/Cultural+Renaissance.htm (on 21/9/07), an article about Glasgow's 'Cultural Rennaissance', specifically referring to the 'Glasgow's Miles Better' campaign of 1983–9.
12 From http://www.glasgow.gov.uk/en/AboutGlasgow/History/Cultural+Renaissance.htm (on 21/9/07).
13 'Critic Fuel – An Epilogue', *SL*, p. 232.
14 Ibid.
15 Ibid., pp. 232–3.
16 Ibid.
17 S. J. Boyd 'Black Arts: *1982, Janine* and *Something Leather*', in Robert Crawford and Thom Nairn, eds, *The Arts of Alasdair Gray*, p. 108.
18 *SL*, 1991 edition, p. 253.
19 E-mail, SWM to RG, 20/8/07.
20 'Introduction', *WS97*.
21 Ibid.
22 *WS97*, p. 64.
23 RG interview with BMacL, 5/2/07.
24 Ibid.
25 Ibid.
26 *Guardian*, 27/11/92.
27 Jonathan Coe, *London Review of Books*, volume 14, no. 19, 8/10/92, p. 11.
28 'Scottish Fiction', *Scotsman*, 5/12/92.
29 This story, on the subject of labourer's etiquette, was later included in Ali Smith's collection in the 'Histories' chapter of a book of her favourite stories. *The Reader*, Constable and Robinson, 2006.
30 *TT*, p. 105.
31 RG/AG conversation, Soho, 1/10/07.
32 RG letter to AG, 17/10/05.
33 First meeting of Gray's ex-secretary and new one.
34 This essay was published in Gavin Wallace and Randall Stevenson, eds, *The Scottish Novel since the Seventies*, Edinburgh University Press, 1993.
35 Joe Murray, 'Making Books with Alasdair Gray', *ScotLit* magazine, Issue 31, 2004, p. 12.
36 EK, from *Unlikely Murals, Mostly* documentary, dir. Kevin Cameron, 2002.
37 RG/AG car conversation, on way to London, 30/9/07.
38 *Books in Scotland*, Summer 1996, No. 58.
39 *MB*, p. 11.
40 *Books in Scotland*, Summer 1996, No. 58, p. 5.
41 AG, Louise Jones, 2000.
42 AG's mistake: Francis Head died in 1976.
43 *WL*, p. 129.
44 Ibid.

45 Ibid., p. 55. Morag did not play the part in the staged version. The chatracter and situation was based on her experiences as a bookseller.
46 *WS97*, p. 1.
47 Ibid., p. 33.
48 Ibid., p. 111.
49 Grayblog, 22/11/06.
50 Ibid.
51 *Revelations*, p. 181, 2005 edition.
52 Ibid., p. 185.
53 Ibid., p. 187.
54 AG, in *Unlikely Murals, Mostly* documentary, dir. Kevin Cameron, 2002.

DIARIES: Health
1 Unclear here whether AG meant this biography or *LP*.
2 Taken from AG's obituary of Ian McIlhenny, *Herald*, December 2005.
3 Sir Walter Scott: highly influential in evolution of European novel. AG said Marx thought Scott had a good understanding of the class system – a theory explored by George Lukacs in *The Historical Novel*. AG defended the short story 'The Two Drovers', then proceeded to tell the whole of Scott's *The Tale of Old Mortality*.

7 2000S: RECENT STATES
1 This is a reference to *The Philosophy of Natural History* by William Smellie (1790). Smellie is best known for editing the *Encyclopaedia Britannica* in 1768.
2 *BP*, p. 7.
3 Ibid., p. 8.
4 Ian Sansom, *Guardian*, 20/05/2000.
5 Adam Mars-Jones, *Observer*, 21/5/00.
6 *BP*, p. 528.
7 From George Bruce and Paul H. Scott, eds, *A Scottish Postbag: Eight Centuries of Scottish Letters*, Saltire Society Publications, 2002.
8 Nicholas Lezard, *Guardian*, 9/11/02.
9 Ian McCulloch, *The Artist in His World: With Eight Descriptive Poems by Alasdair Gray*, Argyll Publishing, 1998.
10 RG interview with Andrew Gray, 6/3/07.
11 This quote is taken from an email from AG to RG sent on 11/12/08 after the publication of the hardback of this book. AG felt he had misrepresented the end of Inge's life in the original published quote on p260 and requested the opportunity to correct what he said during a hospital conversation between RG and AG on 5/11/05.
12 Also published as 'The End of Inge', and 'Inge, 2000'. There are now several versions of this poem, including a shorter one in *Saltire* magazine, Autumn 2006.
13 Published as 'Morag, 2002' in *Chapman*, 11/02.
14 ALK, e-mail to RG, 2/11/07.
15 From *Unlikely Murals, Mostly*, dir. Kevin Cameron, 2001.
16 *CSW*, p. xiv, 2001.
17 Ibid., p. 145.
18 Ibid., p. 146.
19 From AG in *The Knuckle End*, p. vi, Freight Publishing, 2004.
20 Ibid.
21 AG, *The Knuckle End*, p. vii.
22 JK, e-mail to RG, 15/10/07.
23 WM, e-mail to RG, 30/10/07.
24 RG/AG hospital conversation, 5/11/05.
25 Liam McDougall, *Sunday Herald*, 5/10/03.
26 RG/AG car conversation on way back from London, 3/10/07.
27 After being recommended by Janice Galloway, RT was first published in *Leonard Pepper*

and Other Stories, a joint book with Irvine Welsh published by Long Lunch Press, 1/5/07.

28 RG interview with RT, 26/10/07.
29 Grayblog, 22/11/06.
30 RG interview with RT, 26/10/07.
31 This is similar to events in *L*, where Thaw's well-meaning helpers desert him through exasperation.
32 This piece has not been published, but did appear on Grayblog, 22/11/06.
33 Grayblog, 22/11/06.
34 Ibid.
35 Ibid.
36 *ET*, inlay.
37 AG/RG conversation, 2003, exact date unknown.
38 *ET*, p. 66.
39 Nicholas Blincoe, *Daily Telegraph*, 28/10/03.
40 Allan Massie, *Scotsman*, 18/10/03.
41 RG interview with MG, 7/4/07.
42 Irvine Welsh, *Guardian*, 11/10/03.
43 Michael Standaert, *San Francisco Chronicle*, 4/4/04.
44 JK, e-mail to RG, 26/10/07: 'Probably it was Alasdair they asked and he just got me involved. I spent a couple of days on it. I was away at the time of the [Calton Hill] event. I don't know if they used any of the finished paragraph we put together.'
45 RG/AG conversation, 15/3/07.
46 *Alasdair Gray: 0–70*, dir. Kevin Cameron, 2004.
47 RG interview with AT, 21/8/07.
48 Ibid.
49 Ibid.
50 Ibid.
51 Ibid.
52 *HWS*, p.2.
53 Despite having to finish off AG's section, AT did not get to see a full version of the book until it was printed.
54 AT e-mail to RG, 7/11/07.
55 RG interview with AT, 21/8/07.
56 Ibid.

DIARIES: Current States

1 This became *Midgieburgers*, first performed at Oran Mor in 2007.
2 This was supposed to appear in late 2006 or early 2007, to be organised by Irvine Welsh, but IW was unable to secure funding to bring AG over to Dublin for it.
3 This is the main road several minutes' walk from the Gray–McAlpine home, as described in the introduction to this book.
4 Paddy Cuneen: director, composer, music director, playwright. Worked extensively on Broadway, won numerous awards for musical scores, and directed David Harrower's *54% Acrylic* at Oran Mor.
5 *Midgieburgers* was revised with additions after this performance, and was updated on Grayblog on 9/10/07, including a new poem by Larry Butler at the end.
6 AG later wrote to AS, correcting him.
7 *82J*, p. 56.
8 Ibid., pp. 55–6.

NOT DEAD YET! A HAPPY ENDING, OF SORTS

1 13/9/07, 17.02: Alasdair recognised symptoms he last got when he had his heart attack, and was complaining of a 'tightness of the chest and queasiness of the stomach'. He went straight to doctor. 18.49: False alarm. *Gray Not Dead Yet!*

2 *OMIL*, p. 31.

3 Ibid.

4 Ibid., p. 9.

5 RG letter to AG, 23/01/07.

6 Ibid.

7 AG e-mail to RG, 13/11/07

8 SK in *Scotland on Sunday*, 7/10/07.

9 The latest text of this poem, about 'a tough little sailor' who turns out to be the ruin of the narrator of the poem, was added to Grayblog on 24/9/07 and has since been translated into Hebrew by Avner Shats, and has been published in Israel.

10 This play is now called *Fleck* and was published as a single volume by Two Ravens Press in autumn 2008.

11 This is now titled *A Gray Play Book* and published by Luath Press in 2009.

12 Now intended to be published by Two Ravens Press in 2009/10.

13 *BP*, p. 626.

ACKNOWLEDGEMENTS

My thanks go to all those who gave their time and energy to this project. It is much richer for all the many contributions of Alasdair's family, friends, colleagues, acquaintances, critics and all the other interviewees who have been so generous with help and information. Any mistakes are my fault alone. Thanks also to my insightful editor at Bloomsbury, Bill Swainson, his assistant, Nick Humphrey, Emily Sweet, my ever-supportive agent, Jenny Brown, to all those who have seen versions of this book over the last three years and given advice, and to all Gray secretaries past and present, especially Dr Helen Lloyd. Thanks also go to Robin Smith and all at the National Library of Scotland, who permitted me to see and quote from their Gray archive. Sincere apologies go to the family and friends I have bored with my Alasdair Gray preoccupation over the past decade, especially my parents, Pam Roberts and Martin Glass, who taught me to ask questions many years ago and have been suffering the consequences since.

A different version of this text, minus some jokes and including more sensible academic detail, is currently being turned into a Ph.D. thesis. I am indebted to the Arts and Humanities Research Council for funding me to undertake this at Glasgow University from 2005 to 2008. If they had not done so, this book would not exist because I would not have been able to afford to live while I wrote it. I am also greatly indebted to my tutors at Glasgow University, Professor Gerard Carruthers, head of the Scottish Literature Department, and Willy Maley, Professor of Renaissance Studies in the English Department, for their continuing support and guidance, and for helping to turn a mere fiction writer into the beginnings of an academic.

Finally, I thank Alasdair for cooperating throughout this process and for having the respect not to interfere with it. The result is better for being independent: thank you for understanding that.

Rodge, Glasgow, 2008

A BIOGRAPHY IS A JOINT EFFORT

INDEX